THE FUTURE THEN

THE FUTURE THEN

Fascinating Art & Predictions
from 145 Years of *Popular Science*

weldon**owen**

CONTENTS

7	Introduction
10	**1870s–1910s**
26	**1920s**
56	**1930s**
86	**1940s**
116	**1950s**
146	**1960s**
176	**1970s**
206	**1980s**
236	**1990s**
266	**2000s–2010s**
296	Index
302	Credits & Acknowledgments

INTRODUCTION

While it may have gone down as a sleeper in the history books, 1872 was a pretty eventful year. The United States established Yellowstone—the world's first national park—and the Metropolitan Museum of Art opened its doors. It was the year that US inventor George Westinghouse received a patent for the fail-safe railway air brake, which is still the basic concept in use today, and the year that American suffragette Susan B. Anthony was arrested for voting for the first time. It also saw the HMS *Challenger* embark on a voyage that would establish the study of oceanography, and a massive solar flare make the Northern Lights visible all the way in Cuba; additionally, it observed the death of Samuel Morse, inventor of the telegraph, and the birth of Charles Greeley Abbot, one of the world's first to tinker with solar power. And, of course, 1872 was the year that an unassuming periodical appeared on shelves for the first time: *Popular Science*.

The magazine was the brainchild of Edward L. Youmans, a nearly blind doctor and science educator who, with the help of his sister Eliza Ann Youmans, conceived of *Popular Science* as a way to spread scientific knowledge to the educated masses. While it started off as a vehicle for reprints of English think pieces, *Popular Science* was one of the first publications to cover the increasingly rapid-fire advances kicked off in the 1870s by the Technological Revolution. By the end of the century, the magazine bore witness to the invention of the telephone, the phonograph, and the electric light, as well as the rise of the automobile, and ran pieces penned by Charles Darwin, Alexander Graham Bell, Thomas Edison, and Louis Pasteur. And by the time WWI rolled around, it had evolved from an academic journal of mainly text—peppered with the occasional diagram or black-and-white photograph—to a magazine rich with interior artwork and beautifully illustrated, full-color covers.

Those covers, of course, have inspired the book you hold in your hands.

Wildly inventive from the start, *Popular Science*'s covers have always looked to the future, presenting readers with marvelous contraptions that would end wars, revolutionize personal and communal travel, connect people near and far, take us to space and the deepest part of the sea, and improve the hum-drum American domestic experience with new entertainment technologies and clever DIY projects. Created by American cartoonist and illustrator John Olaf Todahl for the July 1917 issue (see p. 25), the magazine's first illustrated cover shows a kite balloon—a sausage-shape observation airship used in wartime since the 1890s—newly outfitted with telephone wires that allowed the soldier to communicate what he saw to ground control, as well as a daring new development: a rudimentary parachute that let him jump to evade enemy fire. Other early covers would veer into more speculative territory, like September 1917's fairly insane "air-propelled unicycle" and November 1917's stationary gun buoy (see pp. 24 and 20, respectively), the latter of which curiously suggested sailors would be better off fighting submarines from an inescapable lookout tethered to the bottom of the sea.

Which brings us to an obvious but noteworthy point about predicting the future: Some things pan out, and some things do not. Over the past 145 years, *Popular Science* has had varying approaches to the likelihood of its forecasts—from the hyped-up, you-gotta-be-kidding-me personal vehicles of the 1930s (a Depression-dominated decade in which readers craved escapism) to the straight-forward reportage of just-over-the-bend new gadgets of the 1980s.

In this book, we've sought to figure out what ever *did* happen to all these contraptions and developments, diving deep into the archives to determine if, say, Igor Bensen's autogyro, the cover star of our July 1954 issue, made it to market (sure did—see p. 133), or if the Laserdisc featured on the February 1977 cover ever took off (nope; check out p. 198). There's also the bewildering human centrifuge shown on the February 1948 issue, which actually did—terrifyingly enough—train the United States' first astronauts in the ways of acceleration (see p. 111), and the US government's 1994 declaration that the aliens discovered in Roswell, New Mexico, were actually just crash test dummies. (On that one, the jury's still out; see p. 259.)

For each cover, we've asked ourselves, "Did it happen?," classifying the invention or development with a yes, no, or "it's complicated"—i.e., the contraption in question perhaps didn't take off but contributed to another development that did, or it hasn't made the big time yet but we think it still might. You'll also find an introductory essay for each decade to provide context for the covers that follow; that way, you read about the energy crises of 1973 and 1979 before seeing dozens of covers featuring alternative energy sources throughout the 1970s. It's also important to note that some eras ended up with less real estate: the first 40 years of the magazine, as it didn't run art on its covers until the late 1910s, and the past two decades, as we trust you can remember if more recent predictions have panned out.

In the course of researching nearly 400 covers across the decades, we've stumbled across a few ideas that just would not die—like the strange and unfulfilled dream of circular cars (see pp. 24, 41, 69, and 283) and curious hydrofoil boats that we've yet to make happen (see pp. 143 and 224). We also found ourselves running into repeat characters: visionaries such as physicist and explorer Auguste Piccard (see pp. 60, 108, and 150), aeronautics and submersible inventor Ed Link (see pp. 161 and 165), and engineer and business mogul Elon Musk (see pp. 268, 272, and 290).

While this book certainly paints a picture of the last 145 years of science and technology, it also tells the story of picture-making itself. Flipping through the covers—all carefully and creatively directed by decades' worth of design teams—you'll see styles of bygone eras, from the prismatic art deco covers of Herbert Paus in the 1920s and 1930s (see pp. 49-53 and 64-67) to the classic Americana and pulp-fiction designs of Reynold Brown in the 1950s and 1960s (see pp. 113 and 144). Many were created by artists with whom the magazine enjoyed decades of collaboration, such as prolific illustrators Jo Kotula and Robert McCall; others were artists who made a real mark with one-time contributions, like iconic populist painter Norman Rockwell (see pp. 54-55) and renowned caricaturist Stephen Brodner (see p. 256). We're grateful for all their efforts in helping *Popular Science* capture the imaginations of its readers over the last 145 years. Stay tuned for the next 145.

The Editors of *Popular Science*

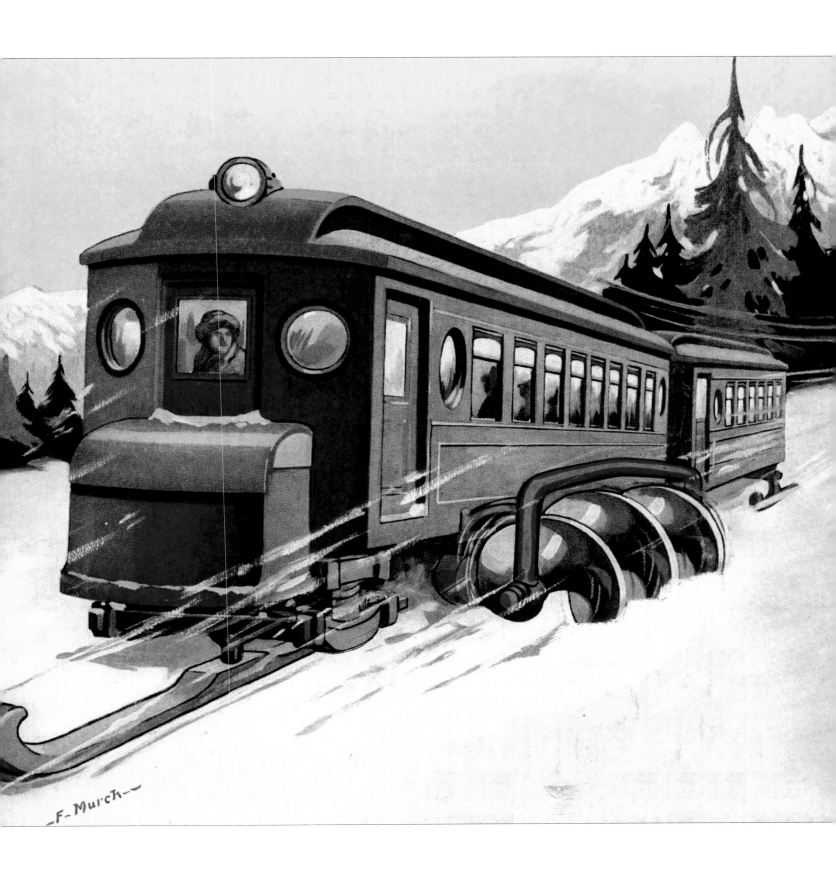

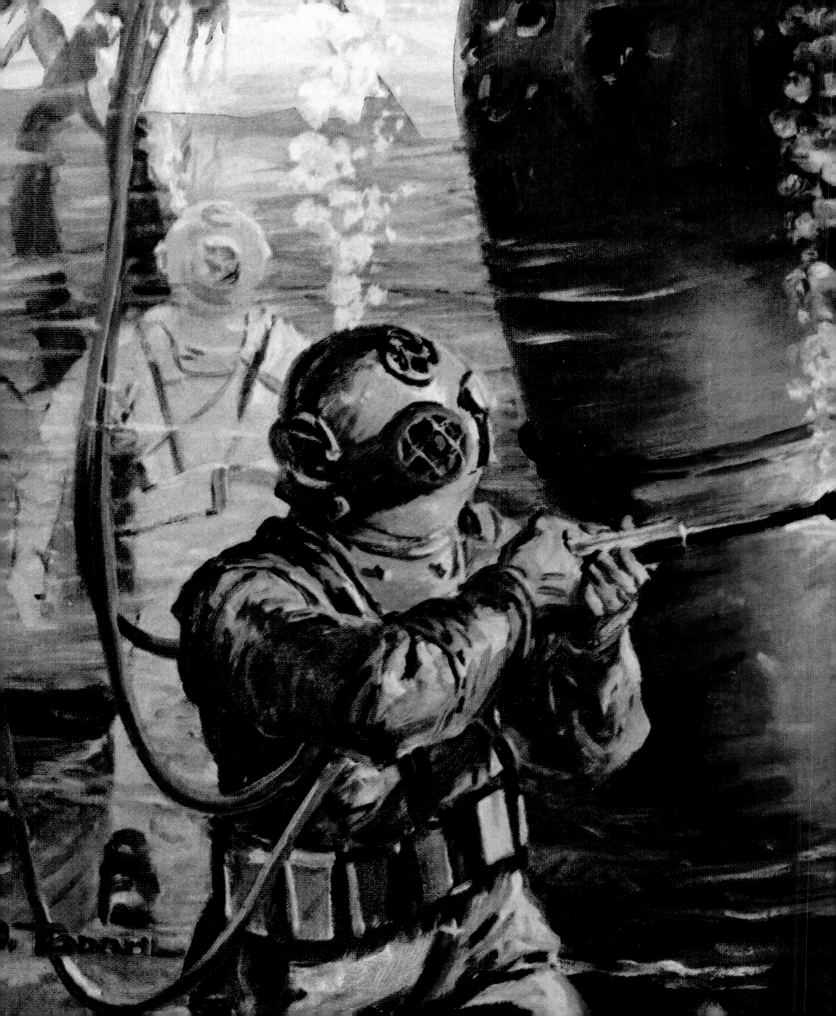

1870s ~ 1910s

1870s–1910s

AMERICAN INDUSTRIALIZATION AND THE GREAT WAR

Not 10 years after the close of the American Civil War, the first issue of *Popular Science* was printed. A black-and-white affair leading off with a portrait tribute to the recently deceased Samuel Finley Breese Morse (inventor of the telegraph and namesake of Morse code), the first issue covered topics such as the science and immortality of the soul, and current thought on disinfection. It was thoughtful and philosophical and, in the coming years, would cover much more on the frontiers of science. Against a backdrop of rapid industrialization and migration toward cities—and, eventually, WWI—the years between 1872 and 1920 would forever change the way we interact with the world, communicate with each other, and even understand the laws of physics.

IT'S ALL RELATIVE

Before Einstein, Newton's laws of physics were largely accepted as true. Newton thought that gravity pulls on every part of the universe—from snowflakes falling from the sky to the moon orbiting Earth. But he never figured out why, or where gravity, as a force, comes from. This wasn't good enough for Einstein, who, in 1905, penned a paper proposing his theory of special relativity. The theory is based on two main suppositions: 1) for all nonaccelerating observers, the laws of physics appear the same, and 2) the speed of light is constant—it can't be increased or decreased. From these two statements, Einstein asserted that there is no such thing as a fixed frame of reference—that instead, everything in the universe exists relative to everything else—and that space and time are not separate but rather form a space-time continuum. Ten years later, Einstein would propose his theory of general relativity, essentially expanding his earlier work to include acceleration. In it, he would explain that large objects—like, say, the sun or Earth—actually warp space-time, the same way a ball might weigh down the center of a sheet held taut on all edges. This warping creates what we experience as gravity.

THROWING VOICES

While the telegraph had been around for decades, the late 1800s brought with them the invention of two gadgets with staying power: telephone and radio. The telephone is credited to Alexander Graham Bell, a professor in speech and vocal pathology and a champion of the deaf—occupations that gave him a greater understanding of phonetics and language than others working on similar technology at the time (say, Elisha Gray, who fought Bell over patent rights). In 1876, Bell spoke the first words on the phone from his laboratory: "Mr. Watson, come here; I want to see you." When Bell passed away in 1922, millions hung up their phones, observing a moment of silence for the inventor. Radio had similarly

CAN YOU HEAR ME NOW?

At far right, a photo from the *Detroit News* of a man using Bell's original telephone for the first time.

At immediate right, the transmitter from Bell's first phone, so named for being first demonstrated at Philadelphia's Centennial Exhibition in 1876.

Above, German theoretical physicist Albert Einstein at work.

1870s–1910s

Above, a portrait of German physicist Wilhelm Roentgen, obviously thrilled with his discovery of X-rays.

At far right, the first X-ray image Roentgen ever captured—it was of his wife's hand and wedding band.

contentious origins. While Italian inventor Guglielmo Marconi sent and received the first radio signals across the Atlantic Ocean in 1901, he did so using a number of technologies dreamed up and patented by Nikola Tesla years earlier. Undeterred, Marconi raised huge amounts of funds and eventually, in 1904, received a patent for the invention of radio—under somewhat shady circumstances and to Tesla's righteous fury. It wouldn't be until 1943, just a few months after Tesla died, that the US Supreme Court would overturn Marconi's patent, dubbing Tesla the rightful father of radio.

ACCIDENTAL X-RAYS

The years between 1870 and 1920 brought with them a great number of medical breakthroughs: aspirin, vaccines for rabies and cholera, and the understanding that blood comes in a variety of types. But one accidental discovery would have far-reaching implications in medicine for many years to come: X-rays. On November 8, 1895, German physicist Wilhelm Roentgen was working through a series of experiments, passing electric current through a glass tube from which the air had been removed, when he noticed a glow on some light-sensitive paper he had left lying on his workstation—a glow produced by X-rays. After further inquiry, Roentgen noticed that these rays could penetrate all but the densest materials, such as metals and bone. In one early test, he captured an image of the bones of and a ring on his wife's hand. Within months, doctors were using Roentgen's discovery to set bones and examine gunshot wounds. Roentgen would eventually win the first Nobel Prize in Physics for his happy accident, and his work would intrigue Polish chemist and physicist Marie Curie, who—along with husband Pierre Curie and Henri Becquerel—was awarded a Nobel Prize in Physics for the discovery of radioactivity in 1903.

LET THERE BE LIGHTS

Before electric light, the beginning and the end of the day were largely dictated by the rising and setting of that big lamp in the sky. Of course, there were candles and oil lamps after hours, but nothing that approximated the kind of on-demand room-illumination-at-the-flip-of-a-switch that today many of us take for granted. When electricity became a reliable power source after the 1830s, it set the stage for a more constant and safer form of lighting. Of course, the light bulb wasn't created overnight. It took until the late 1870s for American inventor Thomas Edison (who himself occasionally wrote for *Popular Science*) and British physicist and chemist Joseph Swan to develop versions of the incandescent light bulb—which gives off light when a filament inside it is electrified—in their respective countries. By 1882, Edison and Swan were celebrating the lighting of the first electric street lamps in New York City. And advances in the transfer of power—thanks to developments in alternating-current technologies—meant that electric light could cover areas farther away from where that power was generated. For instance, in New York state, power drummed up at Niagara Falls was transmitted to Buffalo.

At right, Marie Curie at work in her laboratory in Paris around 1921. After Henri Becquerel discovered that uranium emits X-rays, Curie spearheaded the search for new radioactive elements, working with her husband, Pierre, to discover polonium and radium. These triumphs earned her a second Nobel Prize—this time in chemistry—in 1911.

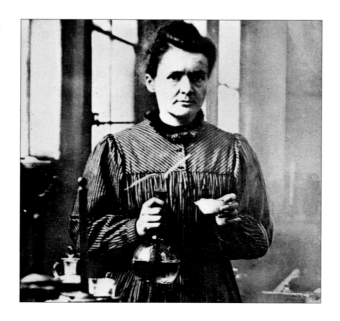

The Future Then

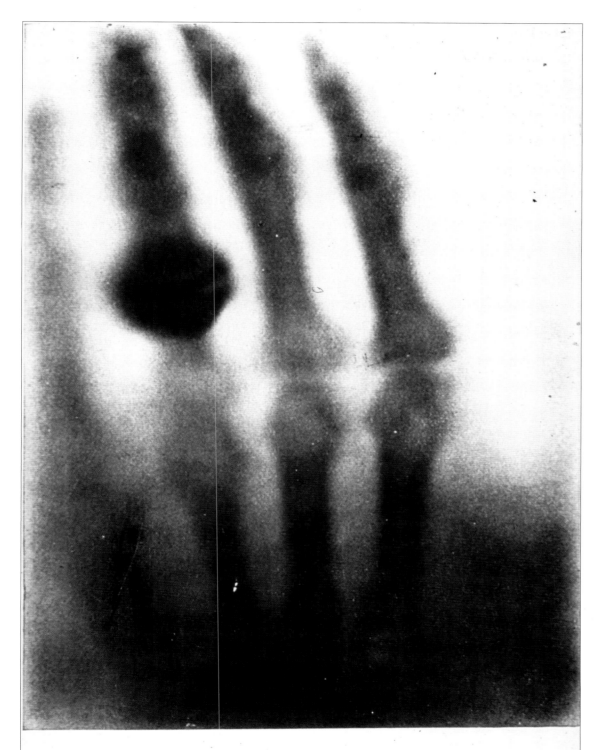

FIG. 39.—The first roentgen photograph. (Mrs. Röntgen's hand.)

ALSO OF NOTE

NOVEMBER 11, 1886
German physicist Heinrich Hertz confirms the existence of electromagnetic waves.

MAY 15, 1888
German-American inventor Emile Berliner patents the gramophone record.

SEPTEMBER 4, 1888
American George Eastman patents the roll-film camera and registers "Kodak."

DECEMBER 14, 1911
Norwegian explorer Roald Amundsen and team are the first to reach the South Pole.

MAY 1911
New Zealand-born physicist Earnest Rutherford identifies the atomic nucleus.

APRIL 14-15, 1912
The *Titanic* sinks.

1870s–1910s

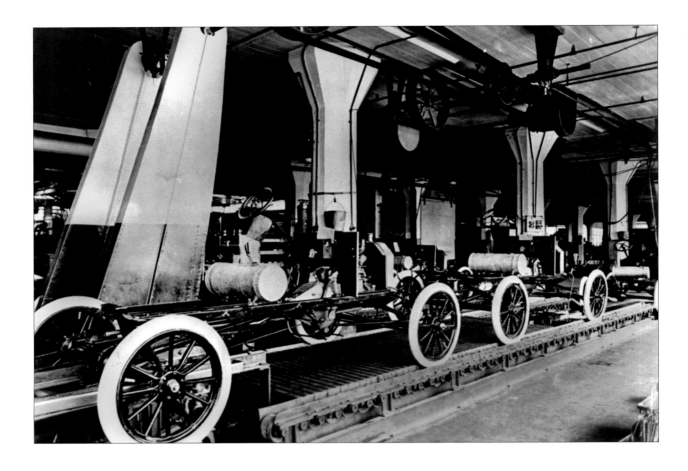

UP AND DOWN THE ASSEMBLY LINE

The Benz Patent-Motorwagen—an open-top, three-wheeled motorized contraption, introduced in 1885—is widely considered the first automobile to use an internal combustion engine, like today's cars. But that's not really the story of autos around the turn of the 20th century. Honestly, it's less about the cars and more about how they were made. Ransom Olds, founder of Oldsmobile, was the first to fire up an assembly line in his factory in 1901. Inspired by the way meat-packers broke down animals and breweries bottled their products using conveyor belts, Henry Ford improved upon Olds's notion and created the first moving assembly line to mass-produce cars—shrinking the time that it took to build one Model T from more than 12 hours to fewer than two. Ford worked to make the process even more efficient over the years, breaking the building of a car into dozens of steps, with workers each trained in a specific one. All of this meant that Ford could make more cars faster and cheaper—and the assembly line itself would change manufacturing for decades to come.

HEAVIER-THAN-AIR MACHINES

You can't really talk about the great leaps and bounds of science around the turn of the 20th century and not mention flight. Earlier, a number of so-called lighter-than-air machines—balloons, dirigibles, and blimp-type contraptions—had flown successfully many times. But it took until 1903 for brothers Orville and Wilbur Wright to make the first powered, sustained, and controlled flight in a heavier-than-air machine—a rough prototype of an airplane—at Kill Devil Hills, just south of Kitty Hawk, North Carolina. The flight covered just over 850 feet (260 m) and lasted just shy of a minute. By 1908, the Wright brothers honed their craft to the point that it was attractive to the US military and, by 1909, they sold the Wright Military Flyer as the first military aircraft. During WWI, planes had a place in battle—first as reconnaissance machines and eventually as rudimentary fighters and bombers.

FORWARD MOTION

Above, partially assembled automobiles sit on the assembly line, presumably while workers take a break.

At right, Orville and Wilbur Wright prepare their biplane for its first military test flight at Huffman Flying Field near Dayton, Ohio. Charlie Taylor, the man who built their first plane engine, looks on.

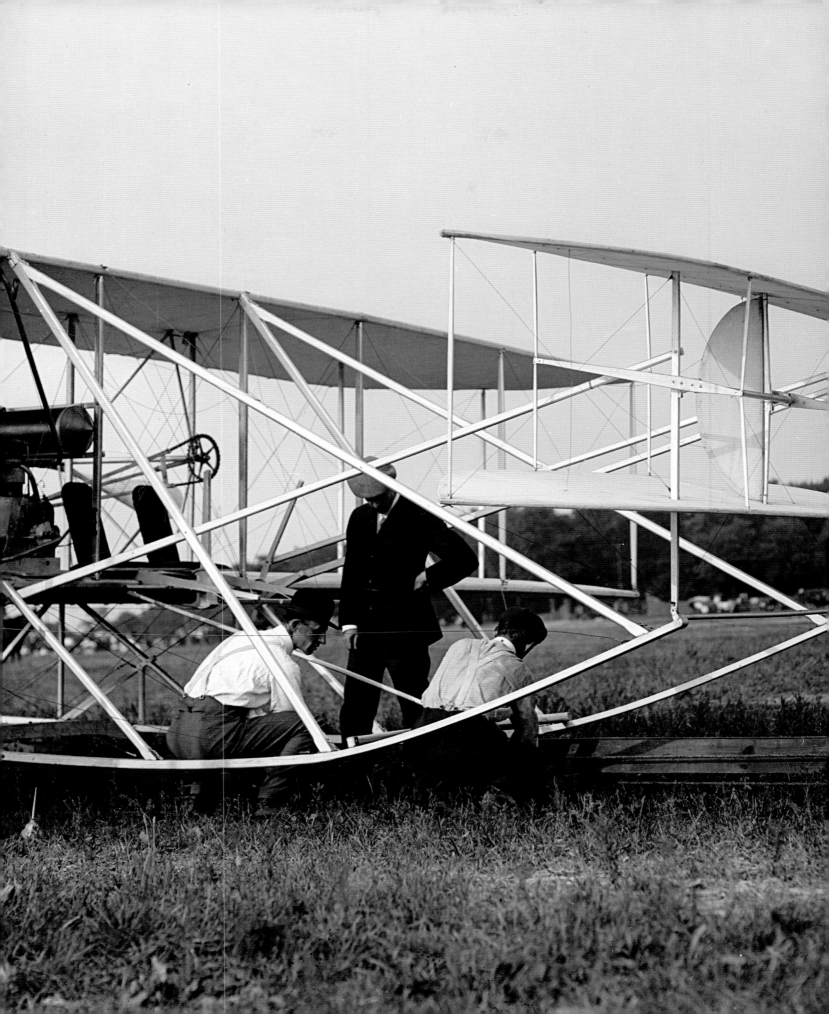

POPULAR SCIENCE MONTHLY.

CONDUCTED BY E. L. YOUMANS.

VOL. I.

MAY TO OCTOBER, 1872.

NEW YORK:
D. APPLETON AND COMPANY,
549 & 551 BROADWAY.
1872.

1870S–1910S

January 1903 · Unattributed · A bust of Henry Shaw, founder of the Missouri Botanical Garden.

✅ DID IT HAPPEN? Yeah. In 1859, Shaw founded what is now the oldest continuously operating American botanical garden. Modeled in part on those that Shaw saw in Europe, and built in consultation with botanists, the garden was (and is) meant to be a place of scientific study as well as a nice place to look at flowers. Perhaps more interesting, this is one of the first (and one of the few in this era) *Popular Science* issues to feature an image on the cover.

April 1916 · Unattributed · A photograph of a pygmy zeppelin's wooden frame before it was covered and sent aloft.

✅ DID IT HAPPEN? Yes, but it failed, just as the editors of *Popular Science* predicted. The Germans had tried a similar wood-composite construction with their Schütte-Lanz airships, and they had already proven too heavy and structurally unsound (the glue in the composite tended to melt when exposed to moisture). Lighter aluminum alloys later won out in dirigible construction—until, of course, airplanes truly took off, rendering zeppelins of any sort curios of the past.

May 1872 (left) · Unattributed · The very first issue of *Popular Science* magazine.

✅ DID IT HAPPEN? Here it is—the remarkably plain first cover of *Popular Science*. Conceived of as an academic journal (not an exploration of what the future might hold, as we know it to be today) by its first editor, Edward L. Youmans, the magazine in its first few decades usually started the text of its main article on the cover and rarely included visuals. When the magazine changed hands in 1915, it evolved from a scholarly affair of 10 or so long-read articles to a collection of zippier pieces with tons of photos and illustrations, some in color. The verdict? Circulation doubled in a year.

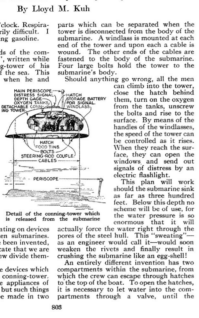

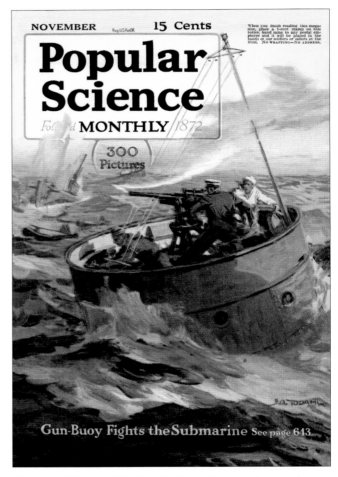

December 1916 · Unattributed · A sketch of a newly invented detachable conning tower, which allowed sailors to escape sinking submarines.

✅ DID IT HAPPEN? Yes. Conning towers—compartments located above a sub's control room, where periscopes were used to navigate and to launch missiles—were revamped to detach from the submarine body in order to save the crew. But such towers haven't been part of submarine design since the 1950s. The last sub to have one, the USS *Triton*, was decommissioned in 1969.

November 1917 · John Olaf Todahl · Sailors fire at a submarine from atop a stationary gun buoy.

❌ DID IT HAPPEN? Come on. In a fight with a submarine, a combat buoy tethered to the ocean floor would be something of a sitting duck, don't you think? Proposed as a replacement for expensive destroyers, these marvels were to be connected to each other by a net that, once disturbed, signaled the presence of a submarine. Red flag: The nets were anchored with bamboo—hardly a confidence-inspiring material.

August 1916 (right) · Unattributed · A simulated sinking in a dry dock.

Popular Science Monthly

239 Fourth Ave., New York

Vol. 89 No. 2 — *August*, 1916 — $1.50 Annually

Catastrophes by the Foot

TO paraphrase the words of a well-known humorist, there is motion-picture realism and, on the other hand, there is motion-picture realism. There is cinema realism which consists mainly in cheap and unconvincing illusions. Into this class falls the director who substitutes a miniature dreadnought in a bathtub for the real article, or the director who mounts his camera on a rolling platform, this device giving to the steady deck of a ship the appearance of rolling and tossing. On the other hand there is the director who will command his players to leap real precipices on horseback. He is the same director who will sink a company of players with a stretch of nailed-down scenery on a floating dry-dock. This type of director is the man who is giving the public its most shivery thrills.

Sinking a "set" on a floating dry-dock has been done more than once. In fact, it is a favorite trick. A stateroom of a ship is built of wood strips, painted canvas and a porthole. It is erected on the platform of a floating dry-dock and the camera adjusted. The action, dramatically speaking, starts. The sea-cocks of the dock are opened and it gradually sinks. Water creeps up—the ship is sinking! The cameraman cranks, the actors go through all of the pantomimics necessary to convey the alarming information that the ship is

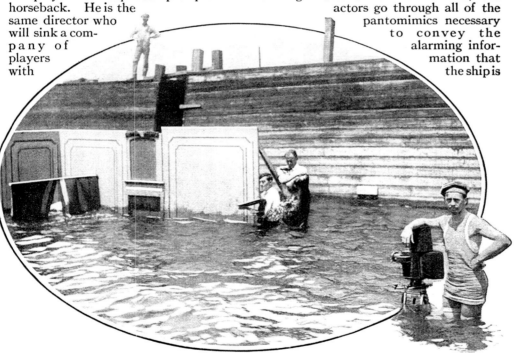

Would you care to be a motion-picture operator or a motion-picture actor, after this? Would you look brazenly out of the picture and care naught for the opinion of the man on the wharf?

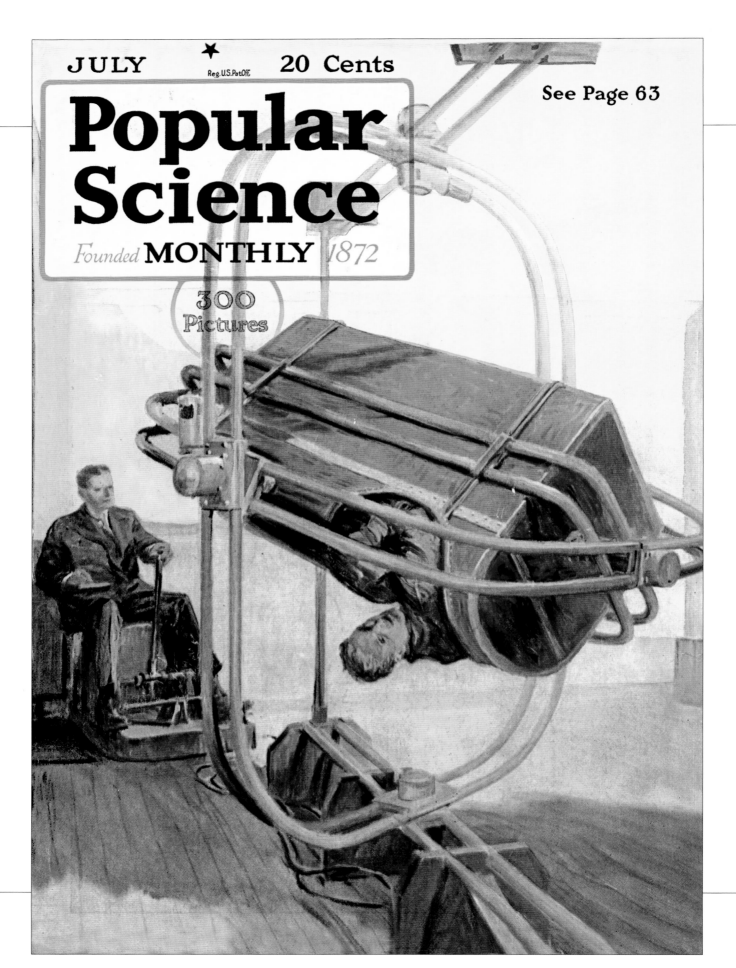

1870s–1910s

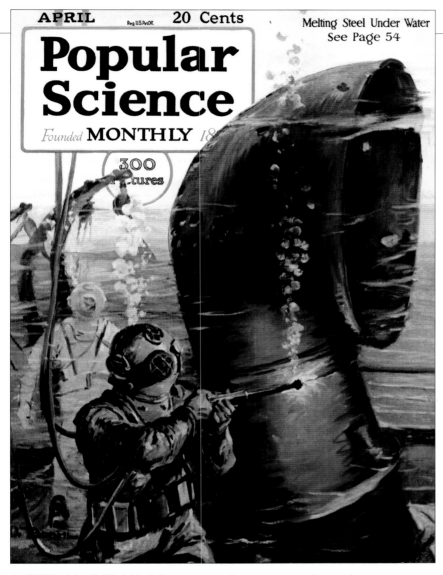

April 1919 · John Olaf Todahl · A diver uses an underwater oxyacetylene torch to cut away a ship's wreckage.

✅ DID IT HAPPEN? Sort of. Invented in the early 1900s, oxyacetylene torches were supposed to be the future of clearing sunken wreckage—at least according to this issue. The authors likely didn't know that, at depths of more than 30 feet (10 m), water pressure is more than acetylene gas can handle, so this torch wouldn't work on the ocean floor. Hydrogen, however, can withstand great pressure and is commonly used underwater.

July 1919 (left) · Unattributed · A pilot-in-training takes a joyride on a bucking orientator while an instructor cranks the juice.

✅ DID IT HAPPEN? Sure did. In 1912, William G. Ruggles invented the Ruggles orientator, which let instructors jostle pilots-in-training around and would-be pilots practice flight maneuvers at safe heights. Some flight simulators today involve similar disorientation training but are more realistic than Ruggles's old "bathtub."

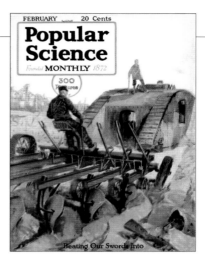

February 1919 · Unattributed · A converted tank tills a field.

✅ DID IT HAPPEN? Sure, some tanks were adapted into farm equipment. But this issue's premise—that war machines would find new purpose after WWI—fell short. Sadly, the world soon found many less-than-peaceful uses for its bombers, guns, and other violent innovations.

July 1918 · Unattributed · A cargo ship with a detachable engine.

❌ DID IT HAPPEN? No. The idea was that cargo ships with detachable engines would save time—since a ship could take off without waiting for a full one to be unloaded. Turns out cargo cranes are more effective.

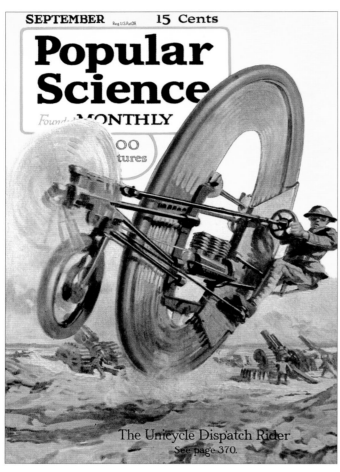

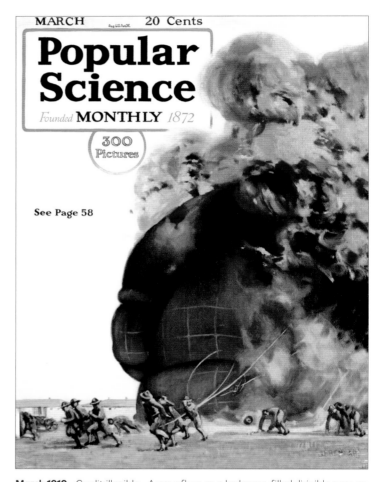

September 1917 • Unattributed • A daredevil rides an air-propelled unicycle invented by Frenchman A. F. d'Harlinque.

❌ DID IT HAPPEN? No way. This thing is a death trap—not to mention a strange name for a two-wheeled vehicle. Basically a backward penny-farthing (one of the first bicycles, invented in the mid-1800s), d'Harlinque's bike featured an air-screw propeller that—at high speeds—forced the front wheel off the ground, allowing the rider to coast on the back wheel. The *Popular Science* editors didn't buy it then (or now) but thought that with a real engine it would prove a "jolly sport machine."

March 1919 • Credit illegible • A crew flees as a hydrogen-filled dirigible goes up in flames at Fort Sill, Oklahoma.

✓ DID IT HAPPEN? Many, many times before airships switched from violently explosive hydrogen to nonflammable helium as their gas of choice. This cover feature explains how wartime scientists secretly figured out how to liquefy natural gas from the American Great Plains to isolate helium and give zeppelins a much safer lift. The element is so rare in nature that the first rigid airship to be filled with it (the USS *Shenandoah*) contained most of the world's supply.

July 1917 (right) • John Olaf Todahl • An officer jumps from an observation balloon with the help of a parachute.

The Future Then

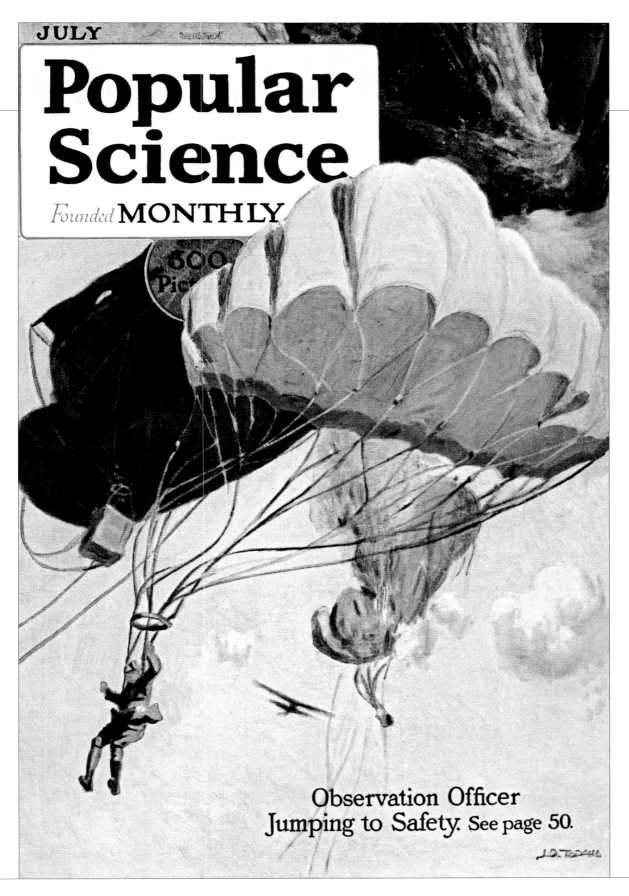

Observation Officer Jumping to Safety. See page 50.

DID IT HAPPEN? Yeah, even before WWI officers manning observation balloons for reconnaissance often had to parachute from them when attacked by so-called balloon busters, which were in turn fired on mightily by antiaircraft shooters on the ground. Good times.

1920s

1920s

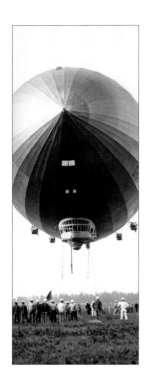

A ROAR AND A CRASH

A lot of things happened in the 1920s. Women gained the right to vote, American wealth essentially doubled, and, for the first time, more people lived in cities than on farms. And with the Great War over, many could hardly fathom anything like it happening again. Enabled by consumer credit, people spent money they didn't have and lived like peace and prosperity were here to stay. But the 1920s were closer to a collective bender—a cathartic postwar consumer binge—than the start of permanent peace. Before the stock market crash of 1929, the decade gave us huge advances: in technology, in medicine and transportation, and in how we see ourselves in relation to history and the universe.

UP, UP, AND AWAY

The 1920s brought us many skyward firsts. Invented by Spanish engineer Juan de la Cierva, the first autogyro—the predecessor to the helicopter—took to the skies at a Madrid airfield in 1923. In 1924, eight US military pilots and mechanics flew four planes more than 27,000 miles (43,500 km) around the globe in 175 days. In 1927, Charles Lindbergh became the first to fly solo across the Atlantic, piloting his *Spirit of St. Louis* from New York to Paris in 33 hours. The *Graf Zeppelin* also crossed the Atlantic in 1928 and completed an around-the-world journey in 1929. But two aeronautical advancements really left their mark: In 1926, Robert Goddard sent the first liquid-fueled rocket skyward on his aunt's farm in Auburn, Massachusetts. While even the *New York Times* ridiculed the idea that liquid-fueled rockets would one day break through Earth's atmosphere, history proved Goddard right. Then, in 1929, James Harold "Jimmy" Doolittle completed the first blind flight—guided solely by instruments from takeoff to landing—and paved the way for the modern cockpit.

GADGETRY AND THE ELECTRIFIED HOME

Made possible by widespread adoption of the assembly line—and a postwar pivot to consumer goods—the 1920s were unrivaled up to that point in home gadgetry and items of convenience. Clarence Birdseye invented a method of quick-freezing food on an industrial scale, making possible today's frozen-dinner aisle. The Electrolux home vacuum cleaner and Schick electric razor came onto the scene. And appliances like the home refrigerator and the washing machine began to appear in homes with increasing regularity. Of course, none of these tools would be worth their salt if it weren't for the expansion of electricity. Beginning primarily in the cities, by the middle of the 1920s, more than two-thirds of American homes were connected to one power grid or another.

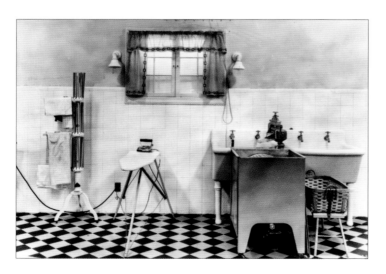

NEWFANGLED LUXURIES

Above left, the *Graf Zeppelin* airship takes flight.

At left, an electric iron and a washing machine bring new meaning to the phrase "all the conveniences of home."

At right, Charles Lindbergh stands in front of his plane, the *Spirit of St. Louis*, flight goggles in hand.

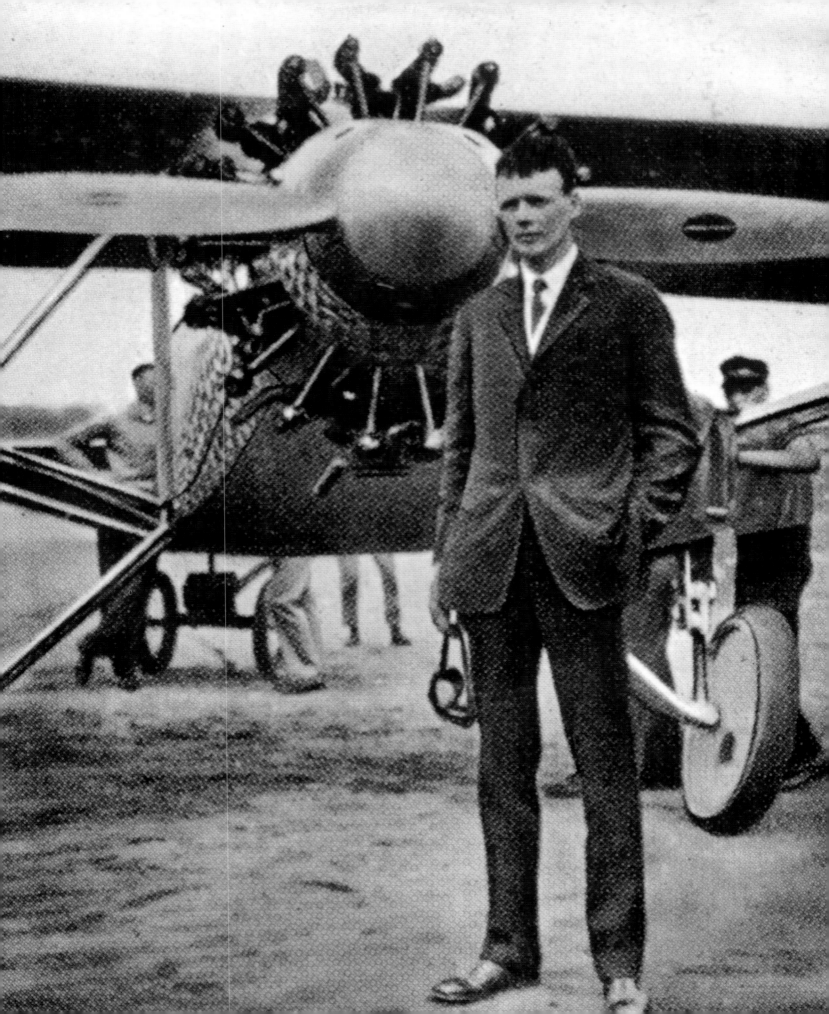

1920s

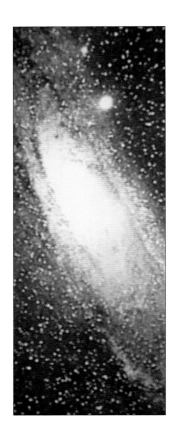

ACROSS THE UNIVERSE

The universe used to be understood as something eternal—orderly and unchanging. During the 1920s, that all, well, changed. First, in 1924, Edwin Hubble discovered that Andromeda (which had been observed since ancient times) is not a nebula but instead is one of many galaxies throughout the universe—like our home, the Milky Way—and expanded the notion of the universe entirely. Later, Belgian Catholic priest Georges Lemaitre proposed that the universe isn't static—rather, it is expanding uniformly in all directions. Without any real evidence, Lemaitre was largely ignored. But in 1929, Hubble, unfamiliar with Lemaitre's work, published "A Relation Between Distance and Radial Velocity Among Extra-galactic Nebulae," a paper presenting just that evidence. Later, Lemaitre followed this theory back to its logical beginning, publishing a report claiming that the universe originated with the explosion of "the Cosmic Egg"—a singular, primeval atom. Sound familiar?

CURES FOR THE INCURABLE

While the 1920s brought the discovery of vitamins A, B, C, D, E, and K, as well as Albert Calmette's vaccine for tuberculosis and Hans Berger's invention of a test that measures brain activity (the electroencephalogram, or EEG), two cures for the previously incurable stand out. The first came in 1921, when Frederick Banting and Charles Best isolated insulin—an effective treatment for diabetes—in a group of dogs. After beginning human tests in 1922, Banting and Best gave drug companies license to produce insulin for free. The second cure for the previously incurable was Scottish Alexander Fleming's accidental discovery of penicillin in 1928—a find made when, returning to his lab after a holiday, he noticed that a mold had overtaken a bacteria sample. Fleming struggled to refine and grow this mold in the lab, however, and it took until the 1940s before anyone developed an effective treatment using it.

THE BEGINNING OF MASS MEDIA

The 1920s brought something of an embarrassment of riches in terms of broadcast and media technology. The first commercial radio station, KDKA, began broadcasting on election night in 1920, leaving a few hundred listeners glued to their radios as the returns for the Harding-Cox presidential race poured in. After that, radio became the first true mass medium. By 1921, the first World Series baseball game was broadcast live on the air, and by 1922 the BBC began regular daily radio programming. The year 1927 was a big one for moviegoers, as *The Jazz Singer* became the inaugural full-length "talkie"—a movie with synchronized sound beyond a musical score, including synced-up singing and speech—marking the beginning of the end of the age of silent film. It was also the year that Philo Taylor Farnsworth, a 21-year-old San Franciscan, demonstrated the first true electronic television.

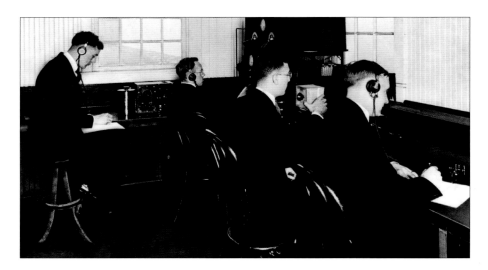

REACHING FOR DISTANT STARS

Above, one of the first photographs of the Andromeda galaxy, snapped by Welsh engineer and amateur astronomer Isaac Roberts in 1899—25 years before we learned it is a galaxy and not a nebula (or a blur on your telescope lens).

At left, four people make up the crew at KDKA as they send the first commercial radio broadcast over the airwaves in 1920.

At right, a 1923 *Popular Science* feature on the discovery of insulin.

The Future Then

POPULAR SCIENCE MONTHLY
SUMNER N. BLOSSOM, *Editor*
SEPTEMBER, 1923

Insulin—A Miracle of Science

How a Young Laboratory Assistant Won World Fame by Discovering Serum that Offers Relief to Millions of Diabetes Sufferers

By Donald Harris

FROM six hospitals in the United States a few weeks ago came some news that electrified the scientific world. A serum derived from the entrails of animals, given to the hospitals for clinical test of its efficacy as a treatment for diabetes, had proved so extraordinarily successful in administration to many hundred patients, that the physicians who conducted the tests asserted without qualification that it appeared to be a sure method of controlling the disease.

What "Insulin" Means

The new serum is insulin, a name derived from the Latin word meaning "island." This name was applied because the particular groups of intestinal cells from which the serum is extracted are known in medicine as the "Islands of Langerhans."

Since the first announcement of the successful tests of insulin, eminent medical men have been almost a unit in declaring that through its general use probably will be sounded the death knell of diabetes, a disease which until now has resisted the best efforts of medical science.

Dr. Simon Flexner, director of the Rockefeller Institute for Medical Research, has said that insulin promises to prove "one of the great medical contributions to the world."

Dr. A. I. Ringer, in charge of the test of insulin at the Montefiore Hospital in New York, stated unequivocally that "insulin is undoubtedly one of the greatest discoveries of the age," and that, now that it has been given to the world, "no person should die of diabetes."

Dr. Nellis B. Foster, writing in the "New York Medical Journal," declared, "I think it is safe to say that could one start with insulin before operation, one could be reasonably sure that the patient would not die of diabetes."

Other medical authorities expressed their endorsement of the new serum with equal enthusiasm, and John D. Rockefeller, Jr., only a few weeks ago contributed $150,000 to permit 15 hospitals in the United States to introduce the use of insulin in their clinics.

Probably the most amazing and dramatic feature of this remarkable discovery is the personality of its discoverer. The man who gave insulin to mankind was no famous medical authority, nor was he even a recognized scientist, trained in the intricacies of research, fortified by exhaustive knowledge of medical lore, and possessing extraordinary equipment in laboratory and materials. Instead, he was an obscure Canadian doctor of 31, less than six years out of medical college, a farmer's son, who had accepted with pride a humble position as a laboratory assistant in a Canadian university when he returned wounded from war service only three years ago.

Moreover, the most valuable part of the discoverer's work was accomplished in the incomplete home laboratory of a young Toronto doctor, a school friend, who permitted him the use of his home and equipment merely because he, the owner, was going away on a vacation and had no use for them.

The discoverer of insulin is Dr. Frederick Grant Banting. Probably there is no better illustration of the general attitude of the medical profession toward him and his discovery than the recent comment of Doctor Flexner:

Where Experts Failed

"No one had ever heard of him. In fact, there was no reason why any one should have heard of him.

"This young doctor didn't know much about diabetes. Quite by chance he discovered how to get insulin and use it as a cure. At Toronto he proved the efficacy of his treatment. We experienced physicians who had so much material and so much scientific background to help us find a cure for diabetes, failed. We feel like kicking ourselves.

"The world is enormously richer today as a result of Doctor Banting's discovery of insulin. It seems to me that mankind never again will be in the grip of this disease as it has been for so long. There is still a bit of danger in its use, but some day we shall all know just how to administer it. Then all the world, every hamlet of it, will appreciate the benefits."

In speaking of "chance" as a factor in Doctor Banting's discovery, Doctor Flexner had no intention of belittling either the discovery or the discoverer. The truth is that in what Doctor Banting has accomplished, chance played a prominent part, and no one is more ready to admit the fact than he.

Diabetes is caused by the failure of the Islands of Langerhans properly to perform their functions. In the normal man these "islands" secrete insulin—the same insulin which now is taken from animals to supply a means of fighting diabetes.

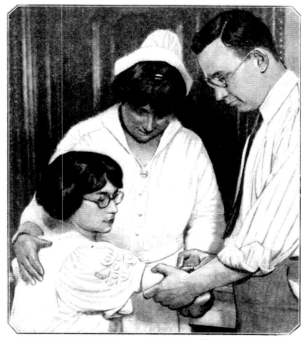

Injecting insulin into the arm of a diabetes sufferer in the insulin clinic of the Montefiore Hospital, New York City. Dr. Benjamin Duborsky is shown administering the new serum

ALSO OF NOTE

OCTOBER 2, 1928
Russian Leo Theremin patents his eponymous musical instrument, and a cult classic is born.

AUGUST 12, 1920
Italy-born conman Charles Ponzi is arrested for defrauding investors of US$20 million.

OCTOBER 1920
Detroit cop William Potts invented the first automatic four-way, three-light traffic signal.

JULY 21, 1925
A guilty verdict is reached in the Scopes Trial–a case of a US teacher, John T. Scopes, accused of the crime of teaching evolution. Scopes was given a US$100 fine.

NOVEMBER 23, 1926
Norwegian chemical engineer Erik Rotheim patents the aerosol spray can.

1920s

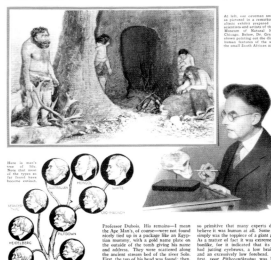

HISTORY IN ROCKS AND RINGS

In the 1920s, the fossil record told us a lot about ourselves. While Howard Carter and team's 1922 unearthing of Egyptian King Tutankhamen's tomb was probably the most headline-grabbing, two developments had farther-reaching implications—one for how we understand ourselves as a species and one for our understanding of prehistoric America. First, in 1924, Raymond Dart discovered the first fossil specimen of *Australopithecus africanus*—one of our early ancestors—near a South African quarry. Calling his discovery the Taung Child after the town where it was found, Dart proposed humanity's African origins based on the find. While some scoffed at the suggestion, time would prove Dart right. The second development had to do with the tree ring record. By piecing together tree rings left on beams and timbers excavated from ruins in the American Southwest, A. E. Douglass, an American astronomer by trade, ultimately created an accurate calendar stretching back to the year 700. In so doing, Douglass founded and formalized the study of dendrochronology—the method of using tree ring records to chart weather patterns throughout history.

BRIDGES, TUNNELS, AND SKYSCRAPERS

The 1920s brought cars to the masses. Falling prices and consumer-credit plans led to a car-buying frenzy, to the point where traffic as a phenomenon first came into existence. By 1927, when Ford's Model T stopped production, the company had sold 15 million low-cost, reliable vehicles to consumers. Such a drastic uptick in auto purchases spurred its own boom in infrastructure building, with a huge number of highways, bridges, and tunnels constructed throughout the era. Some notable ones include Route 66—a highway between Chicago and Santa Monica that opened in 1926—and New York City's Holland Tunnel, which first saw traffic in 1927. The 1920s also brought construction in a direction perpendicular to all those new roads: up. While the first skyscraper was built in 1885 in Chicago, the 1920s' booming economy led to high-rises in most cities. And in New York City, developers sparred for the title of tallest skyscraper. Ultimately, the Empire State Building won out at 1,454 feet (445 m).

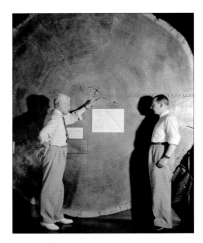

Top, a 1931 interview with American zoologist Dr. William K. Gregory, who discusses Raymond Dart's discovery of the Taung Child.

Above, A. E. Douglass points to a cross section of a sequoia to show how large the tree was at a point in history.

At right, a worker waves from a girder of the under-construction Empire State Building with the Chrysler Building—the world's tallest structure when finished at the decade's end—in the background.

The Future Then

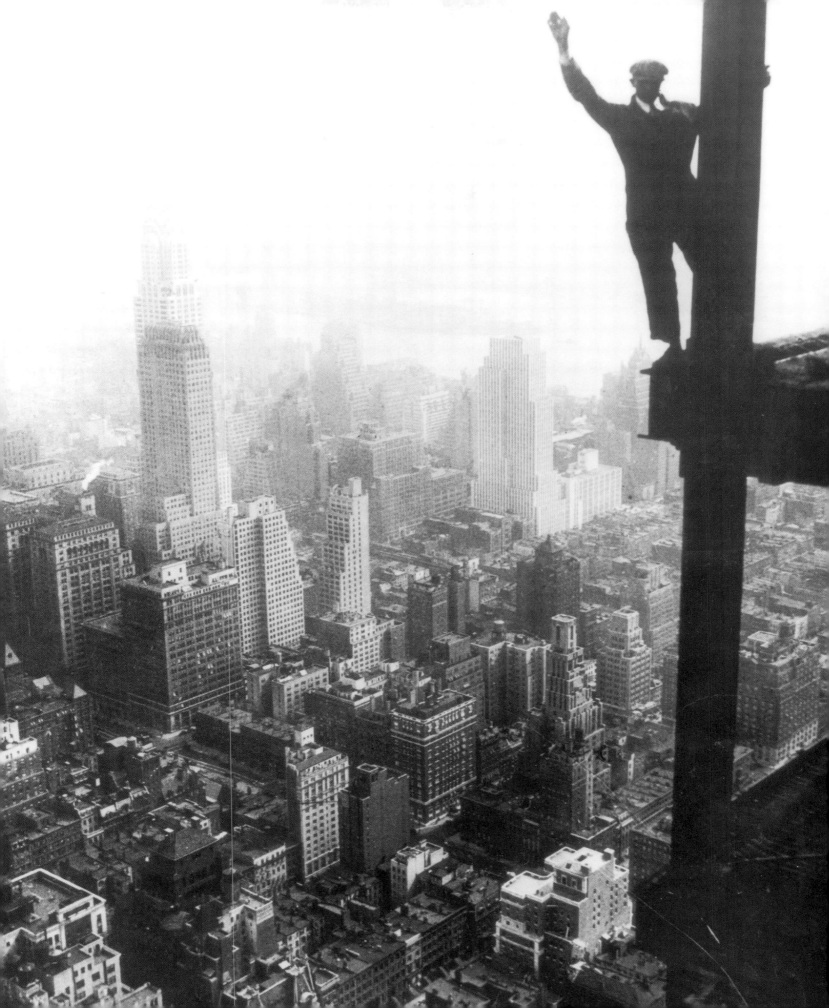

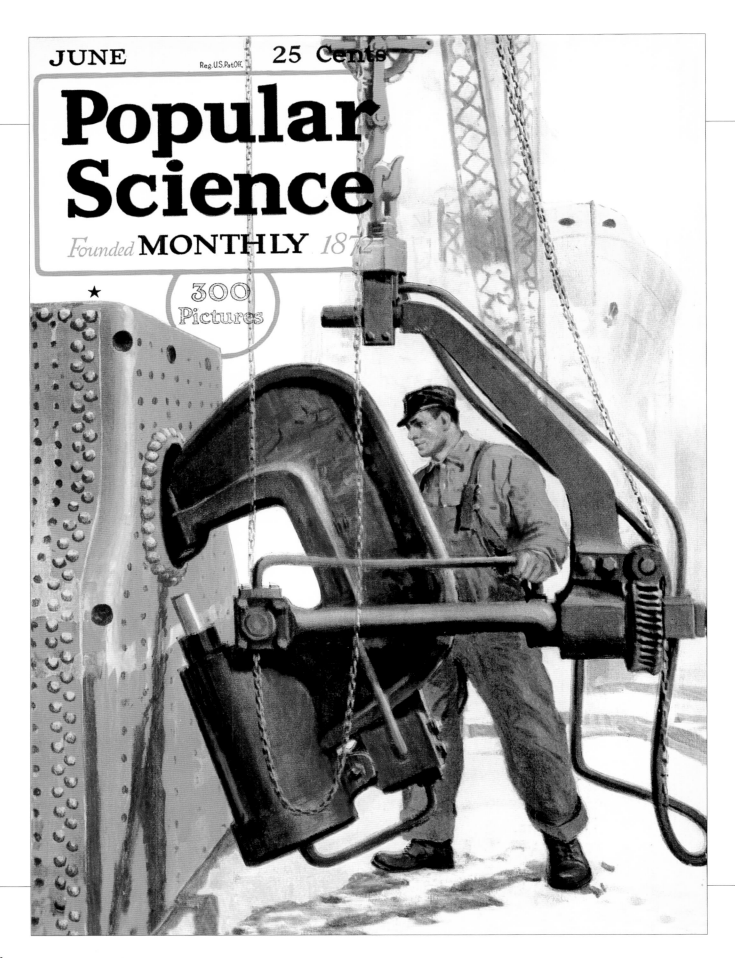

1920

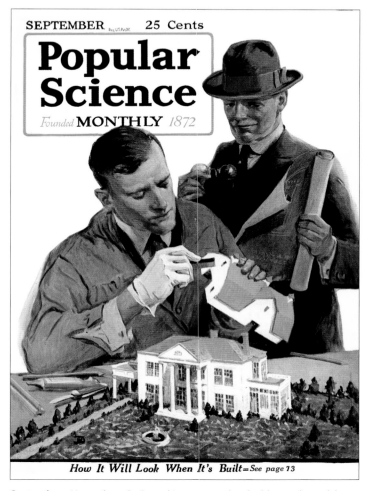

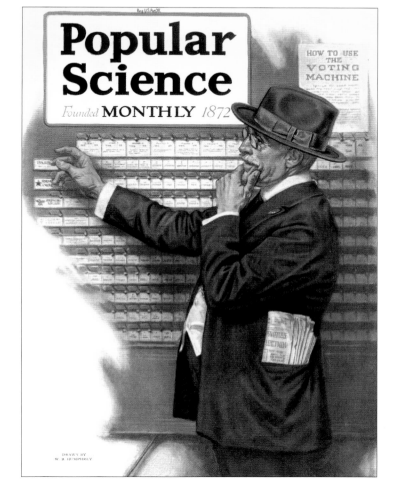

September · Unattributed · An architecture student builds a scale model while an instructor watches.

✅ DID IT HAPPEN? Um, definitely. Architects and students use models to mock up future buildings. In this issue, the use of models was highlighted as a new way for architecture students at Columbia University to show their work, so to speak. Before scale models, students would draft plans and paint simulations of what a building would look like.

November · W. B. Humphrey · A fellow uses a voting machine to cast his ballot.

✅ DID IT HAPPEN? Yes, voting machines have been used in some capacity since the 1870s. In this issue, the voting machine—which "cannot be manipulated"—is held up as the triumphant slayer of voter fraud. The *Popular Science* of the 1920s just couldn't anticipate hackable electronic voting machines when it claimed that "the voting machine insures honest elections." Simpler times.

June · Unattributed · A worker uses a giant, crane-suspended pressure clamp to hot-rivet in silence.

❌ DID IT HAPPEN? Yes and no. Hot riveting was a common practice for decades, but the tools used to mold white-hot rivets into shape functioned more like a jackhammer than a quiet clamp (and sounded more like one, too). Today, nuts and bolts have largely taken the place of hot riveting, since they take a smaller team to put in place.

December · John Olaf Todahl · A mailman delivers letters in a DIY aero sled.

❌ DID IT HAPPEN? Nah. Cold-weather maker types have built a bunch of fan-boat-type snow machines, but none of them has a propeller on the front—and the US Postal Service certainly doesn't use them.

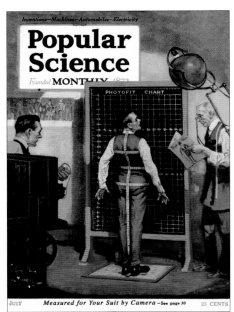

July · Ben Kidder · A man is measured for a suit by photograph while his tailor idly reads.

✅ DID IT HAPPEN? Yeah! Actually, today you can have glasses fitted by photo, punch measurements into the internet and have a tailored suit shipped to you in the mail, or "try on" clothes in a virtual fitting room. All so you don't have to go out in public.

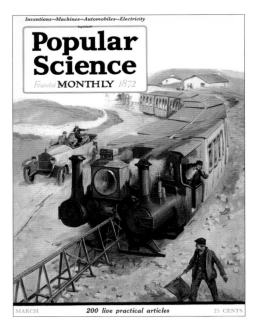

March · Unattributed · A train designed by French engineer Charles Lartigue zooms down a curious railway track made of trestles.

✅ DID IT HAPPEN? Oui. A handful of these monorails were built in Ireland, France, and Algeria. The idea never took off (likely because it had to be perfectly balanced), but you can ride a restored 1,000-yard (1-km) strip in Kerry, Ireland.

February (right) · W. B. Humphrey · Son shows Pops his new electrical circular saw—"a sawmill on wheels"— while a curious puppy watches.

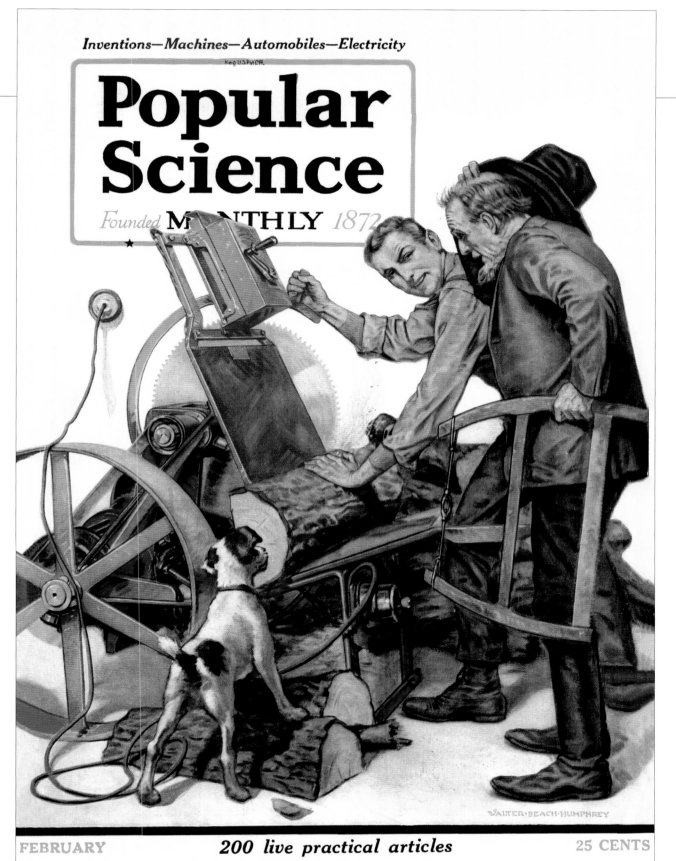

✓ DID IT HAPPEN? Of course, though later portable saws of the handheld variety would have just as much power without needing to be wheeled around. Also, this motif—in which an older person holds a piece of dated technology while a younger person demonstrates the cutting-edge one—is one that would reappear on Popular Science covers throughout the years.

October • Unattributed • The demons of waste keep this car from running at peak efficiency.

✓ DID IT HAPPEN? Indeed it did—and it hasn't stopped since. You're probably due for an oil change yourself right about now, aren't you?

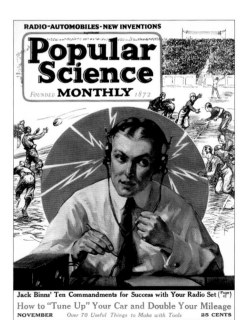

November • Clarence Rowe • A man listens to the big game on his radio headset.

✓ DID IT HAPPEN? At the onset of the Golden Age of Radio, expert Jack Binns shares tips for using early crystal receivers. Sample advice: how to clean the crystal in a jar of carbon tetrachloride. The fun never stops.

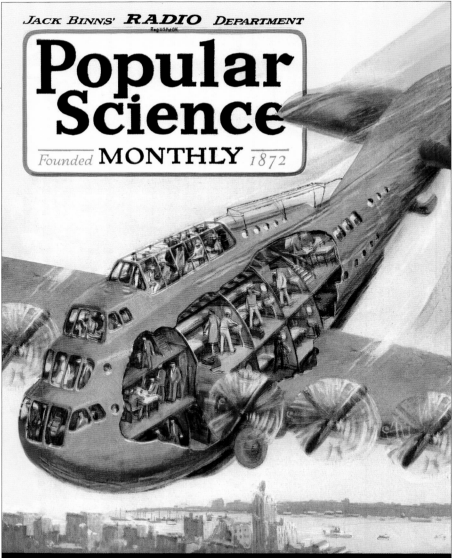

July • Unattributed • A diorama of a multideck passenger jet airliner, as dreamed up by American WWI fighter pilot Eddie Rickenbacker.

✓ DID IT HAPPEN? Yes! And while some of the predicted features (such as the ability to take off from water) never came to fruition, this depiction of a multideck airliner is quite close to at least one in our present-day reality: the Airbus A380, which has two passenger decks and a third for cargo. It is the world's largest passenger plane.

August (right) • Ben Kidder • Couples gleefully ride water toboggans down a big slide in Tampa, Florida.

✓ DID IT HAPPEN? Yes, this ride by F. M. Catron and J. W. Sherman featured a 113-foot- (34-m-) long chute, down which stylish toboggans would plunge at 60 miles per hour (97 km/h). Today, you can enjoy modern variations on this theme at water parks all over—minus the swim cap.

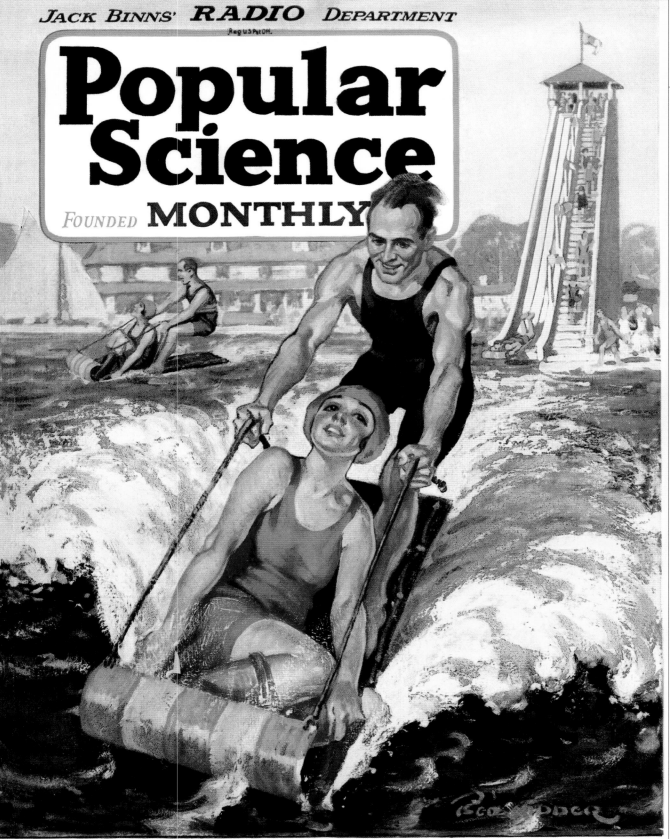

Sixty Miles an Hour on New Water Toboggan (See page 23)

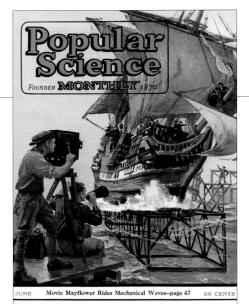

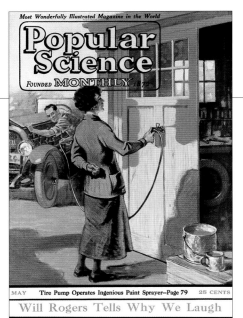

June · John Olaf Todahl · A film crew shoots a sailing-ship simulation.

✓ DID IT HAPPEN? Absolutely. Hollywood can fake pretty much any phenomenon. In this case, producers used an engine-and-ball-and-socket setup to pitch and roll a model of the *Mayflower*.

May · Credit illegible · A woman paints a garage with a paint sprayer powered by a tire pump.

✓ DID IT HAPPEN? Yes. Paint sprayers that you can hook up to an air compressor have been around for many years. Put down the brush.

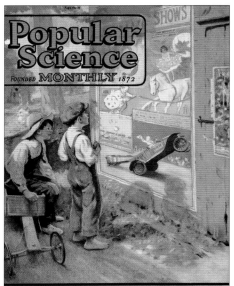

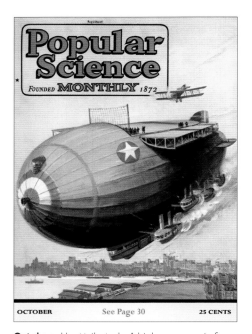

July · Credit illegible · Two boys gawk at a circus poster featuring a trick car doing a wheelie.

✓ DID IT HAPPEN? Sure, trick cars have been lifting their front tires off the ground for decades. But this feature highlights practical tools that were inspired by circus gadgets—for one, a car hoist for mechanics based on the trick flivver.

October · Unattributed · A biplane comes in for a landing atop a plane-carrying airship.

✗ DID IT HAPPEN? Not really. The USS *Macon* was an airship from the 1930s that was designed to carry a few small airplanes, but you couldn't land a plane on it. Besides, it was in service for only two years before it crashed off the California coast.

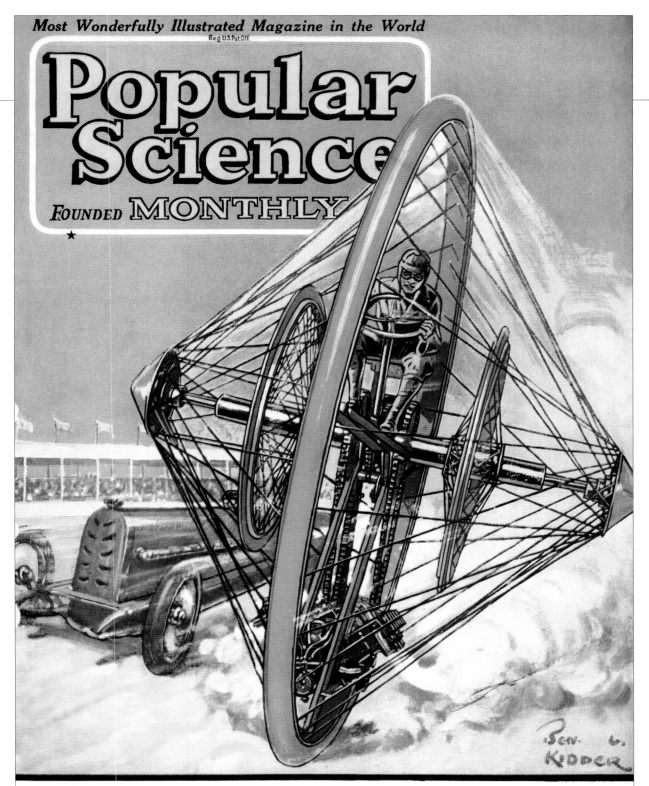

April • Ben Kidder • Professor E. J. Christie's giant gyroscopic wheel, predicted to hit up to 400 miles per hour (645 km/h).

ⓧ DID IT HAPPEN? Sadly, no. Powered by a 250-horsepower engine, this 14-foot- (4.25-m-) tall, 2,400-pound (1,090-kg) vehicle had two gyroscopic wheels that were supposed to help it turn and maintain equilibrium. (Its inventor later committed suicide.)

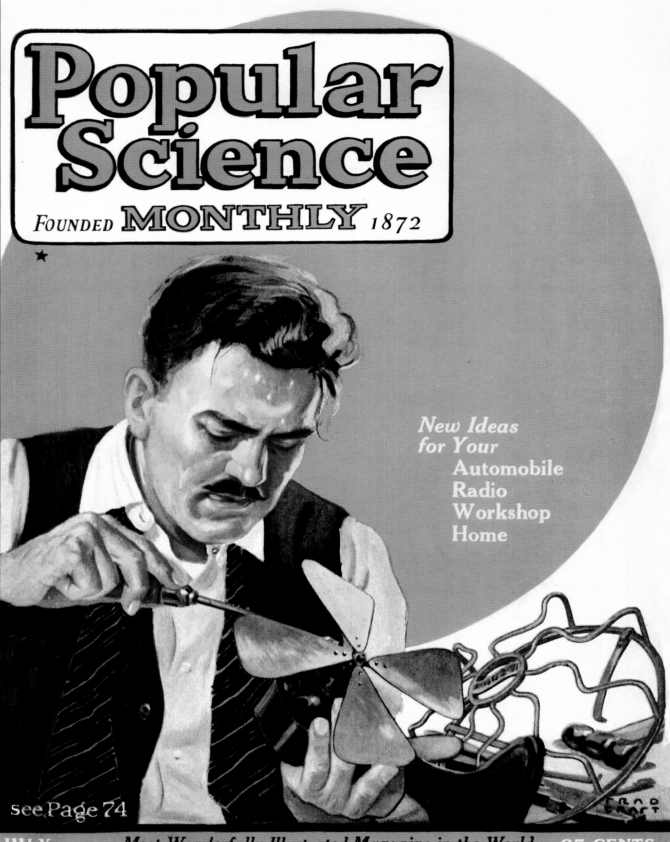

1924

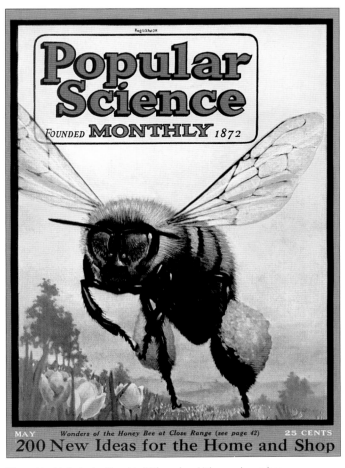

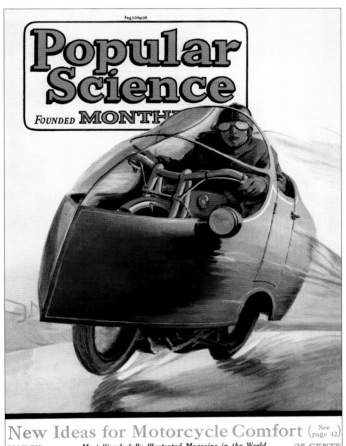

May · Unattributed · It's a bird! It's a plane! It's . . . a honeybee.

✅ DID IT HAPPEN? This *Popular Science* feature is all about the wonders of honeybees, namely their infallibility when it comes to predicting weather. Almost a century later, the jury is still out on that one, though a recent Chinese study showed that bees tend to work later in the afternoon if the following day is going to be a wet one. Some scientists think bees may be sensitive to the changes in humidity, air temperature, and air pressure that signal a coming rain shower.

March · Unattributed · A man on a motorcycle beats the elements with an all-weather shield.

✅ DID IT HAPPEN? Yes, and with surprising accuracy. It took a few years (like, almost 100), but a number of covered motorcycles that look pretty close to this uncredited design exist today.

July (left) · Fred Craft · A really hot and sweaty guy just needs his fan to work.

✅ DID IT HAPPEN? This piece was all about what to look for when your fan goes on the fritz and how to fix it. Some things have changed, but good ol' fans are still fixable.

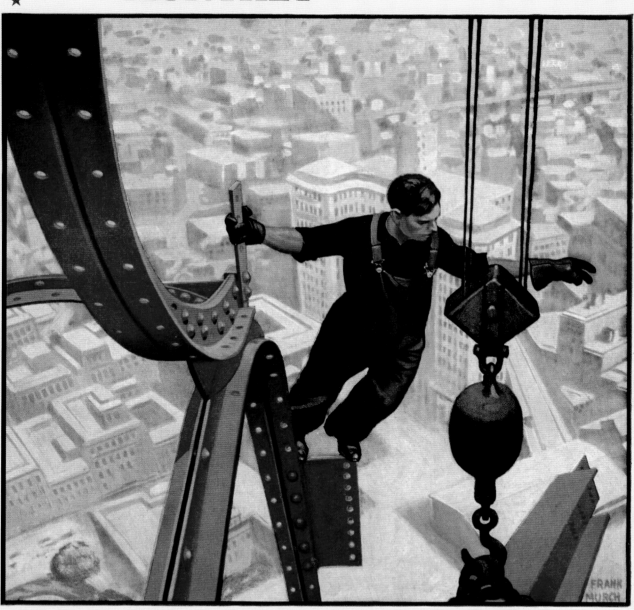

Popular Science Monthly

Founded 1872

INVENTIONS
DISCOVERIES
RADIO
AUTOMOBILES
AVIATION
HOME WORKSHOP

NOVEMBER — Where every day's work is a gamble with death. *See page 18* — 25 CENTS

In this Issue—Houdini's Own Story

1925

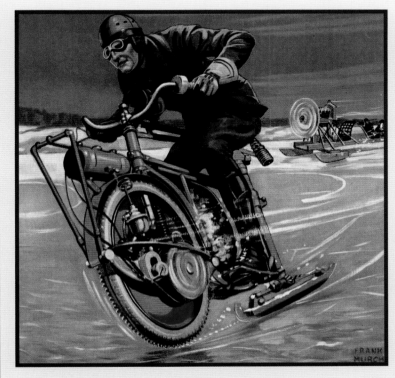

December · Frank Murch · Thomas Avoskan's ice cycle flies across a frozen lake.

✅ DID IT HAPPEN? Yes, this enterprising Swiss immigrant designed at least a dozen prototypes of his "motorskate," which went 50 miles per hour (80 km/h). While his invention didn't make it to production, ice racing did become an extreme sport in which a bunch of lunatics ride similar motorcycles with sharp studded tires around a frozen track.

November (left) · Frank Murch · A construction worker puts his life at risk to help build a skyscraper.

✅ DID IT HAPPEN? Yeah, it was pretty hazardous to build skyscrapers before the US Occupational Safety and Health Administration (OSHA) was established in 1971. There were very few protections (no hard hats), and, in the early years of high-speed development, the rule of thumb was to expect one dead worker for each US$1 million put into the job. Yikes.

October · Frank Murch · Gas masks protect the lungs of horses and soldiers.

✅ DID IT HAPPEN? Yup. Particularly in WWI, gas masks for horses and soldiers alike were regularly deployed on the battlefield. (Sure beats the sea sponges the ancient Greeks used to protect their faces from poisonous warfare.)

March · Frank Murch · A screw-driven bus barrels through the snow.

🤔 DID IT HAPPEN? It's a bit complicated. While it never took over for sled dogs as promised, a *lot* of functioning prototypes of this idea have popped up—developed by everyone from hobbyists to Chrysler to the Russian military. The most common version these days seems to be remote-control-toy-size.

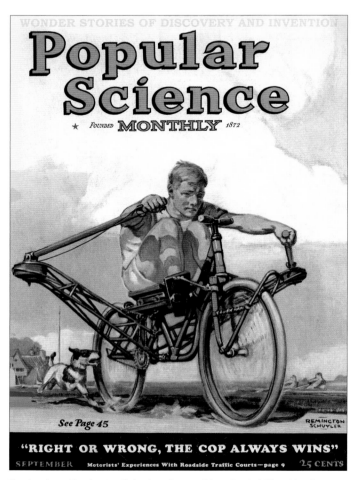
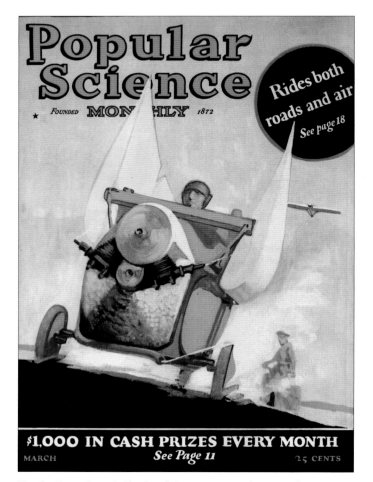

September · Remington Schuyler · A man rides a land skiff—a bicycle propelled by rowing rather than pedaling.

✓ DID IT HAPPEN? You bet. Row-powered recumbent bikes most certainly exist today (though the rowing mechanism isn't exactly like the one in this drawing). One popular model was even invented by the creator of Rollerblades.

March · Unattributed · The first flying car to grace the cover of *Popular Science*.

✗ DID IT HAPPEN? It's complicated, but ultimately no. In the 1920s, Ford made the Flivver (which was more of a personal plane than a flying car) but, after a fatal test ride, stopped production. Then, in the 1930s, American Waldo Waterman invented the closest thing to the vehicle depicted in this drawing—the Arrowbile, a strange vehicle with detachable wings that did, in fact, fly. Today, there are a number of experimental car/plane hybrids, but they're not quite *Jetsons*-level practical yet.

January (right) · Remington Schuyler · A man takes flight on the Dragonfly, a DIY winged toboggan.

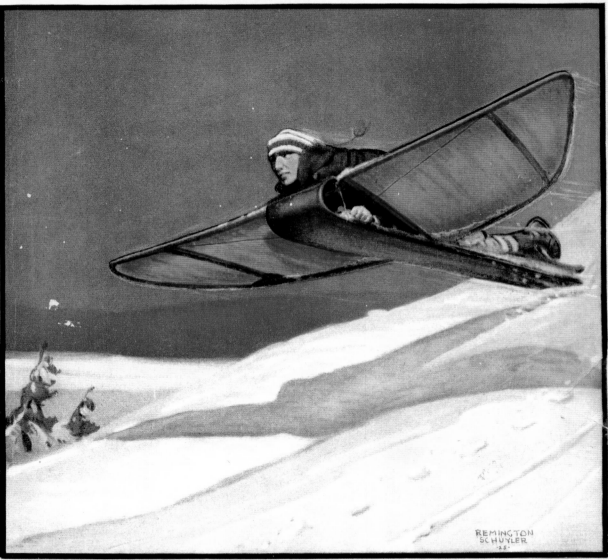

1926

Popular Science Monthly

Founded 1872

INVENTIONS
DISCOVERIES
RADIO
AUTOMOBILES
AVIATION
HOME WORKSHOP

JANUARY How to make the new and thrilling winged toboggan. *Page 72* 25 CENTS

Inventions I Hope to Make—*Edison*

DID IT HAPPEN? Yes, but not for sustained flights. Hobbyists and adventurers (and the only two members of Colorado's so-called Suicide Club) Paul Keating and Harley Tryon got air a few dozen times on the flying toboggan before Keating crashed—hard—and put an end to the crazy thing.

1927

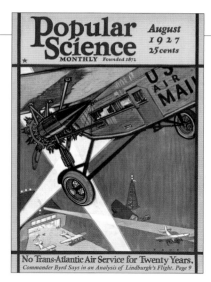

August • Hebert Paus • An airmail plane comes in for a landing.

✓ DID IT HAPPEN? Yes, mail is delivered by plane all the time. This issue explored the future of commercial flight—right after Charles Lindbergh flew from New York to Paris in a modified airmail plane, similar to the one shown here.

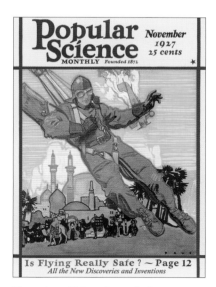

November • Hebert Paus • A pilot parachutes from a crashing plane.

✓ DID IT HAPPEN? Many pilots have survived in-air disasters thanks to parachutes; this feature questioned if flying was safe. In 1927, the answer was "not yet," with 25 deaths over oceans and "scores of mortalities on land" that year.

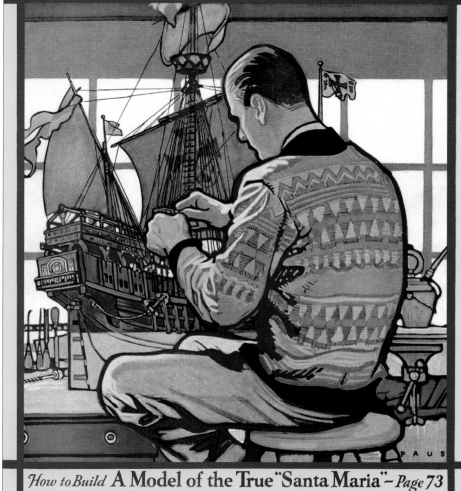

December • Hebert Paus • A hobbyist in a mesmerizing sweater assembles an exact replica of the *Santa Maria*.

✓ DID IT HAPPEN? Of course. Models of all sorts of vehicles—ships, planes, cars, trains—are popular among a certain type of hobbyist. This feature lays out the plans for an exact replica of the *Santa Maria* based on full-scale ship plans sent to the United States for the 1893 World's Columbian Exposition in Chicago.

March (left) • Frederico LeBrun • An artist's dramatization of the spirit of engineering.

✓ DID IT HAPPEN? In this issue, *Popular Science* tried out a whole bunch of new features—from printing fiction for the first time to kicking off a series of articles on Glenn Curtiss, the first man to fly a plane in public. The cover kick-started a series in which fine artists illustrated the spirit of a number of fields of science.

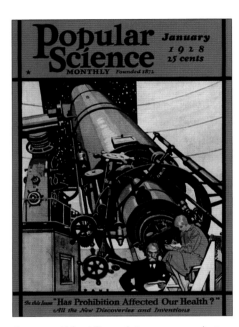

March · Hebert Paus · A logger prepares a charge before dynamiting a logjam.

✓ DID IT HAPPEN? Yeah! As a last resort, loggers would use explosives to break open an otherwise impossible logjam. This feature—titled "Romance Jams the Log Jams"—recounts one such episode in New Hampshire. Today, computerized machinery makes logging less dangerous—and less thrilling. (Oh, well. We'll always have the log flume.)

June · Hebert Paus · A giant magnet moves metal from one place to the next.

✓ DID IT HAPPEN? Definitely. Electromagnets make moving metal junk very easy (visit your local scrapyard for a live demo). This issue extolled magnets' many uses, including mining diamonds and removing iron splinters from workers' hands.

January · Hebert Paus · Astronomers work at the base of a telescope.

✗ DID IT HAPPEN? This feature explores the studies of American Dinsmore Alter, who theorized that asteroids came from an exploded planet—and that Earth would someday rupture, too. This idea was disproved, but Alter became a prominent astronomer, serving as the director of Los Angeles's Griffith Observatory.

August (right) · Herbert Paus · Boats race with outboard motors capable of hitting speeds of "more than 30 miles an hour!" (48 km/h).

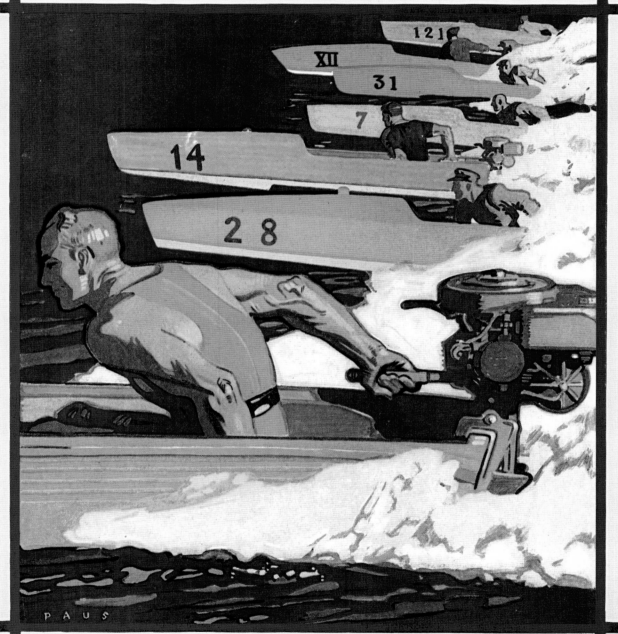

DID IT HAPPEN? Yes, boats with outboard motors gained in popularity in the 1920s due to their simple, reliable, and lightweight design, as well as their low cost. But the "breakneck" pace advertised is almost laughably slow today: The current record for speed with an outboard motor is around 175 miles per hour (280 km/h).

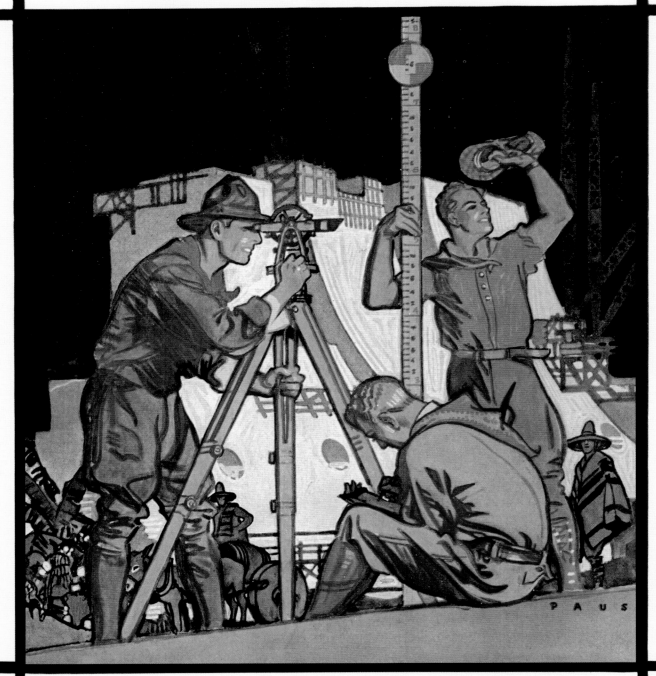

1929

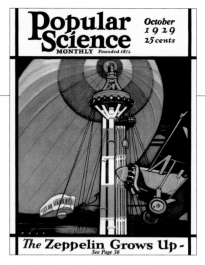

October · Hebert Paus · The German-built *Graf Zeppelin* dwarfs an airplane in the sky.

🌀 DID IT HAPPEN? Yes, triumphantly—but only for a decade. The *Graf Zeppelin* was the first commercial airship, making nearly 600 transatlantic trips. Its service was halted for good the day after the tragic *Hindenburg* explosion in 1937.

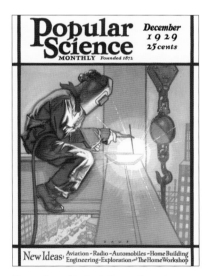

December · Herbert Paus · A worker welds a steel column in Los Angeles's Pacific Mutual Building.

✅ DID IT HAPPEN? Yes, welding in its many forms has played a crucial role in making the world around us. But *Popular Science*, at this time, was elevating it as an example of "silent construction"—which, while a nice idea, does not exist.

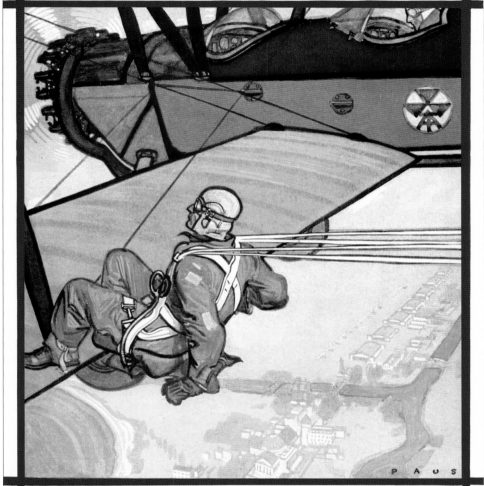

March · Hebert Paus · Staff Sergeant Roy Hooe of the *Question Mark*—a plane that at one time held the record for longest continuous flight—goes out on a wing to make engine repairs.

✅ DID IT HAPPEN? Totally. The *Question Mark* spent more than 150 hours in the air as a way of testing in-flight refueling. During the flight, meals, newspapers, letters, and telegrams were delivered to (and sometimes sent by) the aerial crew.

April (left) · Herbert Paus · An artist's dramatization of a survey crew, under Herbert Hoover, introducing American construction methods "into the untamed regions of foreign lands."

✅ DID IT HAPPEN? Yes. From building the Panama Canal to introducing gold-mining techniques in Australia, American engineering chops have touched a lot of countries. This feature was written by Will Irvin, a childhood friend of Herbert Hoover's. The piece essentially lionizes Hoover, the first true scientist and engineer to live in the White House, as he began his term as president.

ARTIST PROFILE

NORMAN ROCKWELL

Without question, the best-known painter to put brush to canvas for the face of *Popular Science* was Norman Rockwell. After beginning art classes and painting covers for a number of youth magazines throughout his teenage years, Rockwell landed his first piece of cover art on the front of a real magazine—the *Saturday Evening Post*—in 1916, at the ripe old age of 22. During the next 60 years, Rockwell would paint for a number of publications, with works gracing the cover of the *Post* hundreds of times.

While Rockwell was not widely respected by so-called serious art critics—people who would occasionally refer to Rockwell as an illustrator in the pejorative sense rather than as a true artist (not that it bothered him)—his work earned great appreciation among the broader American populace. His ability to give regular folks a glimpse of their own lives through his rosy lens endeared him to many.

Rockwell's paintings largely focused on elevating what might be dismissed as the banalities of everyday small-town America in an often sentimental, sometimes even humorous, way. His work for *Popular Science* during the 1920s was no exception. For instance, *Perpetual Motion*, his most famous work to appear in the periodical, depicts an inventor showing off his attempt at building a perpetual motion machine, scratching his head, as if he himself is unsure of whether it will work—or why it does, if it does. Another shows an older gentleman in his study, welding a kettle while a curious kitten watches over his shoulder.

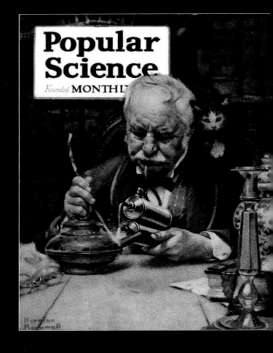

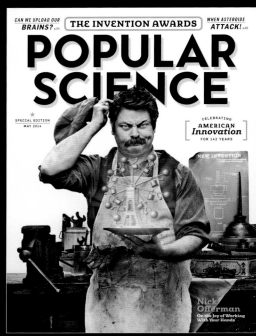

Top, this April 1921 cover shows a new soldering torch equipped with barrels for not one but two types of fuel. The same year saw the invention of the first electric soldering iron—a true breakthrough for early DIY types.

At right, the magazine devoted its October 1920 issue to innovation and used the cover to poke fun at an old mechanical impossibility that rears its head to dupe the masses every so often: a machine works indefinitely without needing power. *Popular Science* recreated the classic cover with DIY enthusiast and actor Nick Offerman on its May 2014 cover.

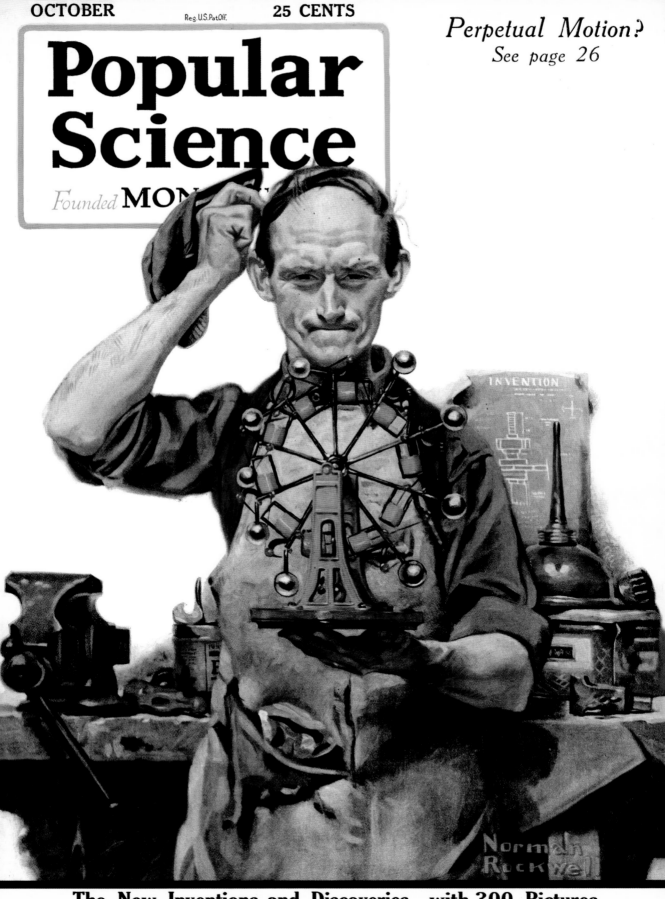

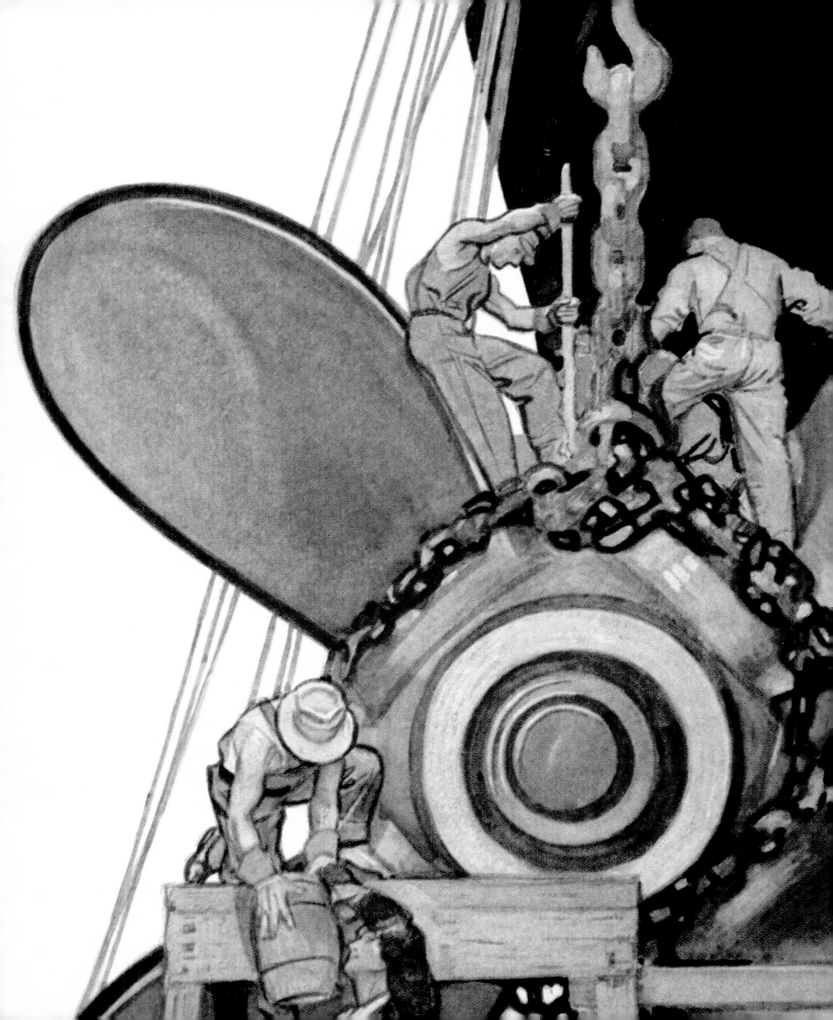

1930s

1930s

NO DEPRESSION IN HEAVEN

The 1930s were dark. On the heels of the 1929 stock market crash came the Great Depression, which quickly spread around the globe. On top of extreme economic hardship came the drought and "black blizzards" of the Dust Bowl. And across the pond, rumblings of Hitler's rise would prove fears of a second world war founded by the end of the decade. While the outlook grew increasingly bleak as the 1930s wore on, it was still a decade of huge technological advances—in medicine and aviation, entertainment and communication, computing and physics.

MUSIC, MOVIES, TV, AND RADIO

Despite—or perhaps because of—the Depression, the 1930s were something of an entertainment boom. In music, they gave us the electric guitar and the Hammond organ, as well as a patent for stereophonic sound. In television, Russian-born Vladimir Zworykin's iconoscope—the first practical cathode-ray-tube TV camera—became reality in 1932, Telefunken began cranking out the first commercial cathode-ray TV sets by 1934, and the BBC started a daily TV broadcast service in 1936. In movies, special effects took a big leap forward with films such as *Frankenstein* and *King Kong*, and Disney released the first full-length animated feature, *Snow White and the Seven Dwarfs*. But the king of media in the 1930s was radio. Over the course of the decade, radio ownership would jump from around 40 percent at the outset to nearly 85 percent by the end—at least partially a function of electricity stretching to more rural communities under the New Deal. With this expansion also came improvements in voice transmission over radio and frequency modulation (FM), a technology that made for less static on the listener's end.

FIRST HEART BYPASS

While vaccines for yellow fever and typhus shored up human immunity to terrible diseases, and the first blood bank made blood preservation possible for more than a week's time, one particularly important medical advance of the 1930s is the cardiopulmonary bypass pump—a.k.a. the heart-lung machine. After one heart surgery patient died on the table, Dr. John H. Gibbon and his wife, Mary, set out to create a machine that could essentially take on the work of a patient's heart and lungs for the length of a surgery. In 1935, Gibbon successfully tested the heart-lung machine on a cat, keeping the animal alive with machinated vitals for 20 minutes. It would take until May 1953 for him to be able to perform such a surgery on a human, but the method, based largely on the Gibbons' design, is still used in open-heart surgery today.

GATHERING DUST

Above, a promotional poster for the first full-length animated film, *Snow White and the Seven Dwarfs*—a technological marvel that cost US$1.5 million to create. That's more than US$13 million in today's dollars.

At left, an April 1933 feature on making monsters and special effects in Depression-era movies. (Sample highlight: hitting a man with padded drumsticks to create that famous chest-thumping sound.)

At right, vehicles buried in dirt near Dallas, South Dakota, in the aftermath of a 1936 dust storm.

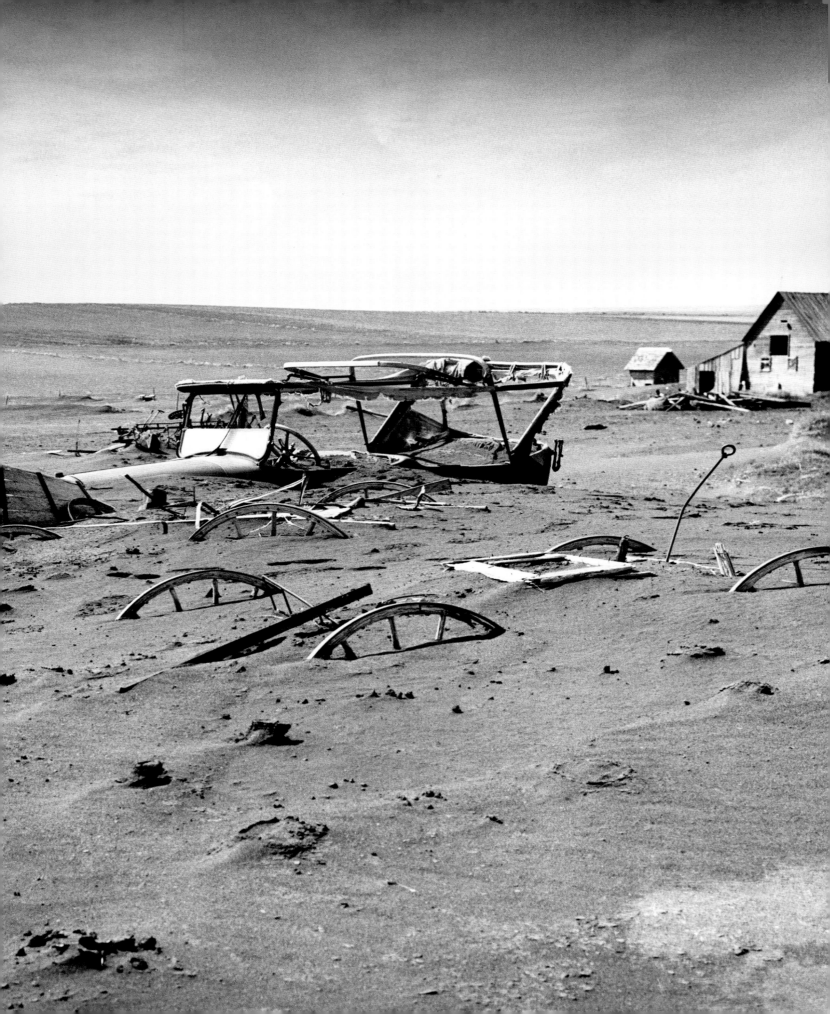

1920s

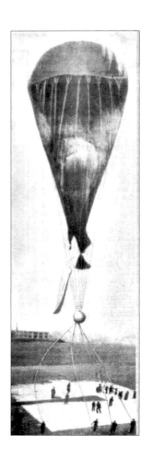

ENTER ELECTRON MICROSCOPY

Until the 1920s, magnification under a microscope was essentially limited by the resolution of light microscopes, which use visible light to magnify a sample. Toward the goal of greater magnification, German researchers Ernst Ruska and Max Knoll set to work building what would come to be known as the transmission electron microscope (TEM). Whereas traditional light microscopes use a beam of light to help viewers see up close, the TEM fires a beam of electrons—which have a much shorter wavelength than visible light—at a sample. The TEM then essentially measures how these electrons scatter through the sample, creating a magnified visual representation of the specimen. By 1933, Ruska had created a TEM more powerful than any light microscope in existence. Today's electron microscopes, far more powerful than Ruska's, are still based on the same principles.

AVIATION'S HIGHS AND LOWS

Not 40 years after the first manned flight, Swiss physicist Auguste Piccard and his assistant, Paul Kipfer, reached the stratosphere, nearly 10 miles (16 km) up, stuffed inside a pressurized gondola attached to a giant balloon. Others had suffocated trying, but Piccard's journey proved that people could survive the stratosphere by using oxygen tanks inside a sealed and pressurized capsule, among other discoveries. Of course, not all airborne travelers were so lucky. In May 1937, the *Hindenburg*, a giant passenger zeppelin filled with hydrogen, met its fiery end while trying to land in Lakehurst, New Jersey. And after a number of world firsts—first woman to fly solo across the Atlantic and coast to coast, and first person to fly solo across the Pacific from Honolulu to Oakland—famed American aviator Amelia Earhart and her navigator, Frederick Noonan, went missing over the Pacific Ocean during an around-the-world attempt.

ARTIFICIAL RADIOACTIVITY AND NUCLEAR FISSION

Two notable breakthroughs in physics were the 1934 discovery of artificial radiation and the 1938 discovery of nuclear fission—a later win for medicine and a later win for war. By hurling alpha particles—helium nuclei that some radioactive substances emit—at aluminum, magnesium, and boron, Irène Curie-Joliot, daughter of Marie Curie, together with her husband, Frederic Joliot, created a number of radioactive isotopes, proving that radioactivity could be produced artificially. Today, doctors and scientists use artificially created radioactive tracers for a number of diagnostic purposes. The story of nuclear fission has a bit more drama. Lise Meitner—after years of collaboration with her research partner, chemist Otto Hahn—periods of which she was forced to spend working in Berlin basements for the crimes of being Austrian, Jewish, and female—fled the Nazis for Sweden in 1938. Despite their physical distance, the two partners continued to work together. Eventually, Hahn found that, when bombarded with neutrons, uranium atoms split—a phenomenon Meitner dubbed nuclear fission. Meitner was ultimately snubbed by the Nobel Committee, which awarded Hahn for "his" discovery in 1944.

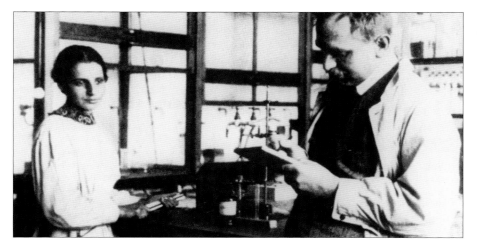

UP AND CLOSE

Above, Auguste Piccard floats toward the stratosphere, dangling from a giant balloon, in 1932. He made many such voyages; the loftiest was 14 miles (37 km) high.

At right, Ernst Ruska and a second-generation electron microscope in a November 1938 issue. Its higher-resolution lens was designed with the help of Dr. B. von Borries.

At left, physicist Lise Meitner with Otto Hahn. After being passed over by the Nobel Committee for her work on atom splitting, Meitner was later the namesake for the universe's heaviest element, meitnerium.

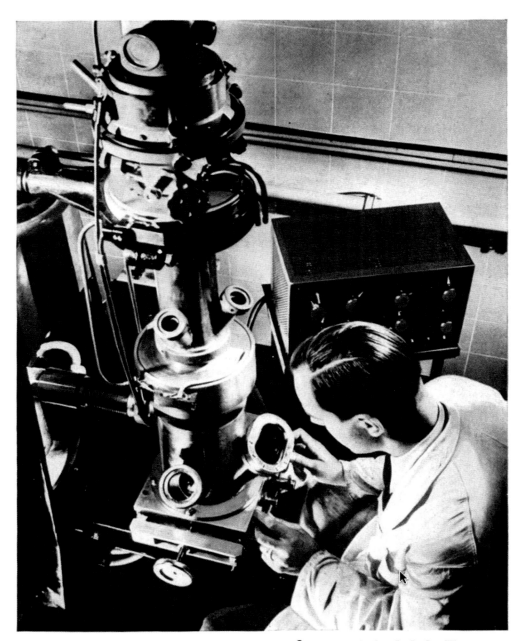

Supermicroscope Magnifies 100,000 Times

EMPLOYING a stream of electrons, tiny electrified particles, instead of a conventional glass lens, the gigantic supermicroscope pictured above can magnify minute objects as much as 100,000 times—a magnification comparable to enlarging the head of a pin to a diameter of 330 feet. Designed by Dr. B. von Borries and Dr. Ernest Ruska of Berlin, the German giant electric "lens" is adjusted and regulated by means of a control panel resembling a radio switchboard. It is expected to aid in fighting disease.

NOVEMBER, 1938

ALSO OF NOTE

FEBRUARY 18, 1930
American Clyde Tombaugh identifies Pluto, the "Planet X" predicted in 1906 by Percival Lowell.

MARCH 10, 1933
An accelerograph records the strong ground motions of an earthquake for the first time.

APRIL 25, 1935
The first round-the-world phone call allows people sitting 50 feet (15 m) away from each other to speak over 23,000 miles (37,000 km) of cable.

SEPTEMBER 14, 1936
US psychologist Walter Freeman performs the first lobotomy.

OCTOBER 30, 1938
Orson Welles broadcasts *The War of the Worlds*—a radio drama made up of simulated news bulletins about an alien invasion.

1930s

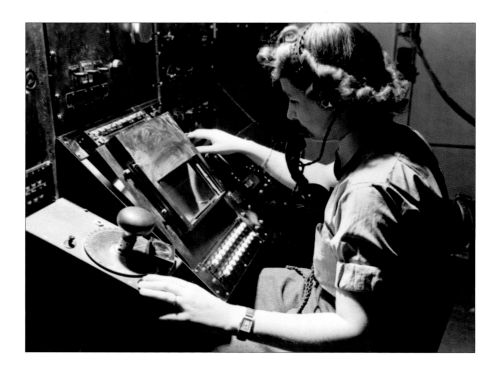

NO MORE FLYING UNDER THE RADAR
We'd known since 1866 that solid objects could reflect radio waves, thanks to German physicist Heinrich Hertz. But it would take more than 60 years for radar to become a defensive tour de force. In England, Scottish physicist Robert Watson-Watt led the charge. He first developed huff-duff, a method of detecting enemy radio transmissions, in 1926, then pulled off the first practical demonstration of radar in 1935 by bouncing the signal of a shortwave transmitter off a plane. By 1939, Watson-Watt and his team had built an array of covert early-warning radar stations—just in time for WWII, in which it proved a secret weapon to reckon with. It also proved a secret too good to keep: Watson-Watt crossed the Pond to share the technology, which ended up giving the United States an hour's notice before bombs hit Pearl Harbor in 1941.

THE NEW DEAL DELIVERS
When Franklin D. Roosevelt took his place in the Oval Office in 1933, 15 million Americans were out of work. Roosevelt needed big ideas to jump-start the economy, and a few of those ideas—the Public Works Administration, the Works Progress Administration, and the Civilian Conservation Corps—also remade the nation in concrete and steel. Under Roosevelt's New Deal, 6 million citizens got back to work, many of them building marvels such as the Hoover Dam (the largest concrete structure of its time, which still pumps hydroelectric power to Nevada, California, and Arizona). With more than 750,000 miles (1.2 million km) of new road, 125,000 repaired government buildings, and nearly 1,000 new state parks and airfields, the New Deal contributed more to infrastructure technology than any other government action to date.

LAYING THE GROUNDWORK FOR MODERN COMPUTING
Some of the thinking that later proved foundational to computing came out of the 1930s. For starters, Alan Turing's *On Computable Numbers, with an Application to the Entscheidungsproblem*—that German translates as "decision problem"—was published in 1936. Turing describes a concept that would become key in the development of computer technology: a "universal machine" that could solve any mathematical problem within a set of given rules in the abstract. In the concrete, the 1930s also brought the Z1, the first programmable computer to use binary code. Built by German Konrad Zuse in his parents' living room, the Z1 ran "programs" on punch tape. While it could add, subtract, multiply, and divide, it didn't have much memory, and it was pretty unreliable—perhaps paving the way for our blue screens and beach balls of death, too.

REIGNING IN RADAR AND RIVERS

Royal Air Force radar operator Denise Miley plots enemy aircraft in the Chain Home station at Bawdsey Manor in 1945.

At right, important-looking folks hitch a ride in one of the penstock pipes used in the construction of the Hoover Dam, originally known as the Boulder Dam, sometime in the early 1930s.

The Future Then

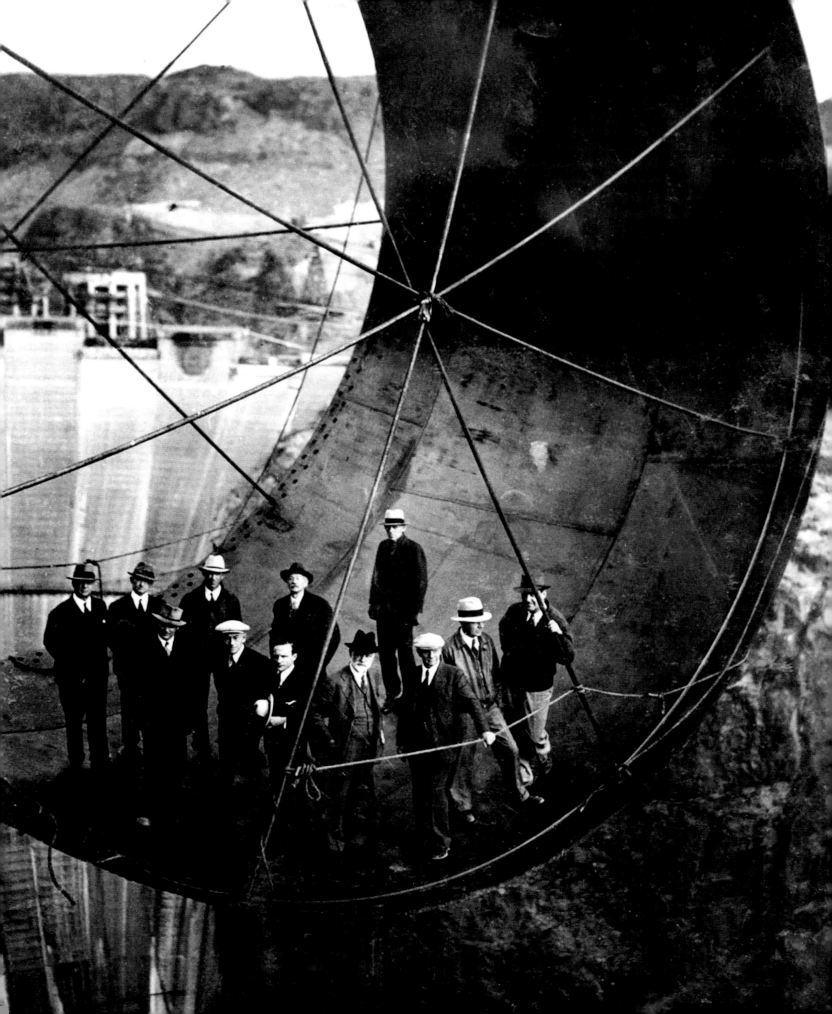

April · Herbert Paus · Man steers a glider while the group that launched him watches from the ground.

✓ DID IT HAPPEN? Indeed. While past glider launches involved calling on your strongest friends to fling you into the air with a bungeelike apparatus (much like shooting a marble from a giant slingshot), today's gliders are more commonly towed into the sky by plane or given a boost by winch.

February · Herbert Paus · Large mechanical "shovel" outpaces worker many times over.

✓ DID IT HAPPEN? Of course it did. You've seen construction sites. And it's not the last time machines would replace human labor. In this instance, a giant electric shovel—weighing 1,600 tons (1,450 t) and capable of carrying 100 tons (90 t) of material as high as seven stories—went to work in the Fidelity Coal Mine in Du Quoin, Illinois.

October (right) · Herbert Paus · Scotsman George Bennie's railplane—a propeller-driven train proposed to separate passengers and freight, allowing for swifter journeys.

The Future Then

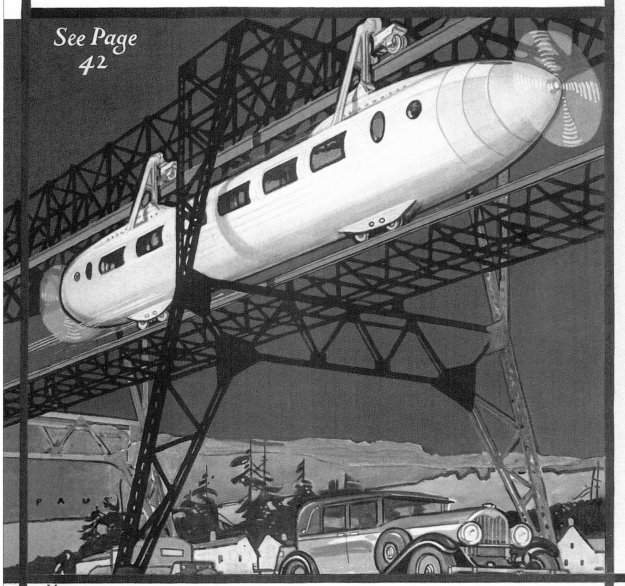

❌ DID IT HAPPEN? No. After George Bennie demoed his railplane in Scotland, he went bankrupt for lack of investor interest. And since his system had rails on top and bottom, we can't even give him credit for being at the forefront of monorail. Poor Bennie.

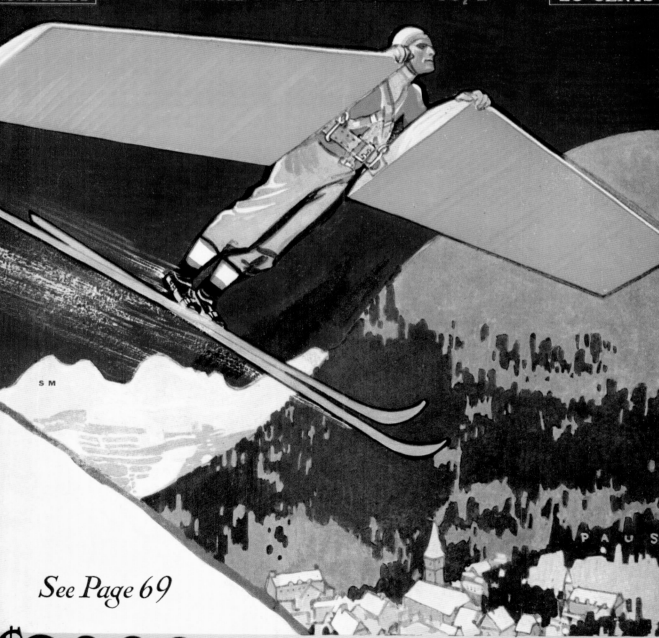

1931

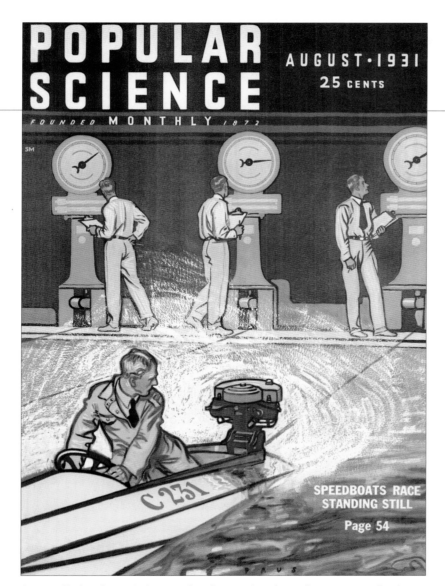

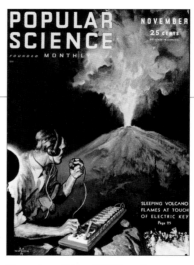

November · Edgar F. Wittmack · Engineer Fred G. Hitt pushes a button to trigger a simulated eruption of Mt. Lassen in California.

✅ DID IT HAPPEN? Yes, believe it or not. To open Lassen Volcanic National Park to the public, Hitt's team rigged the peak with mortars, rockets, and 6,000 pounds (2,700 kg) of gunpowder, modeling their impressive blast on the volcano's 1915 eruption.

August · Herbert Paus · Judges watch scales as tethered speedboats compete for the title of strongest engine in a swimming pool.

✅ DID IT HAPPEN? This one time, yes. But watching a scale spin is less entertaining than an actual race—and dynamometers are better at measuring power. Still, test tanks—pools used to check engine repairs and performance—do exist today.

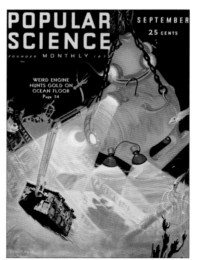

September · Edgar F. Wittmack · In search of US$3 million in lost gold, a one-man submarine grabs on to a piece of the shipwrecked SS *Islander* 365 feet (110 m) under the sea.

✅ DID IT HAPPEN? Yes. The submarine did manage to latch on to the wreck, allowing it to be hoisted to the surface. However, its bow was missing and the inventors of this ingenious contraption netted only US$75,000 in gold.

January (left) · Herbert Paus · A Viennese skier flies through the air with aluminum wings.

✅ DID IT HAPPEN? Eh, yes and no. The guy on the cover, Joseph Krupka, made some ski wings that weren't widely adopted. But wingsuits did come to exist in 1997, enabling adrenaline junkies to fly off cliffs—but more like flying squirrels than birds. (Don't feel bad for Krupka. He had better luck with another of his inventions: the water ski.)

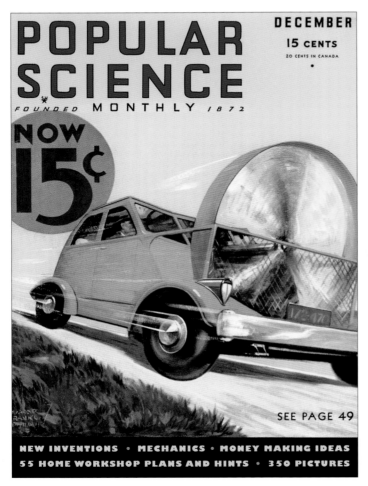

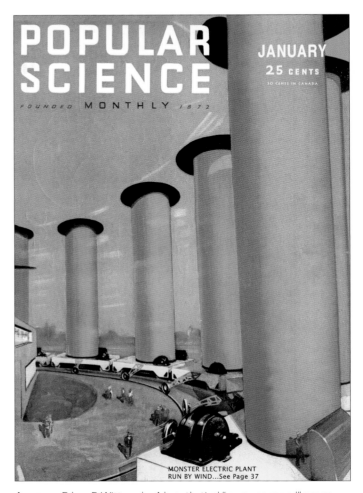

December • Edgar F. Wittmack • An air-propelled car out for a joyride—presumably at 80 miles an hour (130 km/h), as the cover article boasts.

❌ DID IT HAPPEN? Not really. Airboats are a thing, but the fan-powered car? Not so much, beyond a few truly experimental vehicles such as this. There is banned racing technology that uses fans to force a racecar downward (most notably American Jim Hall's totally rad Chapparel 2J, released in 1970 and forbidden from the track the same year), but that's about it.

January • Edgar F. Wittmack • A hypothetical "merry-go-round" power plant makes wind power in New Jersey.

🔄 DID IT HAPPEN? Kind of. Power companies poured money into an experimental cylinder utilizing the Magnus effect—the notion that wind creates force perpendicular to the direction it blows—but the plant never materialized. Even so, ships powered by "rotor sails" demonstrated proof of concept in the 1920s, some modern shipbuilders have revived the idea to reduce reliance on fossil fuels, and engineers have written papers about building wind farms with the cylinders in the future. So stay tuned.

May (right) • Edgar F. Wittmack • Dr. J. A. Purves's dynasphere—"the high-speed vehicle of the future."

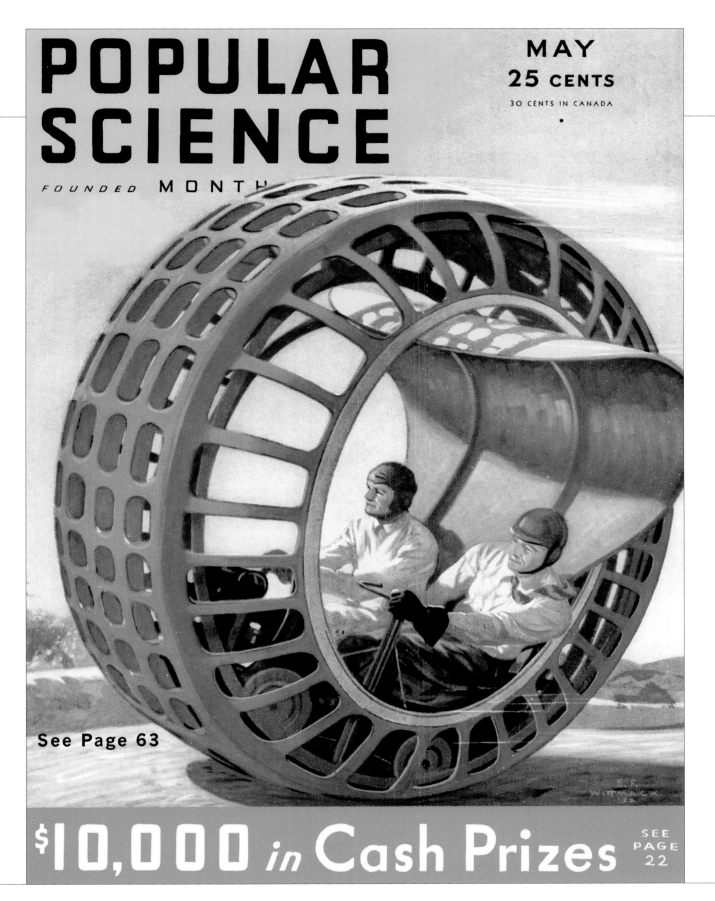

DID IT HAPPEN? Prototypes, yes. Otherwise, no. While inventor J. A. Purves did make a few of these daredevil hoops (YouTube it, trust us), it turns out that a giant iron wheel steered by tilting is not the most practical form of transportation. Go figure.

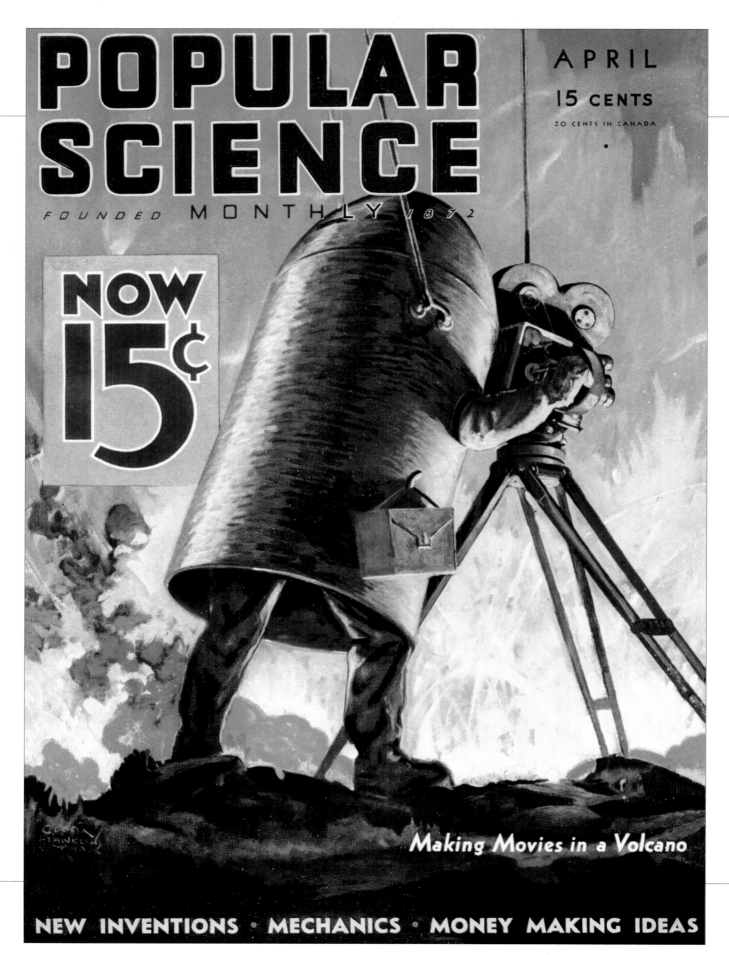

1933

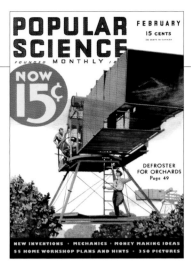

February • Edgar F. Wittmack • A giant defroster keeps a citrus orchard warm during winter.

❌ DID IT HAPPEN? Not exactly. A few people patented devices like it, but they were never widely used. Smudge pots—essentially small oil heaters placed between trees—and hay-bale fires (no joke) are cheaper and at least as effective.

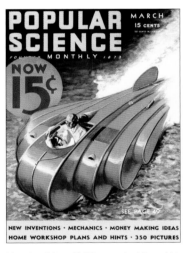

March • Edgar F. Wittmack • Victor W. Strode's plywood "sea gull boat" flies just above the water's surface.

❌ DID IT HAPPEN? Not this one. At high speed, the boat's "wings" were supposed to lift all but the engine from the water, creating less drag. The small-scale prototype worked, but the full 24-foot (7-m) version ordered by Portland, Oregon, to serve as a harbor ambulance? A total flop.

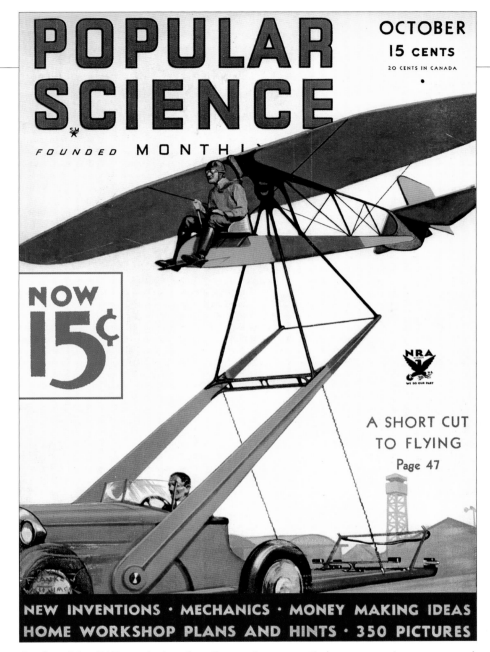

October • Edgar F. Wittmack • A student pilot practices aeronautical maneuvers using a car-powered "foolproof training machine."

❌ DID IT HAPPEN? Not like this, no. The one early flight simulator that actually taught pilots was the Link Trainer, which was essentially a covered cockpit on a motorized mount for practicing flight using only the cockpit's instruments as a guide. (Think a blind mechanical bull that you can steer.) While this flight simulator never amounted to much, its inventor—Harry G. Taver—did better with his fearsome roller coasters, which were the first in the United States to be built of steel instead of wood.

April (left) • Edgar F. Wittmack • Explorer and engineer Arpad Kirner films Stromboli, a volcano off the coast of Sicily, in a steel suit.

✅ DID IT HAPPEN? Yes, and it's a story, all right. Kirner and his friend, Paul Muster, scaled Stromboli's most treacherous slope, wearing steel for protection from falling rock and lava. After a close call with a boulder, the two abandoned their suits and slid to safety, arriving at the base bloody but otherwise uninjured. Before this, Kirner—with an oxygen tank, asbestos suit, and flashlight—descended 800 feet (245 m) into Stromboli's mouth, all for the sake of filming the volcano in action.

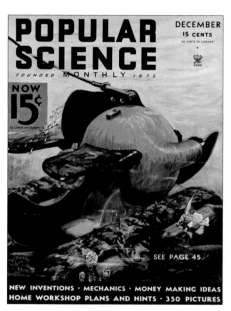
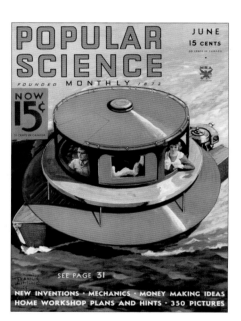
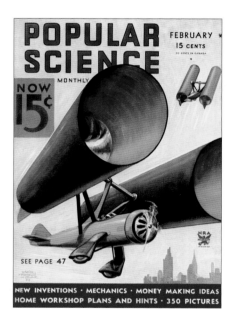

December • Edgar F. Wittmack • American engineer Otis Barton and naturalist William Beebe explore the ocean floor in their tank-tread-fitted bathysphere.

⊗ DID IT HAPPEN? No. The motorized tank-sub hybrid never came to be. But let's not knock their bathysphere. In 1934, the pair took that metal ball with windows more than 3,000 feet (915 m) into the ocean depths—the world record until Barton broke it again in the 1940s.

June • Edgar F. Wittmack • A man and woman cruise the sea in an "unsinkable" round boat.

⊗ DID IT HAPPEN? Not really. Sure, there are round boats, but they're more for fishing, booze cruising, or bumping into other round boats at the fair than storing a week's rations and getting away from the mainland. As for the "unsinkable" claim this Weeble of the waves makes, we all know how that turned out for the last ship that supposedly couldn't sink.

February • Edgar F. Wittmack • A wingless airplane flies using cylinders.

◐ DID IT HAPPEN? This one is truly complicated. As designed, no, it didn't happen. But add fuel and a spark, and these cylinders aren't that far from being jet engines (which made their first appearance on the Heinkel He 178 five years later and have dominated the skies ever since). Additionally, a number of small aircraft have taken flight with rotating cylindrical "wings."

September (right) • Edgar F. Wittmack • A man in a speedboat spears a balloon to advance in a race.

The Future Then

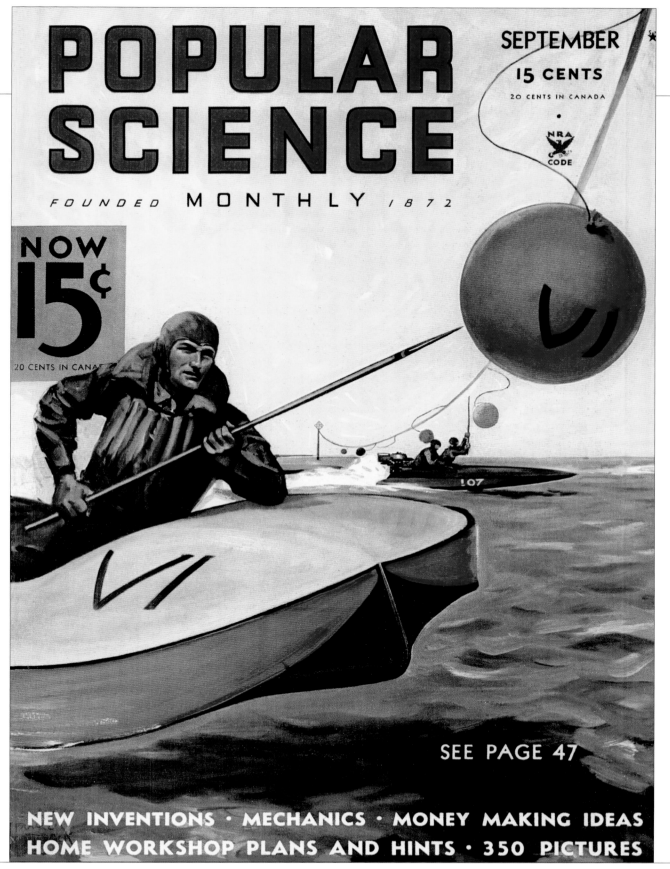

DID IT HAPPEN? Not for long. It appears that, for a brief time, some California boat races required teams to spear balloons hung from a cable at the end of each lap before they could advance. With only the risk of being clotheslined at high speeds or impaling oneself, a teammate, or an opponent, it's amazing that balloon spearing wasn't more popular.

April • Edgar F. Wittmack • Commuters ride in a snazzy propeller-driven, rudder-stabilized monorail car.

❌ DID IT HAPPEN? Nope. While propellers and rudders were meant to keep this vehicle upright, propellers on trains are a bad idea. Spinning blades make "beware the third rail" warnings seem cute, for one. But monorails did succeed and are all over—from airports to municipal transit systems to Disney World.

May • Edgar F. Wittmack • An airship docks at a "hatbox hangar."

🌓 DID IT HAPPEN? Kind of. The roof had a slot that could be aligned with the wind direction so airships could come and go. Nothing came of it, but rotating hangars—which turned so the closed end faced into the wind—were a thing.

November • Edgar F. Wittmack • A vertical turbine harvests wind power.

✅ DID IT HAPPEN? Yes, definitely. There are many, many designs for functional, vertical wind turbines. You can find them on college campuses, cell towers, and wind farms—even on Jay Leno's garage. This particular model was designed with a series of flaps that acted as a governor, letting in more or less air as needed to maintain a constant power output.

February (right) • Edgar F. Wittmack • Hubert Garrigue rides a custom sled down treacherous cliffs with a parachute trailing behind him.

✅ DID IT HAPPEN? Yeah! Hubert Garrigue, a French meteorologist at an observatory in the Pyrenees, came up with this contraption as a way to study prevailing winds. He started by tracking air currents with little paper parachutes, then decided to ride the winds himself—all for science. Today, adrenaline junkies call the sport speedriding and do it on skis or a snowboard.

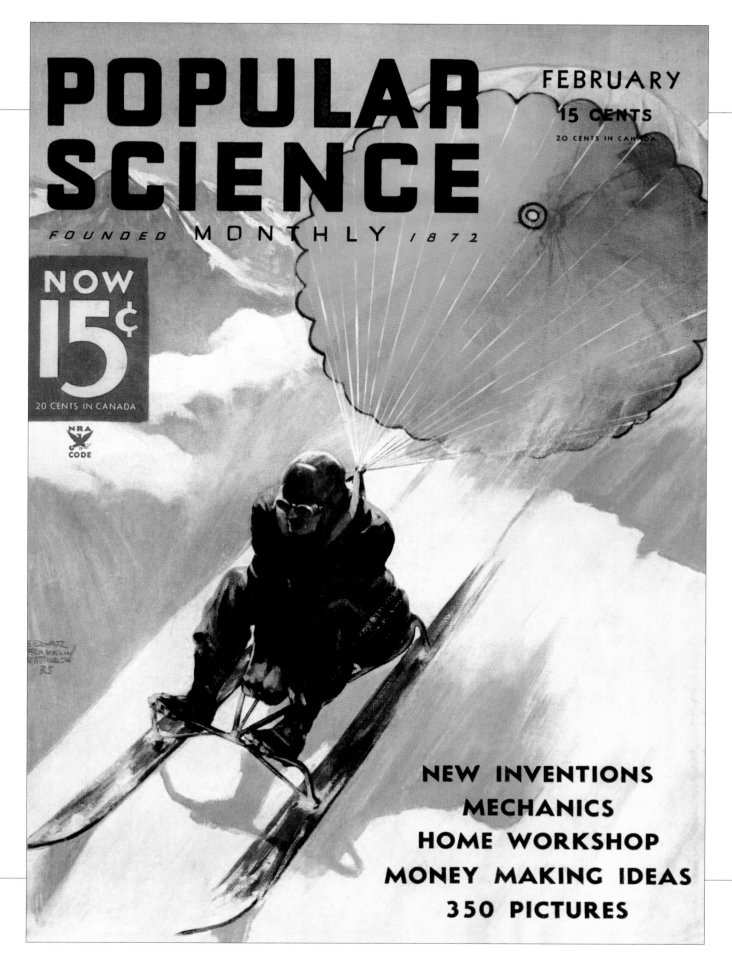

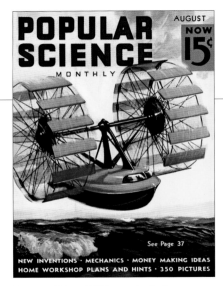

August • Edgar F. Wittmack • A plane powered by the paddles on "a pair of flying Ferris wheels" traverses the sea.

🔄 DID IT HAPPEN? Kind of. While planes that size never really took off (pun intended), researchers have recently tested small, drone-size cyclogyros that look a lot like this. In the old-timey model, the angle of each paddle was controlled by cables tethered to the wheel's hub, creating maximum lift.

December • Edgar F. Wittmack • Soldiers ride over snow on an armored motorcycle tractor equipped with a sidecar.

❌ DID IT HAPPEN? Nah. Russia deployed an armored tractor during WWII, and BMW appears to have developed a prototype snow motorcycle and sidecar called the Schneekrad that looks pretty much like this, but—with no terribly functional turning mechanism—it was a bust.

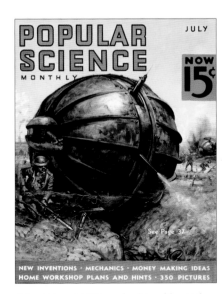

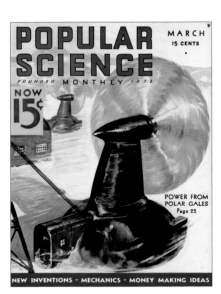

July • Edgar F. Wittmack • A tumbleweed tank, dreamed up by Texan A. J. Richardson in the mid-1930s, sprays machine gun fire willy-nilly.

❌ DID IT HAPPEN? No, thank God. Apart from the German Kugelpanzer, or "ball tank"—a strange WWII relic about which very little is known—spherical tanks were never created, let alone widely adopted.

March • Edgar F. Wittmack • Windmills make power on Antarctica.

✅ DID IT HAPPEN? Yeah! There are multiple wind farms on Antarctica. However, in 1936, the farms were predicted to create more power than Niagara Falls—which powers nearly 4 million homes. In reality, the farms provide just a fraction of the power needed to power Antarctic bases.

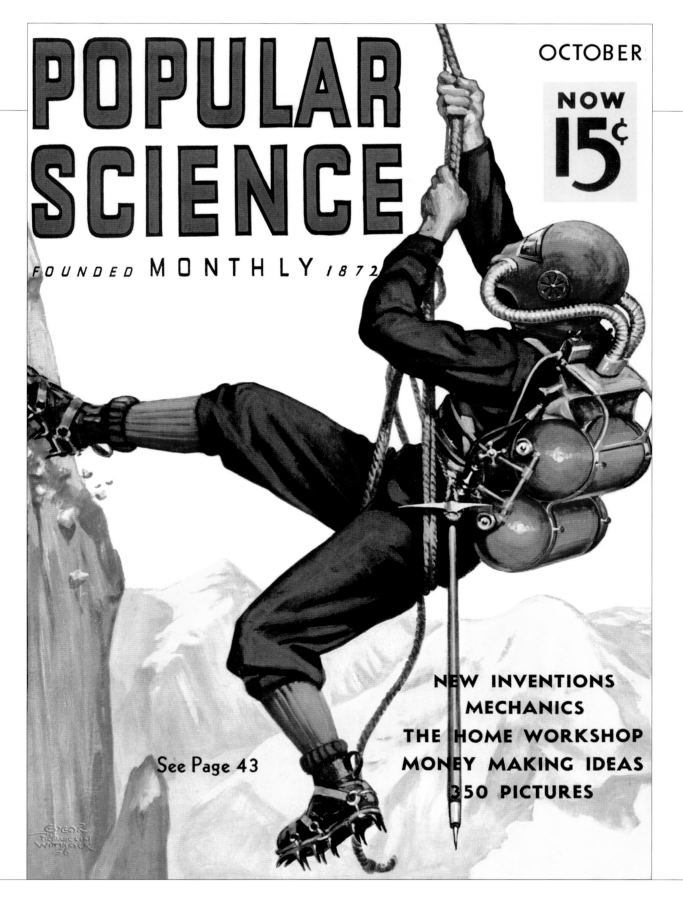

October • Edgar F. Wittmack • A mountaineer breathes in sweet, sweet oxygen while climbing.

DID IT HAPPEN? You bet. Climbers scaling the world's tallest peaks routinely carry their own O_2 to breathe easier in the thin air high above sea level. While personal oxygen supplies had already been used in flight, under the sea, and inside volcanoes by 1936, climbing was a new frontier requiring special lightweight tanks.

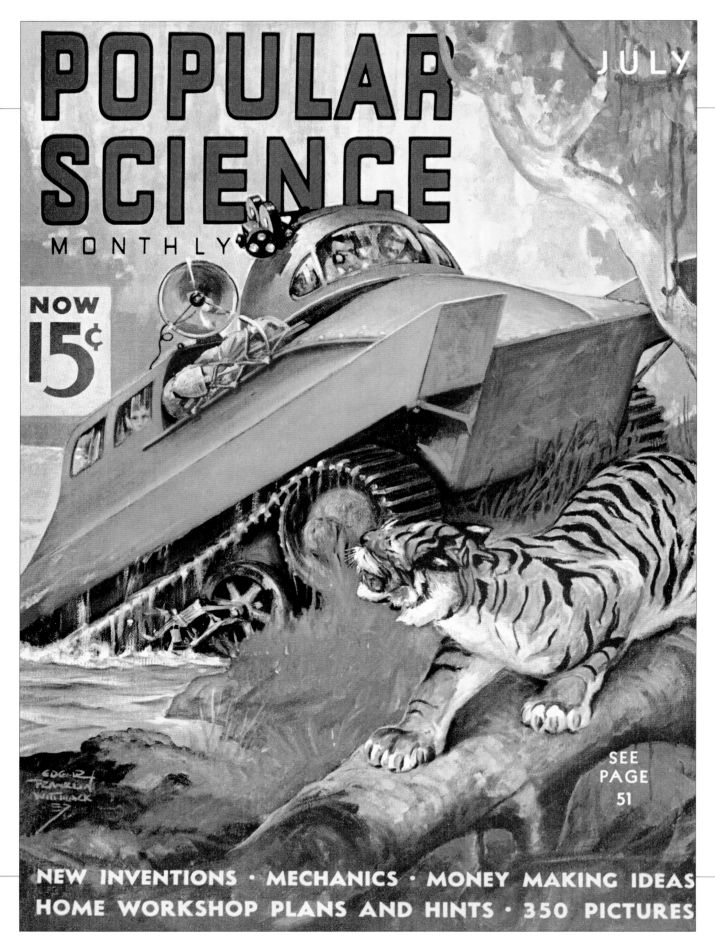

1937

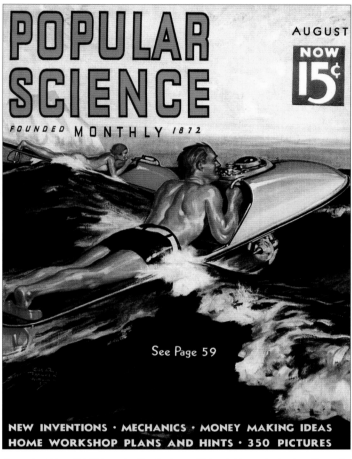

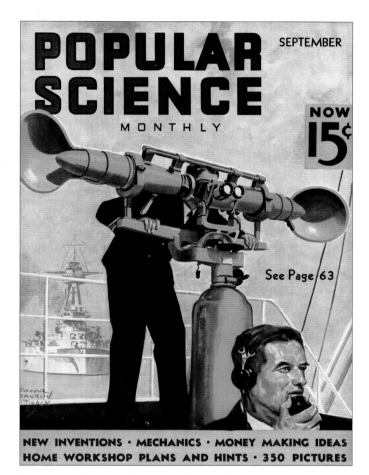

August • Edgar F. Wittmack • Beefcake and friend ride motorized surfboards.

✓ DID IT HAPPEN? Sure did. Outfitted with outboard motors and foot-operated rudders, these motorized surfboards gave way to designs that today can reach speeds of more than 40 miles per hour (65 km/h). They're good for catching exceptionally fast waves—or for surfing circles around your friends as they paddleboard.

September • Edgar F. Wittmack • A directional sound detector is used to find ships in the fog.

✗ DID IT HAPPEN? Probably not. To work this "ear extender," you would rotate the device until you heard the same levels of sound through the cups on either end, thus determining the direction of the sound's origin. But in truth, you'd get a similar result if it originated behind you. (Sound localization is possible but usually takes a number of microphones and a bunch of math.) In addition, radar began to appear on battleships in the 1930s, so this tool never really stood a chance.

July (left) • Edgar F. Wittmack • Filmmakers use an amphibious tractor tank to shoot jungle wildlife.

◐ DID IT HAPPEN? Well, technically, amphibious tanks do exist, and there's really no reason to think you couldn't use them to shoot wildlife, but for some reason this vehicle has yet to make an appearance in the Amazon. It did, however, make clever use of wartime features: The camera was aimed via periscope from what would have been the gun turret.

November • Edgar F. Wittmack • A fictional jockey rides a mechanical horse while a film crew rolls tape.

✓ DID IT HAPPEN? You bet. Even today, Hollywood puts mechanical steeds to work to get precision shots—and to placate movie stars with equestrian phobias. Creepily, the body of this horse was real, stuffed and cut off at the legs. An elaborate array of cams helped make its movements look like a natural gait.

July • Edgar F. Wittmack • Soldiers invade with a mini tank.

✓ DID IT HAPPEN? For a period of time, yes. Several countries developed and deployed mini tanks, more commonly—and kind of adorably?—called tankettes, from the mid-1920s up to WWII. Since they were a lot more easily destroyed than full-size tanks, most were abandoned in favor of more nimble armored cars.

April • Edgar F. Wittmack • A group of passengers ride a rocket on a virtual tour of the universe inside a planetarium exhibit.

◐ DID IT HAPPEN? Yes and no. Created by famed industrial designer Raymond Loewy for the 1939 World's Fair in New York, this exhibit was certainly built. However, it was changed so that visitors didn't ride in the rocket (boo, hiss), and their view was trained on London, not the night sky, to commemorate advancements made in commercial transatlantic air travel.

December (right) • Edgar F. Wittmack • An armchair angler reels in a virtual marlin on a movie screen.

The Future Then

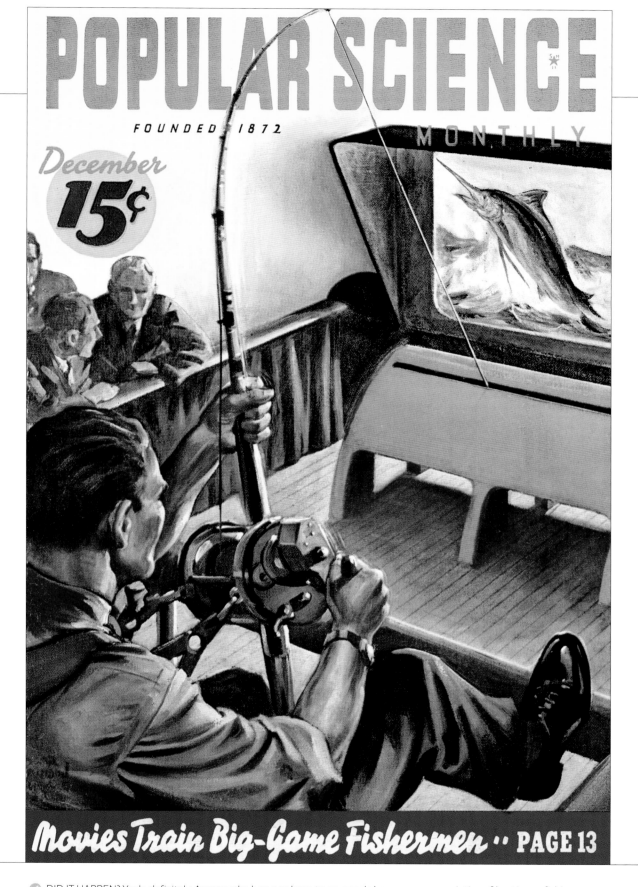

DID IT HAPPEN? Yeah, definitely. Anyone who has ever been to an arcade has seen some variation of hunting or fishing games. Home consoles also have similar diversions, whereby players can troll the deep from the comfort of their living room. But whatever happened to this specific simulator—in which the fishing rod is attached to a motor-driven reel that mimics the tug of a fish on a line, all synchronized with the image of a fish flailing on the screen—is anybody's guess.

POPULAR SCIENCE

July 15¢

MONTHLY
Mechanics & Handicraft

Two Magazines in One.. 15¢

1939

November • Edgar F. Wittmack • Soldier with a death wish skis just feet ahead of spinning blades on a completely bonkers snow contraption.

❌ DID IT HAPPEN? No. This contraption was so ridiculous, it isn't even mentioned inside the actual magazine. Just look at it. Fall and—well, you get the picture.

October • Edgar F. Wittmack • Vacationers ride sail bikes across hard-packed sand at low tide.

✅ DID IT HAPPEN? You bet. While DIYers still cobble together bike-ish rides like the one shown here, today you can buy one (or a kit version). Many are recumbent, so the wind pushes your lazy self around while you recline.

December • Stanley Bate • A group of warplanes fly in formation.

✅ DID IT HAPPEN? Many times over. In war, military pilots will often fly together in formation to boost their power and their ability to defend each other, but it wasn't always that way. This feature looked at the many formations pilots used as war in the air shifted from plane-to-plane combat to the teamwork needed in mass fighting.

July (left) • Edgar F. Wittmack • Firefighter fights fire atop a telescoping water tower.

❌ DID IT HAPPEN? At least one fire engine had this telescoping platform. But fire departments must have realized that the contraptions were better suited to *American Gladiators* than to quickly putting out fires (though this particular version did enable fire fighters to clean power-line insulators when not employed to fight flames). Ladders and buckets are generally safer and more effective.

ARTIST PROFILE

EDGAR FRANKLIN WITTMACK

As a young man, after returning from WWI, Edgar Franklin Wittmack took classes at the Art Students League in New York City and began to work as a commercial illustrator. Surrounded by fellow artists, he made friends with Franklin Booth, an illustrator for magazines such as *Harper's* and *Collier's*, who would ultimately marry Wittmack's sister. Later, Wittmack would briefly skip town to take a few classes at L'Academie de la Grande Chaumiere in Paris.

After Wittmack returned to New York City, his art came to define the look and feel of *Popular Science* for many years. During the 1930s in particular, Wittmack's paintings served as a sort of escape from the drudgery that was the Great Depression. In line with a lot of the art of the time—consider fanciful movies such as *The Wizard of Oz* and pulp fiction titles that played up the sensational—Wittmack's work focused less on what the current world was and more on what a future world might be. From tentacular fire engines resembling lawn sprinklers on tank treads, to fantastical flying machines, Wittmack painted oil pictures of potential in the face of dismal reality.

If his art had a pulp feel, that was likely no accident; he often lent his hand to low-brow rags such as *Frontier Stories, Western Story, Clues Detective,* and *Adventure*—peddlers of inexpensive escapism for the depressed masses. Wittmack's art also appeared on glossier paper for the likes of *Scientific American, The Saturday Evening Post,* and *Outdoor Life,* among others. He was a versatile painter, with a great knack for creating eye-catching poster art on a broad range of topics.

At right, top to bottom,
November 1936
January 1933
June 1933

At far right,
October 1938

POPULAR SCIENCE
MONTHLY
October
15¢

See Page 97

AUTO RACING...750 Miles An Hour?

Can
Sav

1940s

1940s

WAR ALL THE TIME

The 1940s were marked, in many ways, by war. While people thought of WWI as "the war to end all wars," WWII turned out to be the most pervasive and widespread conflict in history. Nations put their whole economic might into fighting what would turn out to be a bloody, drawn-out series of battles affecting many millions of individuals across dozens of countries. As nations worked to keep a military edge against their enemies, they made huge investments in science. While there's no denying the 1940s their boom in military technology, the wartime effort would bring us more than just new ways to kill each other.

THE ATOM BOMB IN THE ROOM

In a decade that gave us loads of wartime tools and vehicles—from the AK-47 to the Jeep, from the jet plane to cruise missiles—the invention of greatest consequence has to be the atom bomb, the war-ender (and potential world-ender). Not long after the physicist-chemist team of Lise Meitner and Otto Hahn discovered nuclear fission in the late 1930s, the race was on to develop a bomb that could unleash the power of splitting atoms in a nuclear chain reaction. While early discussions did occur in Manhattan, the work of the Manhattan Project—the code name given to the endeavor of developing and building the bomb—was ultimately scattered across universities and project sites around the country. All the pieces would come together under US theoretical physicist Robert Oppenheimer in Los Alamos, New Mexico. On July 16, 1945, the first nuclear test took place there in the desert, blowing out windows hundreds of miles away and turning sand to glass. Oppenheimer, after seeing the explosion, would reflect on it with a verse from the Hindu scripture Bhagavad Gita: "Now I am become death, destroyer of worlds." Less than a month later, US bombers would drop atomic bombs on Hiroshima and Nagasaki, killing more than 100,000 people. WWII would end just a few weeks later.

PUNCHING THROUGH THE FIRMAMENT

While humans wouldn't develop rockets capable of putting objects and organisms into orbit until the 1950s, they sure tried in the 1940s. In 1942, Germany's V-2 rocket—which was developed as a long-range ballistic missile—became the first rocket that could fly high enough to reach space. As Germany began to collapse under the weight of the war, the United States and the Soviet Union captured much of their V-2 technology, with the Americans seizing plans, parts, and missile shipments, and the Soviets taking over production facilities. The United States used

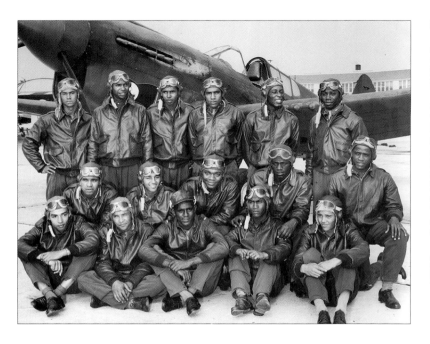

ROCKETS AND BOMBS

Above, a German V-2 rocket, under American control, sends test instruments and fruit flies into space in Project Blossom in February 1947.

At left, the Tuskegee Airmen, the first African American pilots in the US military. After having to fight to serve their country in WWI, black airmen began training in 1940. In March 1941, First Lady Eleanor Roosevelt flew with the squadron's instructor, Alfred "Chief" Anderson, and famously declared upon landing, "Well, you can fly all right." They deployed for combat in 1943 and went on to win numerous honors.

At right, Allied warplanes drop bombs over Hakodate, Japan, in July 1945.

The Future Then

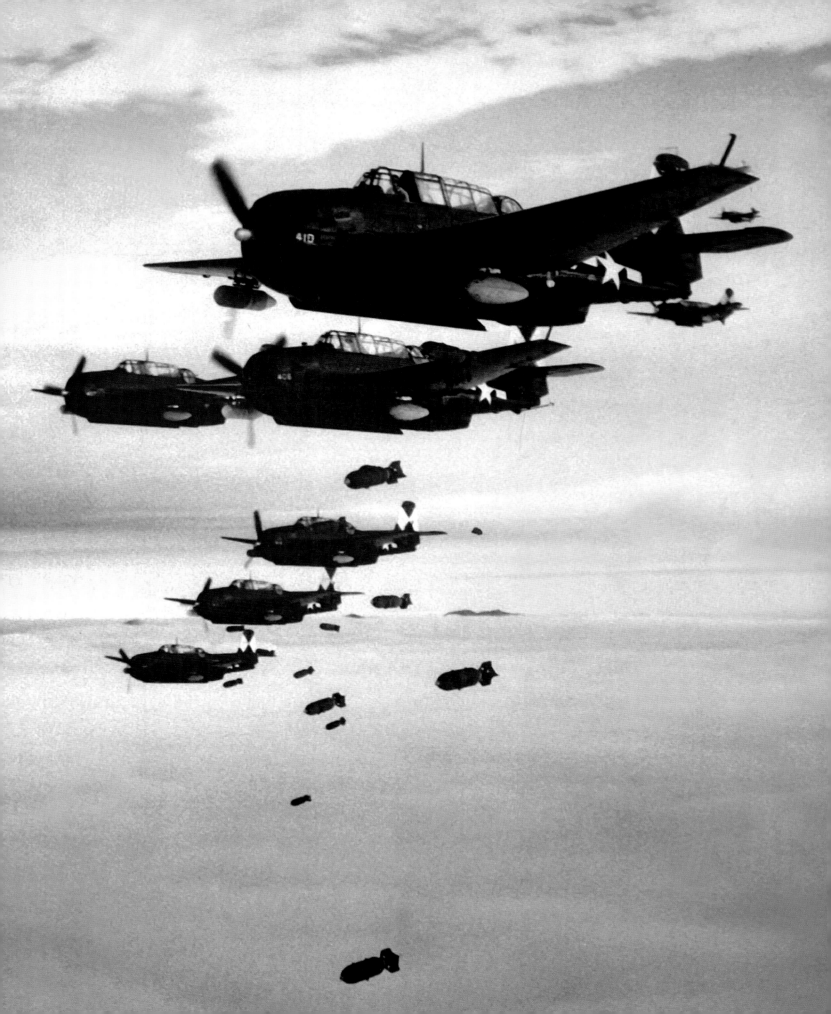

1940s

this limited supply of rockets to send test instruments, and even some living creatures, to the lower reaches of space. On February 20, 1947, the United States sent the first animals—fruit flies—up above our atmosphere, inside what was called the Blossom capsule. At the peak of its flight, the capsule ejected, then descended to Earth with the help of a parachute. The fruit flies survived. Albert II became the first monkey in space in 1949, but he wouldn't be so lucky. When his capsule's parachute failed to deploy, he was killed on impact.

HAPPY ACCIDENTS IN MEDICINE

While Alexander Fleming is credited with discovering penicillin in the 1920s, nothing really became of the first true antibiotic until the 1940s, when Australian scientist Howard Florey came across Fleming's work in a journal. In May 1940, Florey's team infected eight mice with streptococci bacteria. Miraculously, the four mice that were treated with penicillin were cured (the other four, not so much). From there, Florey and his team went on to test on humans in 1941. By 1945, penicillin was in full-scale production. Another happy accident in medicine occurred thanks to a strange, unnatural ally: mustard gas—a chemical weapon deployed in WWI with disastrous effects. While searching for an antidote, American doctors Louis Goodman and Alfred Gilman noticed that affected soldiers had very low white-blood-cell counts. They guessed that, if the gas could kill healthy white blood cells, it could likely kill cancerous ones, too. They were right—and thus began chemotherapy.

"COSMIC STATIC" AND A RADIO MAP OF THE SKY

Way back in 1931, Bell Laboratories engineer Karl Jansky investigated some static causing problems with radio communications. To pinpoint the source, Jansky built a huge rotating antenna system—Jansky's Merry-Go-Round—able to scan the entire sky in about 20 minutes, and discovered that the odd hiss was caused by the Milky Way itself. Problem solved, said Bell, and put him on a new project. But when a young electrical engineer named Grote Reber heard about Jansky's Merry-Go-Round, he decided to build his own heavens-exploring radio device in his backyard in Wheaton, Illinois. Compared to Jansky's invention, Reber's radio telescope was cutting edge, resembling what today we'd call a satellite dish—one you could tilt to point at different areas of the sky. During the next few years, Reber aimed his new toy skyward, first confirming for himself Jansky's findings, then turning to mapping out the radio frequencies of the entire sky. He published the first of many papers, "Cosmic Static," in 1940, and completed radio maps of the sky in 1941 and 1943. Reber was the first to identify many sources of radio waves, including ones in the Cygnus and Cassiopeia constellations. While radio astronomy grew into its own field of research after WWII (especially with the rise of radar), Reber was, for nearly a decade, the only person on Earth studying it. And all from his backyard.

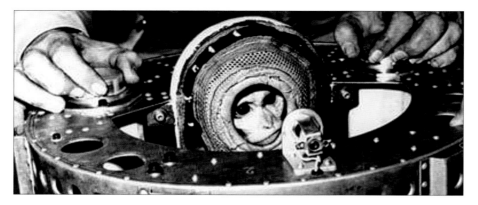

TEST TUBES AND TELESCOPES

Above, a few of the test tubes used to develop penicillin into a form people could use.

At right, an artist's depiction of Grote Reber's radio telescope—which is pretty close to the real thing—in the January 1948 issue.

At left, rebus monkey Albert II, who rode a V-2 rocket 83 miles (135 km) up into space on June 14, 1949.

Tomorrow's telescopes may be huge mirrors that gather faint electronic radiations from stars.

JANUARY 1948

ALSO OF NOTE

FEBRUARY 27, 1940
Americans Martin Kamen and Sam Ruben discover the radioactive isotope carbon-14, the basis for carbon dating.

JANUARY 8, 1942
Stephen Hawking is born.

JANUARY 8, 1943
Nikola Tesla dies.

AUGUST 21, 1946
US inventor Richard James files a patent for a "helical spring toy," better known today as the Slinky.

AUGUST 7, 1947
Thor Heyerdahl and team reach Polynesia after crossing the Pacific on a wooden raft, *Kon-Tiki*, to prove it would have been possible for South American people to settle the islands in pre-Columbian times.

1940s

1940s

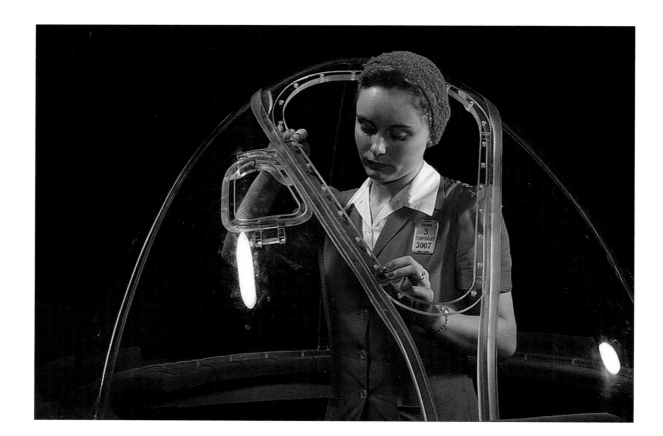

ONE WORD: PLASTICS

With WWII came tremendous shortages—governments around the globe found it necessary to ration food, gasoline, tires, shoes, and even clothes, and metal and rubber became precious and increasingly rare raw materials in the ceaseless manufacture of weapons and war machines. Luckily, the United States and its allies had a whole new ingredient to throw into the mix: plastic. The first manmade materials, celluloid and Bakelite, were created at the turn of the century, but the real game changer was nylon, invented in 1935 by DuPont employee Wallace Carothers. When the war hit, nylon quickly became the tough stuff of parachutes, ropes, body armor, and more. Likewise, Plexiglas—which arrived on the market in 1933—was suddenly the de facto replacement for glass in aircraft windows. In the 1940s, plastic production surged by a pretty incredible 300 percent. And it was just the start: After VE Day, consumers opted for shiny new plastic over traditional materials in every product they could. It seemed the stuff of life—and the environment in which it would last and last—would never be the same again.

THE FIRST ACTUAL COMPUTER BUG

If the 1930s gave us the foundational thinking behind computers, the 1940s gave us the urgency to see that thinking realized. In 1940, George Robert Stiblitz first demonstrated an electrical digital computer. In 1944, the Harvard Mark I (a giant, electromechanical computer that played a role in the WWII effort) came online. And in 1948, Bell Labs unveiled the transistor—arguably the beginning of Silicon Valley. But the funniest computer story of the decade has to do with the Harvard Mark II. Paid for by the US Navy, the Mark II was a faster version of its predecessor, but that didn't make it invincible. One day, the Mark II was acting up, and a technician pulled a moth from between two contacts inside. While the use of *bug* to refer to something that makes a machine malfunction was already common, this was the first literal computer bug to be recorded. The log book documenting the event still exists, with that poor moth still taped to the page.

PLASTICS AND SEMICONDUCTORS

Above, a worker puts the finishing touches on the Plexiglas nose for a B-17 Flying Fortress at the Douglas Aircraft factory in Long Beach, California.

At right, John Bardeen, William Shockley, and Walter Houser Brattain pretend to like each other long enough to develop the first transistor. (Shockley had a strained working relationship with his colleagues.) This tiny marvel is a semiconductor, used to amplify or switch electrical current and power. There's likely been one inside every device you've ever used. It earned the Bell Labs team a Nobel Prize in Physics in 1956.

The Future Then

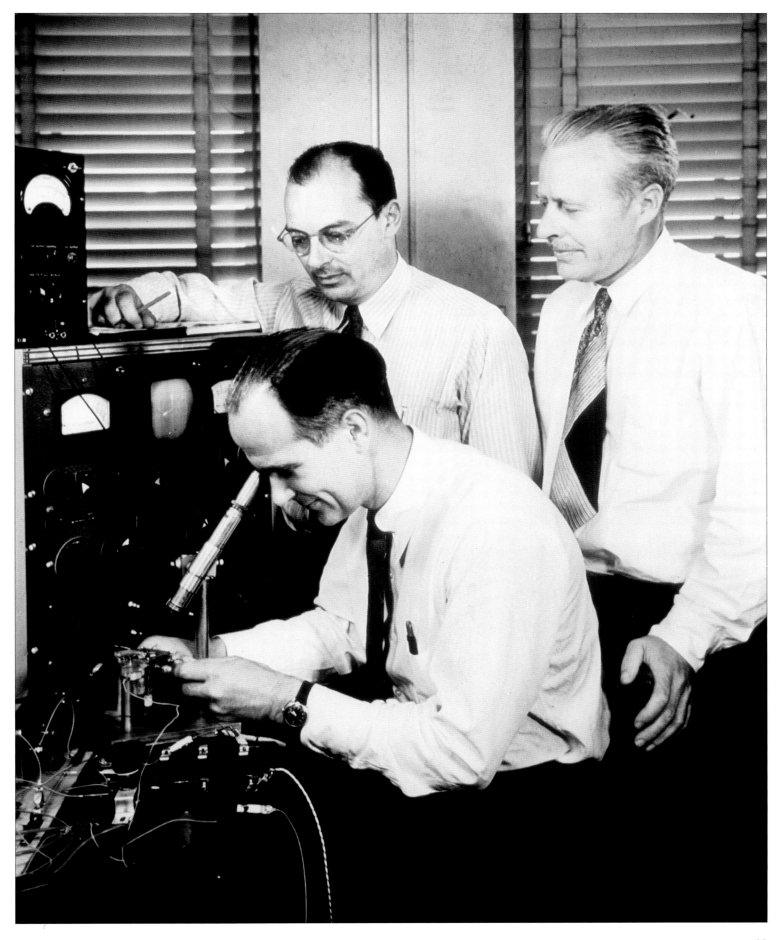

1940s

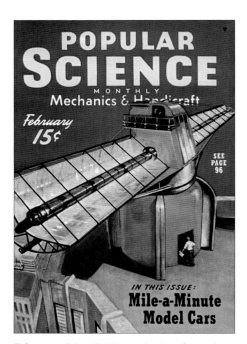
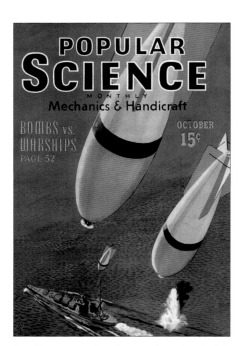
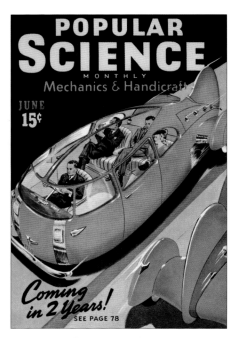

February · Edgar F. Wittmack · A rooftop solar setup harnesses the sun's heat.

⊘ DID IT HAPPEN? It's complicated. Solar cells convert sunlight into energy, and some researchers are developing cells that can do the same with the sun's heat. But contraptions that "can" the summer sun's heat for cooler months don't exactly exist—unless you're hoping to use that heat to cook hot dogs, which this issue will happily show you how to do.

October · Unattributed · Demolition bombs fall on battleships.

✓ DID IT HAPPEN? Over and over. This feature looked at the many ways bombers and battleships destroy each other—such as dive bombing, in which a small plane does severe damage to a battleship but must first get close to many antiaircraft weapons that could blow it out of the sky. In the battle of bombers versus warships, nobody really wins.

June · Unattributed · A small group tools around in a rear-engine vehicle.

✓ DID IT HAPPEN? Yeah, though this strangely elegant fishlike car won't pull up next to you in traffic any time soon. While most car engines still live up front—since having the weight of the engine in the rear can cause steering problems—some vehicles are powered from behind. For instance, heavy city buses use rear-engine designs to make more room for passengers.

March (right) · Edgar F. Wittmack · A soldier pilots a one-man helicopter.

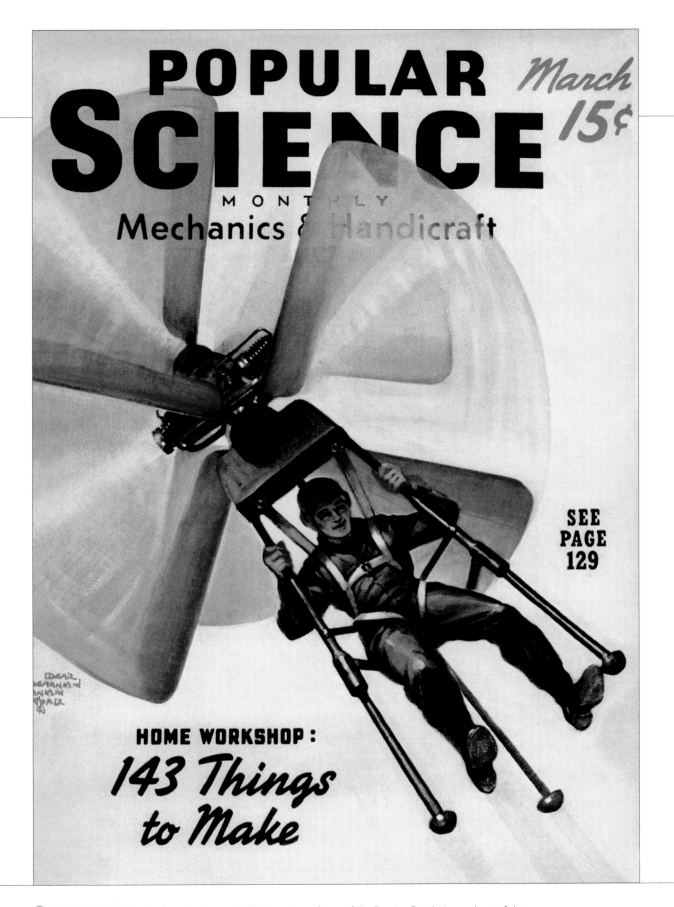

❌ DID IT HAPPEN? No. Designed by George de Bothezat—a refugee of the Russian Revolution and one of the first individuals to get a US military contract to develop a helicopter—this specific design never really got off paper. While some hobbyists have made novelty versions that look pretty close to this, the one-man chopper has never been a real war machine.

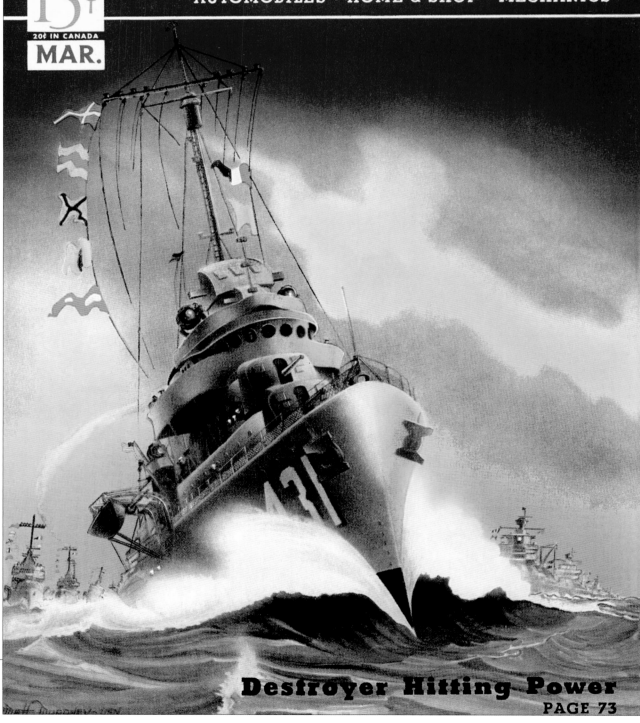

1941

July · Paul Dorsey · One of thousands of American fighter pilots.

✓ DID IT HAPPEN? Yeah, the tagline here—"40,000 Pilots For Defense"—refers to the number the government hoped to recruit annually during WWII. It's also roughly the number of American airmen who died during the war.

August · Harold W. Kulick · Two airmen look skyward under a banner praising American industry.

✓ DID IT HAPPEN? Yes. The cover feature detailed the ways small manufacturers contributed to the war effort. For instance, one bassinet company was put to work making bumpers for ships and subs, while a birdcage manufacturer started churning out fuses for artillery shells.

February · John T. McCoy Jr. · Grumman F4F-3 Wildcat fighter jets fly in formation over the Pacific.

✓ DID IT HAPPEN? Yes. Capable of flying faster than 250 miles per hour (400 km/h) and carrying two 115-pound (50-kg) bombs, the F4F was one of the US Navy's front-line fighters during WWII. It was especially hot stuff at a formation maneuver known as the Thach Weave: Two Wildcats would fly side by side and, if tailed by an enemy aircraft, would turn in toward each other. If the enemy followed Plane A, he'd be vulnerable to attack from Plane B. (Fun fact: John T. McCoy Jr., the artist behind this cover, was also a commercial pilot.)

March (left) · Matt Murphey · A newly commissioned destroyer, the USS *Plunkett*, sails into battle.

✓ DID IT HAPPEN? Yup. The *Plunkett* was launched in March 1941 and saw a fair bit of action, mostly supporting missions in Europe and screening ships in the Atlantic. It was one of the US Navy's new destroyers, intended to race to spots of emerging conflict and hold the line until slower transport ships could bring reinforcements. Today, destroyers rule the seas.

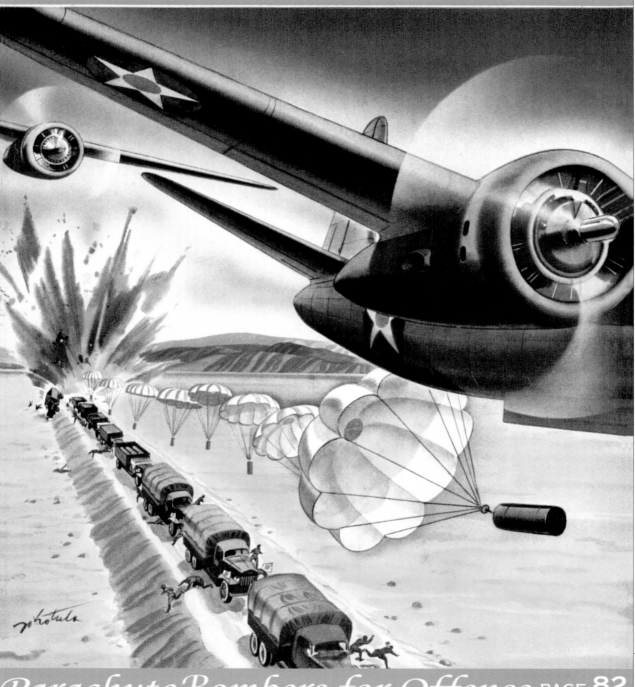

1942

March · Matt Murphey · The USS *Boxwood* lowers an antisubmarine harbor-defense net.

✓ DID IT HAPPEN? Definitely. Antisub defense nets were particularly important for defending vulnerable coastal cities, such as San Francisco, during WWII. The nets were up to 3 inches (7.5 cm) thick and came equipped with gates to allow ships of commerce through. Curiously, the boats in charge of laying these nets were all named after trees (*Boxwood*, *Gum*, and *Locust*, to name a few). These days, more modern methods of submarine detection prevail.

July · W. W. Morris · A bombardier takes aim from the cockpit of a Boeing B-17 Flying Fortress.

✓ DID IT HAPPEN? Many times over. The cover story details the roles of each of the nine crew members that made up a WWII precision bombing crew: pilot, copilot and navigator, two radiomen to handle communications and double as gunners, two engineers to shore up the "flying fortress" and gun when needed, tail gunner to cover the rear, and bombardier to pull the big trigger and handle gunner duties as well.

May (left) · Jo Kotula · The Porcupine Squadron drops parachute bombs.

✓ DID IT HAPPEN? Yes. During WWII, low-flying light bombers dropped munitions with parachutes so that they would have time to flee the blast zone before the bombs hit the ground. This particular plane—the Douglass A-20 Havoc—made attacks against the Germans from as low as 33 feet (10 m) above the ground.

 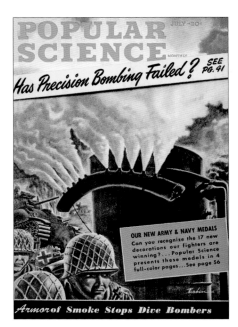 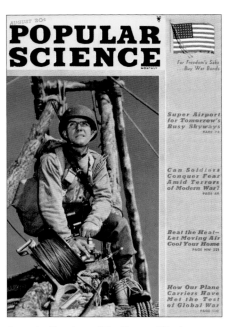

February · Jo Kotula · A US Navy plane bombs an aircraft carrier.

✓ DID IT HAPPEN? Definitely. Navy planes still perform observational and combat roles in support of US sea power, taking off from ocean carriers to defend and offend at sea. This cover story provides baseball-card stats of Navy war planes in the 1940s—from fighters to dive bombers to torpedo launchers.

July · George D. Erben · Troops and tanks hide behind a smoke screen.

✓ DID IT HAPPEN? Yes, smoke has long been used to hide troop movements during combat, dating back to Roman times. In this image, the Army's M-1 smoke generator throws up a screen of artificial fog to blind the enemy to would-be targets. Today, we've developed artificial fog opaque enough to block infrared lasers on sensors and target designators.

August · Courtesy of the Corps of Engineers, US Army · An anxious soldier looks at what's headed his way from a perch on a barricade.

✓ DID IT HAPPEN? This cover feature asks "Can Soldiers Conquer Fear Amid Terrors of Modern War?"—a question still very relevant. The article details techniques for combating panic, such as calling the roll or—strangely—informing soldiers of the odds of their demise. As less grim reading, this issue offered a section of DIY projects, including making toy birds for a nursery.

December (right) · Jo Kotula · Britain's "wooden wonder bombers" take out a Nazi airfield.

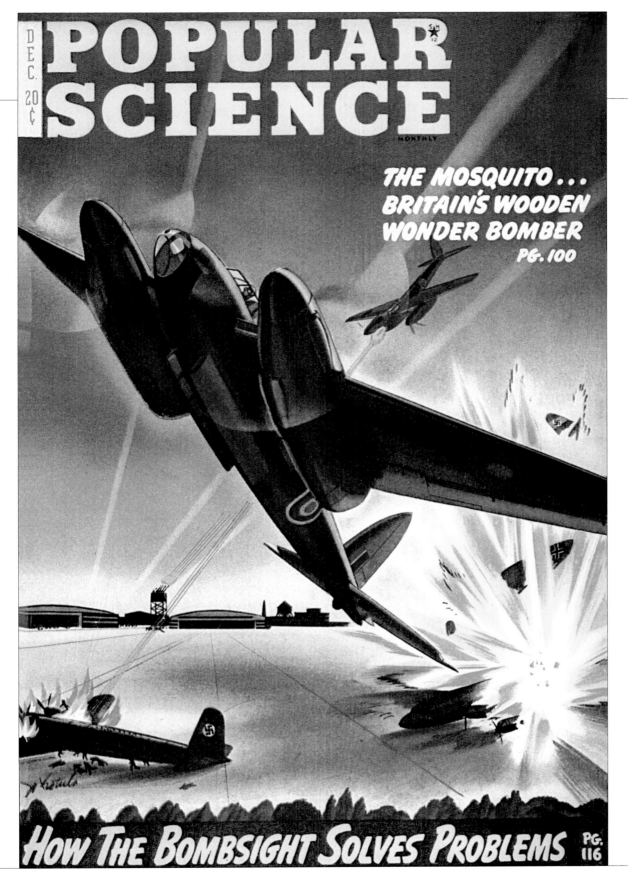

DID IT HAPPEN? Yeah. The British de Havilland Mosquito was an almost entirely wooden combat plane used during WWII—to surprisingly successful effect. "A termite's dream but a real nightmare for [Nazi forces]," this lightweight plane surged in production because it didn't sap materials or manpower from the manufacturing of all-metal fighters and heavy bombers.

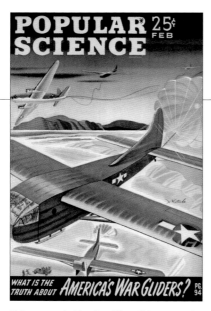

February · Jo Kotula · War gliders come in for a landing.

✓ DID IT HAPPEN? Believe it or not, yes. Engineless, often one-time-use gliders such as this CG-4A were towed in fan formations behind aircraft to carry troops and supplies. When they arrived over their destination, they'd cut loose and land.

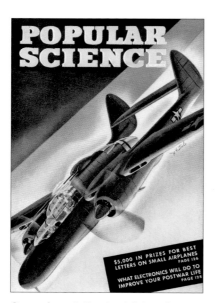

September · Jo Kotula · A fighter fires ominous-sounding "automatic weapons."

✓ DID IT HAPPEN? Oh, boy, yes. The cover story grapples with the potential that automatic weapons have to change warfare—including innovations like robots and "pilotless planes." In this featured article, there is an eerily prescient sketch of what we might call a military drone.

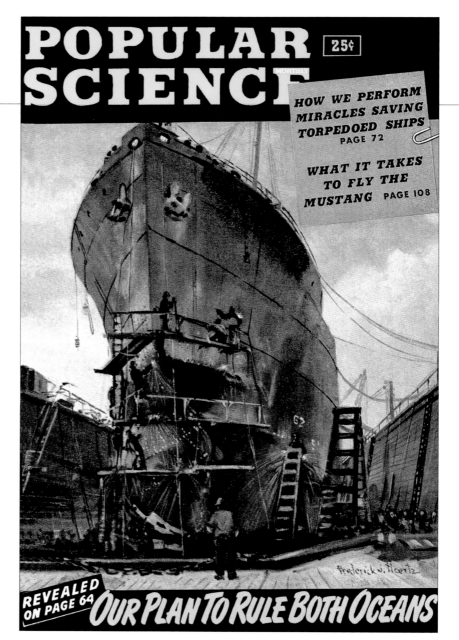

August · Frederick J. Hoertz · Workers repair a torpedoed British warship in a dry dock at New York's Todd Shipyards.

✓ DID IT HAPPEN? Yes. Many ships that sustained wartime damage were repaired and sent right back out to the fight. One covered in this article, the USS *Nashville*, was even "rechristened by the same lady who cracked the champagne bottle" over its helm the first time. Dry docks, which date back to 200 BCE Egypt, are still commonly used in shipbuilding and ship repair. If it ain't broke . . .

June (right) · Jo Kotula · An artist's mockup of a postwar private plane.

✓ DID IT HAPPEN? You bet. This cover announced a contest in which readers wrote in imagining private planes that "[they themselves] would like to own and fly after the war is won." Makes sense that the desired features were all those of comfort: foot throttles, built-in cigarette lighters, and arm rests—not machine guns and ejection seats.

The Future Then

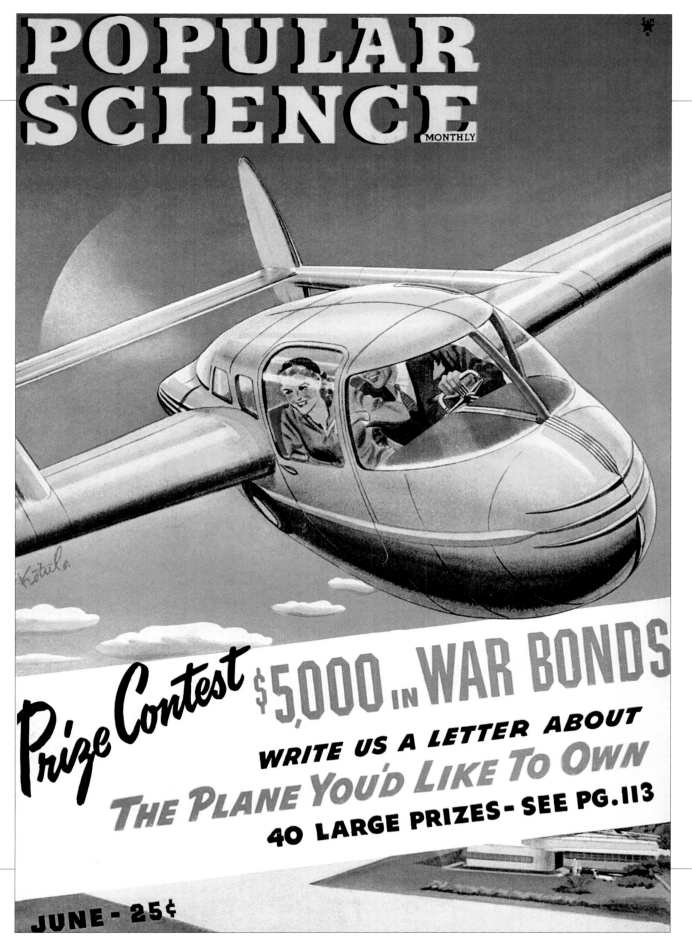

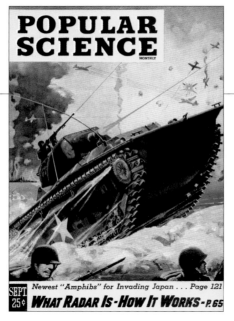

September · Frederic Tellander · Amphibious tanks invade Japan.

🚫 DID IT HAPPEN? It's complicated. Some amphibious vehicles were deployed in WWII—such as tanks that could climb reefs where landing crafts would run aground. But five days into September 1945, WWII ended. We ended up not needing 'em.

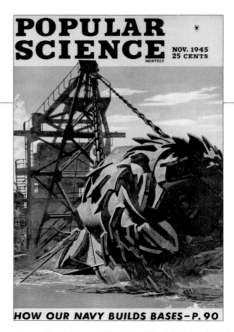

November · George Englert · The US Navy builds an overseas base.

✅ DID IT HAPPEN? And then some. The US military has roughly 800 international military bases—up from the 434 used during WWII. Also included in this issue: tricks for splicing rope and DIY plans for a miniature cardboard golf course.

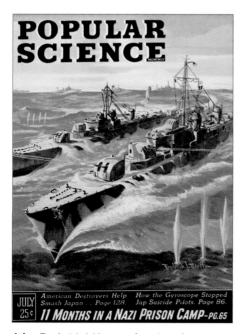

July · Frederick J. Hoertz · American destroyers skirmish with Japanese adversaries.

✅ DID IT HAPPEN? Yes, of course. Developed in the 1900s for torpedo defense, destroyers have now replaced battleships at surface combat. Today, they're equipped with guided missiles, and they can carry out antisub and antiaircraft operations as well.

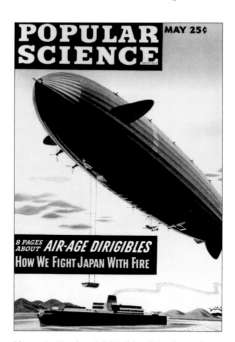

May · Jo Kotula · A "dirigible of the future" loads cargo onto a ship.

❌ DID IT HAPPEN? Nah, not really. This feature predicts airships with full-size dining rooms and hotel-room-size accommodations. It's no secret that planes came to rule the skies instead.

March (right) · Jo Kotula · Travelers deplane onto a shiny shuttle bus.

The Future Then

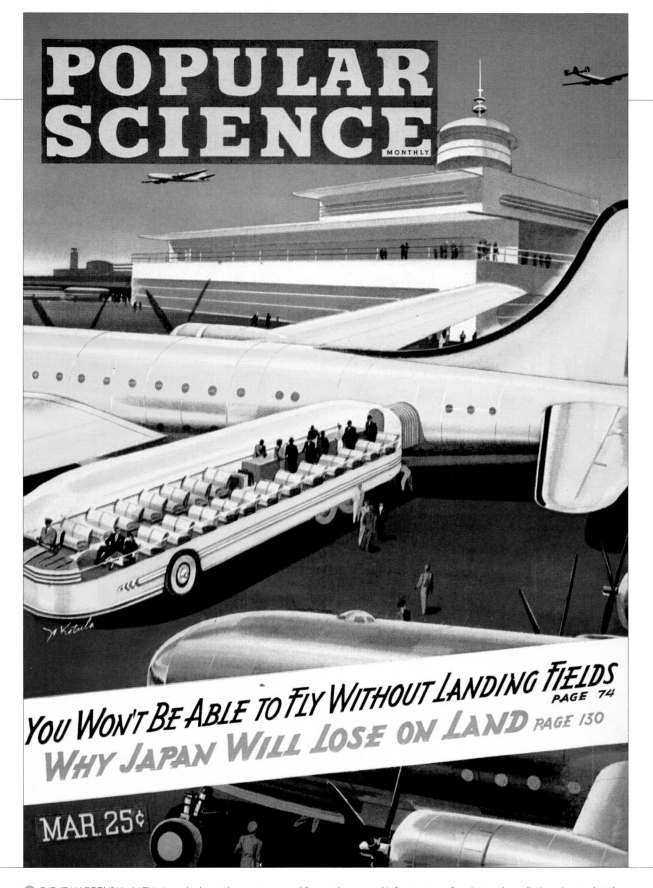

DID IT HAPPEN? Yeah! This issue looks at the postwar need for on-the-ground infrastructure for air travel, predicting airport shuttles, luggage transport, and different runway types. (Though few would consider the airports of today "airparks," the glorious landing strip-cum-recreation center envisioned in this piece.)

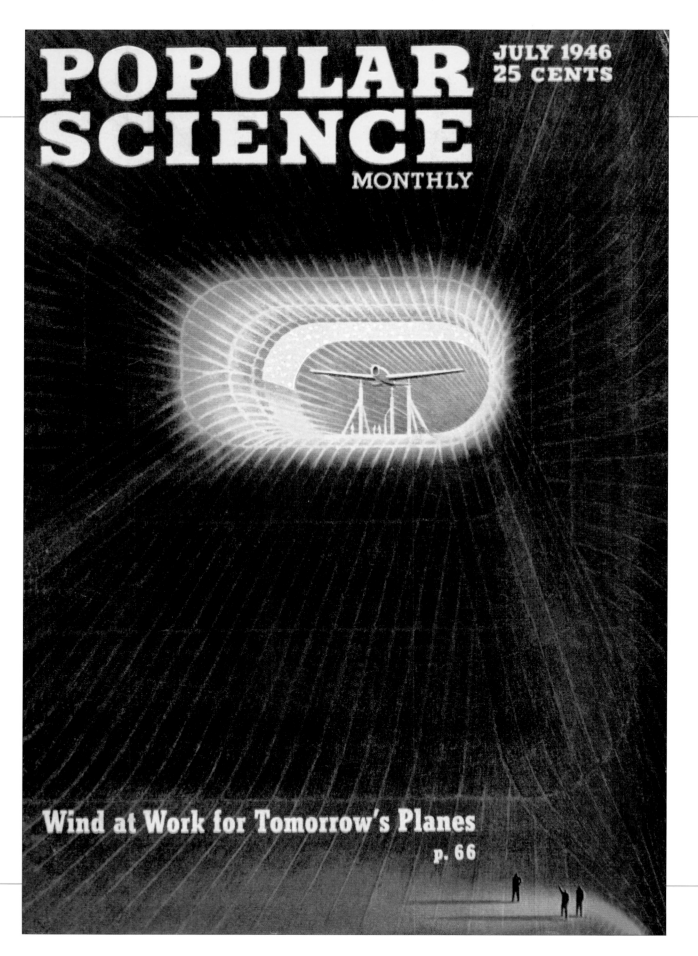

1946

August · Ray Pioch · Would-be buyers check out prefab homes.

✓ DID IT HAPPEN? Definitely. In response to housing shortages of the 1940s, prefabrication emerged as one potential solution—the idea being that homes could be cranked out faster assembly-line-style than they could one at a time with hammer and nails. Today, prefab homes are tacky and beautiful and everything in between. (Can you tell the war ended?)

January · Alfred D. Crimi · The 200-inch (5-m) telescope on Mount Palomar near San Diego, California.

✓ DID IT HAPPEN? Yeah! It came online in 1948 and was the largest telescope on Earth until 1993. Notable discoveries include correcting earlier thoughts about the distance to Andromeda in 1961 (essentially doubling the size of the universe in one observation) and spotting quasars billions of light years away (the most distant bodies observed up to that point) in 1963.

July (left) · Ray Pioch · A plane takes a test flight through a wind tunnel.

✓ DID IT HAPPEN? Totally. Outfits like NASA test the aerodynamics of full-size planes, shuttles, and aircraft segments—such as tails—along with scale models in wind tunnels. They mount the test subject in the middle of the tubular space, then blast it with air currents at specific velocities. This particular wind tunnel, the National Full-Scale Aerodynamic Complex at NASA's Ames Research Center, is 40 by 80 feet (12 by 24 m)—the largest in the world when it was first built. Every major aircraft manufacturer has tested there.

1947

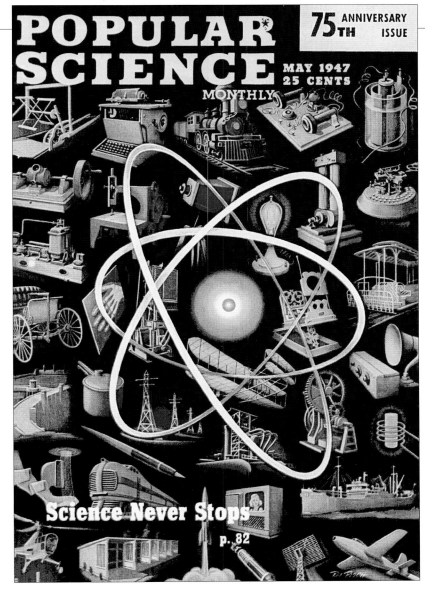

May · Ray Pioch · Major scientific breakthroughs of the first 75 years of *Popular Science*.

DID IT HAPPEN? This cover pays homage to a number of advances in science: early telephone and radio, the Wright airplane, radar and the V-2 rocket, X-rays, vaccines, and the linotype machine, among others. The feature itself, though, contained spot-on predictions of the future, including humans on the moon and wireless communication—and some, well, less correct musings, too. (Luckily, we're still waiting on "beefsteaks," a yeast-based meat replacement from Anheuser-Busch.)

January · Ray Pioch · Firefighters use a newfangled aerial fire truck.

DID IT HAPPEN? You bet. While fire trucks had carried ladders and other blaze-fighting tools since the late 1800s, this was the first integrated system—with ladders, life nets, water-delivery systems, and more.

April · Robert E. Bingman · A cutaway illustration shows off the potential safety features in cars of the future.

DID IT HAPPEN? Yes and no. Some features predicted in this cover story (like seat belts) became ubiquitous, while others (like braking distance indicated on speedometers) never caught on.

December (left) · Ray Pioch · Swiss scientist and inventor Auguste Piccard and assistant Max Cosyns submerge in the first bathyscaphe.

DID IT HAPPEN? Sure did. Piccard created the first free-floating, self-propelled deep-sea submersible, the bathyscaphe. (It differs from a bathysphere in that it's suspended under a float, rather than tethered to a ship, and can navigate its own path.) The operator uses ballast to control its buoyancy.) After years of testing and development, Piccard's most successful bathyscaphe, *Trieste*, went 10,300 feet (3,150 m) deep in 1953.

1940s **109**

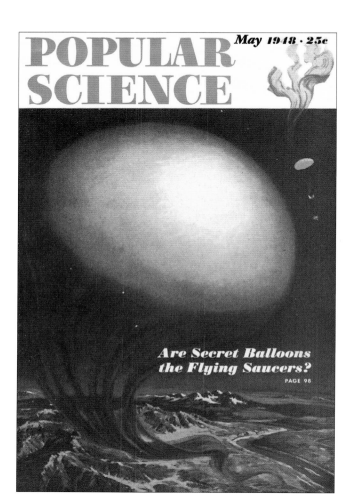

June · Ray Quigley · A family without a care in the world enjoys hanging out in their backyard.

✅ DID IT HAPPEN? Of course. This feature looked at simple ways readers could transform backyards into home resorts, including plans for brick fireplaces, climbing contraptions and other children's playthings, screens for discreet sunbathing, and a sun deck that doubles as a Ping-Pong table. (Seriously, though: Can you tell the war is over?)

May · A. E. Leydenfrost · An ominous sphere rises in the sky, with the headline: "Are Secret Balloons the Flying Saucers?"

✅ DID IT HAPPEN? Yes—but hold on to your tinfoil hat, Mulder. This issue covers Project Skyhook, a covert General Mills program in which balloons were sent 100,000 feet (30,500 m) into the sky to conduct research—and looked an awful lot like UFOs to people on the ground. Today, balloons are still big; we're contemplating using them for space tourism and networking them to share Wi-Fi with the world.

February · Lester Fagans · A pilot-in-training rides a human centrifuge.

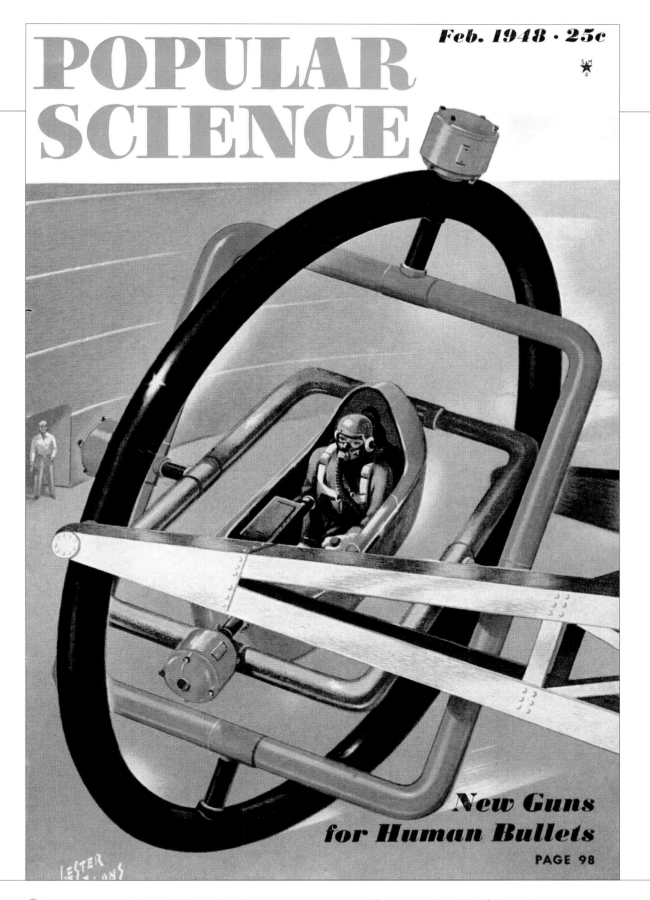

DID IT HAPPEN? Definitely. NASA and the military use giant human centrifuges to test the ability of pilots and astronauts to deal with strong forces of acceleration. This one in particular opened in 1949 at Pennsylvania's Johnsville Naval Air Development Center, and it's where most astronauts of the early space race trained, including Ham the Astrochimp—the first hominid the United States launched beyond our atmosphere.

1949

May · Ray Pioch · An "Earth satellite vehicle" goes into orbit.

✅ DID IT HAPPEN? Within a decade. But the iconic first satellite—*Sputnik I*—adopted a more modern design approach than this depiction, with a sleek, reflective silver sphere and just four thin antennas.

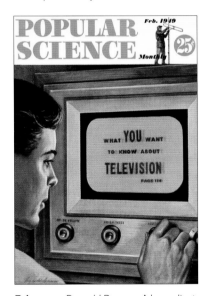

February · Reynold Brown · A boy adjusts the picture on his new TV.

✅ DID IT HAPPEN? This feature walks readers through the practical considerations of buying a set—from optimum screen size to best location to mounting your antenna. Quaint stuff.

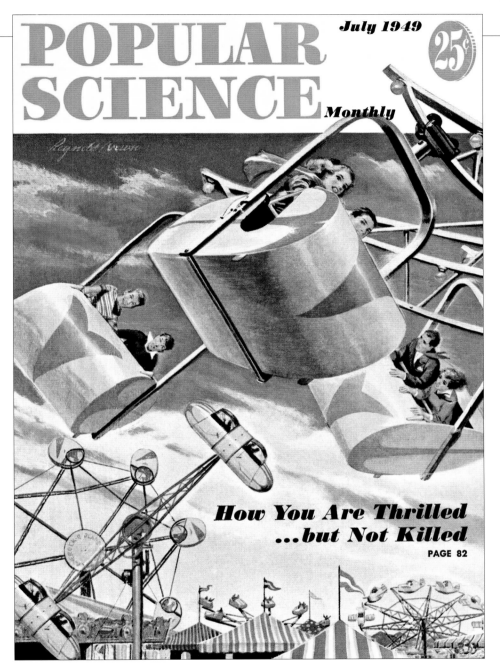

July · Reynold Brown · Revelers soar in an amusement park ride.

✅ DID IT HAPPEN? *Popular Science*'s amusement park credo still rings true: "The successful ride is one that scares the living daylights out of you without actual danger." This feature compared attractions of 100 years past—such as the Upside-Down House, where patrons sat in a stationary bucket while a house moved around them—with later thrill rides, including the whirling, 52-foot- (16-m-) tall Hi-Ball, shown here. (Wonder what they would have thought of Space Mountain.)

March (left) · Ray Pioch · The Dover House—the first home to be heated entirely by solar energy, created by MIT researcher and inventor Dr. Maria Telkes and architect Eleanor Raymond.

♻️ DID IT HAPPEN? Yes and no. Telkes's system managed to heat the house for two Boston winters, storing warmth in Glauber's salt (a chemical that holds heat gathered by a solar panel). But by the third winter, the salt separated so much that the heating system failed.

ARTIST PROFILE

RAY PIOCH

If *Popular Science* did its own lifetime-achievement awards—you know, like those touching Academy Awards montages that lionize a person who has done a ton of good work over the years—then Ray Pioch's mantelpiece would definitely boast that golden beaker or atom or whatever other trophy seems appropriate for an award given by a science magazine. In fact, Pioch is one of the only artists who worked for *Popular Science* to ever get that sort of adulation. On more than one occasion, the magazine's editors felt it necessary to spend a paragraph—sometimes a whole page—praising the talents of their most valuable illustrator.

And for good reason. Pioch drew and painted countless covers, diagrams, and pinups from the 1940s through the mid-1980s. And while he may not have been the most famous person to ever make art for the magazine (cough—Rockwell—cough), he was something of an anomaly in that he was actually an engineer. He did a stint in the US Navy and spent some time at General Motors, where he worked to bring shape and form to automobiles. You can see some of that experience come through in his many cutaway drawings—illustrating everything from car engines to televisions and the sun. (You can also see it on the cover of this book, which features Pioch's art for the December 1962 issue of the magazine.)

Not only were Pioch's works beautiful, they were also incredibly precise—to the point where editors remarked that he often kept the magazine honest. So here's to you, Ray Pioch, for making your mark on four decades' worth of *Popular Science* "with a technical accuracy photographers would envy."

At right, top to bottom,
November 1948
August 1947
May 1946

At far right,
June 1946

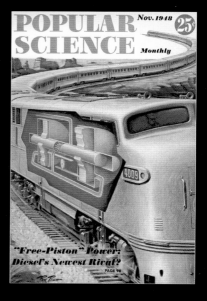

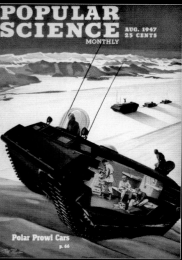

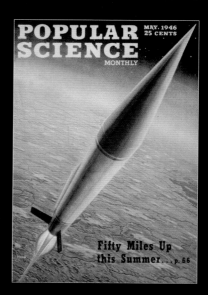

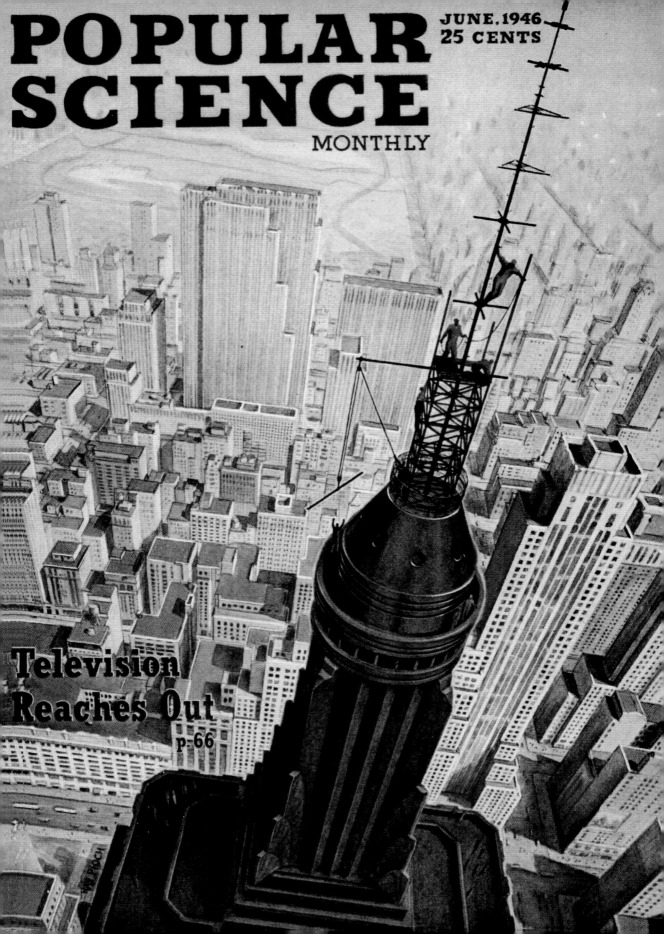

1950s

1950s

ARMS RACE TO SPACE RACE

With WWII in the rearview, things were looking up for a lot of people stateside during the 1950s. As European allies struggled to rebuild after massive loss of property and life, the United States overall felt the effects of postwar economic growth, with home construction spiking and thousands of soldiers gaining higher education through 1944's GI Bill. Throughout the decade, much of the wartime industrial power shifted to the production of consumer goods—from war machines to automobiles, from battleships to the family boat. For an emerging middle class, life started to look a lot like *Leave It to Beaver* in more ways than one.

TELEVISION SPREADS

In the late 1940s and early 1950s, TV ownership was still limited to the wealthy, with fewer than 1 percent of homes having a set in their living rooms. But as the price of TV dropped, its adoption across the United States grew faster than any other home technology in history. By the end of the decade, nine out of ten households were crowded around the glowing boob tube every evening. Networks leveraged TV's massification to push products on a growing and captive audience, filling homes around the country with a kind of bland, inoffensive programming designed to appeal to as broad a swath of the population as possible. As the decade wore on, color became commercially viable, and some companies pushed miniaturization and portability. TV revolutionized not only entertainment but also news and public health bulletins.

THE H-BOMB COMETH

As surely as marked material improvements characterized the lives of many, the shadow of one cloud still hung over the collective American psyche: the mushroom cloud. Once a WWII ally, the USSR had tested its own atomic bomb by the end of the 1940s, only further chilling Cold War relations and increasing the urgency of a burgeoning arms race. Not to be outdone, by 1952, US military scientists cratered an entire island in the Pacific with Ivy Mike—the first full-scale H-bomb—scattering radioactive debris as far as 35 miles (56 km) from the blast center (though this wouldn't truly become public knowledge until 1954, when video of the blast was even shown on television). In tit-for-tat efforts, the Soviets tested their own thermonuclear device in 1953. With no way for either nation to defend against that kind of fallout, the deterrent power of mutually assured destruction became cold comfort for people on either side of the Iron Curtain.

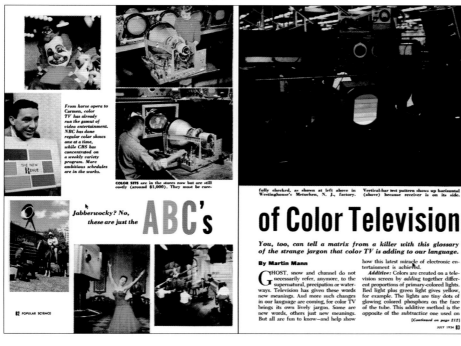

GATHERING DUST

Above, Ivy Mike—the first thermonuclear device ever detonated—craters Elugelab, a former island in the Marshall Islands, on November 1, 1952.

At left, a July 1954 glossary intended to demystify color television for consumers. The first nationwide color broadcast occurred in January of that year, and many Americans grappled with whether to buy a new all-color set or stick with B&W.

At right, students "duck and cover" in a nuclear-attack drill in the 1950s. Grim stuff.

1950s

THE RISE AND FALL OF POLIO

While polio had been around since prehistoric times, it reached truly epidemic proportions in 1952 with a staggering 55,000 total diagnoses—including 3,000 deaths and 21,000 cases of full or partial paralysis. Traditional remedies—like vitamin C treatment and the iron lung—were either dubiously effective or prohibitively expensive. A cure seemed so unlikely that inventors started devising gadgets to help people in iron lungs use the telephone and turn book pages on their own. But the outbreak lit a fire under the scientific community to find a cure. In 1952, American virologist Jonas Salk first tested what would become the inactivated poliovirus vaccine (IPV)—a dose made up of dead poliovirus, released to the public in the mid-1950s. After a mass immunization program in 1957, the number of cases dropped to just over 5,000 per year. Also in 1957, Albert Savin would develop a second prong of attack, the oral polio vaccine (OPV), made up of a weakened strain of the virus. Between the two treatments, the number of polio cases would all but vanish, falling to fewer than 200 by the early 1960s. Today, the disease barely exists.

ATOMS FOR PEACE

Not all atomic scientists were interested in destruction. In fact, in 1953, President Eisenhower laid out a peaceful vision in his "Atoms for Peace" speech to the United Nations General Assembly, saying, "Against the dark background of the atomic bomb . . . the United States pledges before you, and therefore before the world, its determination to help solve the fearful atomic dilemma—to devote its entire heart and mind to finding the way by which the miraculous inventiveness of man shall not be dedicated to his death, but consecrated to his life." Out of the strange existential threat of the Bomb came the drive to put such power to peaceful use—to harness, rather than unleash, the energy of the atom. In 1957, Pittsburgh's Shippingport Atomic Power Station—the world's first nuclear power plant devoted to purely peaceful uses—came online.

EARLY RUMBLINGS OF THE SPACE RACE

The Cold War was as much a propaganda war as anything. And it seemed, for a time, that the United States held the decisive upper hand in technology. But that perception changed in 1957, when the USSR launched *Sputnik I*, the first artificial satellite, into orbit. About the size of a beach ball, *Sputnik* circled the globe in a little more than an hour and a half, marking the beginning of the Cold War space race. At the time, the launch was a huge propaganda victory for the Soviet Union. Seeing the importance of a technological advantage just a year earlier, Dr. Lawrence R. Hafstad, director of research at General Motors, said to *Popular Science*, "Our choice is brutally clear . . . We can either learn mathematics and science—or Russian."

EARTH'S BIRTHDAY GOES ON THE CALENDAR

Before the 1950s, all we knew about Earth's age was that it was somewhere in the billions. We have a geochemist from Iowa to thank for dialing in the number of candles on our planet's birthday cake—and, interestingly, we also have the same man to thank for preventing mass lead poisoning. In 1956, Clair Cameron Patterson successfully measured the lead isotopes in a

Phone Designed for Patient in Iron Lung

When three telephone men were asked to provide a man in an iron lung with a telephone, this is what they devised. The main problem was a switch that could be worked by a patient who could move only his head. The solution was a small box with a lever-type switch in it, attached to a long rod with a rubber tip. The patient opens and closes the circuit by biting on the tip and turning his head.

HOLD THE PHONE

Above, a worker inspects a reactor bottom plate delivered to Pennsylvania's Shippingport Atomic Power Station, which was heralded on its opening day as the first full-scale facility to use atomic power peacefully. It was decommissioned in 1982.

At left, a polio patient confined to an iron lung uses the phone with a "hands-free" gadget.

At right, the USSR's 1957 launch of *Sputnik I* captivated imaginations across the globe.

The Future Then

ALSO OF NOTE

SEPTEMBER 10, 1953
University of Chicago graduate student Eugene Aserinsky copublishes a paper on his discovery of REM sleep.

DECEMBER 30, 1953
RCA begins to sell the first color television set—the CT-100—for a cool US$1,000, or about half the cost of a new car.

JUNE 29, 1954
Buckminster Fuller is awarded a patent for the geodesic dome—a building shape that couples the strength of the triangle with the volume-to-surface-area ratio of a sphere.

OCTOBER 9, 1957
Canadian engineer Lewis Urry patents the modern alkaline battery.

OCTOBER 8, 1958
Swedes Rune Elmqvist and Åke Senning implant the first pacemaker.

1950s

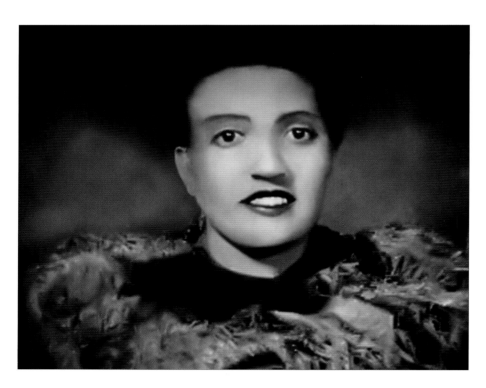

CELLS AND THEIR BUILDING BLOCKS

At left, Henrietta Lacks in the late 1940s. Unbeknownst to her family for 25 years, Lacks's mysterious, continuously replicating cells figured in a number of modern scientific discoveries, like gene mapping and in vitro fertilization.

At right, James Watson and Francis Crick with their 1953 model of DNA. The two—along with Maurice Wilkins—shared the Nobel Prize in Physiology or Medicine in 1962. Rosalind Franklin, who took the X-ray images that tipped Watson off to DNA's double-helix structure, did not receive a Nobel; she had died in 1958 due to cancer developed during her research, and the prize is not awarded posthumously. Her exclusion is still a controversy.

fragment of the Canyon Diablo meteorite. These leftover space rocks contained no uranium—an element that radioactively decays into lead at a constant rate over millions of years. So, by comparing the lead in this meteorite to that in other rocks, Patterson determined that Earth is 4.5 billion years old. But curiously, he and his team were continuously thwarted by lead contamination in rock samples—an annoyance that led him to realize that the dangerous element was, indeed, everywhere... even in their hair. Studying rocks from the ocean floor, he was able to show that lead levels had surged with the dawn of manufacturing and the use of tetraethyl fuel, which had caused sickness and death in several auto workers. Horrified, Patterson devoted his life to educating the public about the dangers of lead and removing it from the environment; by the 1990s, his efforts had helped reduce the amount found in Americans' bloodstreams by a staggering 80 percent.

THE INSTRUCTION MANUAL FOR LIFE

On February 28, 1953, a British molecular biologist named Francis Crick interrupted patrons lunching at Cambridge's Eagle Pub with some exciting news: He and American geneticist James Watson had discovered what he termed "the secret of life": the double-helix structure of DNA, the molecule that contains genetic information in every living creature. Swiss doctor Friedrich Miescher had first isolated DNA way back in 1869, and several scientists had determined that the molecule was made up of two strands of linked nucleotides. Most notable, British chemist Rosalind Franklin and New Zealand–born physicist Maurice Wilkins had produced X-rays of DNA, which revealed that the molecule's structure was made up of not one helix—as commonly believed—but two. Watson spotted one of these images in January 1953, and he and Crick hurriedly began building a physical model of the molecule, correctly pairing the nucleotides (adenine with thymine, and guanine with cytosine) for the first time.

HELA CELLS—THE GIFT THAT KEEPS ON GIVING

In 1951, the world lost Henrietta Lacks, an African American tobacco farmer and mother of four in Baltimore, Maryland, to cervical cancer. But in one way, Lacks never died: A sample of cancerous tissue from her cervix yielded the world's first immortal cell line, a group of cells that can be reproduced indefinitely in a culture. Called HeLa cells, Lacks's tissues have figured in a dizzying number of scientific breakthroughs—from the creation of the polio vaccine to cloning. They were even sent to space to test zero gravity's effects on cellular function.

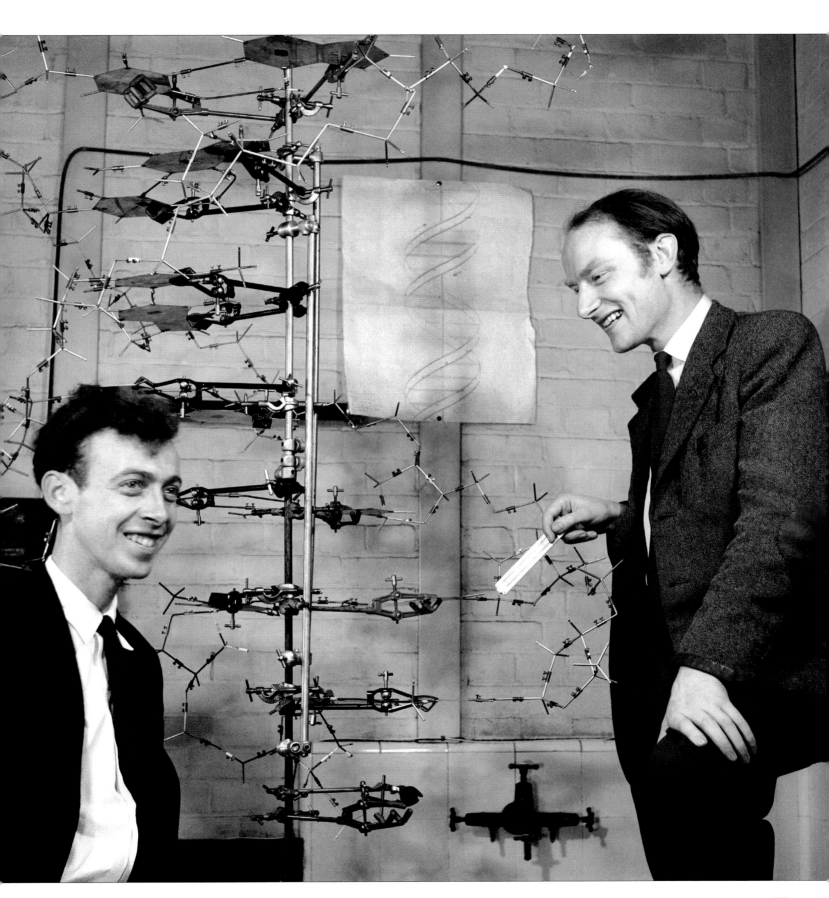

1950s

1950

December • W. W. Morris • A Kodachrome photograph of a gold Santa Fe Streamliner marks 50 years of miniature electric trains.

✅ DID IT HAPPEN? Sure. This feature looked back at model electric trains, starting with the invention of the miniature electric motor in 1900 and the electric third-rail track in 1909, then cars that dumped loads, magnetic traction that allowed steep climbs, control via electronic switch, and real billowing smoke in later years. Today, all this stuff works digitally.

February • Ray Pioch • A giant earth mover eats a ton of dirt.

✅ DID IT HAPPEN? Absolutely. At the time of this book's publication, earth movers capable of shifting 1 million cubic yards (765,000 m³) of dirt per day were carving through King of Prussia, Pennsylvania, working on extending the turnpike. Today's largest earth mover can do up to 400 tons (365 t) at a time.

October (left) • Denver Gillen • A souped-up camera rig "magically" makes studio scenes seem like they really happened for *The Fred Waring Show*.

✅ DID IT HAPPEN? Oh, yeah it did! This journalist was mighty impressed by tricks like mimicking a pond with a trough of shallow water, and faking the night sky by placing a piece of perforated black paper in front of a light. CGI would have really blown his mind.

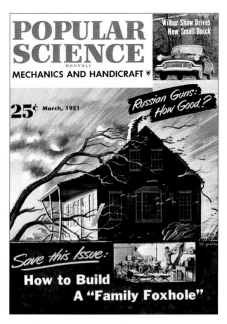
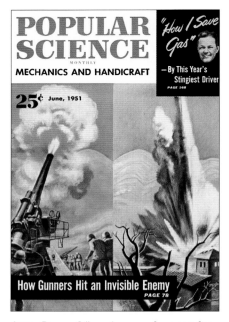
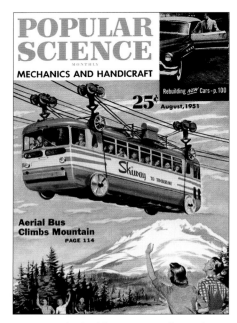

March • Denver Gillen • A family hunkers down in their foxhole while the Bomb levels their house.

❌ DID IT HAPPEN? The Bomb part hasn't happened (yet), but the bunkers of today's survivalists and doomsday preppers—with hydroponic gardens, medical clinics, even spas—make that foxhole look like child's play.

June • Denver Gillen • A group of gunners fire at a target 20 miles (32 km) away.

✓ DID IT HAPPEN? Yeah, and it still does, often at even greater distances. This feature looked at the development of a target grid and firing for effect, whereby multiple pieces of artillery fire on the same target, all of which made distance shooting more accurate.

August • John Gould • Mount Hood's aerial tramway, the Skiway, takes a few dozen passengers up the mountain in Oregon.

✓ DID IT HAPPEN? Somehow, yes, it did. This crazy sky bus ran from the parking lot to the slopes from 1951 until 1956. But skiers preferred the good ole land bus, which was faster, cheaper, and less insane.

January (right) • Jo Kotula • A swarm of Russian jets fly in formation.

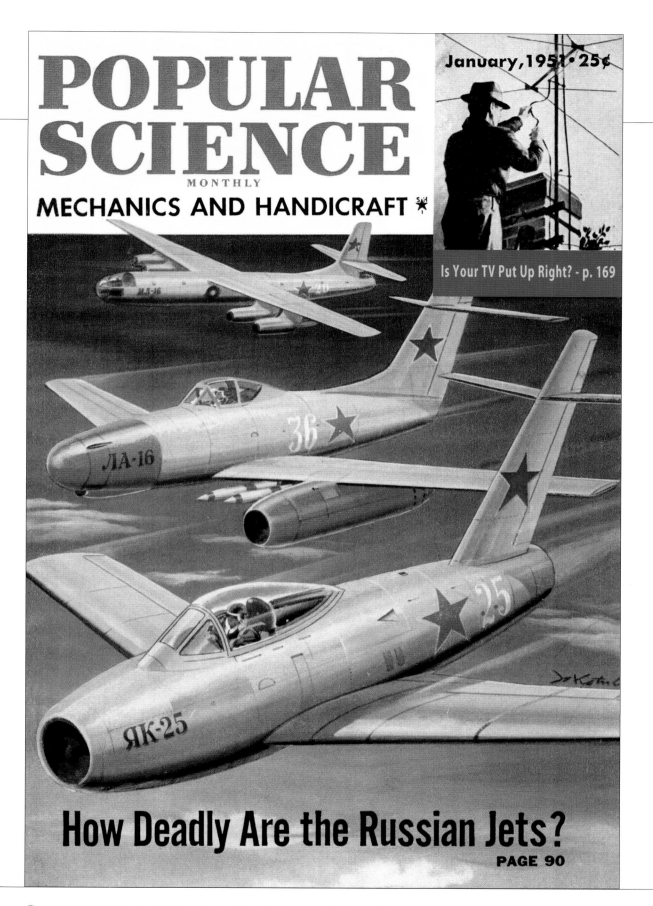

DID IT HAPPEN? Ah, the Cold War. Simpler times. This feature looked at intelligence on a number of Russian jets—many of which were copycats of American jets, and some rumored to perform better. Most notable, the piece included sketches of early-version MiG fighters and Ilyushin Il bombers—modernized versions of both still exist today—and profiles of their designers.

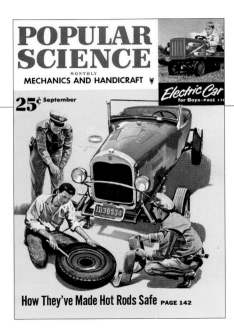

September • Unattributed • Police officers help a hot-rodder change a flat.

DID IT HAPPEN? Maybe. This piece tells how, in Pomona, California, hot-rod deaths dropped because one cool cop regulated drag racing instead of criminalizing it. It became a legal sport that year, taking it off the streets.

May • Jo Kotula • The Belanger Special rolls out of the pit.

DID IT HAPPEN? Yeah, Murrell Belanger's souped-up model won the 1951 Indy 500. It was half the weight of its competitors and lower to the ground, with a smaller engine.

October • Unattributed • A nuclear family gets really excited about basement renovations, while the neighbor kids watch through the window.

DID IT HAPPEN? Kind of? As refrigeration made cold food storage less of an issue, folks sought ways to transform root cellars into finished basements with full-on recreation zones. But we doubt anybody ever got this excited about putting up paneling and hanging wallpaper.

December (right) • Unattributed • Gawkers check out the 1953 Plymouth and Packard.

DID IT HAPPEN? In the early 1950s, *Popular Science* ran a recurring feature called "Wilbur Shaw's Reports from the Driver's Seat," in which the famed race-car driver test-drove new vehicles. Product reviews like this—critiquing everything from cars to cosmetics to electronics—would become a mainstay in the magazine industry.

The Future Then

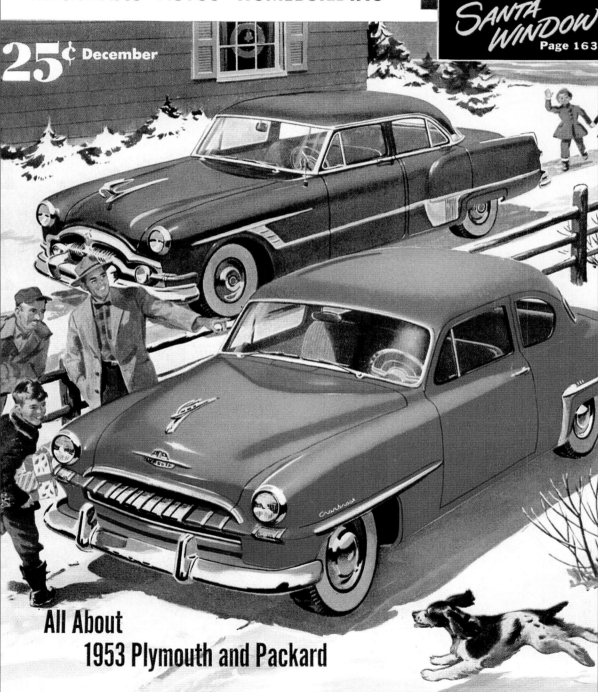

October · Unattributed · A "subway in the sky" and a fireplace anybody can install.

🌀 DID IT HAPPEN? The fireplace? Definitely. The sky train in California? Nope, though this article's San Francisco Bay map looks a lot like today's BART route—none of which is monorail, though.

November · Unattributed · A couple takes their new power-steering vehicle out for a joyride.

✓ DID IT HAPPEN? Sure did. Power steering first appeared in the 1951 Chrysler Imperial, under the much cooler name Hydraguide. Today, the technology is ubiquitous—and just called power steering. But you knew that.

May · Unattributed · New guns, boats, cars, and ideas for your vacation.

🌀 DID IT HAPPEN? Sure, but the real story of this issue is that it marked the first use of fluorescent ink on the cover of a national magazine. It was the bomb.

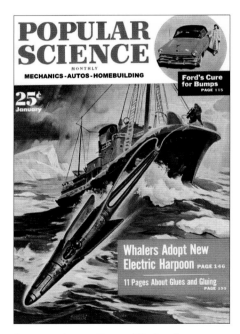

January · Jerome Rozen · Whalers fire an electric harpoon at an unlucky sea mammal.

🌀 DID IT HAPPEN? It's complicated. Such a contraption likely existed for a spell, but whaling was internationally banned in 1986. Only a few countries objected and still hunt whales today.

POPULAR SCIENCE

MONTHLY

MECHANICS - AUTOS - HOMEBUILDING

25¢ July

Courteous Cops Cut Crashes
PAGE 62

Build Your Own Diving Lung
PAGE 160

How to Outwit Poison Ivy
PAGE 116

1953

July · Credit illegible · A few brave souls dive with homemade scuba tanks.

✅ DID IT HAPPEN? Sure, you can make your own diving lung, like a *Popular Science* editor did for US$40 worth of parts. But just because you can do something, doesn't mean you should. (Legal would never let us get away with this now.)

1950s

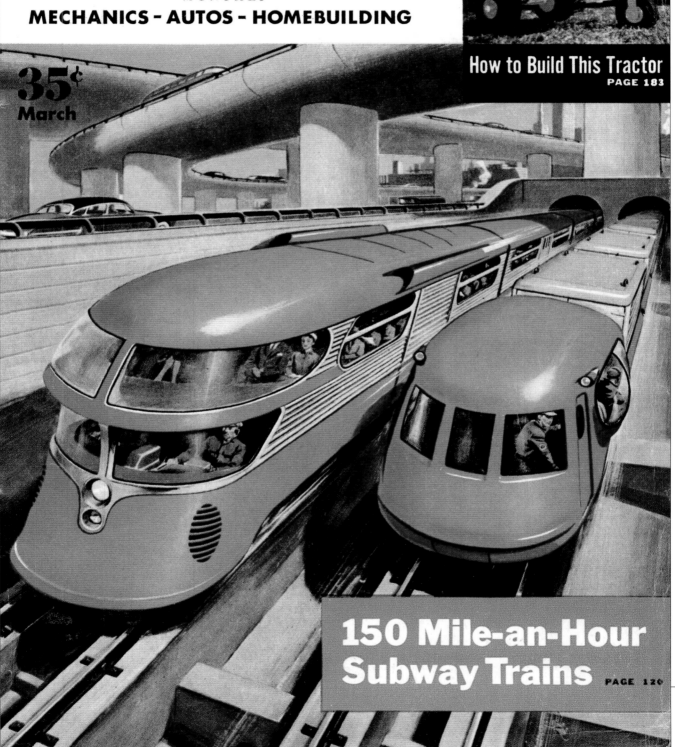

1954

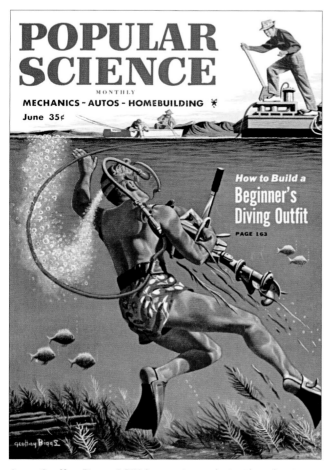

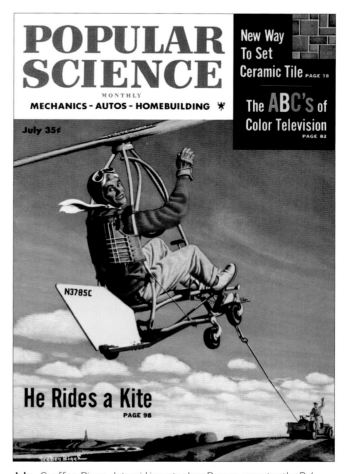

June · Geoffrey Biggs · A DIY diver retrieves a lost outboard motor, while a friendly attendant pumps air into his mask from a dock on the surface.

✅ DID IT HAPPEN? This feature walks through how to build your own surface-supplied air kit. Again, while it's possible, it's probably not something you really want to try. Buy one instead, please.

July · Geoffrey Biggs · Intrepid inventor Igor Bensen operates the B-6, his one-person flying machine.

✅ DID IT HAPPEN? Sure did. Bensen built a whole line of these contraptions and sold them commercially and as DIY kits for a spell, with the most successful model being the Bensen B-8 autogyro. The top-selling autogyro in history, Bensen's B-8 was in production from 1955 to 1987.

March (left) · Credit illegible · A subway train screams along at 150 miles per hour (240 km/h).

✅ DID IT HAPPEN? In some places, yes. Older subway trains (like those in New York) tend to top out at highway speeds. But the world's fastest subway, China's maglev train out of Shanghai, hits almost 270 miles per hour (430 km/h). This specific train, designed by John Hastings, never really panned out, though cities like Havana initially expressed interest.

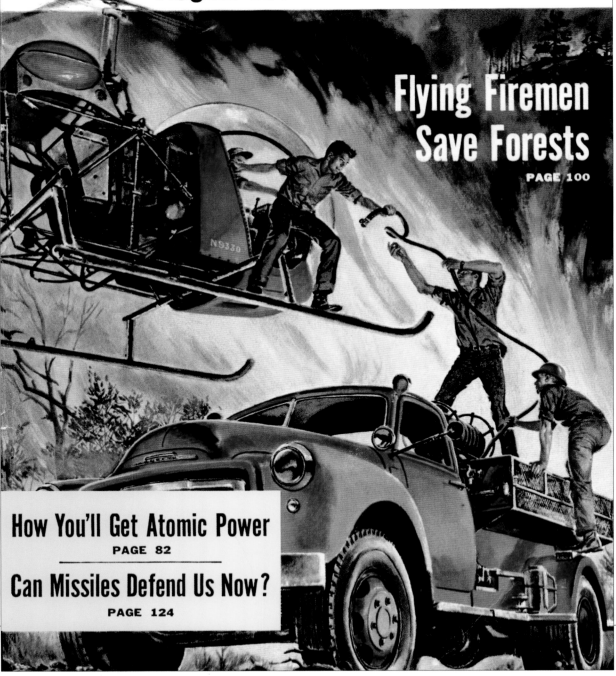

1955

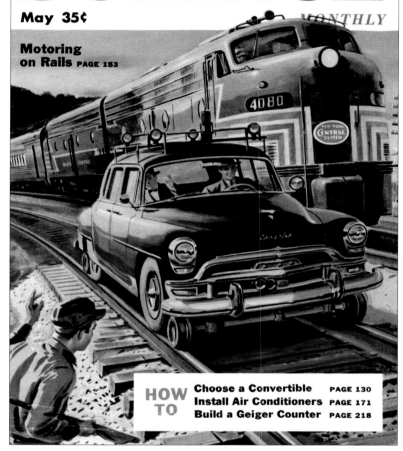

May · Unattributed · The "100," a modified Chrysler Windsor, rides on railroad tracks for God knows what reason.

✅ DID IT HAPPEN? Actually it did, and there was a good reason: so the railroad inspector could drive on roads to different tracks and then drive the car on the tracks like a train to reach places on the railway where roads don't go. It sounds crazy because it is, but the 100 wasn't the last of its kind. Today, road-rail vehicles mainly assist in towing train cars, though for a time there was a "high-rail" passenger bus in Germany called the Schi-Stra-Bus.

March · Ray Pioch · A cutaway of what was then called a panel truck.

🌀 DID IT HAPPEN? Eh, sort of. Panel trucks exist, and gull wing doors exist, but the two don't really exist in one vehicle. This feature has GM predicting panel trucks with these kinds of doors to be "the future of trucks," which, from here in the future, is hardly the case.

February · Unattributed · A cutaway of the 1955 Packard, and a super-enthusiastic family doing home renovations.

✅ DID IT HAPPEN? Yes, the car existed. As for the family, the feature on ways to brighten up the home was real, though at least the kid's enthusiasm for chores may have been feigned.

August (left) · Unattributed · Two firefighters hand up a hose to a third standing on the landing skid of a helicopter, with a background ablaze.

✅ DID IT HAPPEN? Absolutely. First used to fight a forest fire in 1947, helicopters allow for speedy delivery of cargo and personnel to remote areas, and they can be outfitted with water tanks and snorkels for replenishing from lakes and streams. Firefighters even rappel into fires from them. (But can we get these guys some proper firefighting suits?!)

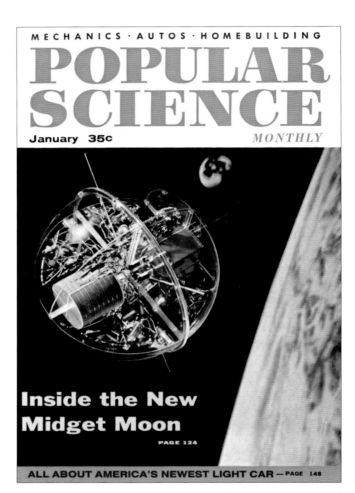

April · Unattributed · A husband and wife cheerily assemble a screened-in terrace.

✅ DID IT HAPPEN? This issue featured some 50 pages on DIY stuff you could do at home—from installing appliances and putting up wallpaper to building a quick patio and masking ugly driveways. Hey, the 1950s weren't called "the Decade of DIY" for nothing, thanks to American postwar prosperity and a surge in home ownership. This spirit evolved and pretty much sputtered out in the 1980s, as mass yuppification took hold.

January · Hubert Luckett · A small plastic model satellite, designed and constructed by *Popular Science* associate editor Herbert R. Pfister.

✅ DID IT HAPPEN? You bet. And this feature even estimates the first versions being roughly beach ball size—same as the early satellites launched in the late 1950s. To be fair, this model didn't actually launch (duh), and it also got some things wrong: Pfister made the outer shell out of plastic due to its nonmagnetic and nonconductive properties, while the USSR's *Sputnik I* actually used aluminum.

December (right) · Unattributed · The Xplorer, "train of the future," zips between New York City and cities in Ohio.

POPULAR SCIENCE

DECEMBER · 35¢ *Monthly*

1956

Riding Tomorrow's Train Today
Also: New Buick—Olds—Pontiac—Cadillac

DID IT HAPPEN? For a short while, yes. But with a reputation for a bumpy ride and frequent breakdowns—and with the interstate highway system expanding around the same time—the Xplorer was retired in 1960 and reduced to scrap metal by the end of the decade.

POPULAR SCIENCE Monthly

JANUARY · 35¢

Firsthand performance report on
OUR DEADLIEST BOMBER

Who Are America's Worst Car Drivers?

1957

August · O. W. Link · Listening to the game on his portable transistor radio, a baseball fan offers—er, shouts out—an alternate call.

✓ DID IT HAPPEN? Definitely. Portable transistor radios were the first gadgets to allow people to take music, news, and sports wherever they went (and signal reached). They were the ear buds of 1957.

October · O. W. Link · Two fellows look at a pile of tires for snow and mud.

✓ DID IT HAPPEN? The first snow tires with deep treads hit the US market in 1952, and ever since, many wouldn't dare drive on a winter's night without 'em. Later innovations include studded tires (1965) and hydrophilic rubber (1980s).

March · Unattributed · Rooftop TV antennas boost signals throughout this whole neighborhood.

✓ DID IT HAPPEN? Yeah. This feature compares the pros and cons of more than a dozen TV antennas—from clearing up white "snow" on-screen to blocking double images to catching extra channels. Antennas made quite a journey from their humble rabbit-eared origins in 1953 before the forced digital conversion of the 21st century.

January (left) · Robert McCall · The tail gun turret on a B-52 bomber fires at the enemy.

✓ DID IT HAPPEN? Though the B-52 debuted in 1955, this article follows a crew as they compete in the 1957 Strategic Air Command's simulated World Series of Bombing, where various planes drop steel eggs on US targets. Impressively, our "deadliest bomber" is still active, with more than 700 built in its lifetime. It'll likely be retired in the 2040s.

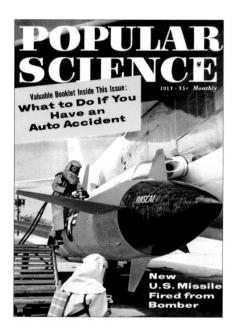 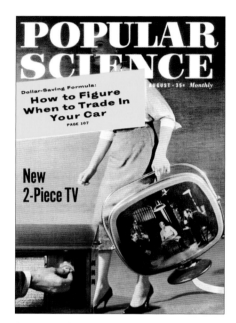 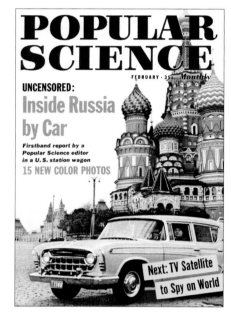

July · W. W. Morris · Two men in hazmat suits inspect the Rascal nuclear missile.

DID IT HAPPEN? Yes and no. The supersonic air-to-surface missile—which was designed to allow the launching aircraft enough time to get out of Dodge—was developed and tested, but it was never operational in battle. Another (the Hound Dog) took its place before it ever got a chance.

August · Robert D. Borst · A woman carries a TV monitor while a man adjusts the sound.

DID IT HAPPEN? Yes, sound systems separate from a TV screen have been around forever. But why did they matter? In TV's early years, manufacturers made the same thing over and over—and people weren't buying. To create demand, Philco developed the two-piece TV, which made for a less hulking device.

February · Harry Walton · Harry Walton at the wheel of an American car in Soviet Russia.

DID IT HAPPEN? Affirmative. Harry Walton was the first American journalist to drive through the Soviet interior. He discovered full-size railways entirely operated by children, massive "Overtake America" billboards, and women threshing flaxseed in the middle of the highway. He also learned the hard way that you're not allowed to photograph gas pumps.

May (right) · Unattributed · Dr. I. M. Levitt points to a mark on the moon as he lays out a hypothetical timetable.

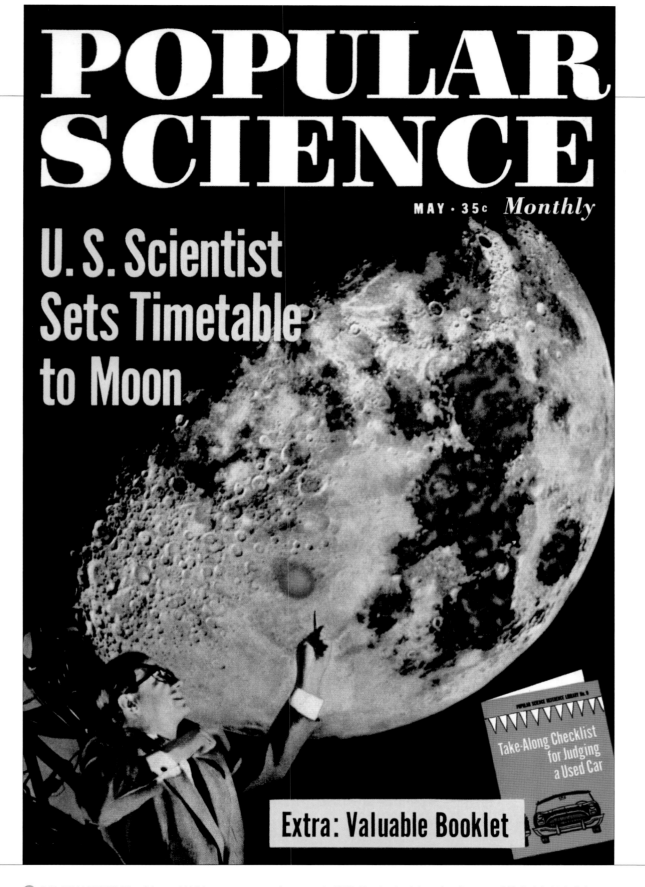

1958

POPULAR SCIENCE

MAY · 35c *Monthly*

U. S. Scientist Sets Timetable to Moon

Extra: Valuable Booklet

Take-Along Checklist for Judging a Used Car

❌ DID IT HAPPEN? We all know NASA put a man on the moon in 1969. But Levitt (then the director of Philadelphia's Fels Planetarium) was wrong, predicting we would first "mark" the moon by 1960, nuke it in 1962, gather dust there in 1975, and put a man there only in the year 2000. Thanks for making us look so good, Levitt.

1950s **141**

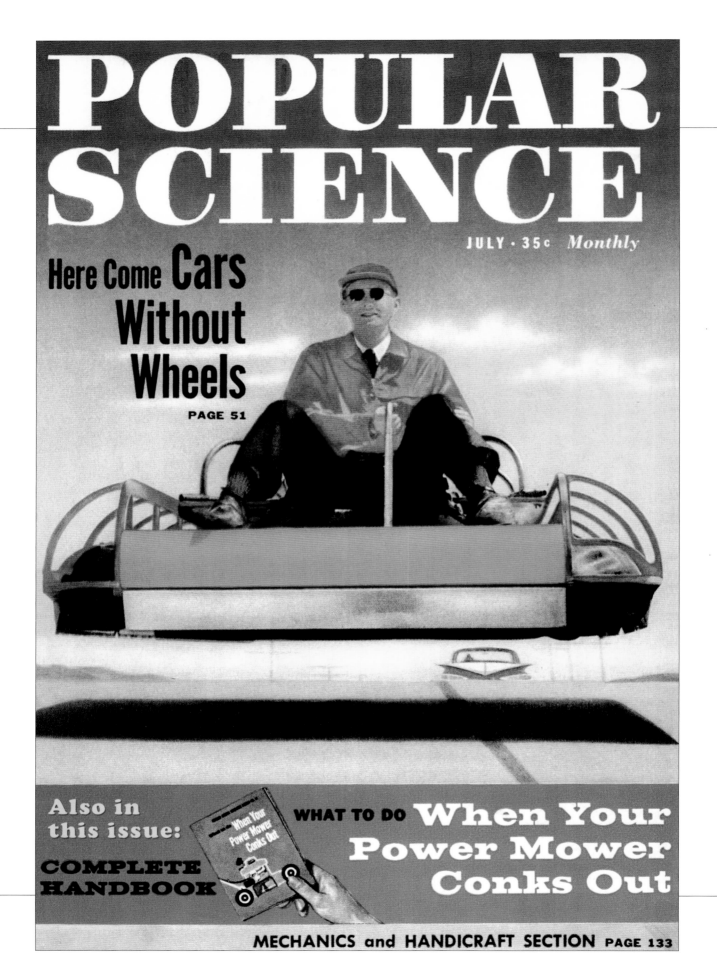

1959

March • Robert McCall • A hydrofoil liner hits 100 knots.

🌀 DID IT HAPPEN? Kinda. Hydrofoil boats lift their hulls out of the water at high speeds, reducing drag as they race ahead on weird winged stilts. They peaked in the 1960s and 1970s, then fell out of favor due to cost, with a few dozen in operation worldwide.

May (left) • Arthur Shilstone • A cop nabs a speeding vehicle with radar.

✅ DID IT HAPPEN? Yes, and covering your bumper in foil or putting loose ball bearings in your hubcaps—tricks resembling the use of chaff by military planes—still doesn't fool police radar. Radar detectors, though illegal in a lot of places, do exist, so you can hit the brakes before passing a cop.

June • Robert McCall • Frogmen assist in submerging the Aquabat—the US Navy's two-man wet submarine, designed to let scuba teams travel along the seafloor, exit through a hatch, and swim up to enemy seacraft, then do their dirty work undetected and escape.

🌀 DID IT HAPPEN? While the Aquabat's Plexiglas roof and windows made it a little delicate for combat, its design may have informed more robust swimmer-delivery vehicles (SDVs)—such as those used in the Navy SEALS Mark program, which is still active today. Two-person subs for leisure exist, though, if you have a few million dollars to blow on underwater toys.

July (left) • W. W. Morris and Robert D. Borst • A Members Only–jacketed Dr. William R. Bertelson takes a joyride on his invention, the Aeromobile.

🌀 DID IT HAPPEN? Yes and then no. Bertelson was a country doctor in need of a rapid way to make house calls during winter. He designed an air-cushion vehicle (ACV), which could glide a few inches over ice and snow and be piloted in all directions—catching the eye of the US military. The Brits were ahead of the game, though, and Bertelson's star faded. Undeterred, he devoted his life to developing hovercrafts, and *Popular Science* profiled him again in 2008, a year before his death. Today, ACVs are few and far between, and typically operate over water not land.

ARTIST PROFILE

REYNOLD BROWN

Reynold Brown's work for *Popular Science* in the 1940s and 1950s saw him at the peak of his technical drawing career. His realism spoke to the pragmatics of planes, trains, and automobiles, but it was this artist's eye for detail—paired with his out-of-this-world imagination—that later gained him a cult following for movie posters he created in the 1960s.

Born in Los Angeles in 1917, Brown began sketching in his youth, and went to work on the aviation comic strip *Tailspin Tommy* in 1936. But Brown saw bigger horizons for himself in illustration than in comics. The path became clearer when he met Norman Rockwell, who advised him to quit cartooning if he wanted to be taken seriously as an illustrator.

During WWII, Brown worked for North American Aviation, creating portraiture and cutaways of airplanes. Here, he honed the technical skills that you see in *Popular Science*'s many auto-focused features, as well as improved his hand at capturing human expression. His work also made its way to the covers of *Outdoor Life*, *Boy's Life*, and *Popular Aviation*.

In the early 1950s, Brown met Misha Kallis, an art director at Universal Pictures, who got him a gig drawing movie posters. From then on, Brown's talents took flight, with his work appearing in Academy Award–winning films such as *Ben-Hur* and *Spartacus*. But it was the far-out and freaky scenes he created for sci-fi and horror B-movies, like *Creature from the Black Lagoon*, *Mothra vs. Godzilla*, and *Attack of the 50 Foot Woman*, that caught the imagination of the masses and, to this day, define his legacy. Brown suffered a stroke that paralyzed his dominant side in 1976, putting an end to his commercial career, though he continued painting until his death in 1991.

At right, top to bottom,
January 1950
October 1949
March 1948

Far right:
July 1950

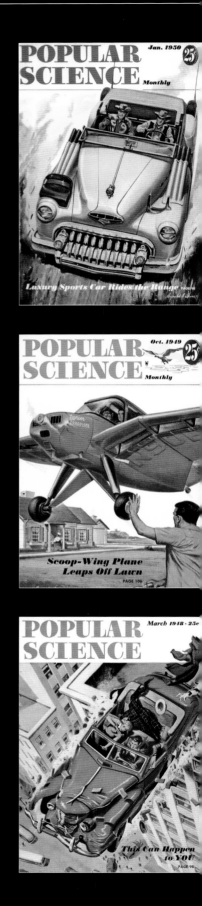

144 The Future Then

POPULAR SCIENCE
MECHANICS AND HANDICRAFT

July, 1950 • 25¢

Patching With a Brush — p.218

Making the Death Seat Safer

1960s

1960s

OPPOSING FORCES

It's hard to believe that the decade of free love was also one of assassinations—that it ended with a field of peace-loving hippies in Woodstock, New York, but also saw some of the bloodiest days of the Vietnam War. Democracy expanded with marked advances in civil rights, but the Cold War got even chillier. And some humans walked on the moon, while others died trying. The 1960s were nothing if not a time of tumult—of love and war, of hope and cynicism. And with all not always well at home, looking skyward may have given earthbound observers something otherworldly on which to pin their hopes. For all the tragedy the decade gave us, it also gifted humanity some of history's greatest scientific advancements.

SATELLITES OVERTAKE THE SKIES

While the first satellites entered orbit in the 1950s, the first useful ones punched through the atmosphere in the next decade. In April 1960, *TIROS-1* became the first fruitful weather satellite to orbit Earth. Designed by RCA and equipped with cameras and other instruments, it allowed people on the ground to make the earliest space-based weather predictions. Another more-than-symbolic satellite of the 1960s was the solar-powered *Telstar-1*, which was the first to relay telephone and television data from space—and the first to transmit transatlantic television broadcasts. On July 23, 1962, *Telstar-1* completed the earliest public broadcast; it included pictures of the Eiffel Tower and the Statue of Liberty, snippets of a Cubs vs. Phillies baseball game, and remarks from President Kennedy. While it wasn't operational for much more than a year (it was damaged by radiation from nuclear tests), its mark on science would be indelible.

SHOWTIME AT THE APOLLO(S)

In May 1961, President Kennedy announced the United States's commitment to putting a man on the moon by the end of the decade—just a month after the Soviet Union launched the first human into space. While Kennedy didn't live to see his goal realized, a determined NASA eventually launched a moon-landing mission from the space center that bears his name. It wasn't all cause for celebration—*Apollo 1*, for instance, caught fire during a simulated countdown, killing all three astronauts on board. Still, NASA incrementally made its way moonward, testing lunar and command modules with crewed Earth orbit missions *Apollo 7* and *9*, and putting astronauts in orbit of the moon with missions *Apollo 8* and *10*. Then, on July 16, 1969, Neil Armstrong, Buzz Aldrin, and Michael Collins blasted off toward our only natural satellite. Four days later, while Collins remained in orbit, Armstrong and Aldrin landed on the lunar surface—an event that some 600 million people watched from their living rooms.

FAR OUT

Above, a photo from a *Popular Science* October 1962 profile on a Bell Labs "wireman" who worked on the *Telstar-1* satellite.

At left, an April 1965 feature on the forensic science that went into convicting President Kennedy's assassin, Lee Harvey Oswald, including fingerprints, bullet angles, and paraffin tests that detected gunpowder on Oswald's hands. Despite this evidence, more than 50 years later, many US citizens still believe Oswald did not act alone.

At right, American astronaut Buzz Aldrin takes his first few steps on the moon, with Neil Armstrong and the American flag reflected in his helmet.

The Future Then

1960s

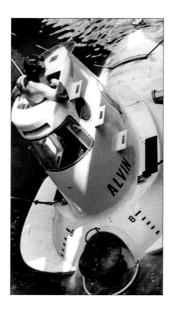

VOYAGING TO THE DEEP

While many scientists had their sights set on the stars, others were more interested in taking a plunge—all the way to the seafloor. Spurred on by the 1951 sonar survey of the ocean's deepest point, the Challenger Deep in the Marianas Trench, the 1960s saw several oceanic exploration vehicles make their way to the docks. First in the race to the bottom was Swiss inventor Piccard's *Trieste*, a bathyscaphe that made it to the 36,000-foot- (11,000-m-) deep seafloor in 1960. But most famous of the 1960s subs is *Alvin*, a three-person vehicle operated by the US National Oceanic and Atmospheric Administration (NOAA) that has made nearly 5,000 dives, including recovering a hydrogen bomb in 1966, discovering tube worms in 1977, and exploring the *Titanic* in 1986. All this interest in the ocean's ridges and valleys also helped confirm seafloor spreading—one of the key indicators that we used in the decade to solve a true puzzle: plate tectonics, or how our continents have shifted over millennia.

CARS GET BIGGER, FASTER, AND CLEANER

The 1960s were good years for automobiles. Looking back, two models really picked up momentum: station wagons and muscle cars. Fueled by the postwar baby boom and rising incomes, station wagons gained popularity with a new suburban populace that had a lot of kids and wanted to take them places. Cars like Mercury's Marquis Colony Park were more than 15 feet (4.5 m) long and could seat up to 10 people. On the muscle end of the spectrum, car manufacturers strove to outdo each other in speed, style, and power, dropping race-car engines into cool commercial-car bodies. With the advent of positive crankcase ventilation (PCV)—a system of sending fumes back into engine cylinders for additional combustion—and electronic fuel injection, cars got cleaner and more efficient. Sure, they still burned fossil fuels, but, you know, baby steps.

PILLS AND TRANSPLANTS

You can't talk about the transformations of the 1960s without mentioning the sexual revolution. And one little invention that helped facilitate this shift in attitudes and behaviors is the Pill. Enovid, the first combined hormonal contraceptive, gave women control over whether or when to have children. While Americans Gregory Pincus and John Rock developed the Pill in the 1950s, the US Food and Drug Administration didn't approve its use as a contraceptive until 1960. By 1963, it was the most profitable drug on the market, pulling in more than US$25 million—US$200 million today—that year alone. Another pill from the decade that eventually gained ubiquity was ibuprofen—a drug whose British inventor, Dr. Stewart Adams, almost

GETTING AROUND

Above, an aquanaut climbs aboard *Alvin*, General Mills's acclaimed research submersible, which made its 6,000-foot (1,800-m) maiden voyage in July 1965.

At left, a woman pops open a monthly pack of birth-control pills. American activist Margaret Sanger and British scientist Marie Stopes began rallying for contraception in the 1910s, but it took science and the law a half a century to develop and approve the first Pill, Enovid.

At right, photogenic young people gather around one of the most iconic muscle cars of the 1960s, the Ford Mustang.

The Future Then

ALSO OF NOTE

NOVEMBER 4, 1960
Jane Goodall watches chimps use tools to gather a termite meal, marking the first recorded tool use by a nonhuman animal. Later in the decade, she would teach Washoe, a chimp, to sign in American Sign Language.

JULY 10, 1962
Swedish engineer Nils Bohlin, working for Volvo, receives a patent for the modern form of the three-point seatbelt. Volvo later let other car manufacturers use it for free.

SEPTEMBER 27, 1962
US conservationist Rachel Carlson publishes *Silent Spring*, a treatise on the harmful effects that pesticides have on the environment.

JUNE 6, 1968
US inventor and businessman Roy Jacuzzi receives a patent for—well, it wasn't the Zamboni.

1960s

1960s

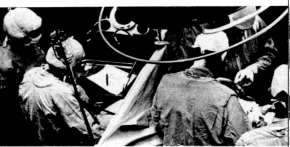

SPARE PARTS

Above, a December 1964 feature on the as-of-then-kinda-sketchy organ-transplant procedures. At that time, only 10 percent of transplants were successful. The main difficulty then persists now: The immune systems of organ-donation recipients may reject the transplanted tissue.

At right, a September 1962 story on "the Incredible Ruby Ray," a laser gun that took a whole briefcase of electronics to operate (bow tie sadly not included). Called the PistoLaser by the manufacturer, Kollsman Instrument, this device hit the market for a cool US$2,950 just a few years after American inventor Theodore Maiman built the first functional—if not elegant—laser. In 50 years, Kollsman would be selling laser sights to the US Marine Corps.

presciently tested on his hangover. Of course, the 1960s weren't all about pills: The first liver, lung, and human-to-human heart transplants all occurred during the decade—though some recipients didn't survive more than a few weeks after the donor organs were transplanted.

THE INTERNET COMES ONLINE, KIND OF

In the world of computers, the 1960s brought us the first working prototype of a mouse—carved from wood, no less. They gave us Sketchpad (the precursor to CAD, or computer-aided design) and BASIC, a programming language that inarguably made computing accessible. But one advancement overshadows the rest: ARPAnet, the first iteration of what we now know as the internet. With origins in military experimentation, ARPAnet was initially just two nodes: one at the University of California–Los Angeles and one at Stanford. On its first successful go, this fledgling internet got across "lo" (the first two letters of *login*) before crashing. After a few bugs were fixed, all five letters transmitted on the second try, and days later nodes at the University of California–Santa Barbara and the University of Utah came online, followed by many others. While ARPAnet didn't exactly evolve into today's internet, two of its features came to define our own World Wide Web: packet switching—the idea that information travels more efficiently when routed separately in smaller packets—and TCP/IP, the rules that determine how information should be packaged, where it should go, how it should get there, and how it should be received.

LASERS AND LEDS

Physics was not to be left out of the 1960s sci-fi-becomes-reality theme. Drawing from the work of US physicists Charles Townes and Arthur Schawlow, US engineer Theodore Maiman built the earliest laser in 1960, coaxing a short blast of coherently focused light (i.e., light waves of the same phase difference and frequency) from a school-science-project-looking device made from artificial ruby and a high-powered flash lamp. One related discovery came in 1962, when Nick Holonyak, a young American scientist at GE, almost accidentally invented the light-emitting diode (LED) while trying to develop an infrared semiconductor. By applying electric current to a diode of gallium arsenide phosphide, he made a little red light that, many years in the future, would find a home in taillights, stoplights, flashlights, and many, many otherwise dark places.

The Future Then

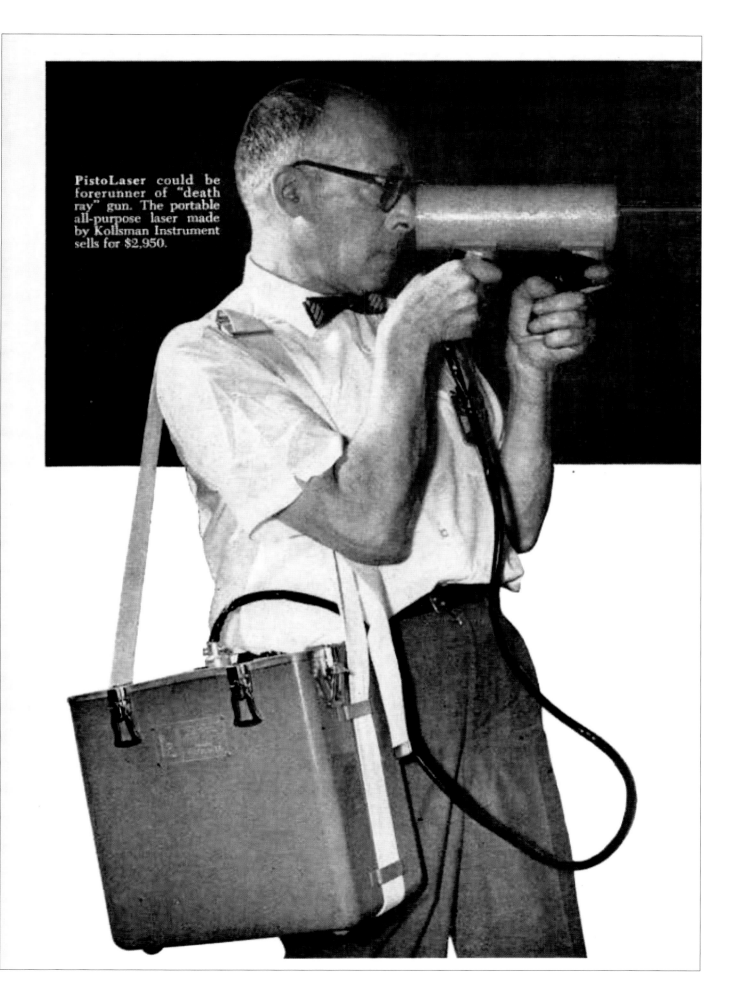

PistoLaser could be forerunner of "death ray" gun. The portable all-purpose laser made by Kollsman Instrument sells for $2,950.

Tricks for Driving on Two Lane Roads PAGE 43

POPULAR SCIENCE

AUGUST · 35¢ *Monthly*

Fixing Your Own TV

Money-saving series starts in this issue PAGE 141

CURING VERTICAL DISTORTION

1960

July • W. W. Morris • A man pushes his son along on a DIY flying cart.

✓ DID IT HAPPEN? Air-cushion vehicles ("ACVs" for short) definitely exist (though they're largely used over water). Still, there's no reason you couldn't construct your own hovering contraption, and, in this issue, *Popular Science* presents detailed plans for building what is essentially a hybrid of a wheelbarrow and a hovercraft. Three cheers for a wheelbarrow that requires no lifting. (And for being a hero to your kid for a few hours.)

February • Robert McCall • Workers on the icy streets of Camp Century, the US government's experimental underground town in Greenland.

✗ DID IT HAPPEN? Not a snowball's chance in hell. Camp Century was an elaborate cover for Project Iceworm—a plan to build top-secret launch sites within striking distance of the USSR—but the ice sheet was so unstable that it was abandoned in 1966. The Danish government didn't find out about Project Iceworm until 1995. (Let's just say they're still thawing out about it.) As for Camp Century itself, scientists predict that the ice will soon recede to expose its subterranean remains.

August (left) • Mel Crair • A stretched forehead caused by vertical distortion.

✓ DID IT HAPPEN? Yeah. Old TVs could get distorted in a lot of ways, for a lot of reasons. This issue looked at the many tube changes and adjustments readers should make to fix problems with vertical distortion. Today, the advent of flat screens and media streaming have introduced their own charming annoyances to the viewing experience, such as dead pixels, screen burn, frozen frames, and so on.

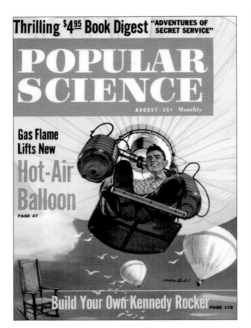
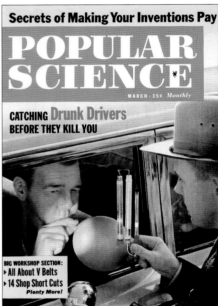

February · Ted Streshinski · The Turbo Chief, a newfangled turbine-powered fire engine.

DID IT HAPPEN? Kind of. American-La France made four of these trucks with Boeing turbine engines. (The world wanted turbines in everything in the 1960s.) Since they were great at climbing steep inclines, they found eager homes in hilly US cities like San Francisco and Seattle. They were hard on brakes, though, and so never became common.

August · Robert McCall · A man heads skyward in the *Vulcoon*, one of the world's first gas-powered hot-air balloons.

DID IT HAPPEN? Yep. In 1960, American Ed Yost made a breakthrough in the centuries-old sport of ballooning: He figured out how to make the balloons carry their own fuel with portable propane burners. He also designed the teardrop shape, synthetic fabrics, maneuvering vents, and deflation systems. He was a game changer.

March · W. W. Morris and Robert D. Borst · A suspected drunk driver blows into the Intoximeter, a kinda comical "breath balloon."

DID IT HAPPEN? Sure. Before today's robo-breathalyzers, officers would use these balloon things, which determined blood-alcohol levels by comparing the CO_2 and alcohol in a person's breath to different alcohol solutions. In some US states in the 1960s, it was legal to drive with levels under 0.15 percent—almost twice today's 0.08 percent.

January (right) · Walter Dey · A nuclear family enjoys the warmth of a DIY air-bubble sun port.

The Future Then

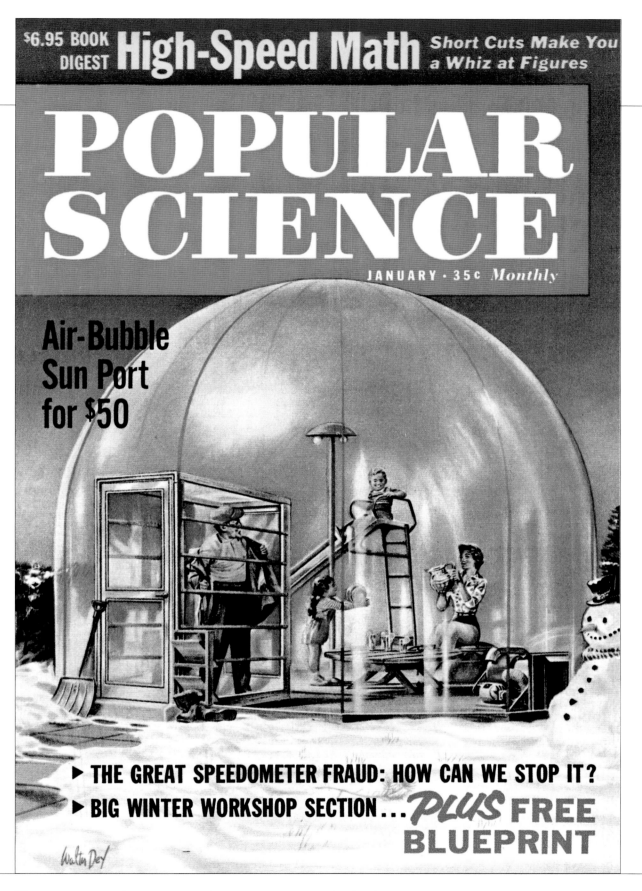

✓ DID IT HAPPEN? Definitely. These giant bubble sunrooms—essentially, inflatable tentlike structures that keep the heat in and the bugs and/or other weather out—are still around. You can either buy one or, as Pennsylvania man Ernest Muehlmatt did, make your own, though it'll run you more than US$50 these days. They're most often used over swimming pools or gardens in the winter.

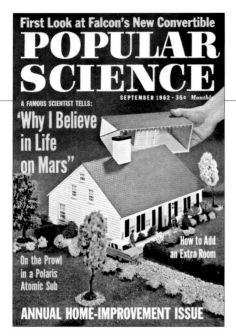

September • W. W. Morris • A model house gets a whole new room.

✅ DID IT HAPPEN? Yeah. In this issue, *Popular Science* looked at the many ways you can add a room to your house. (But, you know, your actual house. Not the dollhouse pictured.)

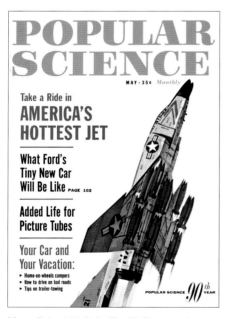

May • Robert McCall • The F4 Phantom I jet fighter-bomber.

✅ DID IT HAPPEN? Yes. The F4 saw a lot of action during the Vietnam War; it could cruise faster than two times the speed of sound and carry 9 tons (8 t) of munitions. It was slowly replaced then retired in the mid-1990s.

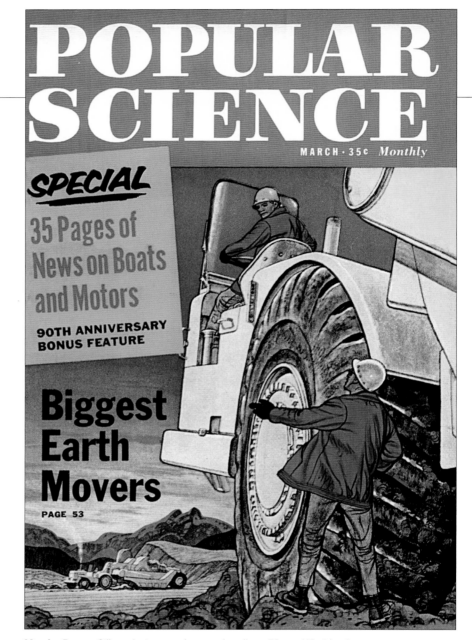

March • Denver Gillen • A giant earth mover handles a 75-ton (68-t) load.

✅ DID IT HAPPEN? You bet. But not all earth movers are created equal. Some of the machines featured in this issue—in particular, the Caterpillar 641—can do their job even in the thin air of 12,000 feet (3,650 m) above sea level. One thing's for sure: They've all come a long way since the Fresno scraper (i.e., a horse pulling a blade attached to a bucket, invented in 1883 by Californian James Porteous).

December (right) • Ray Pioch • An artist's dramatization of a prototype for the world's first "space station": an inflatable doughnut made by Goodyear.

❌ DID IT HAPPEN? While we definitely have had space stations (ISS, anyone?), none of them ever made good on the rotating-wheel design. Explored because centrifugal force will create artificial gravity (which is healthier for astronauts), this concept has seen many glorious iterations; look up the 1975 Stanford Torus, which could have housed a city. But none—including this one—ever took flight.

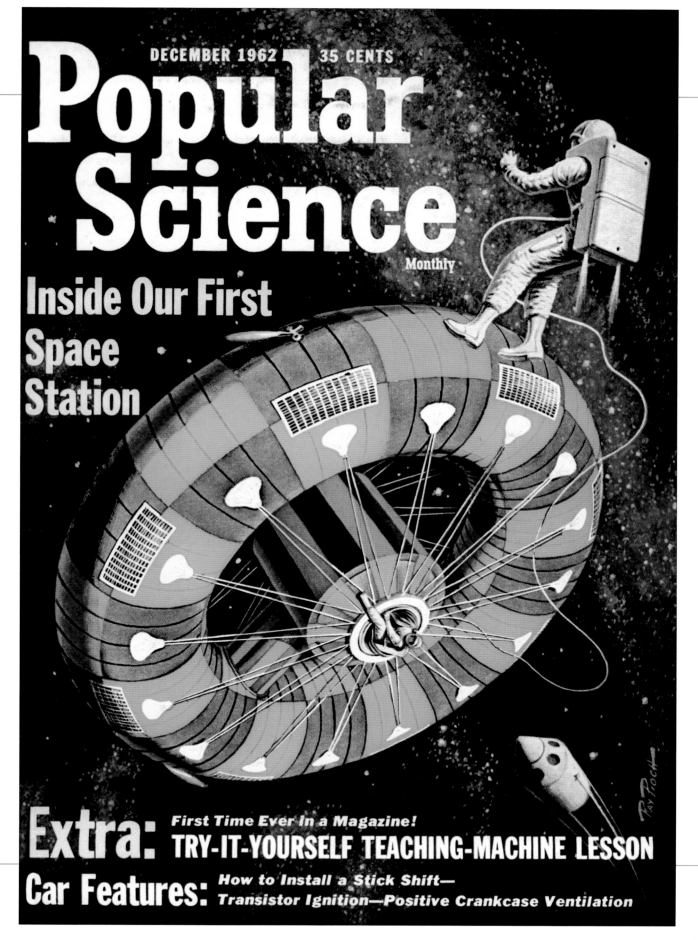

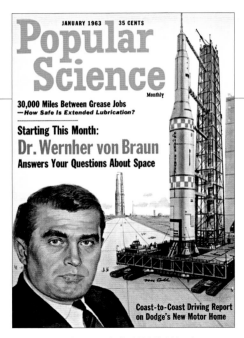

January · Robert McCall · NASA's Wernher von Braun with an American rocket.

✓ DID IT HAPPEN? For a time, von Braun answered reader questions, such as "How does an astronaut enter or leave his pressurized crew compartment in airless outer space?" (A: "By means of an air lock.")

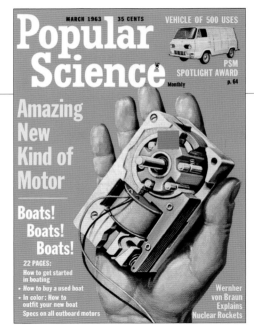

March · Ray Pioch · A high-torque slow motor.

✓ DID IT HAPPEN? Yes, low-RPM, high-torque motors do still exist. This one was unique—it turned slowly but still produced a lot of rotating force, lending itself to uses in office appliances, freight doors, aerospace applications, and more.

April · John McDermott · A jet-driven boat moves sideways.

✓ DID IT HAPPEN? Sure did. Some jet-driven boats can get lateral motion, and this boat from Upson Marine was one of the first capable of it. Confusingly, the technique is called "walking."

June · Robert McCall · A test simulates an unlucky driver taking a car out for a swim.

✓ DID IT HAPPEN? Yes. Most of the survival tactics shared in this issue became gospel—such as, you can't open the doors until water pressure inside the car equals that outside the car.

July • Pierre Mion • American Ed Link—inventor of the famed flight simulator—is back at it with Project Man in Sea, an inflatable tent designed to allow the world's first "aquanauts" to stay at extreme depths for long periods.

DID IT HAPPEN? Absolutely. Link's team spent 49 hours at 400 feet (120 m) below sea level in this vehicle. It led to 1966's *Deep Diver* and 1975's *Johnson's Sea Link* submersibles, the latter of which helped recover the *Challenger* space shuttle after its 1986 explosion.

SEPTEMBER 1964 35 CENTS

Popular Science
Monthly

QUINTS
Could It Happen to You?

Special!
THE NEW NAVY
From the Forthcoming Book
By Hanson W. Baldwin,
America's Top Military Analyst

How to Drive in a Crisis
—Tips on Staying Alive in the 6 Most Dangerous Highway Situations

Best Buys in FM Multiplex Tuners
PAGE 102

Wernher von Braun: Do Rockets Need Fins?

Ideas for Your House
...How to build and use scaffolding
...All about those new house paints
...Creating more parking space

Smokey Yunick's Car Clinic

| New Exposure Meters That Tell You More | How to Repair Fiberglass Hulls | Saw-Sharpening Short Cuts PAGE 144 |

1964

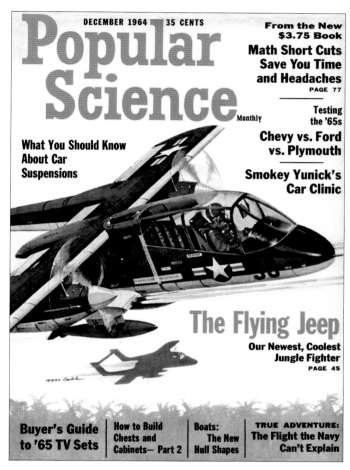
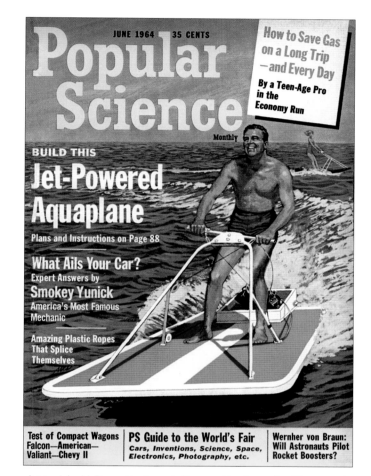

December · Robert McCall · The OV-10A Bronco—a.k.a. "the Flying Jeep."

✓ DID IT HAPPEN? Sure did. The OV-10 has seen action as recently as 2015. The idea behind it was to create an aircraft that was faster and more nimble than a helicopter, but slower and easier to maneuver than supersonic fighter jets. It got a lot of use during the Vietnam War and, outside of war zones, proved helpful in disaster relief and geological survey.

June · John McDermott · An ecstatic man rides the surf on his personal jet-drive aquaplane.

✗ DID IT HAPPEN? No. Well, a guy built one and put his plans in *Popular Science*, but this is one little piggy that never made it to market. One that did, however, was the invention of Norwegian-American Clayton Jacobson II, who is credited with creating the first "boatercycle" in 1966, called the Sea-Doo. It tanked, but Jacobson's next creation—released in 1973 for Kawasaki—had real (sea) legs. You know it as the Jet Ski.

September (left) · Tom Quinn · Two drivers try to avoid a head-on collision.

✓ DID IT HAPPEN? *Popular Science* had a regular feature on how to handle hairy driving situations, offering such gems of wisdom as: If a car stops abruptly in front of you on the freeway, swerve around it. All of their advice is probably still applicable, unless your car is smart enough to stop itself. (Which is expected to be a standard safety feature in all new cars in the United States by the mid-2020s, just FYI.)

1965

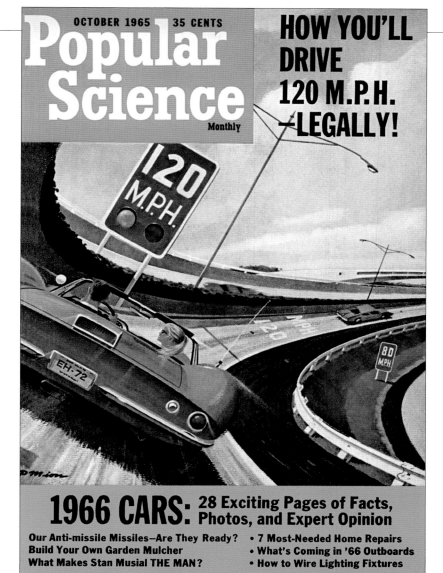

October · Pierre Mion · Cars zip at 120 miles per hour (195 km/h) along runway-like roads.

❌ DID IT HAPPEN? Not really. The prediction here was that speed limits would rise as cars grew more powerful. But the highest posted speed limit in the United States is 85 miles per hour (137 km/h), and that's only in parts of Texas. Of course, there's Germany's autobahn and highways in Australia's Northern Territory—which both famously have no real speed limit—but they're certainly the exceptions to the rule.

November · Robert McCall · A man carries 1 ton (0.9 t) while wearing a "man amplifier," an exoskeleton machine from the Cornell Aeronautical Lab.

🔄 DID IT HAPPEN? We're working on it! This model didn't proceed to the motorized stage, but it did inform the design of the Hardiman, General Electric's 1971 effort and the first official exoskeleton. Today, the most successful exoskeleton suits are those that allow the paralyzed to walk, but there are promising models in development for the military and manual labor as well.

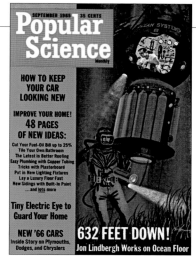

September · Pierre Mion · Jon Lindbergh and team in a diving elevator.

❌ DID IT HAPPEN? It does not appear that this Ocean Systems mission took place, despite best intentions. However, Lindbergh—son of the famous aviator and a US Navy frogman—was on Ed Link's Project Man in Sea team (see p. 161).

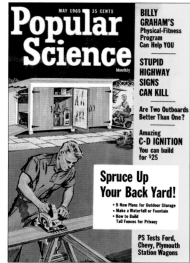

May · Sigman-Ward · Bob and Betsy Homemaker do outdoor projects.

✅ DID IT HAPPEN? Yeah. *Popular Science* did a 15-page feature on outdoor home-improvement tasks in this issue. Maybe it was a slow month for science.

1960s 165

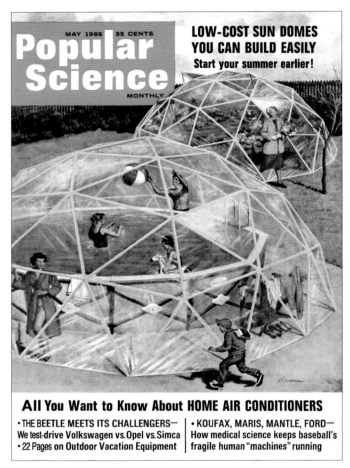

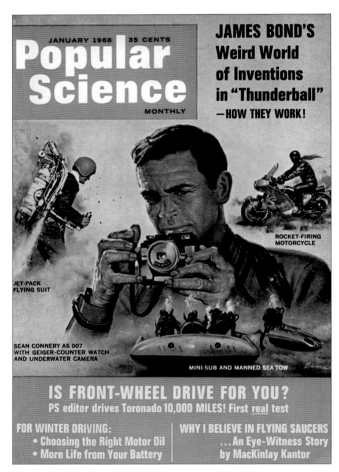

May · James E. Bama · DIY geodesic domes delighting people of all ages.

✓ DID IT HAPPEN? Yes! You can definitely build your own dome—and if you're not particularly handy, kits make it easier. The shape itself was inspired by architect and inventor Buckminster Fuller, who famously introduced the tensile property of triangles to the ancient dome form. His tactic made structures both lightweight and strong; they're still a mainstay on hippie communes and playgrounds alike.

January · James E. Bama · James Bond and his many, many gadgets.

✓ DID IT HAPPEN? Sure, some of Bond's toys made it into real life—like underwater cameras and mini subs. The jet pack on the cover was the real-life Bell Rocket Belt, and it could propel a wearer (in *Thunderball*, Sean Connery's stunt double) into the air for 20 seconds. But only 10 of those seconds could be used for upward flight, else the wearer would find himself or herself high in the air with nowhere to go but down.

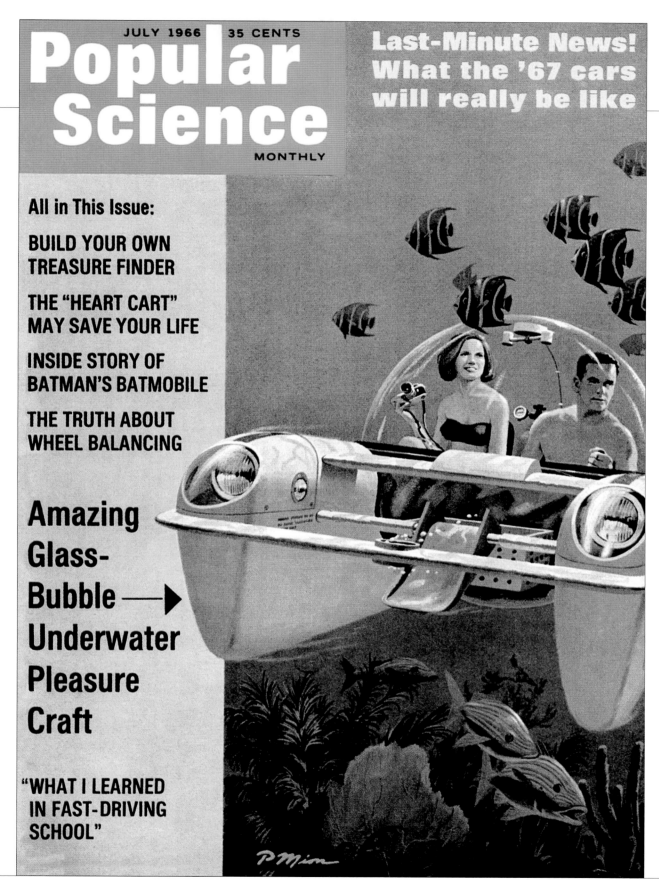

July • Pierre Mion • A couple tours the deep in a mini bubble sub.

✅ DID IT HAPPEN? Yeah, this illustration is actually amazingly close to what today's personal subs, which are mainly manufactured for the luxury market and deep-sea research teams, look like. Haven't seen one beachside? That's because they cost around US$1 million.

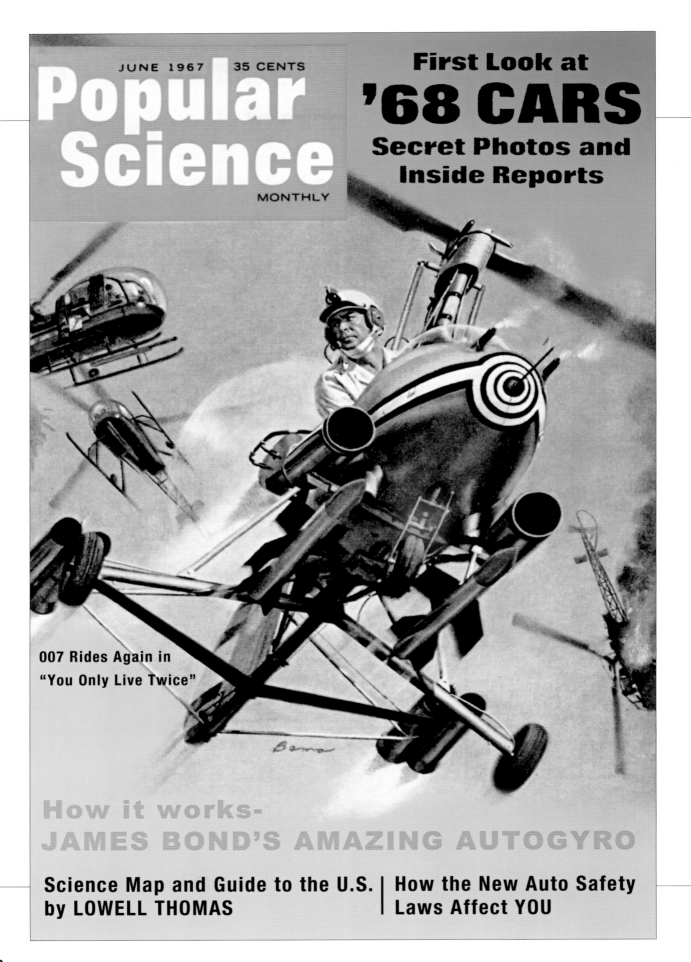

1967

January · Ray Pioch · A variety of rotary engines challenge the standard piston engines of the era.

✅ DID IT HAPPEN? Yes, for a time. Mazda, for one, sold a few rotary-engine-powered vehicles from the late 1970s through the early 1990s.

May · W. W. Morris · A man drives an adorable pint-size DIY tractor.

✅ DID IT HAPPEN? Yeah. Funny enough, Struck Corporation still sells this "yard-dozer." The company celebrated 50 years of tractor kits in 2017.

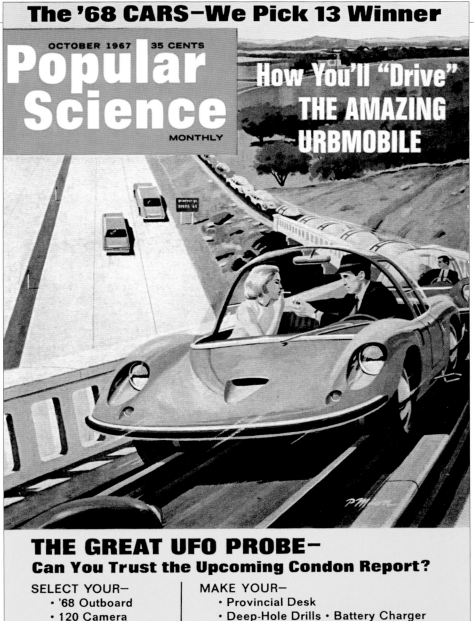

October · Pierre Mion · The Urbmobile rides the rails, freeing up carpoolers' hands for other stuff.

❌ DID IT HAPPEN? No, not as a commercial vehicle. Conceived of as an all-electric car that would become autonomous as soon as it clicked into a freeway's track and that could—wonder of wonders—park itself, the Urbmobile was a rapid-transit solution to traffic congestion dreamed up by the technologists at the Cornell Aeronautical Laboratory. While this dual-use vehicle never emerged, electric cars did hit the streets in 2008 and long-awaited autonomous vehicles are imminently within our reach.

June (left) · James E. Bama · James Bond pilots Little Nellie, his fighter autogyro, in 1967's *You Only Live Twice*.

✅ DID IT HAPPEN? Yes, Little Nellie was a real autogyro—an adapted Wallis WA-116 Agile, to be precise—though some of its capabilities existed only in the movie. (For starters, you couldn't pack it into four suitcases, like Q did.) Only five of these autogyros were ever built; one even popped up for sale a few years back.

1960s

June · Robert McCall · An astronaut lost in space in the 1968 film *2001: A Space Odyssey*.

🌎 DID IT HAPPEN? The movie? Yes. The actual story in which a spacecraft monitored by an artificially intelligent computer heads to Jupiter to investigate a force changing the evolution of the human species? No. Kubrick and Co. did use some pretty future-forward film tricks, though, like the largest-scale front projection to date.

December · Pierre Mion · An artist's dramatization of hazardous snowy roads.

✅ DID IT HAPPEN? Tips for being a better winter driver are great, but you'll probably learn more by doing snow donuts in an empty parking lot. At your own risk, of course.

May · Robert McCall · The supersonic F-111 takes off against a blazing sun.

✅ DID IT HAPPEN? Indeed. The F-111 saw action from 1967 through the late 1990s. At the time, its two turbofan engines made it the world's fastest fighter-bomber—reaching speeds of two and a half times the speed of sound. Its navigation system also let it fly under radar defenses.

February · Ken Thompson · An artist's depiction of color television.

DID IT HAPPEN? Yeah, this issue included a buyer's guide for color TVs. If parsing out the color quality from the same test-pattern on 11 screens is your thing, then this was the issue for you.

1969

September • Orlando Guerra • "Go-anywhere vehicles" parade across a lawn.

✅ DID IT HAPPEN? While the all-terrain vehicles (ATVs) in this article didn't pan out, single-rider off-roaders were all the rage from the 1960s on, remaining popular with ranchers, hunters, construction workers, and anyone who likes fun.

April • Ray Pioch • A Pontiac mini-car with a cutaway of its radial engine.

❌ DID IT HAPPEN? Not really. Beyond this experiment and a few old race cars, radial engines haven't really appeared in cars. They were mostly used in WWII planes and tanks.

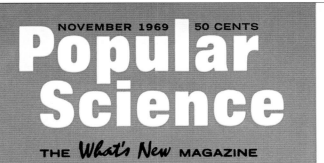

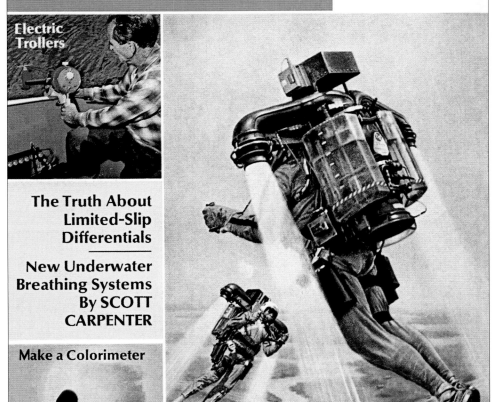

November • James E. Bama • Test pilots fly the Bell Rocket Belt, invented by Wendell Moore.

❌ DID IT HAPPEN? Nope. The US military canceled this model in the 1960s, though not before a flight in front of President Kennedy (and an appearance in the James Bond movie *Thunderball*; see p. 166). But it never disappeared from the public's imagination: A similar make dazzled in the opening ceremony of the 1984 Summer Olympics in Los Angeles, and, in the early 1990s, some hucksters teamed up to create a brand-new jet belt. In true Icarus fashion, they ended up either murdered, abducted, or in jail. The belt itself was never found.

February (left) • Pierre Mion • Jacques Cousteau and team film under the sea for his popular full-color show, *The Underwater World of Jacques Cousteau*.

✅ DID IT HAPPEN? Yeah, and Jacques was kind enough to write up how he did it. It was quite an operation, with two mini subs (the *Sea Fleas*), color cameras designed by Cousteau and his team, divers to shoot footage, and an engineer all aboard their boat, the *Calypso*, an old minesweeper fitted for oceanography that communicated with the subs by sonar telephone.

ARTIST PROFILE

PIERRE MION

In 1966, when Norman Rockwell needed a helping hand with a bunch of space paintings for *Look* magazine, he called up Pierre Mion. For the next dozen years, until Rockwell passed away in the late 1970s, the two would collaborate on a whole host of projects.

Of course, Mion was (and still is) a talented illustrator and fine artist on his own. With a career spanning more than five decades, Mion has worked for and with some of the finest, counting *Life, The National Geographic Society,* and, of course, *Popular Science,* among his many clients. Across that period, he's gotten the chance to work with such space icons as Carl Sagan, Wernher von Braun, and Michael Collins—the man who stayed in orbit while Neil Armstrong and Buzz Aldrin touched down on the moon. He was part of the recovery team for *Apollo 16*—the second-to-last trip to the moon—and covered many rocket launches. A few of his many other adventures include working with Jacques Cousteau in Monaco, and participating in test dives of deep-diving submarines around the Bahamas.

While Mion's talents cover a variety of scenes and subject matter—from farms to boats to portraits and animals—he is perhaps best known for his depictions of space and the deep sea. He had a particular knack for capturing the dark and quiet mystery of the great beyond and the great below. In the 1960s, *Popular Science* was fortunate enough to have Mion share his talents for the submarine on a number of underwater covers and interiors.

Right, top to bottom,
July 1967
November 1967
March 1967

Far right,
August 1967

Popular Science MONTHLY

AUGUST 1967 — 35 CENTS

ELEGANT PICKUPS: Your Next Family Car?

The Go-Go Engines That Power MOTORCYCLES

A Great New Sportscraft You Can Build—
THE AQUA GLIDER

Hottest News About the '68 CARS!

Things You Never Knew About Beer

BLUEPRINT: Build a Coffee-Table Music Center

Come Aboard JOHN WAYNE'S Fabulous Yacht

By WERNHER von BRAUN
HOW WE'LL LAND ON THE MOON

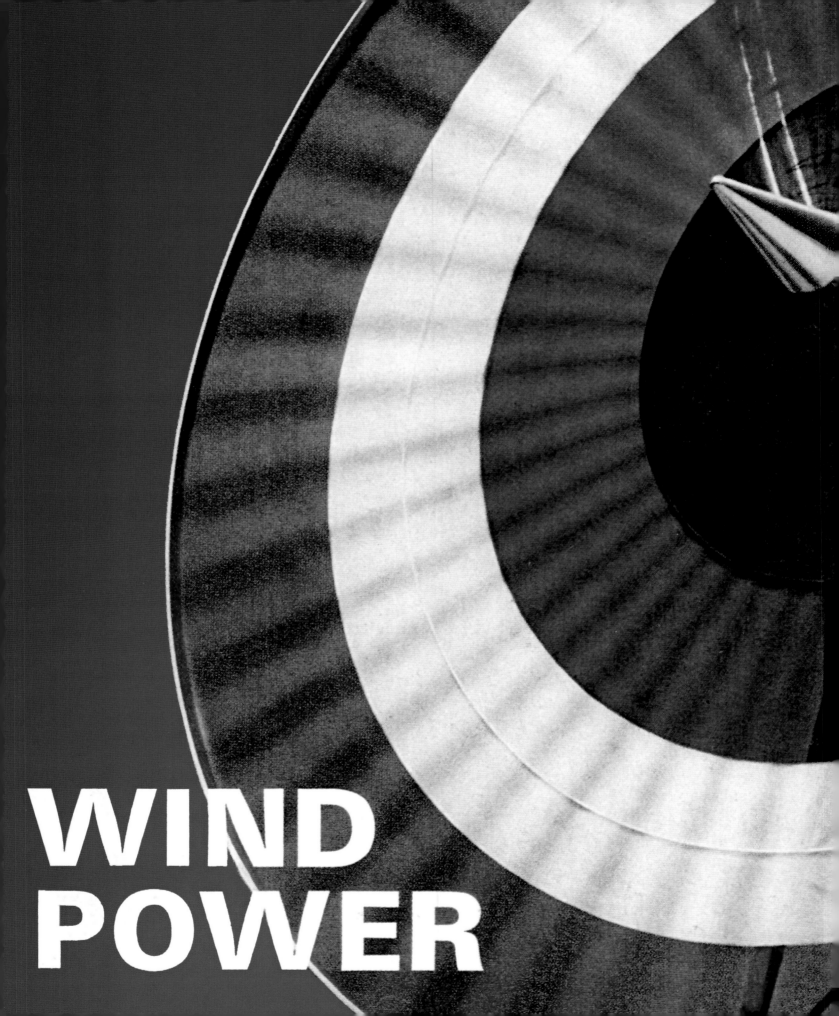

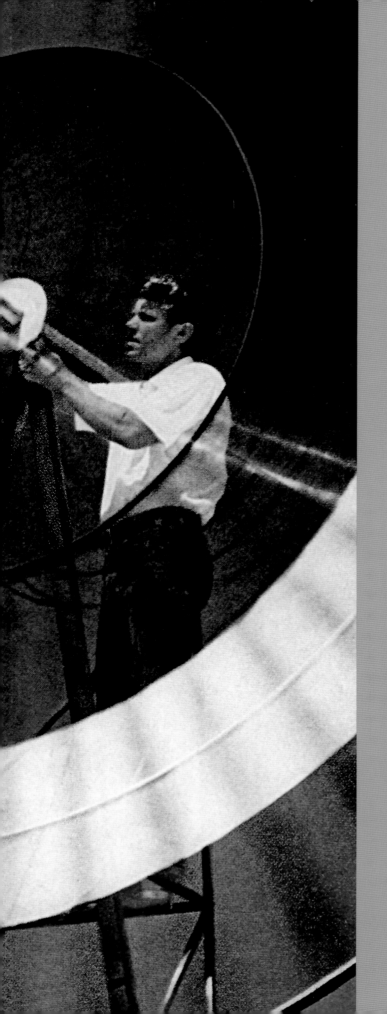

1970s

1970s

A GLIMPSE OF THE PRESENT

After a little more than two decades of solid economic performance, history suggests that the US economy was due for a bit of a correction, and the 1970s sure delivered. While it was nowhere near the Great Depression, the era would be a period of high inflation, high unemployment, and general malaise—disco aside. But even the casual observer can start to see the seeds of our present-day reality in the achievements of the decade: from the cell phone to personal computers, from advanced medical diagnostic tools to alternative energy.

SEEING CROSS SECTIONS

The 1970s brought a host of new diagnostic tools, most notable computed tomography (CT) and magnetic resonance imaging (MRI). Building on progress in X-ray technology and computing, English engineer Godfrey Hounsfield developed the first CT machine, which performed multiple X-ray scans of a subject, then used computing power to assemble the scans into a cross-sectional image. The first human to be scanned was a woman with a brain tumor in 1971. It took five minutes to complete each scan (today's take fractions of fractions of a second). The MRI, on the other hand, is based on nuclear magnetic resonance (NMR)—the phenomenon by which radio waves and magnetic fields make atoms give off small but detectable radio signals. US physician Raymond Damadian discovered that different types of tissue emit different signals—more specific, that cancerous cells produce signals distinct from healthy ones. In 1977, Damadian built and tested the first full-body scanner, and MRI technology exploded soon after.

CPUs AND PERSONAL COMPUTERS

Computer hardware saw real advancements. In 1971, US electronics company Intel released the C4004, the first central processing unit (CPU) chip. The C4004 was a general-purpose processor, meaning engineers could leverage its power in custom ways using a variety of software. About the size of a fingernail, it was as powerful as the first electronic computers produced in the 1940s, which were so large they filled whole rooms. Intel would advance quickly, developing microprocessors such as the 8008 and 8080 in the same decade. Personal computers kicked off something of a boom, first as build-your-own kits like the Altair 8800, which targeted hobbyists and ran on Intel's 8080 microprocessor. Other machines, such as the Commodore PET and the Apple II, were among the first personal computers truly targeted to home users.

A PRANK CALL FROM THE STREET

In a world where there are more cell phones than people, it's sometimes hard to believe that talking on the phone once meant being physically tethered to wires and cables. Portable phones were only as mobile as your cord was long. And while there was some semblance of cell phones before the 1970s, they were really car phones—they were heavy and not something

MORE THAN PONG

Above, one very relaxed guy makes a call while floating on an inner tube in the July 1973 issue.

At left, Atari was everywhere—from personal computing to Pong (shown in a March 1973 issue), the now-iconic game that let two players compete against one another in real time.

At right, Dr. Raymond Damadian, inventor of the MRI, with graduate student Lawrence Minkoff, demonstrating magnet technology used in the first MRI machine.

The Future Then

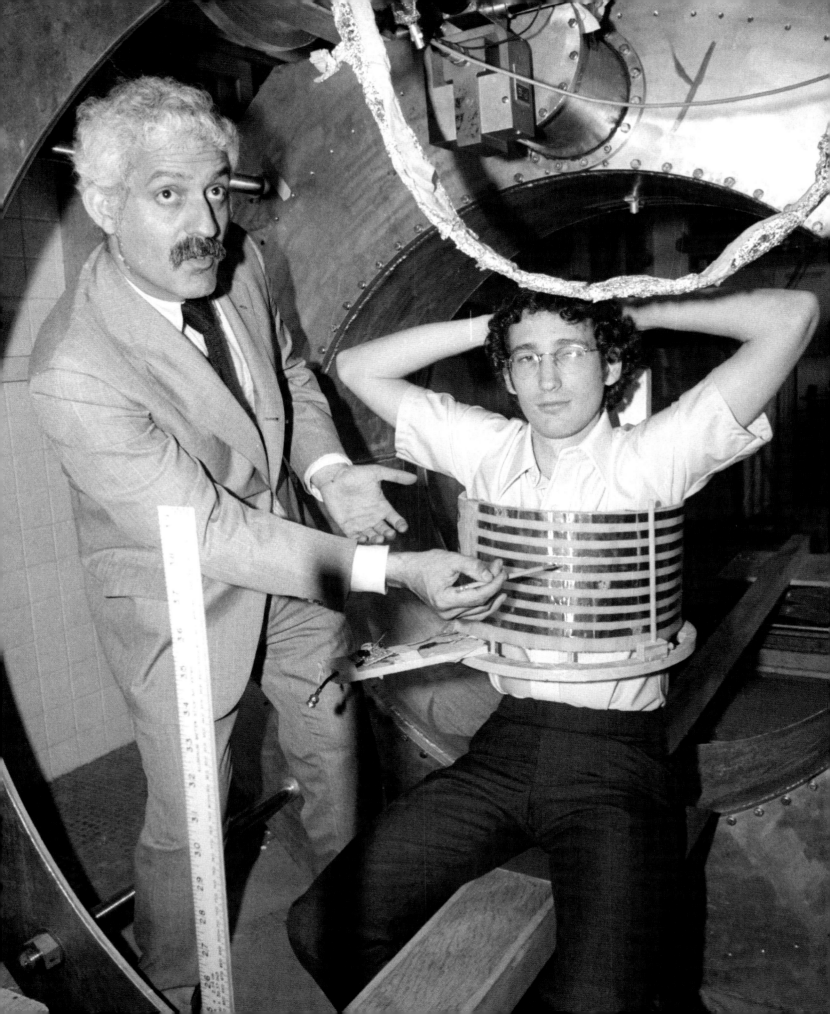

1970s

you could carry down the street. In 1973, that changed. Under US engineer and "father of the cell phone" Martin Cooper, Motorola engineers developed the first truly mobile phone—one giant (by today's standards) brick of a communications device. He announced his invention by demonstrating it for a journalist: He powered on the device, walked down the street, and dialed up Joel Engel—an engineer from AT&T who was working on a similar idea—just to let him know that he was calling him from a cell phone.

THE F-14, CONCORDE, AND THE GOSSAMER CONDOR

One of the more famous fighter jets in popular culture is the Grumman F-14 Tomcat, which first took to the skies in December 1970. Most people know it as the plane from *Top Gun*, and its real-life applications aren't so far off from that depiction. It saw action as an air-to-air fighter, with some air-to-ground abilities added before its retirement in the mid-2000s. Beyond fighter jets, a small fleet of Concordes—supersonic passenger jets—entered commercial service in 1976, zipping wealthy passengers across the Atlantic in half the time it took a standard passenger jet. Concorde was in service for 27 years until a crash in 2000 killed everyone on board. The 1970s also brought a feat centuries in the making: human-powered flight. Designed by Americans Paul MacCready and Peter Lissaman and piloted by Bryan Allen, the *Gossamer Condor*—a big, pedal-powered hang glider—won the first Kremer Prize for person-propelled aircraft.

LUCY ON THE SLOPE WITH SCIENCE

Humanity got one more clue to its origins when, in 1974, US paleoanthropologist Donald Johanson decided to take a third look at a small gully near the Awash River in Ethiopia. When he found a small fragment from an arm bone on one slope, he and a graduate student, Tom Gray, turned up the intensity and found more and more pieces—all of which appeared to come from the same organism. Johanson's finding turned out to be a female from the species *Australopithecus afarensis*—a likely ancestor of ours, dating back more than 3 million years. Named Lucy after the Beatles' "Lucy in the Sky with Diamonds," she had a small skull and walked upright, giving credence to evolutionary theories that propose walking upright on two feet came before human brain growth. After taking the bones to Cleveland for reconstruction, Johanson returned Lucy to Ethiopia, where she still "lives"—in a safe in the National Museum of Ethiopia.

FAMOUS FIRSTS

Above, Concorde supersonically soars with its nose in a streamlined position. During take-off and landing, its nose could be "drooped" to increase visibility for the pilot.

At left, a model at the National Museum of Ethiopia of what Lucy, one of our oldest ancestors, may have looked like. In her home country, Lucy is known as Dinkinesh, meaning "You are marvelous." Marvelous, indeed.

At right, Bryan Allen flies the *Gossamer Albatross II*, the second human-powered aircraft from the team that made the *Gossamer Condor* in 1977. A similar design that got off the ground with the power of pedaling, the *Albatross* crossed the English Channel on June 12, 1979, with Allen at the helm—er, handlebar.

The Future Then

ALSO OF NOTE

MAY 24, 1970
Digging begins on the USSR's Kola Superdeep Borehole, a 22-mile- (35-km-) deep pit used to study Earth's crust.

MAY 3, 1971
Mariner 9 becomes the first spacecraft to orbit another planet, mapping 80 percent of the Martian surface.

AUGUST 20, 1971
The Stanford Prison Experiment—in which 24 US men were assigned the role of prisoner or guard—dissolves into violence after only six days.

JUNE 26, 1974
A cashier in Ohio scans the UPC on a pack of gum—the first time a UPC scanner was used commercially.

JULY 25, 1978
The world welcomes the first person born from in vitro fertilization: English baby Louise Brown.

1970s

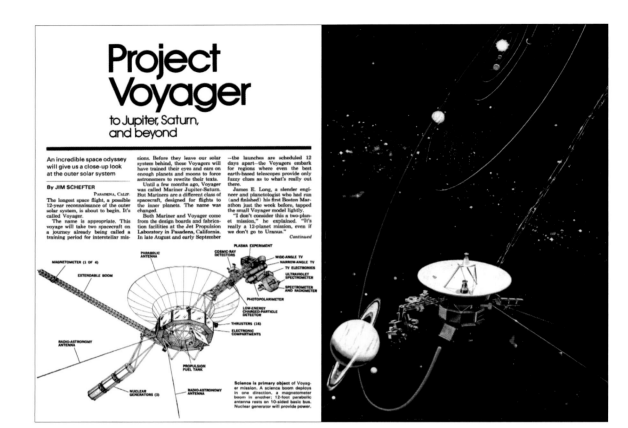

COSMIC MESSAGES IN COSMIC BOTTLES

After we reached the moon, Venus and Mars—our closest planetary neighbors—were on deck for exploration, with the Soviet Union's Venera and NASA's Mariner programs leading the way. But the US Voyager program had farther targets in sight: Jupiter, Saturn, Uranus, and Neptune. Thanks to Voyager 1 and 2, we have tens of thousands of photos of these planets, plus knowledge of their makeup, weather patterns, and natural satellites. Since their launches in 1977, Voyager 1 and 2 continue to transmit data—at this point, from the far reaches of our solar system and interstellar space, respectively. Both ships travel with a copy of the Golden Record: a time capsule containing sights and sounds from Earth, compiled by a team led by US astronomer Carl Sagan. Should intelligent life find one, they would, in theory, learn something about us. Not that we're waiting around for an intro: Since the 1960s, projects in the search for extraterrestrial intelligence (SETI) have used radio telescopes to scan the universe for signs of interstellar communication. On August 15, 1977, an Ohio State volunteer named Jerry Ehman noticed a curiously strong blip on a telescope printout. And that instance—aptly dubbed the Wow! signal after Ehman's scrawled note in the margins—is the closest we've come to chatting up alien life.

CLEAN AIR, CLEAN WATER, AND NEW ENERGY

By the 1970s, we'd put our planet through a lot—from species hunted to extinction to the nasty pollution of the Industrial Revolution. Efforts to conserve the wilderness began in the 1800s, and the 1960s saw fledgling laws to curb the release of chemicals into the environment. Partly in response to Rachel Carson's 1962 book *Silent Spring*, which revealed DDT's toxic effects, and the 1969 oil spill off the coast of Santa Barbara, California, the United States kicked off the 1970s with the creation of the Environmental Protection Agency (EPA), followed by the Clean Air Act of 1970 and the Clean Water Act of 1972—two legislative overhauls that took industries to task for pollution. The decade also saw the energy crises of 1973 and 1979, in which conflicts in the Middle East caused oil prices to surge, further dampening a wet-blanket economy. It also stoked interest in renewable energy: Before the end of the decade, Exxon engineer Dr. Elliot Berman changed the solar game by developing a radically cheaper photovoltaic cell, while the world's first wind farms prepared to open in California and New Hampshire.

OUTER OUTER SPACE AND HOME SWEET HOME

Above, an August 1977 *Popular Science* feature on the Voyager program, complete with sketches and artist renditions of the craft itself. While the spacecraft are equipped with enough fuel to last them through at least 2025, we will someday lose contact with them as they move farther into interstellar space.

At right, a crowd of demonstrators mill around a sign in New York City on April 22, 1970, the first Earth Day. Twenty million Americans showed up for the inaugural day dedicated to environmental reform; today, more than 1 billion people participate worldwide each year.

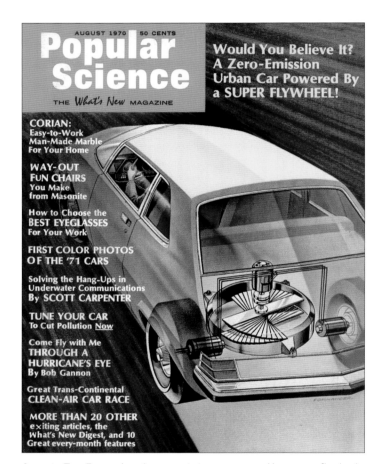

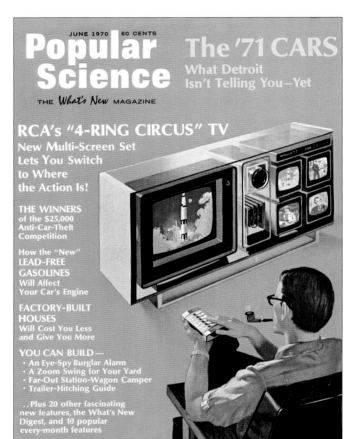

August · Tom Fornander · A zero-emission car powered by a super flywheel.

⊘ DID IT HAPPEN? The zero-emission car? Yes. Powered by a super flywheel? No. (What about a *superfly* wheel? No, again.) While the science here—that a wheel spinning in a vacuum can charge a battery-powered car—is right on, commercial auto manufacturers have struggled to harness the technology safely. Still, some buses and Formula 1 cars use it, and Volvo recently tried retooling its S60 hybrid sedan with it, so stay tuned.

June · Don Crowley · RCA's remote-controlled multiscreen TV brings whole new meaning to the phrase "split attention."

✗ DID IT HAPPEN? No, and RCA never intended it to. The *Popular Science* piece covered an experimental version seen in a "top secret" room at its Indianapolis HQ; it boasted four small black-and-white monitors and a 25-inch (65-cm) color one. The closest current approximation is picture-in-picture, in which an inset window displays another channel.

December (right) · Orlando Guerra · Watches that do more than tell time, built for industries involving time calculations, such as aviation and engineering.

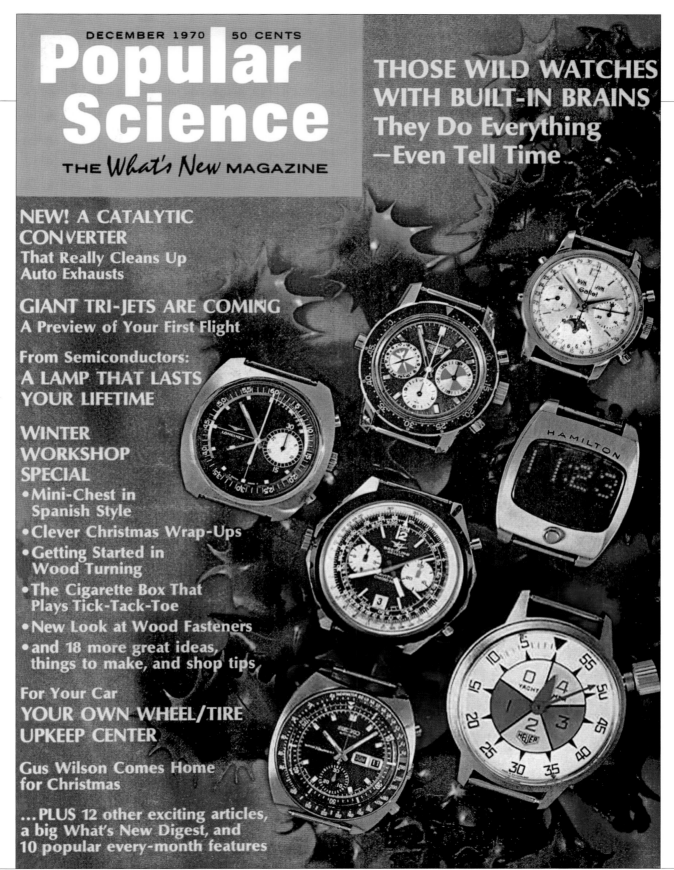

✅ DID IT HAPPEN? And then some. This feature looked at watches that could keep track of moon phases, show the tides, and make calculations such as speeds, distances, and fuel use. It also hyped the first digital watch, Hamilton's Pulsar, which would have run you US$2,000 back in the day. Watches have only gotten smarter since, keeping you posted on your fitness, sleep, heart rate, and social media. Today, you can even talk to some.

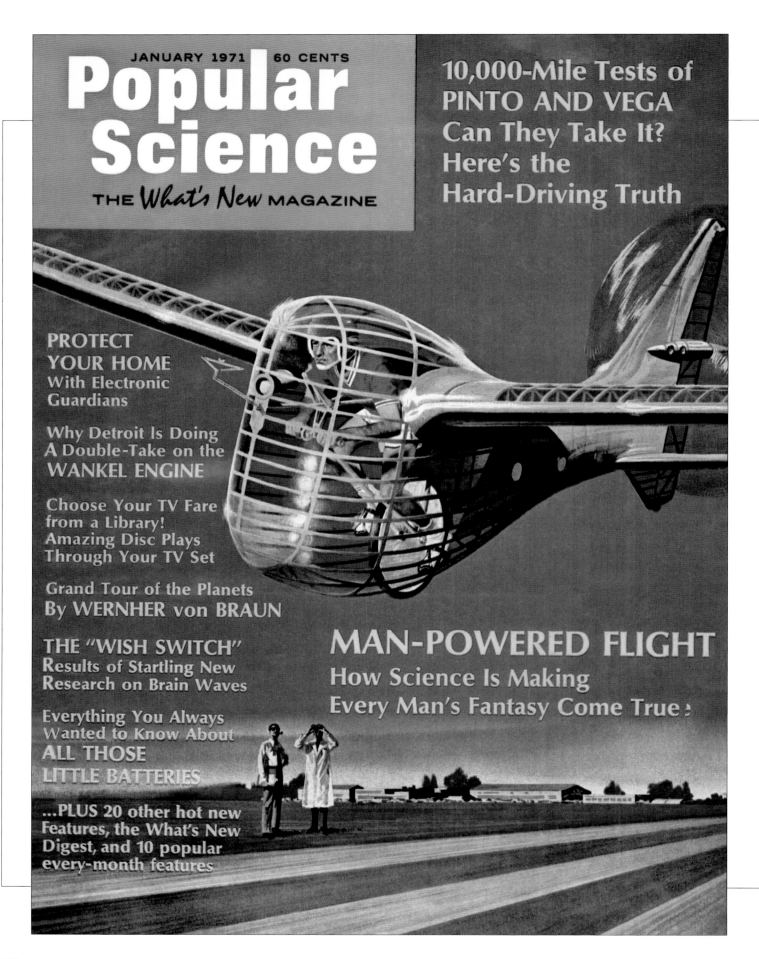

1971

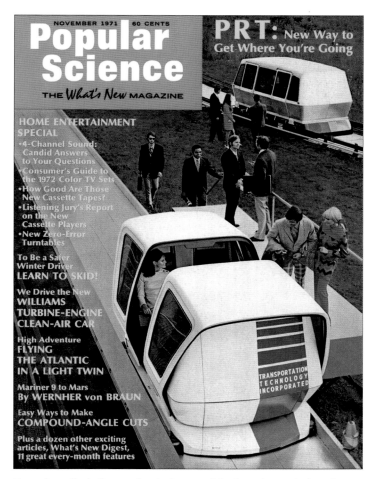

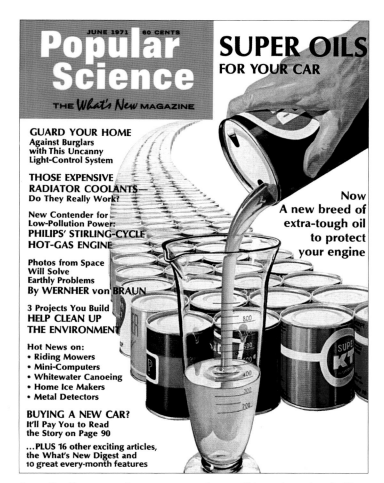

November · Ozzie Sweet · Stock-photo models of another era look really pleased with their personal rapid transit (PRT) pod.

❌ DID IT HAPPEN? Not really. Proposed as a remedy for traffic congestion, PRT systems were supposed to deliver you to your destination without any stops along the way, ensconced in a private pod with airplane-style seats and pumped-in Muzak. Few succeeded, including the one on the cover (and the more delightfully named Dashaveyor). Today, there are five in operation, though Elon Musk has proposed an underground version on this theme.

June · Ken Thompson · A guy pours some "super oil" into a beer-glass-looking beaker in front of an infinite rainbow of commercial options.

✅ DID IT HAPPEN? This cover story was basically a "lubrication consultant" talking about how this year's motor oils were better than the previous year's because they could withstand more heat. Pretty controversial stuff.

January (left) · Don Crowley · A man pedals his way into flight.

✅ DID IT HAPPEN? Human-powered flight definitely, well, took off in the 1970s, with a US$25,000 Kremer prize motivating daredevil designers everywhere to try their hand at a pedal-powered aircraft. This cover depicts the *Puffin*— a British-built human-powered plane that, in 1961, flew nearly 3,000 feet (915 m), making it the most successful plane of its type at that time. The award ultimately went to American engineer Paul MacCready, whose pretty similar-looking *Gossamer Condor* completed the mandatory figure-eight flight course in 1977.

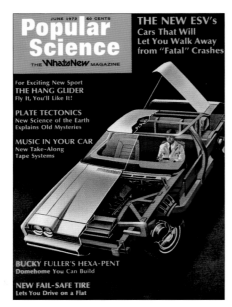 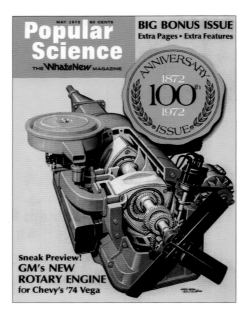 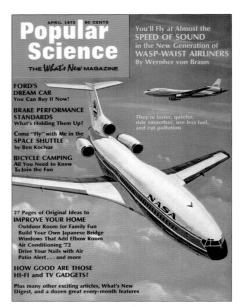

June · Ted Lodigensky · A cutaway of GM's experimental safety vehicle (ESV), a.k.a. "the world's safest car."

✓ DID IT HAPPEN? You bet your life. While the first crash-test dummy, Sierra Sam, debuted in the 1940s, the US government further spurred car safety by investing in test-only cars in the 1970s. The verdict of the first test? The dummies were "only slightly killed."

May · Ray Pioch · *Popular Science* celebrates its 100th anniversary with—drum roll, please—GM's new rotary engine!

✓ DID IT HAPPEN? Yeah, we did. It must have been one special engine. (In theory, its development was supposed to mark a shift from piston to rotary engines in the auto world, but most cars still have piston engines today.)

April · Pierre Mion · NASA's Advanced Technology Transport (ATT), a wasp-waist Mach I airliner with supercritical wings, takes to the skies.

◐ DID IT HAPPEN? Yes and no. Pinched waists and supercritical wings do help combat drag in Mach 1 aircraft, but skyrocketing fuel costs killed supersonic commercial flight in the late 1970s. Anglo-American Concorde and the Russian Tupolev Tu-144 were the only Mach 1-plus models to get off the ground; they're now discontinued.

October (right) · Robert McCall · NASA's supersonic "flying scissors" jetliner (AD-1) cuts the sonic boom.

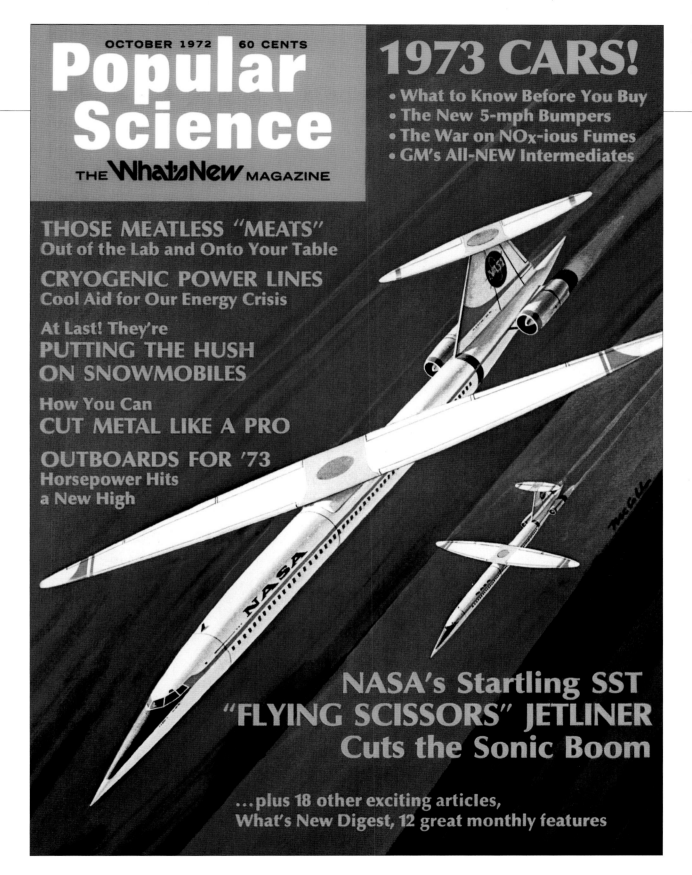

❌ DID IT HAPPEN? In wind tunnels and on test flights, yes, but the aviation community never fully embraced it. Designed by Dr. R. T. Jones at NASA's Ames Research Center, this aircraft's wing could pivot midflight to a 60-degree angle, reducing drag and fuel consumption. It wasn't *quite* boomless; instead, it would have flown so high, we Earthlings wouldn't have heard it.

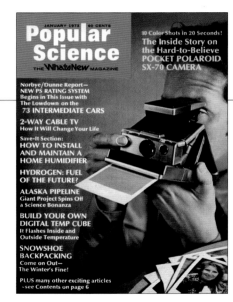

January · Orlando Guerra · The Polaroid SX-70 spits out a self-developing picture.

✓ DID IT HAPPEN? Sure. Before the SX-70, you had to peel the negative from your Polaroid print, which was messy and hit-or-miss. The SX-70 was the first to produce what we think of as a Polaroid: the self-developing photo that you shake as the image appears, though you don't need to. If that wasn't enough, the camera folded up flat for easy transport.

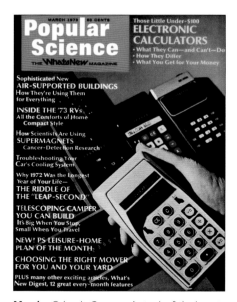

March · Orlando Guerra · A stack of the latest calculator technology.

✓ DID IT HAPPEN? Yup, and it sure beat the abacus. Invented in 1966 by Texas Instruments, the handheld calculator became even more popular when one-chip circuits debuted in 1971, which made calculators smaller and cheaper.

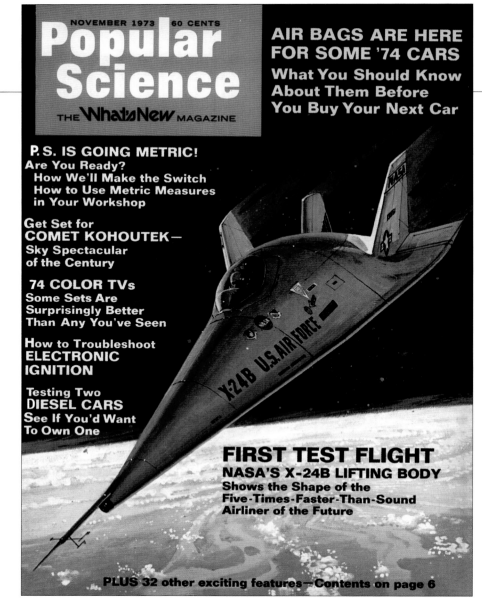

November · Robert McCall · NASA's X-24B "lifting body" aircraft glides down from space after supposedly hitting Mach 5.

◐ DID IT HAPPEN? Sort of. There were definitely prototypes and successful test flights, but the X-24B never reached Mach 2, let alone Mach 5. As for the funky teardrop shape, it gave this "wingless" design lift, while three vertical fins helped out with stabilization. Even if it never broke five times the speed of sound, the X-24B proved that such an aircraft could rapidly but precisely glide—unpowered—to Earth's surface, setting the stage for the space shuttle.

July · A. J. Hand · A driver, broken down on the side of the road, uses Motorola's DynaTAC—a "take-along telephone"—to call for help.

✓ DID IT HAPPEN? You bet. This first monstrosity of a mobile phone made its maiden call in April 1973, but it took a decade for the nearly 2-pound (1-kg) and 13-inch- (33-cm-) tall device to make it to market—and then at a blistering US$4,000. After charging it for 10 hours, you could treat yourself to a marathon 30-minute call.

JULY 1973 — 60 CENTS

Popular Science
THE What's New MAGAZINE

NEW TAKE-ALONG TELEPHONES
Give You Pushbutton Calling to Any Phone Number

Detroit Hot Line—
WHAT'S COMING IN THE '74 CARS

INGENIOUS INVENTIONS
From New York's Patent Exposition

How Science is Solving
THE MYSTERIES OF THE NORTHERN LIGHTS

What's the "Best" Color for Your Car?

Amazing New Alternator Delivers 60-Cycle Power Over a Wide Range of RPM's

DRIVABILITY PROBLEMS?
How to Troubleshoot Your Car's Emission Controls

Now You Can Make Your Own 25-Foot
INFLATABLE DOME

...plus 34 more exciting articles and features—see contents on page 6

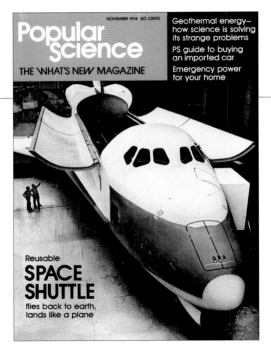

November · Rockwell International · A look at the work-in-progress shuttle, which launched in 1981.

✓ DID IT HAPPEN? You bet. Wernher von Braun reported that the shuttles would be outfitted with silica tiles and carbon caps to withstand the heat of atmospheric reentry, and be reusable "nearly 100 times." Five space shuttles flew 135 missions before the remaining three were retired. Not too bad, NASA.

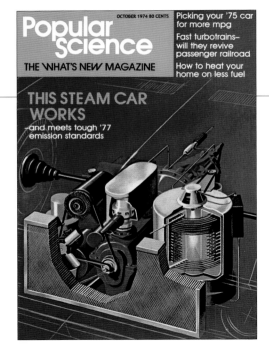

October · Dean Ellis · A cutaway of the engine of the Carter Steamer—the first vehicle to meet the EPA's tough 1977 emission standards.

✓ DID IT HAPPEN? It isn't too surprising that this worked, as cars with steam engines outsold gas-powered ones before electric starters were invented in 1911. But steam cars never made a comeback, and this one has been lost to history.

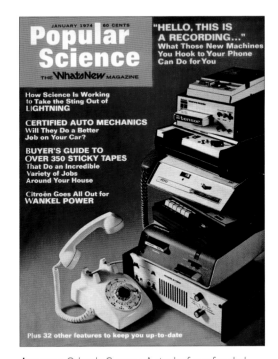

January · Orlando Guerra · A stack of newfangled answering machines and a levitating phone receiver.

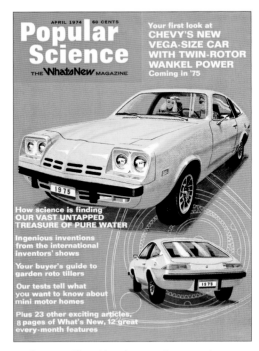

April · Dean Ellis · Chevy's yet-to-be-named car running a Wankel engine.

✓ DID IT HAPPEN? Yes. These gizmos fell in price in the 1970s, surging in sales. You could even call one to hear movie times or the weather, or call Dial-a-Prayer, which presumably put you on hold with your deity of choice.

◐ DID IT HAPPEN? It's complicated. Some Corvettes run a Wankel. But this looks a lot like the Chevy Monza, which was originally designed to run a Wankel in 1975 but ended up with a V8 instead. Go figure.

The Future Then

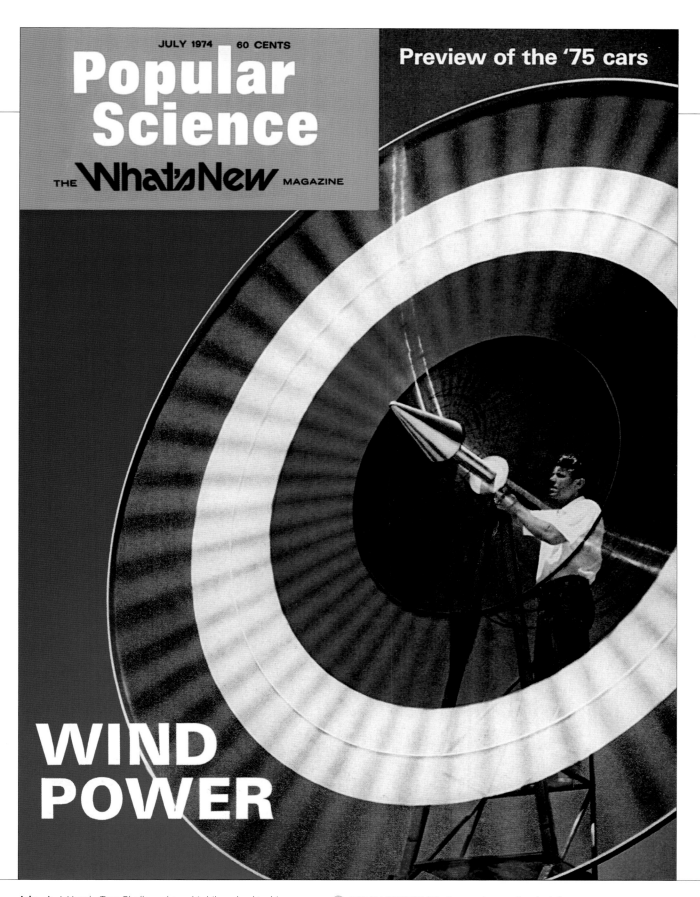

Popular Science
THE What's New MAGAZINE
JULY 1974 • 60 CENTS

Preview of the '75 cars

WIND POWER

1974

July • A. J. Hand • Tom Chalk works on his bike-wheel turbine.

DID IT HAPPEN? Wind power is one of today's fastest-growing forms of renewable energy. This article looked at a number of turbine designs—some worked out, such as the vertical catenary turbine, and some didn't, like the sail-powered car. Chalk's design performed well in initial tests but may have encountered difficulty when scaled.

OCTOBER 1975 75 CENTS

Popular Science

The **What's New** magazine

SOLAR POWER TOWER
How thousands of mirrors will concentrate sunlight to generate electricity

The '76 cars—
How GM, Ford, and AMC are meeting the gas-saving challenge

Wind engineering—it's changing the way we build our cities

Manned deep-sea satellite will tap new oil resources

On-board crash recorders probe buzzling questions about car safety

For fuel-free fun, try a fall bike-camping vacation

Big home-and-hardware section: Getting your money's worth when you fix up your house this fall

1975

January • W. David Houser and Orlando Guerra • A curiously haloed couple use a variable speech control (VSC) tape recorder.

✓ DID IT HAPPEN? Yeah. VSC tape recorders—which let you slow down and speed up playback—definitely exist. They also let you adjust pitch, so when you speed up a recording, you can shift the pitch down from *Alvin and the Chipmunks* level to normal, making the faster playback intelligible.

February • Dean Ellis • A cutaway of the Volkswagen Rabbit, a pint-size German import with staying power.

✓ DID IT HAPPEN? Yep. The wild gas prices and new environmental regulations of the 1970s opened the door for foreign manufacturers, which had been perfecting small, fuel-efficient cars, increasing their interior space and improving drive trains. (As everyone's dad always said, "Dynamite comes in small packages.") When oil costs dropped in the 1980s, folks went right back to gas guzzlers, though the Rabbit lives on as the VW Golf.

October (left) • Howard Koslow • US company Honeywell's concept for a heliostat power plant, which harnesses the sun's energy with the help of many, many mirrors.

✓ DID IT HAPPEN? Yeah, actually, there are a few of these setups creating energy in Europe, the United States, and Turkey. They work by using mirrors to concentrate the sun's rays onto a central receiving tower. And at the Gemasolar plant in Spain, concentrated sunshine heats tanks of molten salt, creating steam that powers turbines, producing energy. The crazy part is that it takes time for the heat stored in those tanks to be released—sometimes up to 15 hours—meaning the plant continues to create power in the dark.

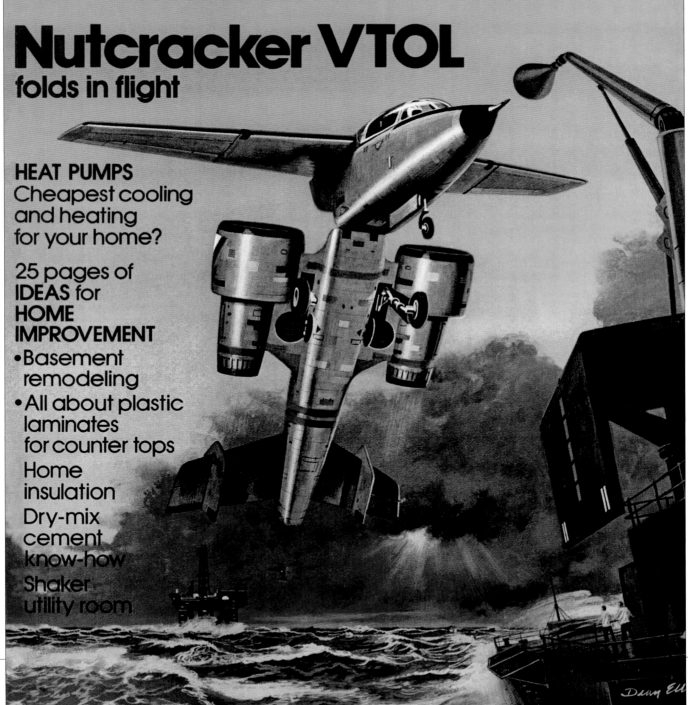

SEPTEMBER 1976 75 CENTS

Popular Science
The **What's New** magazine ®

Coming: Aircraft that use half as much fuel
By Wernher von Braun

THE '77 CARS
Close-ups of the new models from Ford and Chrysler

Nutcracker VTOL
folds in flight

HEAT PUMPS
Cheapest cooling and heating for your home?

25 pages of **IDEAS** for **HOME IMPROVEMENT**
- Basement remodeling
- All about plastic laminates for counter tops
- Home insulation
- Dry-mix cement know-how
- Shaker utility room

1976

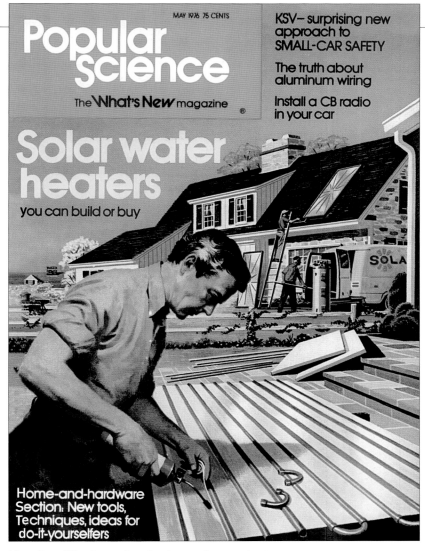

May · Dean Ellis · A team installs a home solar water heater.

✅ DID IT HAPPEN? Yes, solar water-heating systems exist; some models even work in freezing climates. This issue looked at reader-contributed designs for DIY solar setups—from rooftop systems to stand-alone circulating air collectors—and out-of-the box versions that heated water in glass solar panels and worked in tandem with existing heating systems.

April · Ken Thompson · A disembodied hand pours synthetic oil over type.

✅ DID IT HAPPEN? Synthetic motor oil hit the automotive market in the mid-1970s—apparently to huge controversy, largely due to a few oils that caused mechanical damage. Fifty years on, the synthetic-vs.-mineral-oil debate is likely still raging between gearheads near you.

November · Ben Kocivar · The son of Windmobile inventor James Amick takes a seat with a "Look, Ma! No hands!"

✅ DID IT HAPPEN? Sure. The author was able to keep the Windmobile moving at 42 miles per hour (68 km/h) with winds of 10 miles per hour (16 km/h)—after getting a boost from an electric motor. James Amick went on to design several experimental wind-powered vehicles.

September (left) · Dean Ellis · The Grumman Nutcracker folds in flight.

❌ DID IT HAPPEN? Nope. While the US Navy considered this concept for a short vertical take-off and landing (SVTOL) concept (an aircraft that can take off on short runways with a straight fuselage and jackknife to land vertically), it doesn't appear to have made it past model size. While the last century saw several efforts at such an aircraft, the only truly successful one was 1969's Hawker Siddeley Harrier. It looked way less weird.

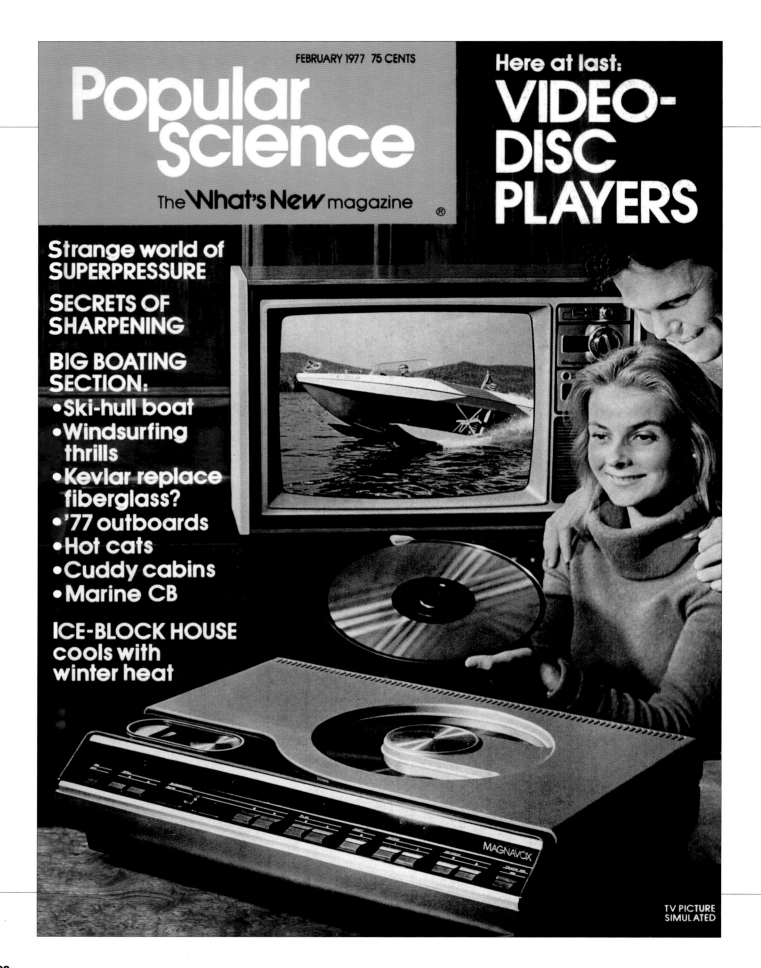

1977

October · Don Cameron · A nerd uses a Commodore PET as a cookbook.

✅ DID IT HAPPEN? Definitely. The PET was one of Commodore's first personal computers, paving the way for the famed Commodore 64. This issue covered its features—like its whopping 4KB of RAM. Slow down, Mario.

January · Craig Kavafes · A Grumman vertical wind turbine powers a city.

❌ DID IT HAPPEN? Not exactly. Vertical wind turbines do exist, but they're typically scrappy and scaled to power, say, your garage.

April · Ray Pioch · A woman strolls across the open courtyard of her underground home.

✅ DID IT HAPPEN? Underground and earth-covered dwellings are totally around—though admittedly hard to spot. For this feature, the author took a tour of US architect John Barnard's Ecology House on Cape Cod, Massachusetts, trumpeting some of the underground home's trend-setting benefits—such as its ability to keep cool in the heat and warm in the cold.

February (left) · Orlando Guerra and Ozzie Sweet · A couple seems thrilled with their new Magnavox Laserdisc player.

✅ DID IT HAPPEN? Yes, this big silver record (and now iconic flop) entered the market in 1978. Despite improved video quality, Laserdiscs were pricey and the players themselves couldn't record. VHS—the little big cassette that could, introduced in early 1977—won the movie-medium war.

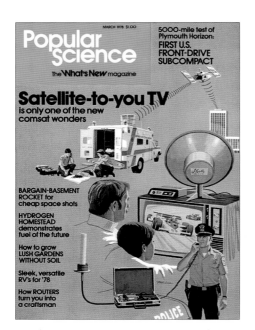

March · Pierre Mion · The many wonders of satellite communication (mostly television).

✅ DID IT HAPPEN? Yeah, satellite TV is basically cable television's only competition (if you don't count streaming). This issue looked at the progress that made it take off—from the increased capacity of satellites to having more of them in orbit to investing in sophisticated digital-transmission gear on the ground.

June · Ray Pioch · A lineup of Stirling engines help generate solar electricity.

🔄 DID IT HAPPEN? This issue suggests that dusting off the then-160-year-old Stirling engine—which harnesses heat to expand gas, which then drives pistons, which then turns a flywheel—might be "the key" to solar electricity. Turns out solar cells do great on their own, though some energy companies are exploring this idea.

October · Ray Pioch · A diagram of the moon, from surface to core.

✅ DID IT HAPPEN? Here, *Popular Science* looked at what we've learned from the *Apollo* missions' photographs and lunar-rock samples about our only natural satellite: that the moon was born 4.5 billion years ago and experiences moonquakes, and that the dark expanse of the Man on the Moon is actually a hardened lava lake.

February (right) · Dean Ellis · US inventor Dr. Daniel Schneider's lifting foils harness energy from water.

DID IT HAPPEN? It's complicated. While experimental versions of Schneider's HydroEngine technology—essentially a venetian-blind-looking turbine that moves like vertically oriented tank treads when wind or water pass through them—performed well in several tests and small-scale rollouts, it just never caught on. But watch this space: Schneider's children have taken up the family mantle and are pursuing further commercial development of the HydroEngine in Alameda, California.

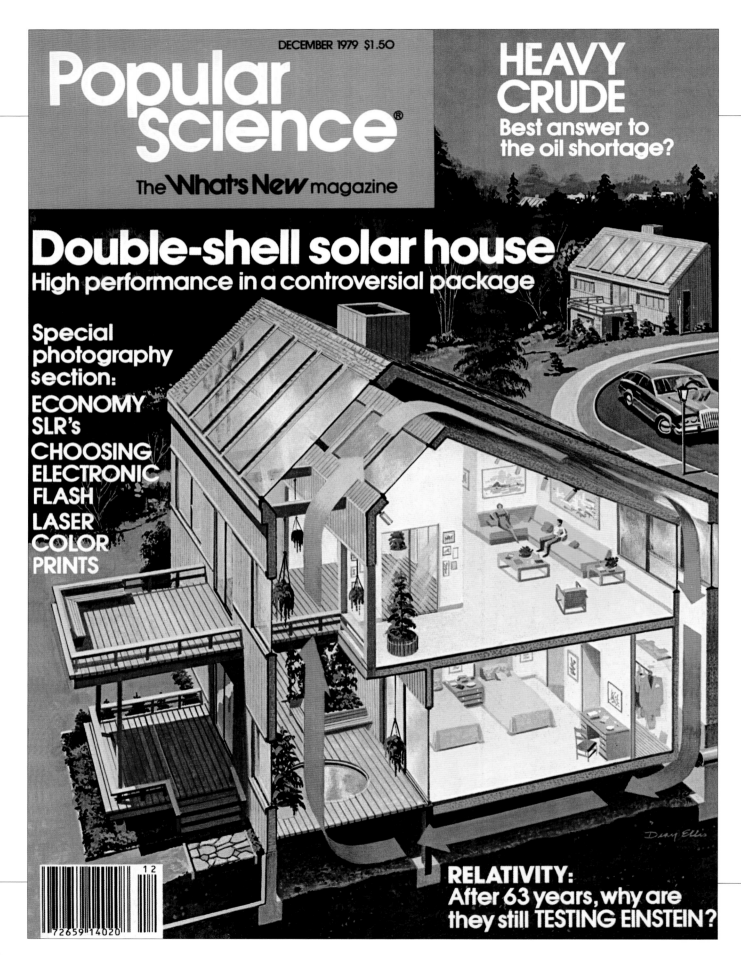

1979

May · Ray Pioch · The hottest projection TVs of 1979 light up the cover.

✅ DID IT HAPPEN? Yes, a few of these ideas went to market, such as star audiovisual engineer Henry Kloss's Novatron. (Kloss worked on the first projection TV—the game changer and cult favorite Advent VideoBeam 1000—which was released in 1972.)

July · Pierre Mion · A scale model of the proposed McDonnell Douglas supersonic transport at the US Langley Research Center's wind tunnel.

⚠️ DID IT HAPPEN? Ironically, this cover story starts off knocking Concorde as a noisy, costly failure, but the three heralded concept aircraft—from McDonnell Douglas, Lockheed, and Boeing—were such long shots that they didn't even get names.

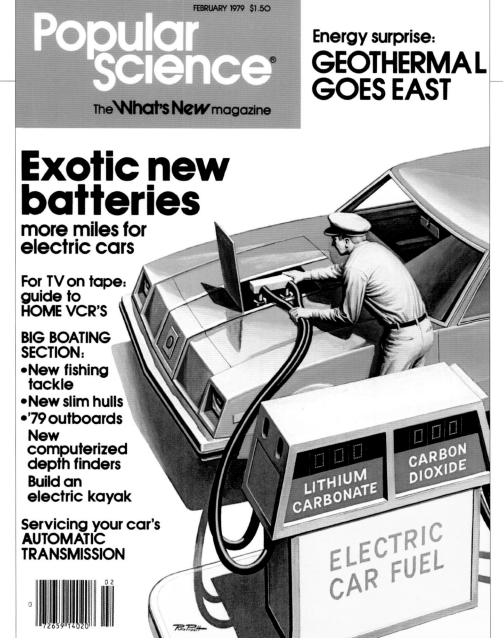

February · Ray Pioch · A station attendant "refuels" an electric car, adding CO_2 and water and removing lithium carbonate.

⚠️ DID IT HAPPEN? It's complicated. While some of this article's predictions about the electric car came true—like having highway speeds comparable to their gas-guzzling cousins, operating 200 miles (320 km) between refuel stops, and boasting reasonable cost—the power mechanism was still a bit of a head-scratcher. Today, you just plug them in, and ta-da.

December (left) · Dean Ellis · A double-envelope house—a house within a house—keeps the heat in.

✅ DID IT HAPPEN? While it looks a bit crazy, yes, there are hundreds of double-envelope homes out there—like this inaugural one near Lake Tahoe in California—thanks to American self-proclaimed "ekotect" Lee Porter Butler. The idea is to trap heat in a south-facing sunroom, then passively circulate the air using temperature differences south to north (as illustrated by the arrows on the cover). It works just fine, though it can't hold heat indefinitely (usually maxing out at 72 hours) and isn't great for extreme climes.

ARTIST PROFILE

HOWARD KOSLOW

Of all of the artists to paint covers for *Popular Science*, you've probably seen more of Howard Koslow's work than anyone else's. In fact, if you've been on the sending or receiving end of a letter or postcard in the past four decades, odds are you've come across some of Koslow's work. For nearly 40 years, beginning in the 1970s, Howard Koslow was best known for his work painting postage stamps. So cherished are his stamps, in fact, that national periodicals the *Washington Post* and the *New York Times*, among others, took it upon themselves to pen obituaries when he passed away in 2016.

In the 1990s, Koslow painted a series of 29-cent portraits (it was the 1990s; stamps were cheaper) of jazz legends like Billie Holiday and Bessie Smith. He also lent his hand to commemorating important treaties and national milestones, honoring the branches of the US government, and celebrating national parks, monuments, and landmarks. He is perhaps most well known for a series of miniature, adhesive-backed depictions of American lighthouses—located from New England to California and from the Great Lakes to the southern tip of Florida.

Of course, Koslow didn't just paint tiny, tacky squares. He also did regular-size commissioned paintings for agencies including NASA and the National Park Service, and illustrations for publications such as *Popular Science*. In the 1970s, Koslow did a few covers and illustrations for the magazine, most notable a pair on the topic of renewable energy. You might see some of his flair for lighthouses in his futuristic painting of a solar power tower.

Right, top to bottom,
October 1975
January 1970 (inset)
September 1968

Far right,
November 1972

204 The Future Then

NOVEMBER 1972 60 CENTS

Popular Science

THE What's New MAGAZINE

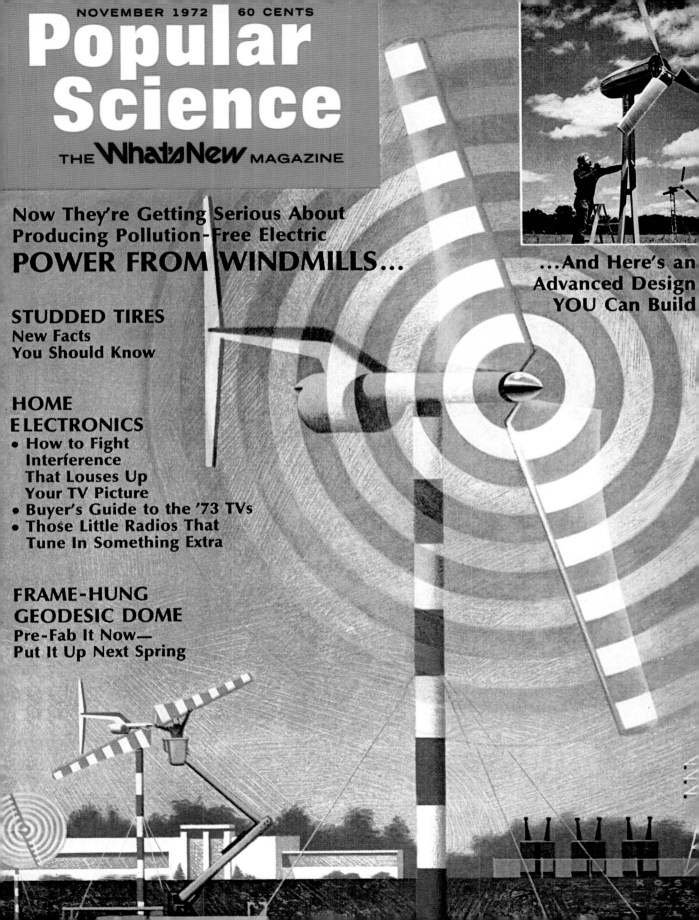

Now They're Getting Serious About
Producing Pollution-Free Electric
POWER FROM WINDMILLS...

...And Here's an
Advanced Design
YOU Can Build

STUDDED TIRES
New Facts
You Should Know

**HOME
ELECTRONICS**
• How to Fight
 Interference
 That Louses Up
 Your TV Picture
• Buyer's Guide to the '73 TVs
• Those Little Radios That
 Tune In Something Extra

**FRAME-HUNG
GEODESIC DOME**
Pre-Fab It Now—
Put It Up Next Spring

MICROMO[TORS]

Motors so tiny they can pass through a needle's eye promise advances in fields from medicine to nuclear energy

1980s

1980s

LIKE, TOTALLY RADICAL

The 1980s were about more than just big hair and shoulder pads. For science, the decade saw giant warplanes become imperceptible to radar, largely invisible biomarkers put criminals behind bars, and new viruses began to spread (through both people and computer networks). It was a decade of compact discs and a movie star US president—one that brought us disposable cameras, Super Soaker squirt guns, the DeLorean, and (more ominously) global warming.

SPACE SHUTTLE TRIUMPHS AND TRAGEDY

While work on NASA's space shuttle program kicked off in the 1970s, the first space shuttle, *Columbia*, left Earth in April 1981. The program was a great success overall, accomplishing many firsts in crewed space flight and helping assemble the International Space Station in 1998. During the 1980s, *Columbia* was the first reused shuttle and flew the inaugural Spacelab mission. *Discovery* took the first sitting politician, Jake Garn, to fly in space, followed by the first member of royalty, Saudi Arabia's Sultan bin Salman bin Abdulaziz Al Saud. And *Challenger*, during 25 flights, made many firsts: carrying Sally Ride and Guion Bluford (the first woman and African American man in space), performing the earliest satellite rescue, and serving as the base from which Bruce McCandless II took the inaugural untethered spacewalk. Sadly, *Challenger*'s final mission was a tragic first—the first crewed American space mission to launch and not make it above the atmosphere. In January 1986, just 73 seconds after launch, *Challenger* broke apart, killing all seven crewmembers, including New Hampshire teacher Christa McAuliffe, on live TV.

A HOLE IN THE OZONE AND A NUCLEAR MELTDOWN

The oil crisis of the 1970s sparked a lot of talk about energy independence—about ways we might harness power from the sun, wind, and waves. But in the 1980s, environmentalism was driven less by geopolitical events and more by disasters. In 1985, a group of three British scientists—Joe Farman, Brian Gardiner, and Jonathan Shanklin—published a paper showing a hole (or, more accurately, a thinning) in the ozone above Antarctica. While a number of scientists proposed causes, it became clear, after a research journey by the Antarctic Airborne Ozone Expedition, that the cause was us—namely, human-made chemicals such as chlorofluorocarbons. Then, in 1986, a nuclear power plant exploded in Chernobyl, Ukraine, leaking a huge amount of radioactive material and killing about 30 people (though thousands more will likely die over time due to cancer and related illnesses). The spill had profound effects on the area—and global attitudes toward nuclear power.

A COMPUTER BOOM—AND VIRUSES, TOO

In the world of computers, the 1980s picked up where the 1970s left off. The Commodore 64 became the best-selling computer of all time, IBM introduced its own personal computer, and Apple debuted the Macintosh—the first mouse-driven computer with a user interface based on graphics rather than text commands, laying the groundwork for the point-and-click reality

HIGHS AND LOWS IN INNOVATION

Above, the DeLorean DMC-12 spreads its wings. Produced from 1981 to 1983, the DeLorean achieved cult status, owing in no small part to its appearance in 1985's *Back to the Future*.

At left, aerospace engineer Lonnie Johnson with his 1982 invention, the Super Soaker, and the hard-won patent for it.

At right, the Chernobyl nuclear reactor after one of the most catastrophic nuclear meltdowns in the history of, well, the world.

The Future Then

1980s

we know today. The internet continued to evolve, as ARPANET connected with NSFNET—the National Science Foundation Network, which, unlike other networks, was more open in terms of who could use it. But it wasn't all sunshine and 8-bit butterflies. In 1983, American computer science student Fred Cohen created one of the first computer viruses—and while he went on to work in virus defense, not everyone with his skill set would. The Brain computer virus began infecting MS-DOS systems in 1986, and two years later the Morris worm became one of the first to infect users via the very fledgling internet—proving once again why we can't have nice things.

A NEW EPIDEMIC EMERGES

Tragically, computers weren't the only entities getting sick in the 1980s. In 1981, the US Centers for Disease Control and Prevention reported a mysterious, highly fatal virus ripping through communities of gay men in California and New York. Manifesting as an aggressive form of pneumonia and a rare cancer called Kaposi's sarcoma, the autoimmune disease that came to be known as AIDS swiftly moved on to other victims (including transplant and blood-transfusion patients, as well as intravenous drug users), killing nearly 100,000 in the United States alone by the end of the decade. It took until the late 1990s for scientists to hit upon a unique multidrug cocktail (HAART, an acronym for "highly active antiretroviral therapy") that ultimately transformed the disease from a death sentence to a manageable though incurable illness. But—despite early panic that AIDS could spread by touch and the US government's initial reluctance to recognize it—the 1980s did see progress. In 1984, a team led by Robert Gallo at the US National Cancer Institute announced that AIDS was caused by human immunodeficiency virus (HIV), and issued the ELISA blood test. The frontline in treatment and containment, it is still the most commonly used diagnostic exam for HIV today.

AROUND THE WORLD WITHOUT STOPPING

Before the 1980s, many people had completed around-the-world flight, but no one had done it all in one shot without refueling, either on the ground or in the air. But in 1986, that changed, as Dick Rutan and Jeana Yeager took off from Edwards Air Force Base in California in the *Rutan Voyager*—designed by Dick's brother, Burt—and landed at the same airfield nine days later. The *Voyager* was the first plane to be constructed almost entirely of composite materials, and its lightweight build and unorthodox design contributed to its success. The feat alone is impressive, but when you factor in that the plane lost pieces of its wingtips during takeoff, the flight path had to change to avoid severe weather and Libyan airspace, and the two pilots—jammed into a glorified phone booth for more than a week—were on the verge of calling off their romantic relationship, it becomes truly remarkable.

FASTER AND FARTHER

Above, a colorized scanning electron micrograph of HIV infecting human T-cells.

At left, everyone's mom from the 1980s lays down some hot licks on a synthesizer attached to a Commodore 64 in the March 1985 issue of *Popular Science*.

At right, the *Rutan Voyager* on one of the nine days it took to fly around the world without stopping to refuel or pee. The *Voyager* is now on display at the National Air and Space Museum in Washington, D.C.

ALSO OF NOTE

AUGUST 1, 1981
MTV launches.

MARCH 10, 1982
All nine planets of the solar system align on the same side of the sun.

DECEMBER 2, 1982
Seattle man Barney Clark gets the first totally artificial heart.

MARCH 15, 1985
Symbolics.com becomes the first ".com"-registered domain name in the world.

MARCH 11, 1986
US engineer Chuck Hull files a patent for 3D printing.

DECEMBER 29, 1987
We get our first taste of a little pill called Prozac.

1980s

1980s

TO CATCH A PREDATOR
Forensic science has a long history. As far back as the 1800s, primitive tests of ballistics, toxicology, and blood had all seen time in court. Fingerprints, too, had long been used as physical evidence placing suspects at crime scenes. But in 1988, a new kind of fingerprinting—DNA fingerprinting—was used to convict someone of a crime for the first time: Colin Pitchfork, a 28-year-old man accused of two rapes and murders in England, was sentenced to life in prison when prosecutors demonstrated that his DNA matched semen left on the victims. While a similar test had been used to prove paternity for nearly a decade, this new technique—developed in 1985 by a team led by British geneticist Alec Jeffreys—paved the way for later DNA-based convictions (and exonerations), as well as seemingly innumerable detective dramas.

INVISIBLE WAR MACHINES
After the United States lost too many bombers during the Vietnam War, the race to build a plane invisible to radar intensified. In the mid-1970s, researchers gained ground developing what would come to be known as stealth technology. Formally called radar cross-section reduction, this technique works by deflecting and absorbing radar signals, giving enemy operators the impression that a large object is much, much smaller. For instance, a B-2 bomber, with a wingspan of nearly 200 feet (60 m), looks more like a large bird than a large plane on radar screens. In the 1980s, the Lockheed F-117 Nighthawk was the first plane to put some form of radar cross-section reduction into practice—followed by the Northrop Grumman B-2 Spirit Bomber—making for some seriously deadly and nearly undetectable aircraft.

GAMING GETS GOOD
By the mid-1980s, the video-game craze unleashed by Atari's Pong had stalled, as the market soured on the home console in favor of the PC. Enter Japanese company Nintendo and its entertainment system, complete with a pretty amazing "laser gun" and a raft of games that became instant classics, such as *Duck Hunt*, *Donkey Kong*, and later *Super Mario Bros.*—the system's crown jewel and still the best-selling game in history. The decade saw tons of innovation in the home-gaming space (including controllers with gamepads instead of joysticks, smoother 16-bit graphics, and dedicated sound cards), and arcade games experienced a similar surge—thanks to blockbusters like *Pac-Man*. While competition was hot from brands like Sega, Nintendo capped off its dominance in 1989 with the release of the Gameboy, a handheld console that promptly made being a teenager the best thing ever.

LOOKING SHARP

Above, Alec Jeffreys examines a DNA fingerprint at Leicester University. He was knighted for his contribution to genetics in 1994.

At left, Japanese video game designer Shigeru Miyamoto with one of his creations, Nintendo's beloved Mario, in 1990. Miyamoto also designed the *Legend of Zelda*, *Donkey Kong*, and more.

At right, artists' renderings of the US supersecret stealth planes from the January 1989 (top) and September 1986 (bottom) issues. The F-17 and B-2 certainly made it into operation, but some conspiracy theorists believe that the F-19 (bottom left) was built but never revealed to the public. Others say the F-19 *is* the F-17, citing confusion over the naming convention.

The Future Then

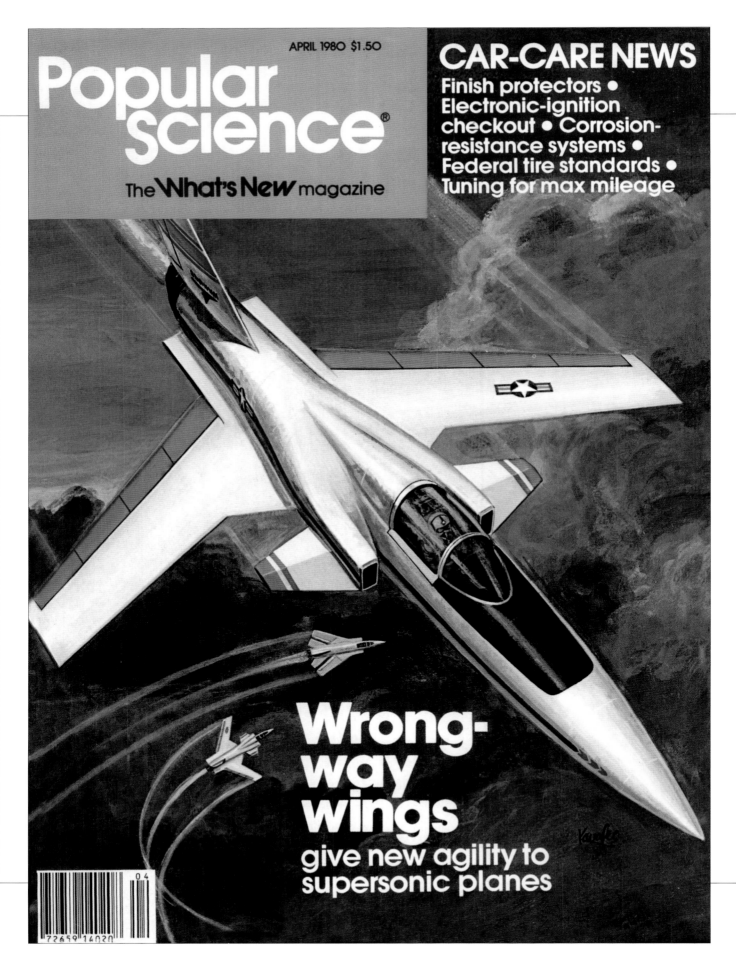

January · Dean Ellis · Two views of the high-tech and supersafe Minicar RSV, one with its gull-wing doors open.

DID IT HAPPEN? Yes and then no. After Ralph Nader's *Unsafe at Any Speed* caused public outrage in 1965, the US National Highway and Safety Administration secretly built the Minicar to make 50-mile-per-hour (80-km/h) crashes survivable. Two of its revolutionary features included a front end designed to safely crumple and a fuel tank placed where it's least likely to rupture. For political reasons, the Minicar never went into production, and most were destroyed. But gull-wing doors still make cars look high-tech, even today.

August · Dean Ellis · An artist's depiction of the *Popular Science* energy house.

DID IT HAPPEN? Yes—and it is really cool. Ralph Merrill, a Salt Lake City architect and loyal reader of the magazine, built this house, incorporating nearly every energy-saving tip, trick, and device that appeared in the magazine throughout the 1970s. A high-efficiency furnace, solar water heater and collector, insulated steel doors, triple-glazed south-facing windows, and an insulated all-wood foundation are just a few.

April (left) · Craig Kavafes · A pair of X-29 supersonic jets with forward-swept wings dogfight with a regular old fighter jet.

DID IT HAPPEN? Not really. Grumman built precisely two X-29s, the first forward-swept-wing aircraft to reach supersonic speeds. But while it flew a staggering 422 test flights from 1984 to 1991, the X-29 never went into production—likely because the design didn't quite demonstrate the desired drag reduction. But it did teach us about constructing with composite material—which became the norm—and aeroelastic wing design.

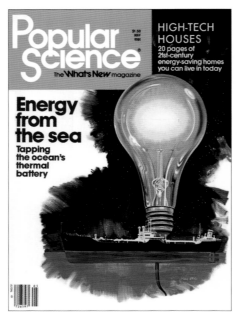
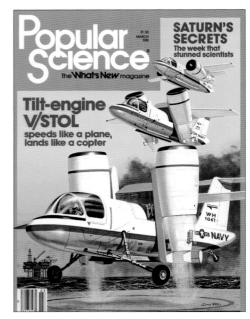

December · Dean Ellis · A remote-controlled robot sub scours wreckage on the ocean floor.

✓ DID IT HAPPEN? Definitely. The 1980s ushered in a class of uncrewed subs designed to scout wrecks—taking pictures and shooting video to be analyzed on the surface—and do dangerous recon on offshore oil rigs, like the RCV-225, shown here. The piece predicts one class of sub that was then very much experimental: the free-swimming, untethered robotic vehicles we have today.

May · Dean Ellis · An artist's dramatization of harnessing energy from the ocean around Hawaii.

✓ DID IT HAPPEN? Yeah. This piece is about tests of ocean thermal energy conversion (OTEC), which uses temperature differences at varying ocean depths to generate power. While testing went on for more than 30 years, the world's largest closed-cycle OTEC power plant opened in Hawaii in 2015. More are in the works.

March · Dean Ellis · The Grumman 698 tilt-engine VTOL aircraft hovers like a copter and flies like a jet.

✗ DID IT HAPPEN? Nope. Sounds like the 698 may have been shelved in favor of the V-22 Osprey, which achieved the same copter-jet goal but uses propellers instead of swiveling jet engines. Few full-scale model 698s were built, and it didn't really see air outside NASA's wind tunnel. It sure did inspire a lot of cool artwork, though.

January (right) · Dean Ellis · Dr. Rudolph Meggle's *Gross Windenergieanlage* ("big wind energy unit").

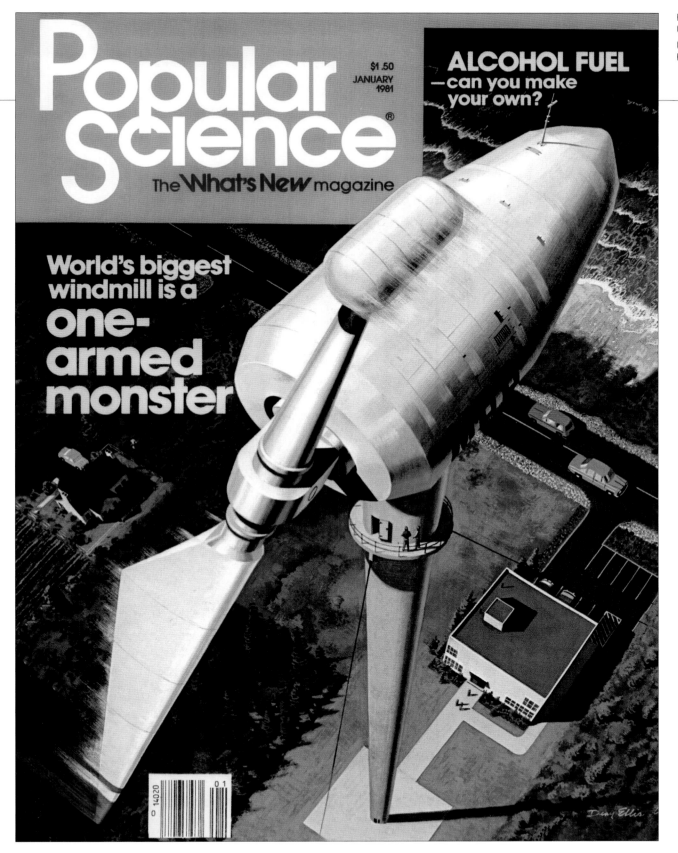

❌ DID IT HAPPEN? Not really, no. The idea behind this one-blade windmill from Maschinenfabrik Augsburg-Nürnberg, called Growian II, was to cut costs and weight and simplify construction. But Growian I—a publicly funded two-blade design that was the world's largest turbine when it first opened in 1983—was such an expensive disaster that it still makes Germans curse Gott, and so its sequel never had a chance. While Meggle did go on to build three single-blade turbines, two or more blades clearly became the standard.

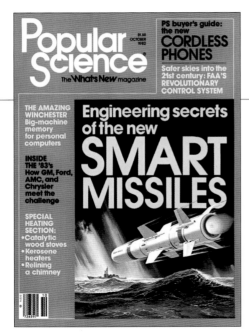

October • Dean Ellis • A smart missile heads toward an unlucky target.

✅ DID IT HAPPEN? This issue looked at new tricks at play in US missiles—from radar-guided to heat-seeking, from antitank to antimissile. All but the fiber-optic-guided missile panned out.

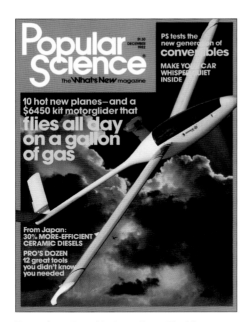

December • David A. Gustafson • The Monnett Monerai sailplane-motorglider kit plane flies all day on 1 gallon (3.75 L) of gas.

✅ DID IT HAPPEN? Yeah, for a few years. With US$4,000 and 500-plus assembly hours, you could stay airborne for a long period of time on very little fuel, though it was a pretty poky ride.

September • Ray Pioch • The Polimotor I, the Ford Pinto's "impossible" plastic engine.

◐ DID IT HAPPEN? Turns out "impossible" was a pretty apt qualifier here—but for a surprising reason: The engine never saw the inside of a Pinto, because Ford wasn't actually involved in its creation. American inventor Matti Holtzberg simply based the design on the Pinto's crankshaft, replacing all the engine parts with polymer versions for an end product that weighed half as much as its more traditional cousin. While the Polimotor I made it only into a handful of championship race cars in the 1980s, Holtzberg is back at it with Polimotor II, so stay tuned.

February (right) • Paul Alexander • An astronaut takes an untethered space walk using a nitrogen-propelled manned maneuvering unit (MMU).

✅ DID IT HAPPEN? Yeah, a handful of times. The MMU was a nitrogen-jet backpack that astronauts could use to propel themselves through space, attached to nothing (yikes!). US astronaut Bruce McCandless II did it first and farthest in 1984, propelling himself more than 300 feet (90 m) from the safety of the *Challenger*. It was replaced by a similar but smaller design, the Simplified Aid for EVA Rescue (SAFER), in 1994.

May · W. David Houser and Greg Sharko · A personal robot hands you a lesson on robotics.

✅ DID IT HAPPEN? Sure. This issue looked at robots of the future that would eventually be able to do household chores and more (three cheers for the robot vacuum!). The robot pictured, the HERO 1—made by the Michigan-based Heath Company from 1979 to 1995—was a kit robot designed to help teach robotics, equipped with several sensors and a manipulator arm. It sang "Happy Birthday" to the author of this piece.

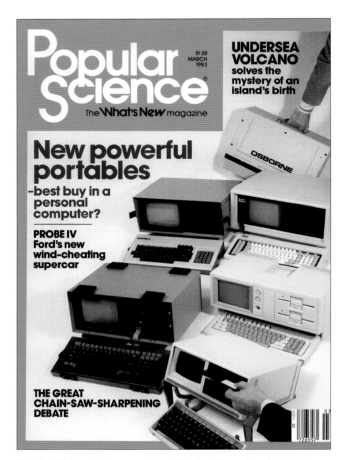

March · W. David Houser and Greg Sharko · One of the first laptop computers is fed a floppy disc, while another is folded up into a briefcase for easy-ish transport.

✅ DID IT HAPPEN? Yes, and the dream of ever-more-portable personal computing will never cease. While the late 1970s saw several prototypes and false starts, the first commercially successful, mass-produced portable computer was the Osbourne 1. Introduced in 1981, it weighed nearly 25 pounds (11 kg) and closed up into a suitcase about the size of a sewing machine. You had to plug the computer in to use it, and it had only enough RAM to store about 40 typed pages.

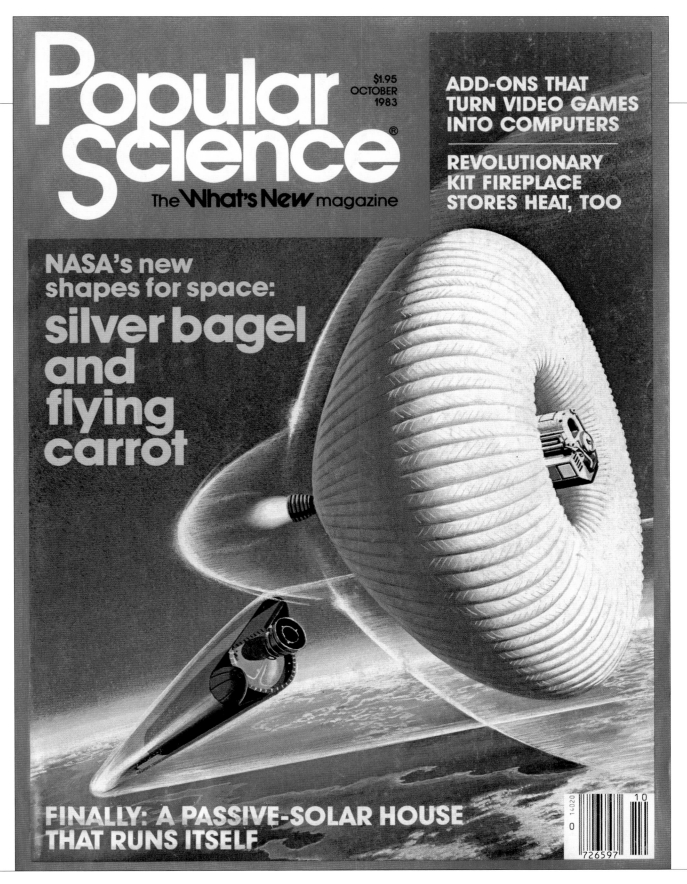

October · Dean Ellis · A trailing ballute—the term is a portmanteau of *balloon* and *parachute*—and an inflatable umbrella provide aerobraking assistance above Earth's atmosphere.

DID IT HAPPEN? Not exactly. Aerobraking uses inflation to create drag, slowing down a spacecraft as it reenters our atmosphere and shielding it from heat. While neither of these designs became common (you'd certainly remember seeing them if they had), the principles are sound, and NASA periodically revisits the concept.

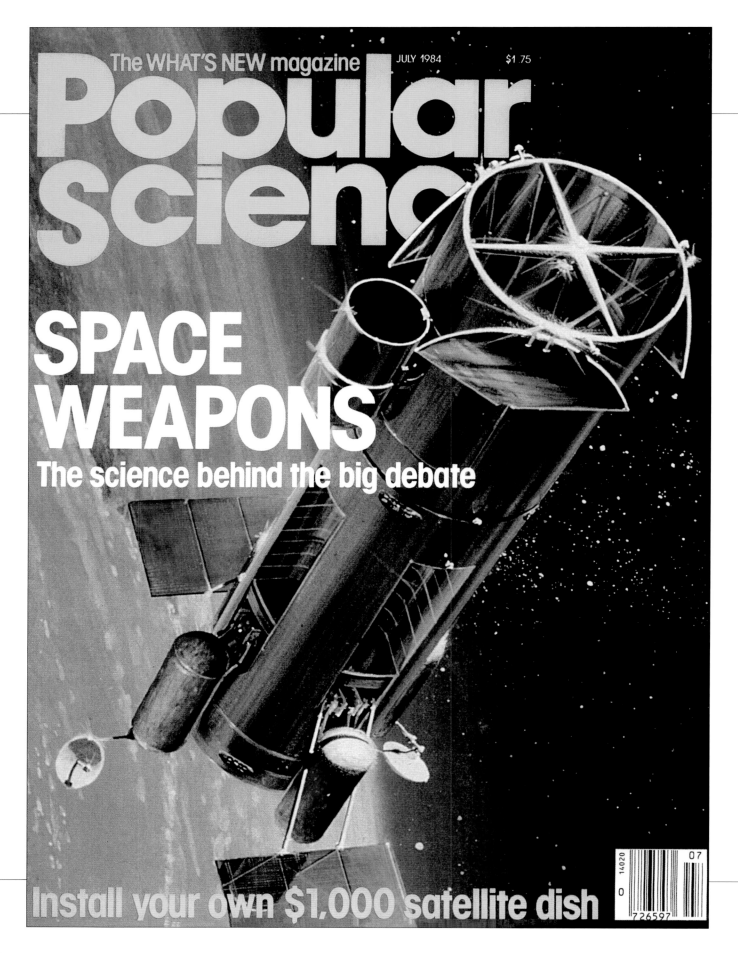

1984

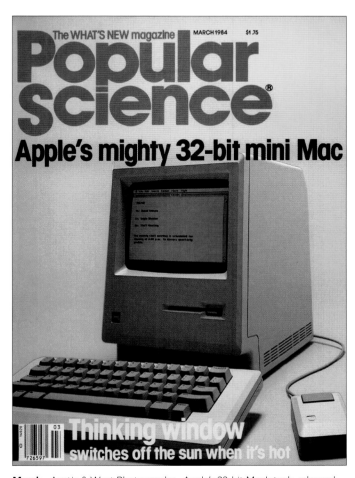

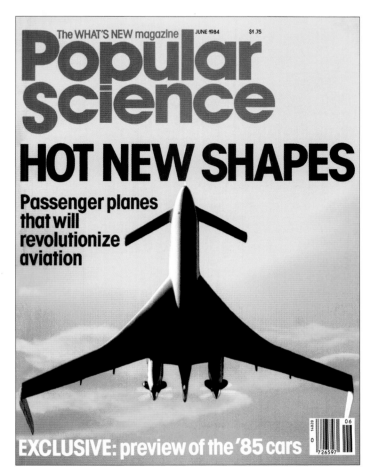

March · Austin & West Photography · Apple's 32-bit MacIntosh, released in January 1984 to great acclaim.

✅ DID IT HAPPEN? Sure did. Developed to compete against 1979's famed IBM PC, the Mac outperformed its counterpart in nearly every category, from microprocessor (32-bit vs. 16-bit) to standard RAM (128KB vs. 64KB), and it did it cheaper. This all-in-one computer also ran a very primitive version of the graphical user interface and operating system of today's Macs—it was way ahead of its time. (As was the Ridley Scott–directed Super Bowl ad that announced it to the world, which riffed on George Orwell's *1984*.)

June · TRW Inc. · A shot of the underside of Beech Aircraft Corporation's futuristic Starship 1.

DID IT HAPPEN? For a little while, but this revolutionary private jet was ultimately doomed. With help from Burt Rutan of *Rutan Voyager* fame (see p. 208), Beechcraft opted for a canard design, composite construction, and unique wingtips, all of which contributed to delays. It didn't hit the market until 1989, and then its US$4 million price tag caused sticker shock during an economic downturn—plus, Starship wasn't as fast as less expensive planes. Even so, there are still some kicking around as private corporate jets today.

July (left) · TRW Inc. · Space weapons set their sights on earthly targets.

DID IT HAPPEN? Not quite, but it ain't over yet. This issue looked at possible space weapons—from lasers that could burn warheads to orbiting atom bombs—that the United States was developing in response to President Ronald Reagan's 1983 "Star Wars" speech, in which he urged scientists to come up with space-based ways to fight nuclear weapons. While satellites have long played a role in military operations (including surveillance and missile defense), the Outer Space Treaty of 1967 has largely kept weapons of mass destruction out of outer space . . . so far.

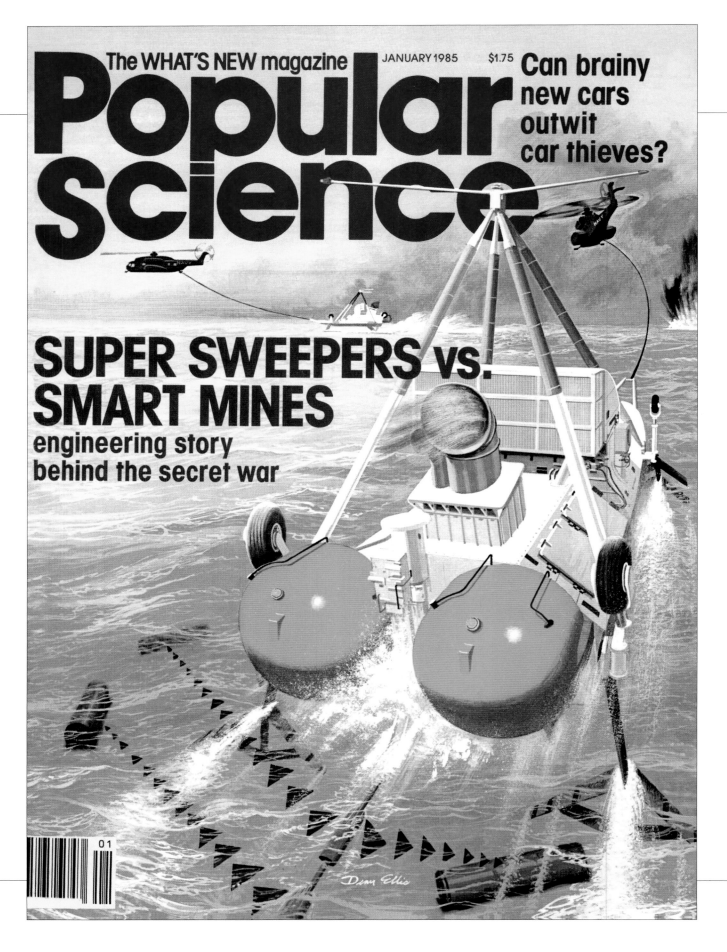

1985

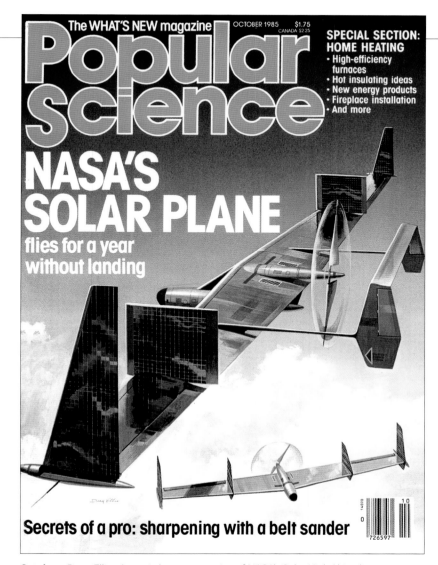

October · Dean Ellis · An artist's representation of NASA's Solar High Altitude Performance Platform (HAPP).

❌ DID IT HAPPEN? No. Lockheed got a contract to study a solar-powered unmanned plane—dubbed the Solar Star—that could stay aloft at 100,000 feet (30,500 m) for a year or more in order to study agriculture in California's Central Valley. It never quite made it off paper, but the concept of photovoltaic-covered wings came up again in a nifty prototype for NASA's experimental Pathfinder aircraft in the early 1990s.

November · Jeff Mangiat · A plane is superimposed on a giant bomb.

😐 DID IT HAPPEN? This issue looked at airport-security measures to thwart terrorist attacks, which—as you know—sometimes work and sometimes tragically do not. One thing's sure: We didn't predict the TSA's highly awful full-body scanner.

June · Austin & West Photography · A computerized car-navigation system provides directions—and your position—within 50 feet (15 m) of where you are.

✅ DID IT HAPPEN? Yes, of course. The Etak Navigator, shown here, is in many ways the ancestor of car-based GPS systems. Instead of satellites, it used a digital compass, motion sensors, and a "smart" dead-reckoning system to update a car's position on a digital map.

January (left) · Dean Ellis · A mine-neutralization sled—hauled by a helicopter—sweeps an area of sea for explosives.

✅ DID IT HAPPEN? Definitely. The US Navy employed several minesweepers to safely trigger bombs lurking in the ocean deep. This one—a hydrofoil sled called the AN/ALQ-166—dragged two electrode cables through the water, creating an electric field that detonated magnetic mines, as well as a noisemaker to trigger acoustic explosives.

June · Dan Cornish · A headshot of Lady Liberty, postrenovation.

✅ DID IT HAPPEN? Oh, yeah—to the tune of US$62 million. This feature took an inside look (sometimes literally) at the huge restoration of the Statue of Liberty that took place during the 1980s. Not the least of the improvements were a new torch, a new emergency elevator, and the correction of a structural (and incredibly dangerous) flaw in Lady Liberty's shoulder joint, which had been there since she was first erected in 1886.

September · Barry Bichler · An artist's best guess as to what the US Air Force's stealth bomber would look like.

✅ DID IT HAPPEN? Yeah. And given the very limited information that the magazine was working with—"like assembling a jigsaw puzzle with only 10 percent of the pieces"—it's pretty amazing how close this drawing looks to the real-life F-117 Nighthawk and the B-2 Spirit, the superstealth aircraft that made it into the skies in 1983 and 1989, respectively.

May (right) · Dean Ellis · An array of scramjet designs punch through the atmosphere.

DID IT HAPPEN? Not yet. Scramjets—or "supersonic combusting ramjets," for long—would make aircraft smaller and faster. How? Well, traditional rockets create thrust by combining rocket fuel with liquid oxygen. A scramjet, in theory, would harvest oxygen from the atmosphere, making heavy O_2 tanks unnecessary and drastically cutting travel times. While there's been success in testing—most notable, NASA's experimental X-43, which in 2004 set the record for hypersonic flight at Mach 9.6—scramjets are not zipping us from coast to coast (or up into space) just yet.

1987

April · Dean Ellis · A painting of a computer-generated model of an airplane. How meta.

✅ DID IT HAPPEN? This feature looked at ways airliners of the future would be better—from wider seats (LOL) to seatback entertainment (in-flight movies!) to a conveyor cargo hold (also yes).

August · Greg Sharko · A person holds a pea-size bug.

✅ DID IT HAPPEN? Yeah. Before we all carried phones that can be hijacked to act as bugs, hostile actors had to plant these things when they wanted to eavesdrop. (Bonus: This article explains how to make a bug that looks like a martini olive.)

October · Unattributed · The Lockheed MQM-105 Aquila—a remotely piloted vehicle (RPV)—takes to the skies.

✅ DID IT HAPPEN? Yes, but today we have the good sense to call them drones. The piece tells a pretty crazy story of their adoption in the US military. Apparently, two days after a US Marine barracks in Beirut was destroyed in 1983, General P. X. Kelley secretly flew to the scene. A few hours later, in Tel Aviv, Israeli intelligence played for Kelley an RPV-taken video of him arriving and inspecting the barracks—zoomed in with crosshairs on his head. A few months later, the military bought their own system.

November (left) · Jim Caccavo · The Sunraycer smokes its competition in the Pentax Solar Challenge in Australia.

✅ DID IT HAPPEN? Sure did. The contest—today called the World Solar Challenge—invites engineers to design, build, and race solar-powered cars across Australia. In 1987, the Sunraycer—a collaboration between GM, Hughes Aircraft, and AeroVironment—beat the competition. By a lot.

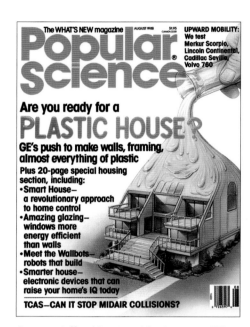 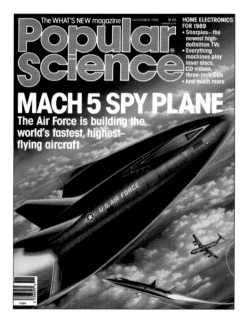 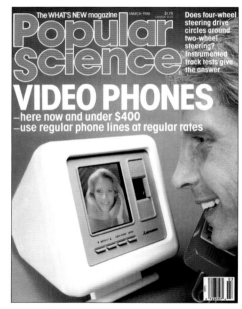

August · Jeffrey Mangiat · A beaker pours GE's plastic abode, called the Living Environments House, in Pittsfield, Massachusetts.

DID IT HAPPEN? It's complicated. GE built this home to show that its thermoplastics could do everything traditional building materials could do. While such dwellings didn't take off (and the Living Environments House itself was torn down), plastic homes do exist—made from polymer panels and blocks, and even plastic bottles filled with sand.

November · Mark McCandlish · An artist's depiction of the Aurora spy plane breaking Mach 5.

DID IT HAPPEN? Depends on who you ask. The official story is that the plane was nothing more than a rumor. A number of Lockheed Martin's Skunk Works veterans deny it existed, or insist it was an early internal name for what became the B-2 Spirit bomber. But a few supposed sightings, and a quickly concealed crash at a UK testing site in 1994, have all fueled rumors.

March · Greg Sharko · A long-distance couple keep up appearances over a video call.

DID IT HAPPEN? Yeah, and nowadays you don't have to use two corded devices to place a video call—or have both parties purchase and use the same device, as the Mitsubishi VisiTel here required. And after all that, you could still only see your loved ones in herky-jerky black-and-white stills—not actual moving images.

January (right) · Dean Ellis · The University of Toronto's experimental microwave-powered plane, designed to stay aloft for a year or more.

230 *The Future Then*

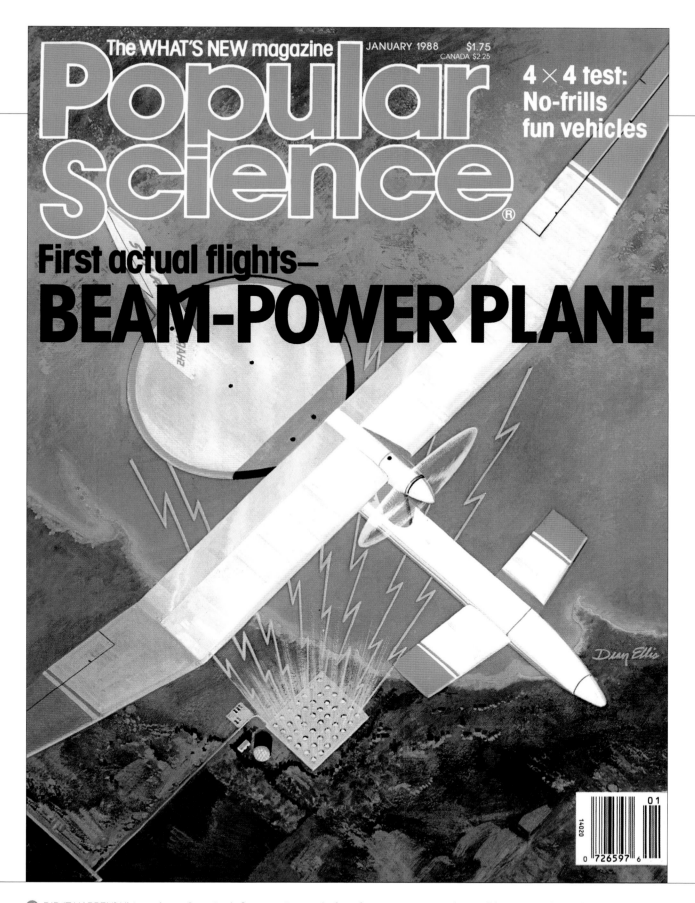

❌ DID IT HAPPEN? Ultimately, no. Conceived of as a stationary platform for communications that could serve as a cheap alternative to satellites at about 70,000 feet (21,300 m) above sea level, the Stationary High Altitude Relay Platform (SHARP-5) plane, powered only by microwaves beamed to it from a ground antenna, was successful in tests of 20 minutes and 1 hour. But funding stalled before long-duration tests occurred and, while SHARP-5 was in storage, some field mice ate parts of its balsa-wood frame, delaying tests indefinitely. Whoops.

SPECIAL SECTION: HIGH-TECH LIGHTING FOR YOUR HOME

SEPTEMBER 1989 $1.95
CANADA $2.50

Popular Science®

TWO-SEAT HEAT:
Nissan 300ZX
Porsche 944 S2
Mazda RX-7 Turbo

VIRUSES, WORMS, TROJANS, BOMBS

THESE ELECTRONIC INFECTIONS MAKE COMPUTERS SICK. HOW CONTAGIOUS? CAN YOU PROTECT YOUR COMPUTER?

1989

March • John B. Carnett • Micromotors about two-thirds the width of a human hair fit through the eye of a needle.

✅ DID IT HAPPEN? Not yet, but nanotech is just getting started. Scientists hope that these tiny motors will one day swarm the world, ridding blood of cholesterol deposits, colonizing Mars, and more. Despite a few successful tests in mice, they are, for the most part, still hoping.

April • Unattributed • Atoms through a scanning tunneling microscope.

✅ DID IT HAPPEN? Yes. Developed in 1981, the scanning tunneling microscope allows researchers to image surfaces at the atomic level. It kick-started the field of nanotechnology, garnering its creators—IBM researchers Gerd Binnig and Heinrich Rohrer—the Nobel Prize in Physics in 1986.

July • NASA • A tethered astronaut tumbles and drifts in space.

✅ DID IT HAPPEN? This feature covered the soul-searching that went on in the US space program in the years following the 1986 *Challenger* disaster. Two schools of thought—those from NASA and the critics opposed to it—debated the future of various space initiatives, including a US$30 billion space station, in *Popular Science*. It took until the late 1990s, but NASA ultimately teamed up with agencies around the globe to fund the International Space Station, a habitable artificial satellite in low Earth orbit where scientists conduct experiments and—someday—might prepare for crewed journeys to the moon and Mars.

September (left) • Timothy Young and John B. Carnett • A sculpture of a computer being infected by a virus, very literally.

✅ DID IT HAPPEN? Yes, minus the tissues and OJ. This feature explains to a populace still getting familiar with computers how to navigate the internet, as well as what computer viruses are and what they do. It gives examples of cutesy bugs that make the monitor of an infected PC look like a front-loading washing machine, as well as more malicious attacks on military and industrial targets. If you're alive on Earth today, you know full well that viruses have only gotten worse.

ARTIST PROFILE

DEAN ELLIS

If a lot of the *Popular Science* covers of the 1980s have something of a science-fiction feel to them—perhaps rivaled only by the fantastical pulp covers of the 1920s and 1930s—that's probably no accident. Dozens of covers, from the late 1970s through the 1980s, came from the mind and hands of Dean Ellis, a commercial illustrator best known for dressing up sci-fi novels and magazines.

After completing art school in Cleveland and Boston and serving a stint in the military during World War II, Ellis almost stumbled into his science fiction fame, picking up a huge number of commissions on the strength of a set of covers he painted for a series of reissued books by Ray Bradbury, including *The Illustrated Man* and *The Martian Chronicles*. After that, sci-fi book publishers and magazines such as *Omni* would keep Ellis busy, churning out fanciful extraterrestrial worlds, conjuring out-of-this-world spaceships, and dreaming up new alien life-forms. He also did his fair share of postage stamp designs—most notable, a 10-cent stamp on the Jefferson Memorial. A man of many talents, indeed.

Though Ellis was tethered a bit more tightly to the real world with his work for *Popular Science* than to the realms of fantasy publishers, you can really see his sci-fi chops come through in a host of imaginative depictions of aircraft and other futuristic contraptions, from Transformer-like folding planes to solar homes that rotate with the sun to his one-armed monster windmill—a machine that looks a bit more like a peg-legged space invader than a way to harness wind power. For a good number of years, Ellis really did his part, giving *Popular Science* a sleek and future-oriented look to match its editorial vision.

Right, top to bottom,
March 1982
July 1983
March 1985

Far right,
October 1981

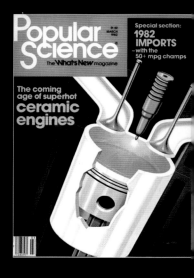

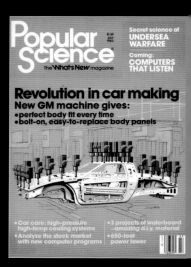

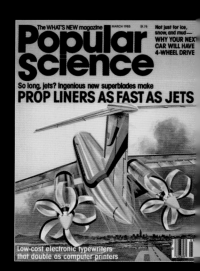

Popular Science

The What's New magazine

$1.50
OCTOBER 1981

'82 CARS
- More Chrysler front-wheel drives
- Baby Continental
- GM's compact pickup

New technologies spark race to build world's mightiest telescopes

Dean Ellis

1990s

1990s

A DIGITAL DECADE

While the precursors to today's doomsday preppers stocked their bunkers with canned goods, bottled water, and freeze-dried ice cream for fear that the Y2K bug would kick-start a nuclear holocaust, lots of other folks found plenty to like about the 1990s. The Sony PlayStation and the e-book came into being. GPS grew up in the military. The Western Hemisphere was declared free of polio. And the world came online. And that Y2K bug? Not so civilization-ending after all.

HUBBLE GOES UP—AND WE GET A HOME IN SPACE

All Earth-bound optical telescopes face many obstacles when it comes to studying space. First, there's light pollution—the reason you see fewer stars in the city than you do out in the sticks. Then there's weather, like rain clouds, and the whole atmosphere itself that tends to get in the way. To get a better view, NASA launched the Hubble Space Telescope in April 1990. While it wasn't an immediate success—a flawed mirror required a 1993 maintenance trip—it has become one of the most valuable tools in humankind's space-exploring arsenal. Some of its most notable accomplishments include determining that the universe is 13.77 billion years old, photographing a planet orbiting a star other than our own sun, and capturing images that support the existence of dark energy—the force behind the universe's expansion. Hubble wasn't the decade's only inroad we made into the great beyond: In 1997, NASA's Mars Pathfinder mission put Sojourner on the Red Planet (making it the first rover on another world) and several space agencies banded together to send the International Space Station up into low Earth orbit, providing us with a microgravity environment for research as well as a potential pit stop for missions farther afield.

GADGETS AND GIZMOS

The 1990s brought with them an explosion in digital gadgetry heretofore unmatched—most of which could easily fit in your fanny pack. While Motorola created its great brick of a mobile phone in the 1980s, the 1990s made mobile phones smaller, more practical, and more versatile—giving people the first taste of text messaging and mobile internet access beyond voice service. The decade also gave us DVDs and their associated players, bringing high-definition sound and video recordings into living rooms. It gave us the first truly affordable digital cameras, meaning that, just a couple decades in the future, your grandmother would be able to easily snap and disseminate terrible pictures of you across all of her social networks. They gifted us with the personal digital assistant (PDA)—one of which, the IBM Simon, was arguably the first smartphone. And they brought us the compressed glory of MP3s—not to mention the tools to play them and the peer-to-peer networks to share (read: pirate) them.

HERE COMES EVERYBODY

Above, an illustration from the December 1998 issue on a new thing you could do on the fledgling internet: download songs onto some device called an MP3 player.

At left, the 1990s saw the pressurized doors to space open for many scientists, including the first Latina and African American women to make it up above our atmosphere: Ellen Ochoa, playing flute on a break on *Discovery* in 1993, and Mae Jemison, floating aboard *Endeavor* in 1992.

At right, the Hubble Space Telescope in all its glory, getting ready to take the best pictures of space humans had ever seen.

1990s

ATTACK OF THE CLONES

Cloning had been the stuff of sci-fi for decades. And before the 1990s, some version of it had already happened—mostly in frogs, rabbits, and cows, and all by nuclear transfer from a donor's embryonic cells. In other words, these clones were made by taking a nucleus from the cells of one animal's embryo and transferring them to another embryo. And then along came Dolly, the first mammal created from nonembryonic cells. It took more than 275 tries, but in 1996, Scottish biologists Ian Wilmut and Keith Campbell eventually created her by taking a nucleus from a mammary-gland cell and fusing it into a denucleated embryo. (Cheekily, she was named after Dolly Parton because of her mammary-gland origins). After Dolly came to life—and other scientists cloned rhesus monkeys in 1997—US president Bill Clinton banned federal funds for human cloning and asked private scientists for a voluntary moratorium on researching it.

. . . AND THE DRONES

While the first US drone strike didn't occur until 2001, the precursor to the now-notorious MQ-1 Predator was hatched in the California garage of Baghdad-born aerospace engineer Abraham Karem 15 years prior. Capable of flying more than a day without landing, Karem's Amber drone soared at 30,000 feet (9,140 m), took only three people to launch, and cost a puny US$350,000. Shelved for nearly a decade due to government bickering, Amber was rebooted as the Gnat 750—just in time for the CIA to need an unmanned aerial vehicle to relay live video and infrared surveillance in the Bosnian War in 1994. Rechristened Predator, it has been used in every US military conflict since. (As for the decision to arm it, Karem wants you—and likely the citizens of his birth country, Iraq, a frequent target of US drone strikes—to know it wasn't his.)

ENTER THE WORLD WIDE WEB

While the internet's foundation was laid in decades prior, you'd be able to recognize our wonderful series of tubes starting in the 1990s—although it was glacially slow compared to today. In 1989, British computer scientist Tim Berners-Lee wrote the first detailed proposal for the World Wide Web, and by the early 1990s he went on to develop the first web server and browser. Then, in December 1990, the first website came online at CERN (and it's still there, though not much to look at). While the web's predecessors were largely used for research and government work, the new web quickly became a place for commerce and connection. Search engines such as Netscape Navigator (RIP), Yahoo!, and Google came into existence. And online retailers and auction houses—Amazon and eBay, respectively—got their humble beginnings. By the end of the decade, the number of websites in existence was in the hundreds (*Popular Science* got its first in 1996), both spam and emojis existed, and the internet counted nearly half a billion users.

HELLO DOLLY

Above, the most famous woolen clone, Dolly the sheep, which made global headlines in the 1990s.

At left, the MQ-1 Predator drone, which got a fairly peaceful start as an unarmed reconnaissance vehicle in the 1990s. Weaponized in 2001, it forever changed modern warfare.

At right, an 18-acre (7.5-ha) Amazon warehouse in Leipzig, Germany. Amazon, originally a bookseller, sold its first title—Douglas Hofstadter's riveting *Fluid Concepts and Creative Analogies*—in 1995, and by the end of the decade it expanded to selling clothing, computers, and more.

The Future Then

ALSO OF NOTE

FEBRUARY 19, 1990
Adobe Photoshop 1.0—
the first full-fledged
image-editing software—
goes on the market.

OCTOBER 1, 1990
The Human Genome
Project launches.

OCTOBER 31, 1992
Pope John Paul II
apologizes for
Galileo's 1633 heresy
conviction for defending
heliocentrism.

MAY 18, 1994
The US FDA approves the
Flavr Savr tomato, the
first commercially grown,
genetically modified food.
It was engineered to be
less squishy.

JULY 23, 1995
The Hale-Bopp comet is
discovered.

1990s

PINPOINTING THE DINOS' DOOMSDAY

The decade began with a rather strange find: one very big, very old hole in the Gulf of Mexico. The 112-mile- (180-km-) wide Chicxulub Crater was made by an asteroid 66 million years ago—roughly when the dinosaurs (along with 75 percent of life) disappear from the fossil record. It supported the 1980 theory of father-son geology team Luis and William Alvarez, who posited that a huge asteroid had turned into a fiery iridium rain as it entered the atmosphere, rendering the world uninhabitable for our reptilian predecessors. (You can see a layer of this iridium in rocks all over the world; it's known as the Cretaceous-Paleogene boundary, and it was one of the Alvarezes' main clues.) Meanwhile, as some scientists were showing us how the Age of the Dinosaurs ended, others were busy introducing us to new ones. In 1990, paleontologist Sue Hendrickson unearthed the largest and best-preserved *Tyrannosaurus rex* to date (it would be named Sue, of course) in South Dakota, and famed dino hunter Paul Sereno dug up a number of new species, notably the T. rex–dwarfing *Carcharodontosaurus saharicus* in the Moroccan Sahara in 1995.

COMPUTER-GENERATED MOVIES

As tech got better, so did movie magic. Before the 1990s, only a few films—such as *Star Wars* and *The Labyrinth*—made use of computer-generated imagery (CGI), and only in a limited capacity. But filmmakers soon harnessed it as a way to create worlds and breathe new life into characters—from monsters and machines to dinosaurs and dead presidents. *Terminator 2* won a visual-effects Academy Award in 1992 for its morphing, liquid-metal villain, all thanks to CGI. And—harnessing the decade's cloning and paleontology finds—*Jurassic Park* broke ground in 1993 with its computer-generated dinos, both savage and serene. Even 1994's *Forrest Gump* got in on the action, staging CGI talks between Forrest and long-dead figures (like John Lennon) and making Forrest look like a world-class Ping-Pong player (the ball was added in later; Tom Hanks and his counterpart mimed the match). And in 1995, *Toy Story* became the first fully CGI-animated film.

A DARK FORCE AT WORK

The 1990s drew to a close on a surprising, if not cryptic, announcement: The universe—long known to be expanding—is not slowing down, as previously thought, but gaining speed. This head-scratcher made the news in 1998, when cosmologists measuring the distance to supernovas found that they are much farther away than expected. Many think this force—dubbed dark energy because, well, we're in the dark about it—may be Einstein's cosmological constant, the counterbalance to gravity in his 1917 theory of general relativity. When he learned in 1929 that the universe is expanding, he struck the constant from the equation—it isn't needed to prevent gravity from pulling the universe in on itself if said universe isn't static. But what does it mean that it's come back as dark energy, besides that Einstein—even when wrong—is always right? It pits dark energy against gravity in the ultimate showdown: the end of the universe. Cosmologists are taking bets on whether it will all go up in the Big Rip, when the accelerating expansion tears galaxies, planets, and stars apart, or in the Big Crunch, when gravity turns the tables on dark energy and sucks us all up. Stay tuned—tickets for this match go on sale in about 3 billion years.

A PORTRAIT OF THE PALEONTOLOGIST AS A YOUNG MAN

At right, in a photo shot by longtime *Popular Science* staff photographer John B. Carnett, American paleontologist Paul Sereno poses in the jaws of a *Carcharodontosaurus*. Yikes.

At left, a young Pixar animator by the name of Pete Docter uses a mirror to draw facial expressions for *Toy Story*'s Sheriff Woody character in 1995. Docter went on to direct Pixar's *Monsters, Inc.*, *Up,* and *Inside Out.*

The Future Then

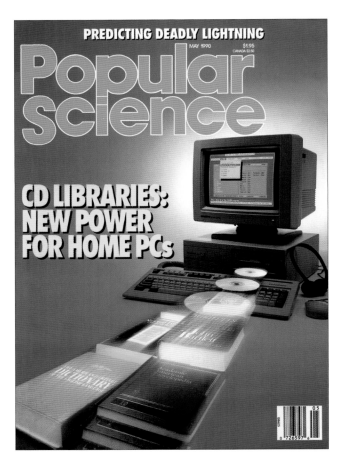

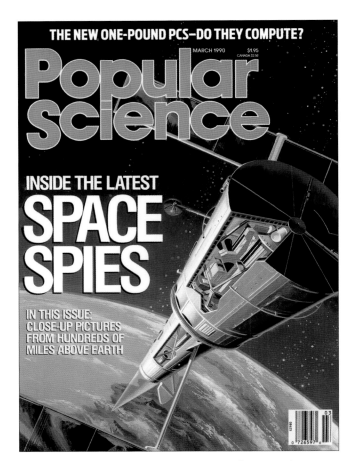

May • Walter Wick • Dusty old reference books sublimate into CD-ROMs, which then get beamed up by a personal computer.

✅ DID IT HAPPEN? LOL, we all remember these, right? Short for "compact disc read-only memory," CD-ROMs can be loaded up with text, photos, audio clips, and moving pictures, creating a multimedia experience that was supposed to carry publishing through the digital revolution. They are still around, though the internet long ago decided that the CD-ROM reader tray is best used as a cup holder.

March • Vincent Di Fate • A US Lacrosse spy satellite peeps down on Earth, providing cutting-edge radar imaging from on high.

✅ DID IT HAPPEN? Definitely. Classified for years, Lacrosse satellites can see through cloud cover and even soil—there are five or so still in orbit. The article also details "ferret" satellites that could steal radio transmissions over enemy territory and the KH-11 Kennen, a Hubble-like satellite that was the first to take digital images (instead of parachuting film back to Earth, which was how reconnaissance satellites used to work—really).

October (right) • James Ibusuki • The *Earthwinds* balloon attempts a nonstop circumnavigation of the globe.

The Future Then

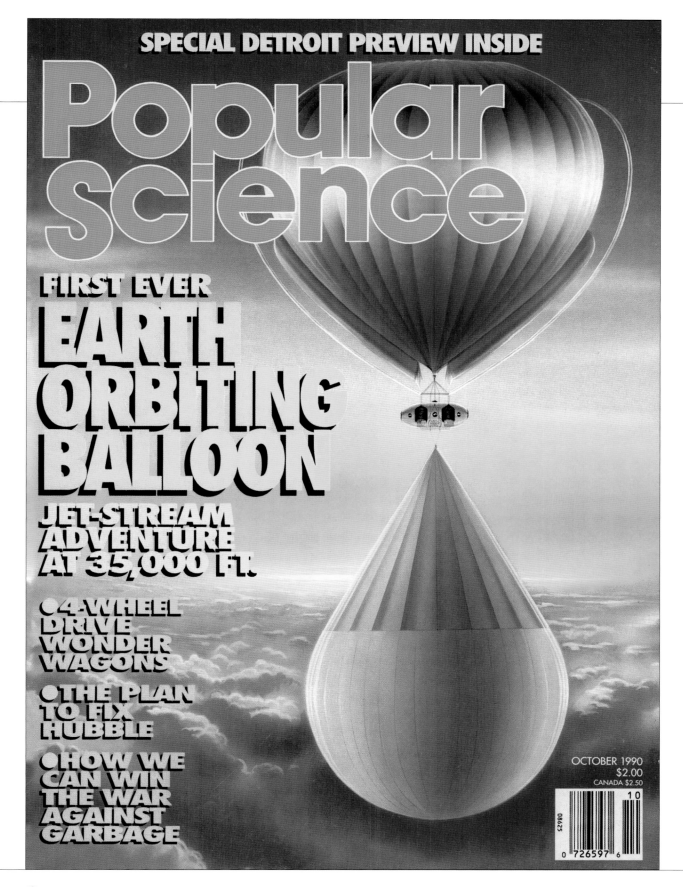

❌ DID IT HAPPEN? Nope. Despite five attempts and the best of intentions, *Earthwinds*—the giant helium balloon with an air-filled anchor, which was to be piloted by Richard Branson (yes, that Richard Branson) and crewed by Russian cosmonaut Vladimir Dzhanibekov and American balloonist Larry Newman—never successfully made it around the world, much less without stopping. Newman (who held records for ballooning across the Atlantic and Pacific Oceans) spearheaded the unique hourglass design, in which the bottom balloon would have provided a "variable ballast" to keep the aircraft aloft for the three weeks required for the trip.

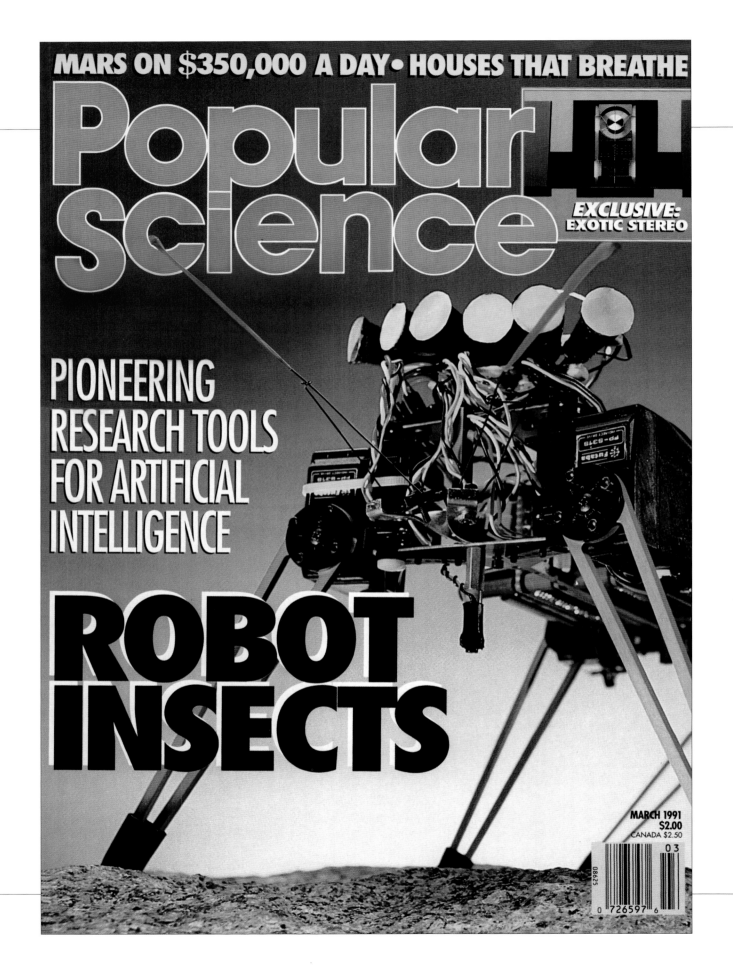

1991

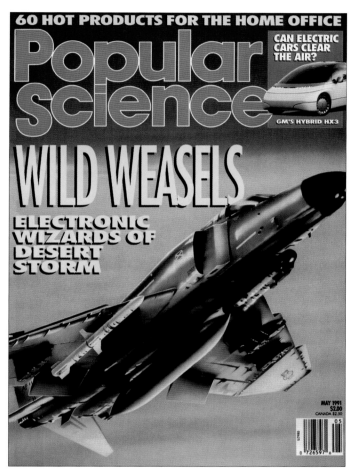

May · Danilo Ducak · An F-4G Phantom II—a so-called Wild Weasel aircraft—does its thing during Operation Desert Storm.

✅ DID IT HAPPEN? Yes, and it's so nuts, the Wild Weasels' official motto is YGBSM ("You Gotta Be Shitting Me"). They are any aircraft armed with radar-seeking missiles whose mission is to destroy enemy radar and surface-to-air missile installations—often getting targets to reveal their position by baiting their radar systems and drawing fire, then tracing their radar waves. In other words, Wild Weasels know where to shoot because they're being shot at.

August · Tom White · The Buckyball—carbon 60—is heralded as foundational for new materials.

🌀 DID IT HAPPEN? Kind of? The discoverers of buckminsterfullerene—so named for its hollow spherical shape, reminiscent of Buckminster Fuller's geodesic dome—won the Nobel Prize in Chemistry in 1996. But to date, there have been few practical applications of the so-called magic molecule, though researchers have tested it in smuggling medication into cancerous cells and transmitting light in fiber optics.

March (left) · John B. Carnett · Meet Genghis, MIT's artificially intelligent robot insect.

✅ DID IT HAPPEN? Sure. This issue covers the now-iconic bug-machines of MIT's Mobile Robotics Lab. Led by Australian-born computer scientist Rodney Brooks—who went on to cofound iRobot and build a little thing called the Roomba—the MIT team equipped these creepy-crawlies of various sizes with sensors and machine-learning power so they could react to their environment, learning to step over obstacles, scale walls, and more. (Today's cloying robotic personal assistants and terrifying wartime pack mules sure make these bug 'bots seem cute.)

June · Marc Ericksen · A high-speed maglev train glides across America, revolutionizing mass transport (and levitating, too!).

🌀 DID IT HAPPEN? Globally? Absolutely. In the United States? Still waiting. Maglev trains took off in the mid-1990s, propelled at great speeds by magnets. Despite the success that nations like Japan have had with high-speed trains, cars are still king in the US of A.

March · John B. Carnett · Intel's Touchstone Delta Supercomputer races to run a teraflop (a.k.a. 1 trillion calculations per second).

✅ DID IT HAPPEN? And then some, though it was Intel's ASCI Red that achieved the goal in 1997. (The Touchstone Delta ended up being more of a teaching tool.) Fast-forward to 2016, when the most powerful supercomputer could run 93 petaflops—93 quadrillion calculations per second.

November · Danilo Ducak · Japan's *Yamato 1*, the world's first boat propelled by super-conducting electromagnets, shreds the seas.

❌ DID IT HAPPEN? In the end, no. *Yamato 1* did move, using magnets to shoot conductive seawater out its thrusters. But the ship never exceeded 10 miles an hour (16 km/h)—slower than a bike commuter—and flopped. But you can still check one out at the Kobe Maritime Museum.

April (right) · David Wiener Ventures · A Flarecraft harnesses the ground effect to skim the water at 70 miles per hour (113 km/h).

The Future Then

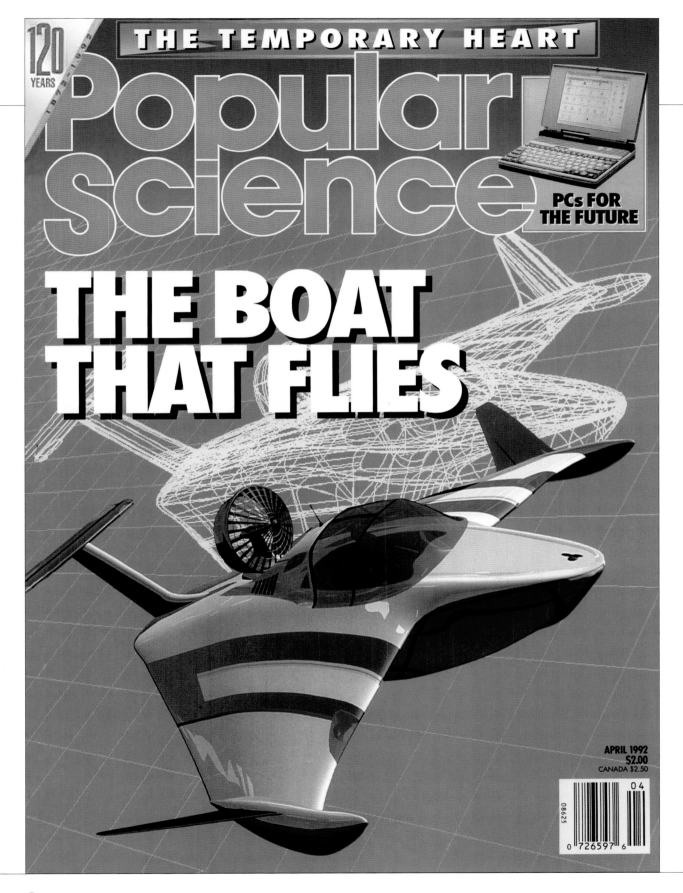

X DID IT HAPPEN? A few experimental ground-effect machines—such as the Soviets' fascinating and strange Lun Ekranoplan—have achieved success in harnessing the cushion of air between craft and waves, allowing them to skim over the water's surface. But the Flarecraft—dreamed up by American investment banker William Russell—ended up getting banned by the US Coast Guard in April 2001 for being too dangerous. As a whole, this sort of "flying boat" is more of a novelty than a real mode of transport.

January · Ian Worpole · An artist's dramatization of a plane being guided in to land by automated air-traffic control.

🕑 DID IT HAPPEN? Not exactly. Some similar—and seriously sophisticated—computer systems do help humans manage air congestion, but an air-traffic-controller strike can still shut down an airport. And, with today's online infrastructure so vulnerable to hackers, it's good to have an experienced, real live human scanning the skies.

August · Tom White · Atoms are split—or not split?—by the controversial power of cold fusion.

❌ DID IT HAPPEN? Good grief, no. In 1989, US chemists Martin Fleischman and Stanley Pons claimed they'd achieved nuclear fusion at room temperature, but no one could replicate their experiment. It's one of history's few physics scams.

October · John B. Carnett · The Dexter Hysol Cheetah breaks the human-powered vehicle land-speed record in 1992 near what is now Colorado's Great Sand Dunes National Park and Reserve.

✅ DID IT HAPPEN? Totally. Clocking in at just over 68 miles per hour (110 km/h), the Cheetah held the record for a while in the 1990s. It was designed by a bunch of University of California–Berkeley mechanical engineering students, led by James Osborn. These days, the new best to beat is almost 90 miles per hour (145 km/h), held by another equally bizarre-looking recumbent-bike contraption.

June (right) · Tom White · Sega's virtual reality headgear for Genesis video games.

✅ DID IT HAPPEN? After a false start, yes. While computer-graphics legend Ivan Sutherland built the first virtual reality headset back in 1968, the VR bug didn't rear its begoggled head until the 1990s. Most companies' devices never made it to market—including Sega's VR-1, which gave testers headaches and nausea. But today the craze is even, well, crazier, with Oculus (purchased for US$2 billion by Facebook in 2014) developing headsets that let you travel to Mars and beyond from the comfort of your living room.

The Future Then

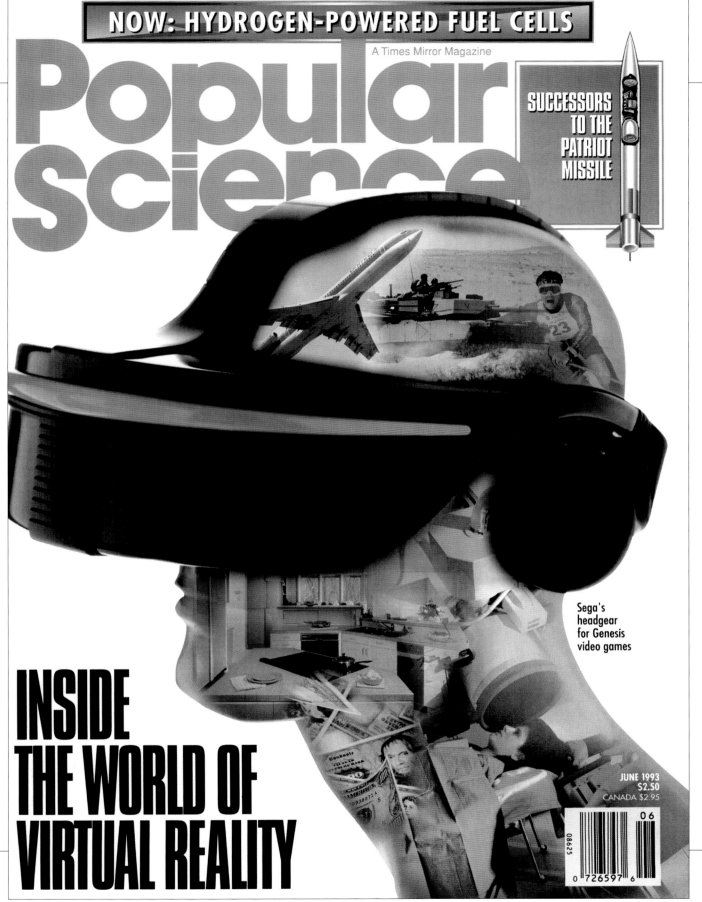

June • Greg Jarem and Tom White • The guts of the Chrysler Patriot, a turbine-electric hybrid race car.

✅ DID IT HAPPEN? Yes, hybrids have taken off—some get more than 100 miles to a gallon (42 km/L). But the Chrysler Patriot faded away.

July • Don Davis • A comet slams into Jupiter.

✅ DID IT HAPPEN? Yeah! People were even able to watch comet Shoemaker–Levy 9 crash into Jupiter in real time with telescopes and spacecraft—an astronomical first. The scars were visible for months.

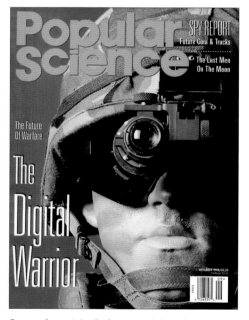

October • Mark McCandlish • A D-21 spy drone with an F-117A stealth bomber and an SR-71 recon jet.

✅ DID IT HAPPEN? These aircraft all came out of Lockheed Martin's top-secret Skunk Works program, but the D-21—intended to fly a set path, deploy a reconnaissance camera, then self-destruct—was retired after four failed missions.

September • John B. Carnett • A digital warrior stares you down with a bionic eye of sorts.

✅ DID IT HAPPEN? Yes and no. Troops carry night-vision and infrared tools, and the US military uses VR in training. But this augmented reality eyepiece—which is hooked up to a computer in a backpack and loaded with maps and plans—never became standard issue.

1994

Popular Science
A Times Mirror Magazine

THE CHUNNEL

A 250-Year-Old Dream To Link England and France Comes True

MAY 1994
$2.50
CANADA $2.95

May · David Teich · The Channel Tunnel—a.k.a. the Chunnel—connects England and France. It actually contains three tunnels (one for a train headed in each direction, and one for service and emergencies).

✓ DID IT HAPPEN? Indeed. Since it opened in 1994, more than 300 million people have taken the 31-mile (50-km) train ride under the English Channel. It still has the longest underwater portion of any tunnel, and it's been named one of the seven wonders of the modern world.

1995

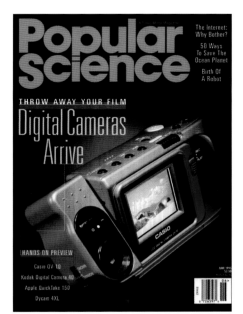

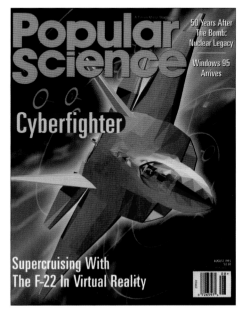

February · Ken Marschall · The *Titanic* sinks all over again in this cover-as-historic-reenactment.

✅ DID IT HAPPEN? Obviously—way back in 1912! But while the *Titanic* was designed to take three days to sink, it went down in a mere three hours. Several expeditions sought to learn why the ship, located on the seafloor in 1985, failed. According to this issue, the hull's highly sulfuric and brittle steel was at least partially to blame.

June · John B. Carnett and Tom White · The Casio QV-10, the first commercial digital camera with an LCD screen.

✅ DID IT HAPPEN? Yes! While the first digital camera went on sale in 1990, this sweet little machine was the first to let people review and delete unflattering snapshots right on the camera back. (It was not, however, waterproof, as the *Popular Science* reviewer sadly found out.)

August · Tom White · An ultra-'90s computer-generated model of an F-22 Raptor stealth fighter, equipped with a "virtual reality" cockpit.

✅ DID IT HAPPEN? Yes, computerized displays revolutionized everything, including combat. While this issue looks at how the F-22's all-digital cockpit protected pilots from "mental meltdown" caused by information overload, its interface—three black screens with some colored circles and squares—is hardly what we call VR today.

April (left) · Terry Ryan · An artist's depiction of a speculative blended-wing megaplane, capable of carrying 800 passengers.

🔄 DID IT HAPPEN? Yes and no. While jets like the Airbus A-380 can carry more than 800 passengers, there's never been a blended-wing commercial airliner like this one. The other megaplanes profiled in this issue (such as the McDonnell Douglas MD-12 and the Boeing New Large Airplane) also never saw the inside of a hangar. The plane that they were aiming to beat? Boeing's 747, which went on to rule the sky for 20 more years.

PopularScience

Tech Guide to Money | All-New Acura | Oshkosh Air Show | Cheap Missions to Space

Ultimate Chess

World Champ Kasparov's Face-off With IBM's Computer

A TIMES MIRROR MAGAZINE
MARCH 1996 $2.45
CANADA $3.50

1996

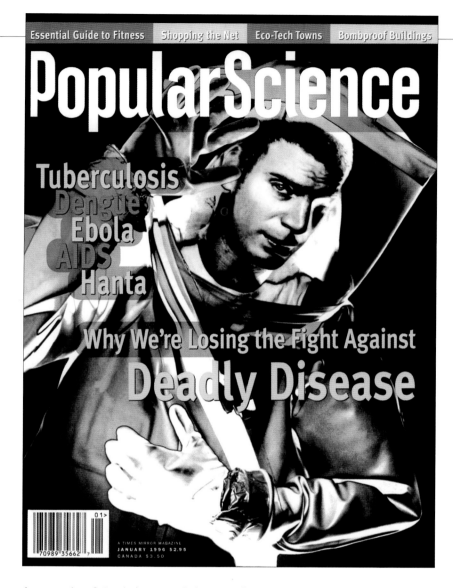

January • Amy Guip • A photo artist's depiction of a microbiologist protecting himself from lethal diseases with a hazmat suit.

✓ DID IT HAPPEN? Yeah, all of the diseases called out on this cover are still as deadly as ever, though a vaccine for dengue now exists, an experimental Ebola vaccine shows promise, and we've largely been able to keep HIV/AIDS in check with antiretroviral drugs. But the larger point of this article is that bacteria and viruses come out of nowhere and morph too quickly for us to stay ahead of them, and that reality will never change. Case in point: Zika.

March (left) • Stephen Brodner • Russian world chess champion Gary Kasparov plays against IBM's Deep Blue supercomputer in February 1996.

✓ DID IT HAPPEN? Sure did. And, while Kasparov won the six-game match in 1996, he lost the first game—making it the first time a reigning master was beat by a computer in standard play, capping off a 50-year effort that began when British computer scientist Alan Turing designed the first chess program in 1951. But Kasparov's victory was short-lived: In a rematch in 1997, Deep Blue spooked him with its "too human" moves. Ironically, those moves were later revealed to be the result of a bug, not superior intelligence. Poor Kasparov.

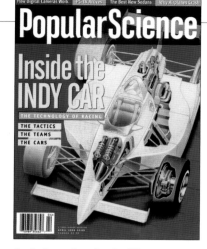

April • Larry Cory/Art Staff Inc. • A cutaway of an Indy car.

✓ DID IT HAPPEN? Yes. This report looked at how computers were changing racing, with pit engineers remotely monitoring car vitals and radioing to the driver when adjustments were needed.

October • John Frassanito & Associates • Lockheed-Martin's VentureStar space plane breaks into space.

✗ DID IT HAPPEN? Nah. Intended to replace NASA's space shuttle, the reusable VentureStar was supposed to launch like a rocket and land like a plane. After the X-33 (an aircraft with a similar design) failed tests, VentureStar lost funding.

THE WHAT'S NEW MAGAZINE

PopularScience

MAY 1997 $2.99
CANADA $3.99

Tech Update on FLAT TV
PAGE 68

TOP SECRET

Invisible Aircraft
Daytime Stealth for Future Fighters

Making AIRBAGS SAFER

BULLETIN
FIRST DNA CLONE
How They Did It

Unlocking the Mysteries of **JUPITER'S MOON**

A TIMES MIRROR MAGAZINE
www.popsci.com

CELEBRATING **125** YEARS OF POPULAR SCIENCE

This Month: Top Tools and Home Technologies

1997

June · John B. Carnett and Tom White · The latest on the infamous 1947 "UFO" crash in Roswell, New Mexico.

❓ DID IT HAPPEN? That is, in fact, the question. In 1994, the US Air Force said the aircraft recovered was a device used to detect nuclear tests, and in 1997 it claimed the alien bodies at the scene were dummies used to test parachutes. No one, of course, was satisfied.

January · Michael Carroll · The Mars Together rover—a joint project from Russia and the United States.

❌ DID IT HAPPEN? Niet. Russia was supposed to send the rover, while the United States would launch an orbiter for communications. It didn't pan out, but Sojourner—the first rover to explore the Red Planet—made it in 1997.

May (left) · John Frassanito & Associates · An invisible fighter jet rules the daytime, making stealth no longer a tool of the night.

July · Don Foley · A remotely operated US Navy Deep Drone searches for the wreckage of TWA Flight 800, which went down over the Atlantic in July 1996 and was ruled an accident after three years.

✅ DID IT HAPPEN? In one of the largest salvage missions every attempted, more than 95 percent of the plane's wreckage was recovered. The mission involved both older technologies—like hundreds of divers making thousands of dives—and higher-tech tools including side-scan sonar, remotely operated vehicles such as the Deep Drone shown here, and a vapor sniffer (a tool that "smells" for explosion residue). Despite the investigation, many still believe that the plane was brought down by a missile.

❓ DID IT HAPPEN? It's right behind you! But, seriously, this issue looked at new aircraft-camouflage tactics—from antireflective paints to light-emitting panels that match the intensity of the sky. Some schemes did make planes detectable only at shorter distances (say, 2 miles [3 km] instead of 12 miles [19 km]), at least in tests.

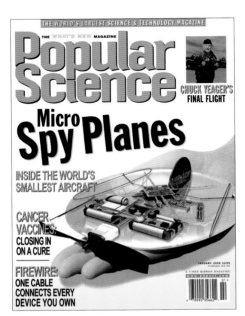
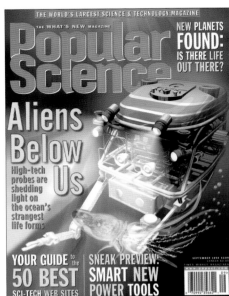
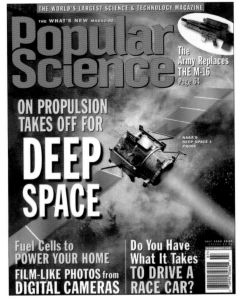

January · Bob Sauls/John Frassanito & Associates · AeroVironment's Black Widow, a micro spy plane that fits in your palm.

✅ DID IT HAPPEN? Sure did. Micro air vehicles are a whole class of tiny, airborne, remote-controlled vehicles used for all manner of purposes—from spying to tracking air pollutants. Today's versions can be as small as actual bugs—fitting on the tip of your finger.

September · Don Foley · The Monterey Bay Aquarium Research Institute's unmanned submarine, *Tiburon*, probes the deep sea.

✅ DID IT HAPPEN? Definitely. *Tiburon* has made 400-plus dives to study weird stuff in the ocean's depths, such as siphonophores: gelatinous creatures with no brain or heart (but multiple mouths and stomachs) that may be small enough to hold in your hand or as long as a blue whale. What a world.

July · Don Foley · *Deep Space 1* flies by asteroid 9969 Braille.

✅ DID IT HAPPEN? Yep. *DS1* was the first spacecraft to utilize an ion thruster—a propulsion system that uses electricity to accelerate ions, creating thrust—instead of costly, heavy fuel. Built as a test, it was abandoned in orbit in 2001, but success story *Dawn*—our eyes on asteroids Vesta and Ceres since 2012—was made with the same propulsion system.

March (right) · Daniels & Daniels · The longest suspension bridge in the world crosses Japan's Akashi Strait.

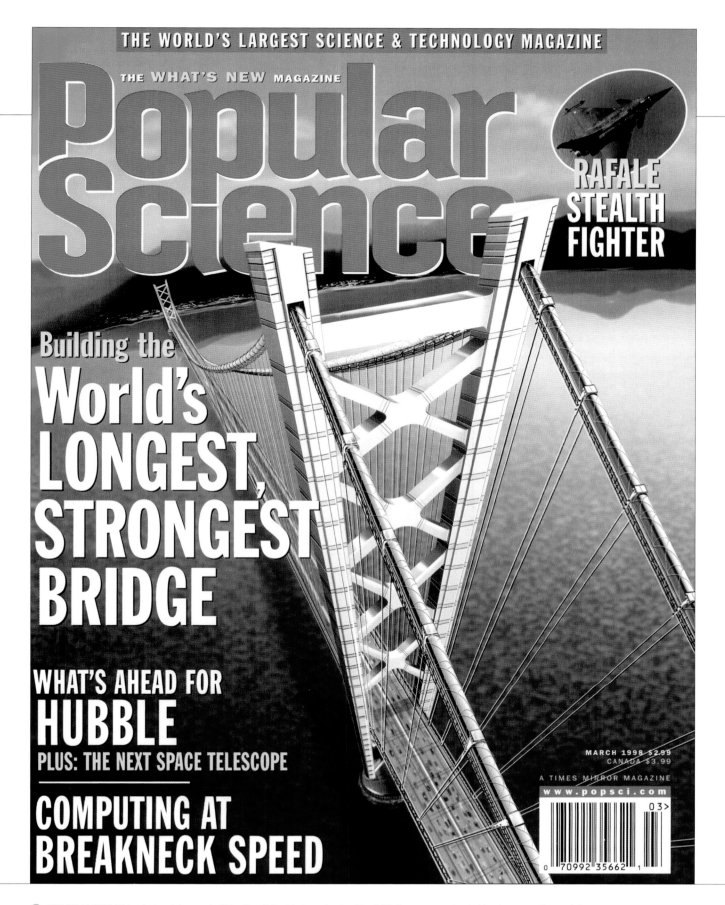

✓ DID IT HAPPEN? Yes, indeed. At nearly 2½ miles (4 km) in length, the Akashi Kaikyo suspension bridge became the world's longest, tallest, and most expensive when it opened in April 1998 after 10 years of construction. Conceived of way back in the 1950s after two ferry accidents in the typhoon-prone waters killed a total of 168 people, this feat of engineering had to be resistant to 180-mile-per-hour (290-km/h) gale winds and an 8.5 earthquake. It got its first test of the latter in 1995 when the tragic 7.3 Great Hanshin earthquake struck. The quake claimed 6,000 lives, but the bridge—which was still under construction—stood strong.

THE WORLD'S LARGEST SCIENCE & TECHNOLOGY MAGAZINE

THE WHAT'S NEW MAGAZINE

Popular Science

DIGITAL TV:
What's On in Your Neighborhood

Antimatter ENGINE

SPACE EXPLORATION AT HALF THE SPEED OF LIGHT

EXCLUSIVE
We Preview the
GAS-ELECTRIC CAR
You Can Buy

IS IT SAFE TO SWIM?
New Tests for
TOXIC MICROBES

JUNE 1999 $2.99
CANADA $3.99
TIMES MIRROR MAGAZINES
www.popsci.com

1999

March • William Duke • An artist's dramatization of a computerized brain.

✓ DID IT HAPPEN? Sure. Scientists were studying animals—even simple ones like nematodes—to develop biobots with humanlike brainpower. Meanwhile, others were looking to computer science (circuitry, specifically) to interpret their findings in neuroscience. This nexus of biology and computing is still alive and kicking.

February • Bob Sauls/John Frassanito & Associates • A manned mission to Mars.

✗ DID IT HAPPEN? Not yet. The plan was to launch an Earth-return vehicle into Mars's orbit; land a power plant, an inflatable habitat, and an ascent vehicle on Mars; and send the crew to inflate the habitat and explore the Red Planet before flying the ascent vehicle to the Earth-return vehicle, which it would then take home to a ticker-tape parade. Piece of cake.

August • John B. Carnett • A credit-card-size DNA scanner identifies predators before they can commit another crime.

◐ DID IT HAPPEN? Sort of. Developed by San Diego–based company Nanogen, the crime chip was a device that could quickly analyze DNA evidence at the scene of the crime and match it to other samples in a national database. While some "fast forensic" tests do exist, "fast" means more like four hours, and most DNA testing is still done in controlled lab settings. The risk of contamination in the field is just too great.

June (left) • Bob Sauls/John Frassanito & Associates • An antimatter-propelled spacecraft heads for interstellar space.

◐ DID IT HAPPEN? It's very complicated. In theory, antimatter—at its most basic, subatomic particles with properties exactly the opposite of those of their matter counterparts—could be the most efficient fuel source ever dreamed up. The problem is that it's scarce in our universe, made only in particle accelerators in very small quantities. All the antimatter made to date isn't enough to heat your burrito.

1990s **263**

ARTIST PROFILE

BOB SAULS

All the way back to da Vinci, artists have challenged themselves to depict our most stunning advancements, using their skills to bring marvels of science and technology to life for the layperson. And in the 1990s, artists got a new tool for explaining the world through visuals: high-quality computer graphics. Previously, you had to sketch, paint, or photograph a physical model to showcase a discovery or an invention. But the evolution of computer-aided design (CAD) allowed designers to create more faithful theoretical or work-in-progress depictions, particularly when it came to space exploration. Enter Bob Sauls, who contributed more than 30 cover and 150 interior illustrations over a period of 18 years.

From macro to micro, Bob Sauls took us places most unexpected and previously unimaginable with his cover designs. Whether a tiny drone that fit in the palm of your hand or a reveal of whatever spacecraft NASA was rolling out next, Sauls brought to the table a level of innovation that would help *Popular Science* readers visualize the future, using CAD and photo mashups to create realistic views of under-development gadgets and aircraft.

After earning his masters in Architecture with an emphasis on Space and Extreme Environments from University of Houston in 1992, Sauls went on to create illustrations, animations, and reference missions for NASA and other aerospace contractors. He served as senior designer at John Frassanito & Associates Inc. for 21 years, during which he contributed most of his cutting-edge covers for *Popular Science*. In 2012, he started his own company, XP4D, specializing in conceptual design, technical illustration, scientific visualization, and animation.

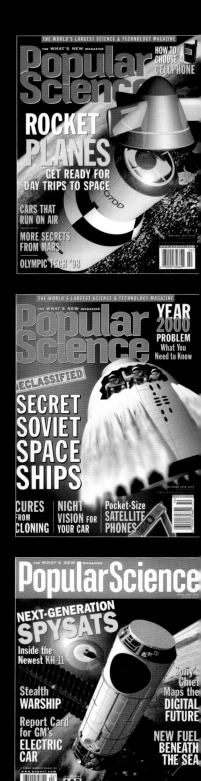

Right, top to bottom,
February 1998
October 1998
April 1997

Far right,
May 1998

FREE SPACE STATION POSTER

THE WORLD'S LARGEST SCIENCE & TECHNOLOGY MAGAZINE

WHAT'S NEW MAGAZINE

Popular Science

SPECIAL ISSUE

JOHN GLENN: A HERO RETURNS TO SPACE

The International SPACE STATION

An Inside Look at the Adventure of the Century

PLUS:

SCIENCE AT ZERO GRAVITY

WALKING IN SPACE

LESSONS FROM MIR

A DAY IN THE LIFE OF AN ASTRONAUT

STATION GEAR FROM SOFTWARE TO SOFT DRINKS

MAY 1998 $2.99
CANADA $3.99

www.popsci.com

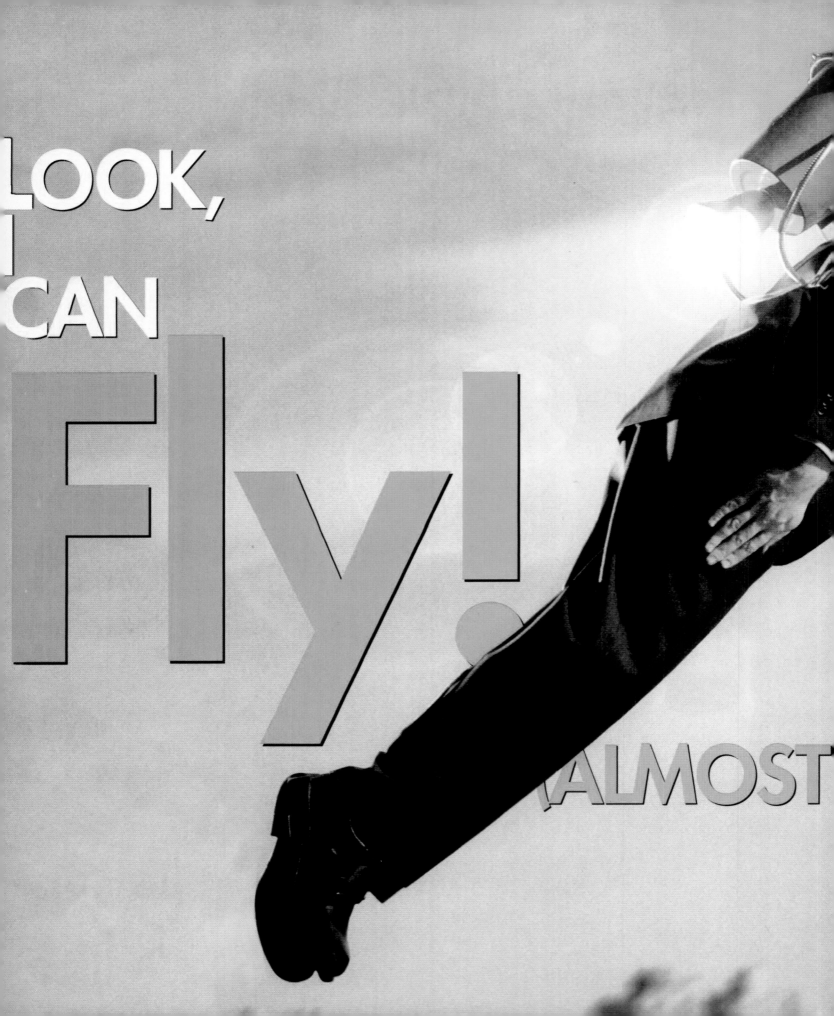

2000s ~ 2010s

2000s–2010s

THE FUTURE NOW

Flipping back through the last 145 years, it's amazing to see how spot-on some predictions for the future turned out to be—say, how Einstein's been right for 100 years and counting—while plenty more proved fantastically wrong. Case in point: Almost two decades into the 21st century, we're still waiting for our flying cars. In the meantime, we've been busy with new advances—from the 2007 launch of the iPhone and the accompanying explosion in apps and social media, to discovering a bunch of new planets and demoting a beloved one. (Pluto—never forget.)

THE INTERNET OF THINGS

From its meek start as a two-node "network" that crashed the first time its developers tried to send a single word across it, the plucky little internet grew from an obscure government plaything to a fact of life for nearly all. And the somewhat clumsily named Internet of Things—the connection and networking of physical devices with online systems—is a uniquely 21st-century development (though the first internet-enabled "thing" dates to 1982, when computer science students at Carnegie Mellon University networked a Coke machine so they could track its inventory online). Today, everything from watches that monitor your sleep and refrigerators that send alerts when you're out of milk to weapons systems and entire power grids are in some way connected. And while it's convenient to unlock your front door with an app on your smartphone, being online also introduces a weakness that nonconnected devices don't have: the ability to be hacked. Just ask those near upstate New York's Bowman Avenue Dam, which was compromised but thankfully not breached by Iranian hackers in 2013, and owners of one generation of Samsung Smart TVs who, in 2017, learned that their device may be watching them more than they're watching it.

AN UPTICK IN MERCURY, A SURGE IN SEAS

According to NASA and NOAA, 2016 was the warmest year in the 135-year history of record keeping, and it's no fluke: Nine of the planet's ten hottest years have gone down in this young century. Barely 100 years after the first explorers reached the South Pole, Antarctica has begun to melt at record rates, with chunks of ice the size of small states breaking off from the continent. All of this is to say that climate change is real, and it's mostly because of us—specifically our carbon footprint, according to nearly 100 percent of climate researchers. But the 21st century has seen a huge growth in alternative-energy production, with nearly 10 million jobs in solar, wind, and other renewables around the world. Today, more than 50,000 windmills power the equivalent of 25 million US homes a year, and advances in photovoltaic technology have made solar panels more affordable. And while the first mass-produced hybrid-electric car, the Toyota Prius, debuted in 1997, the 2000s continued the trend with a number of new electric-vehicle producers—most notably South African Elon Musk's Tesla. There are certainly challenges in our environmental future, but they're not insurmountable…yet.

IT'S ELECTRIC

Above, Elon Musk stands with a Tesla. In the accompanying January 2009 interview, he fields questions about how he'll ever make money selling electric cars in a world of cheap gas. In 2017, Tesla passed Ford and GM as the most valuable American car manufacturer. Point Musk.

At right, all the many ways we'd wear tech, according to our March 2002 predictions. These days, we've got smart watches (thanks to Pebble, then Apple), and Google Glass kinda delivered on the eyewear, but we're still waiting on our lifeshirts.

At left, all the things you could do with Twitter—all the way back in September 2008. Sample advice: "To receive breaking news updates from cnn.com . . . just follow Twitter user 'cnnbrk.'"

The Future Then

Digital Duds

Whether Joe Smith is doing rounds, shopping, or jogging, it's difficult to tell where the PC ends and he begins. Here are some personal computing devices currently under development.

EYEGLASSES

Text will either be displayed on eyeglass lenses or projected directly onto the retina. Dr. Smith's PDA, for example, will constantly check his schedule, then use advanced display technologies to tell him where he needs to go next.

WALLET

The size of a credit card, it will store reams of personal information—calendar, financial records, details about friends and family members, likes and dislikes. It might also automatically tally the price of items Dr. Smith picks up at the supermarket, letting him bypass the checkout line.

WATCH

A combination telephone, voice-text pager, GPS device, and scheduler, the watch keeps track of where Dr. Smith is at all times. If necessary, the hospital can instantly locate and contact him. A beeping alert will tell him where to go and provide a map.

LIFESHIRT

Electrodes and conductive bands monitor heart rate, breathing, and lung performance. In the future, implantable sensors might distribute a stream of real-time information directly from internal organs to the shirt. All of this data can be broadcast directly to Dr. Smith's home computer and to his office.

BODY NETWORK

The skin might be a good alternative to more traditional wiring for conducting the low-grade electricity needed to power the computing devices on Dr. Smith.

RUNNING SHOES

A computer in the sole of Dr. Smith's sneakers senses the speed of his gait in the emergency room. When he is running, the shoe automatically increases support; when he slows to a walk, it lessens the support to increase the cushion.

2000s–2010s

ORGAN FACTORIES OF THE FUTURE

We've come a long way since the heart-lung machine took its first breath for a patient during surgery in 1953. These days, in the hopes of solving the organ shortage and preventing tissue rejection, we are growing and straight-up 3D-printing human body parts using patients' own cells. In 2006, Peru-born Dr. Anthony Atala and his team at Wake Forest University in North Carolina made the first big breakthrough by building and implanting human bladders into children born with spina bifida. In 2016, the same team 3D-printed jawbones, ears, and more—as well as the vascular tissue required to grow them into full tissues—and saw them thrive and take hold inside of rats. The 3D printer has also proven valuable in creating prosthetics, particularly in nations where traveling for fittings can be prohibitively expensive. Meanwhile, other researchers have looked to robotics to transform lives, developing exoskeletons that help the paralyzed walk and brain-machine interfaces that allow paraplegics to control their hands and arms well enough to pick up a drinking glass or even play Guitar Hero. And in 2017, researchers at the Children's Hospital of Philadelphia successfully gestated a premature lamb in an artificial womb for four weeks. Someday, they say, such a womb may reduce mortality of premature human babies.

HACKING THE GENETIC CODE

The 21st century rang in on one of our species' most awesome feats: the first draft of the Human Genome Project, a decade-long international effort to establish the order of our DNA's nucleotide bases and map our 20,500 genes. Since then, genomicists have charted the genetic codes of people with cancer, diabetes, schizophrenia, heart disease, and more in an effort to develop targeted gene therapies. This banked DNA data has helped scientists make early-days but immense strides, such as coming up with CAR-T therapy, in which a cancer patient's T cells are removed, genetically reengineered, and released back into the body to attack malignant growth. And then there's CRISPR, a method of gene editing in which a protein can snip out problematic or splice in beneficial nucleotide sequences. First tried on a patient in China in 2016, CRISPR has a catch: If used on an individual's egg or sperm cells, the changes will be passed on to future generations—forever. And if used on an embryo to prevent disease or select preferred traits (like height or hair color), you've got yourself that ethical conundrum known as a designer baby. Clearly, with great power comes great responsibility, but at least we can now all swab our cheeks in exchange for a printout of our ancestry, eh?

THE AGE OF AI (AND VR, TOO)

We received the first definitive sign that machines could get smarter than us in the 1990s, when IBM's Deep Blue supercomputer took chess master Garry Kasparov's king for the

BRAVE NEW WORLD

At right, from our July 2006 issue, a spring-loaded prosthetic foot and motorized ankle that helps people move with a more natural gait, spearheaded by MIT's head of biomechatronics, Hugh Herr, who is himself a double amputee.

At left, an August 2014 feature on sequencing the genomes of infants born with rare genetic diseases—and the controversial ability to screen embryos for such abnormalities before implanting them in the womb via IVF.

FUTURE TECH: PROSTHETICS

WALK THIS WAY At the Massachusetts Institute of Technology's Media Laboratory, engineers in the biomechatronics group are developing a motorized ankle that automatically adds or dissipates energy while the user is walking to maintain stride and balance.

ALSO OF NOTE

JANUARY 15, 2001
Wikipedia launches.

JANUARY 15, 2002
Roomba, by iRobot, vacuums its first floor. Experts agree it gave its first cat ride soon thereafter.

SEPTEMBER 24, 2009
The Indian Space Research Organisation reports water ice in the polar regions of the moon. NASA wants to mine this water to create propulsion, allowing us to refuel in space.

NOVEMBER 10, 2011
The Western black rhino is declared extinct after a decade of zero sightings.

JULY 4, 2012
Physicists at CERN's Large Hadron Collider in Geneva announced that they had spotted the white whale of physics: the Higgs boson, a subatomic particle that gives all matter its mass.

2000s–2010s

first time. Since then, artificial intelligence has improved to the point that self-driving cars, financial-analysis tools, and even your Netflix suggested-movie queue all run on machine learning, in which a computer uses trial and error to improve performance. While we've yet to make a machine that can trick us into thinking it's human, it's just a matter of time: You can now talk with personal-assistant software—Apple's Siri will even sass back, so mind your p's and q's—and robots are getting the hang of walking around on two legs and doing backflips (not to mention diagnosing illnesses and detecting crop abnormalities). On a related note, the unreal has become increasingly realistic since the turn of the century, as virtual reality and augmented reality prototypes have gone into and through the uncanny valley, coming out on the other side as training tools for soldiers, surgeons, pilots, and more. Beyond its use in the classroom, VR today helps stroke patients rehabilitate more quickly through gamified physical therapy, art lovers stand in front of the *Mona Lisa* from a continent away, and sports fans cheer in the stands of a virtual stadium. Someday, those fans may even be able to smell the hot dogs.

SIGNS OF LIFE IN THE GOLDILOCKS ZONE

Long before we sent humans to the moon and rovers to the Red Planet, we've been tilting our heads skyward and hollering, "Hello? Is anybody home?" While extraterrestrial life has yet to wave back, scientists have come across a promising lead in the search for it: Goldilocks planets outside our solar system but inside a star's habitable zone—close enough to be "not too hot, not too cold" and to potentially support liquid water. In 2015, NASA scientists, with the help of the Kepler Space Telescope, found Kepler-186f, the first Earth-size planet discovered within a star's habitable zone. A year later, we spotted Proxima-b, a world of similar size circling our closest star, Alpha Centauri. And in 2017, NASA and a team of European scientists hit the Goldilocks jackpot when they discovered seven Earth-size planets near the dwarf star Trappist-1, a mere 235 trillion miles (378 trillion km) away. Astronomers plan to study these planets with the hope of detecting signs of life—or signs that *our* life could flourish there. That's right: As the population of Earth nears 8 billion, we may someday need a home away from home, and one of the estimated 40 billion Goldilocks planets just might make prime real estate.

ALL ABOARD THE SHUTTLE TO MARS

While the US Space Shuttle's last flight lifted off the launchpad in 2011, our desire to travel above the Karman line never waned, and a few wealthy big thinkers are determined to get us mere citizens up there. Richard Branson's Virgin Galactic plans to offer suborbital flights on its SpaceShipTwo; celebrities like Tom Hanks and Katy Perry have shelled out US$200,000 to be on the wait list for this bit of space tourism. And Elon Musk (yup, him again) established SpaceX in 2002 with the aim of colonizing Mars. It's made strides toward that goal, becoming the first private company to run regular deliveries to the ISS and build high-capacity reusable launch vehicles. There's also Mars One, the brainchild of Dutch engineer Bas Lansdorp, who plans to pay for the journey by selling the rights for a reality show. About 4,000 people signed up to be considered for the televised mission, which is—here's the kicker—one way.

FAR OUT

Above, a poster from NASA celebrating the 2017 discovery of the Trappist-1 system. A play on travel review sites, it reads, "Best 'Hab Zone' Vacation within 12 Parsecs of Earth." That's 40 million light-years in layperson-speak.

At left, a Tesla Roadster in space, manned by a test-drive dummy named Starman, which Elon Musk's SpaceX company launched on the first high-capacity reusable rocket, the Falcon Heavy, in 2018.

At right, an early idea of what an augmented reality getup might look like, from the February 2002 issue of *Popular Science*. We humans sure do overcomplicate things sometimes, don't we?

The Future Then

THE WORLD'S LARGEST SCIENCE & TECHNOLOGY MAGAZINE

THE WHAT'S NEW MAGAZINE
Popular Science

PALM BUSTER:
Next-Gen Pocket PC Delivers

5-YEAR GUIDE TO SPACE MISSIONS

Where We're Going, How We'll Get There, What We'll Learn

PERSONAL PLANES
Cheaper, Safer, Easier to Fly

SUPERFAST INTERNET ACCESS
Now, Real-Time Movies, Games & Music

JUNE 2000 $3.99
CANADA $4.99
TIMES MIRROR MAGAZINES
www.popsci.com

2000S–2010S

April 2000 · Darren Blum · An artist's depiction of an artificially grown human heart, intended to help the 4,000 people awaiting organ donations in the United States alone.

DID IT HAPPEN? We're not *quite* there yet. This article discusses how an international consortium of scientists had grown heart tissue on scaffolding for valves and arteries. In 2016, US scientists did manage to successfully cover damaged donor hearts with skin cells, which grew into full-size human hearts that actually beat. While it's a triumph, we're still a far cry from hearts stocked on hospital shelves.

February 2000 · Don Foley · A waverider—a hypersonic aircraft that "rides" the shock waves it creates when breaking the sound barrier, generating lift—flies five times the speed of sound.

DID IT HAPPEN? This exact Northrop Grumman hypersonic concept didn't take off. But today, waverider scramjets are in development; leading the pack is Boeing's unmanned X-51, which broke Mach 5 for a little more than three minutes in 2013. It—or something like it—could see service as early as the 2020s.

June 2000 (left) · Bob Sauls/John Frassanito & Associates · A full eclipse of the moon is a backdrop to five years of forthcoming space missions.

DID IT HAPPEN? Yeah, a lot of the missions outlined in this issue's cover feature did happen—from a number of International Space Station assembly trips to 2001's *Genesis*, which collected samples of solar wind, and *Stardust*, which brought home dust from a comet's coma, to the 2003 launch of the Spitzer Space Telescope, an infrared optics tool that was the first to detect buckyballs in space and light from a planet outside our solar system.

August 2002 · Hugh Kretschmer · A jetpack-wearing salaryman commutes to work.

❌ DID IT HAPPEN? Nah. This article looked at a few technologies for personal flight, such as the one-seater helicopter AirScooter and a dual-fan-propelled backpack helicopter known as SoloTrek—neither of which made it into mass production. But the dream isn't dead: In 2015, American David Mayman, CEO of Jetpack Aviation, flew around the Statue of Liberty using the first jetpack to receive FAA approval.

August 2001 · Tom Haynes and Peter Kavanaugh · A meltdown-proof pebble-bed nuclear reactor for "safe" nuclear power.

❌ DID IT HAPPEN? Not really. These nuclear plants run on baseball-size pieces of nuclear fuel called pebbles that are supposedly safer because their graphite and carbide shells trap radiation and heat. But that claim is debated, and there is currently only one such plant in operation in the world. Plus, the plants still create nuclear waste—a literal mountain of used pebbles. No giant flower is gonna cover that up.

July 2001 (right) · Toby Pederson · A pill on a spoon that purports to cure cancer.

DID IT HAPPEN? While there's still no official cure for cancer, this pill, Gleevec, was one of the first medications to target a specific cancer-causing enzyme, effectively shutting it down without as many side effects as standard chemotherapy. Today, Gleevec remains a top drug in the treatment of chronic myeloid leukemia and related diseases—patients who take Gleevec have a 90 percent five-year survival rate—and targeted gene therapies like it are generally seen as the most promising pathway to a cure.

END OF THE JET AGE? The Race for Pulse Detonation Engines

POPULAR science

KILLER ASTEROIDS
The Reality
New Ideas to Find, Hunt & Intercept Earth-Threatening Space Rocks

Brilliant 10:
OUR 2ND ANNUAL LIST OF YOUNG SCIENTISTS DOING MIND-BENDING WORK

WHEN A MAN BUILDS A WOMAN: A TALE OF ROBOTIC OBSESSION

US $3.99 CAN $4.99
SEPTEMBER 2003
popsci.com

2000S–2010S

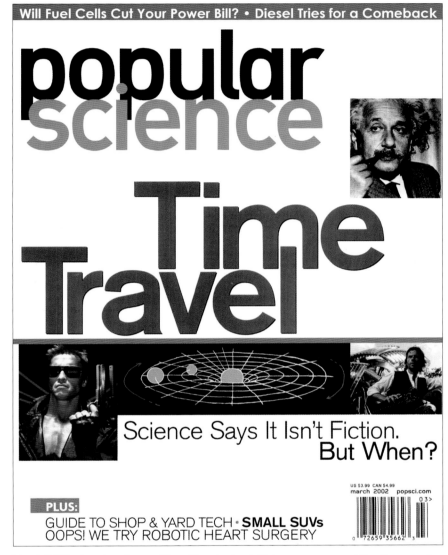

March 2002 • Jonathon Rosen • Albert Einstein, Arnold Schwarzenegger, and Guy Pearce make unlikely cover mates on this issue about time travel.

❌ DID IT HAPPEN? Not that we know of. This issue looks at the logistics of scooting to another time via a wormhole, a passage between two black holes held open with antigravity, or zipping between time zones via a pair of cosmic strings moving in opposite directions at the speed of light. We simply don't have the technology yet to go back to—or come back from—the future. Yet.

April 2003 • John MacNeill • Autonomous underwater vehicles (AUVs) look for mines.

✅ DID IT HAPPEN? Yeah, the US Navy has a number of drone subs, like the Manta and Remus AUVs here. The most startling trivia from this issue is what had swept for mines in shallow waters before AUVs: specially trained military dolphins.

January 2002 • John MacNeill • An X-50A Dragonfly switches from chopper to plane.

❌ DID IT HAPPEN? No. Post-9/11, DARPA hoped Boeing's unmanned semi-stealth chopper/plane hybrid would be helpful in the US war in Afghanistan, but it was canceled in 2006 due to design flaws.

September 2003 (left) • John MacNeill • A killer asteroid slams into Earth.

✅ DID IT HAPPEN? Just ask the dinosaurs. This issue looks at asteroid defense—which, then and now, consists of citizen scientists scanning the skies with software to locate near-Earth objects (NEOs)—plus devices like sails designed to veer space rocks off course. NASA is currently planning its Double Asteroid Redirection Test (DART), the first mission to attempt using kinetic impact to knock an NEO off its path with Earth, so stay tuned.

February 2004 · John B. Carnett · A mind-controlled robot hand tweaks the type on the cover.

✓ DID IT HAPPEN? Yes! Since German psychiatrist Hans Berger learned in 1924 that the brain uses electrical activity, we've dreamed of controlling motion with thought. This study at Duke University showed that, by charting the neural patterns of rhesus monkeys when they completed tasks, researchers could program a robot to do the same actions based on thought alone. Today, similar brain–machine interfaces allow some to move prosthetics; with luck, this tech will continue to become accessible.

January 2005 · April Bell · The Moller M400 Skycar hovers just a wee bit over the ground, teasing you about personal flight.

✗ DID IT HAPPEN? Yes about the tease, no about the flying. Despite Canadian Paul Moller's trying for 50 years (and promising investors that 10,000 would be levitating over roads by 2002), his Skycar never became ready for prime time. Nor did the Facetmobile, the CarterCopter, the Javelin, or any of the other prototype single-seater aircraft covered in this issue. Recently, however, a Moller Skycar did go up for auction on eBay. There was one major catch: It cannot be flown.

November 2005 (right) · John MacNeill · War spreads to space.

DID IT HAPPEN? It's complicated. This issue goes over a host of space-based weaponry—from hypersonic space planes capable of striking anywhere in the world to microsats (satellites the size of a washing machine) that could disable those of our enemies, and from space mines to orbiting mirrors that disarm by reflecting lasers. If these weapons made it past testing, they're hush-hush, as the United States arguably stands the most to lose in a space war. As one expert said, "People who live in glass houses shouldn't organize rock-throwing contests."

BETTER BIONIC FINGERS
P.29

POPULAR SCIENCE

THE FUTURE NOW

GADGET OF THE MONTH
Why this amp costs **$45,000** P.17

WHERE'S MY FLYING CAR?
How and When Our Tech Dreams Will Come True

TO THE MOON! We unveil NASA's next manned spaceship P.50

BUILD AN AQUATIC TANK And 5 more amazing how-to projects P.69

MARCH 2006 · US $3.99 · CAN $4.99
www.popsci.com

2000s–2010s

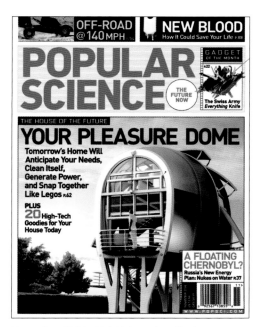
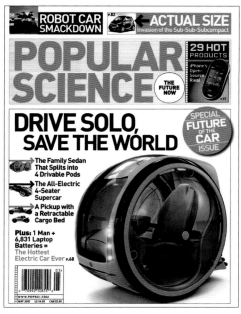
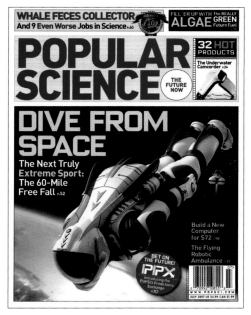

November 2006 · Nick Kaloterakis · The Innovation House, by *Popular Science*, *Sunset*, and architecture firm Dahlin Group.

✓ DID IT HAPPEN? Yeah! This high-tech home built in Alamo, California, features touchscreen OLED walls, RFID-enabled kitchen appliances, self-cleaning surfaces, networked climate systems, and home sensors that scan the body for signs of health—and identify intruders, too.

May 2007 · Nick Kaloterakis · One segment of a SNAP! Multicar, which attaches in pairs or quads.

✗ DID IT HAPPEN? No, but how cool would it be to travel along as a nuclear family, each member comfortably ensconced in his or her own wheeled pod and connected via an open side window, until each pod broke off from the pack toward work, school, the library, or the beach? Come on, people. We can *do* this.

July 2007 · Nick Kaloterakis · A space diver jumps headlong toward Earth.

✗ DID IT HAPPEN? No, this "life jacket of the space-faring age" from Orbital Outfitters has yet to make it off the hanger—for either recreation or emergency-ejection purposes. But Austrian skydiver Felix Baumgartner and Google executive Alan Eustace have both taken dives from about halfway to space, which is nothing to sneeze at.

March 2006 (left) · Nick Kaloterakis · Flying cars whip around New York City.

✗ DID IT HAPPEN? LOL—next! But, in all seriousness, this issue looked at how we've been making steady progress toward humankind's most lusted-after but elusive innovations—for example, we don't each have a robomaid, à la the Jetsons' Rosie, but some of us may have a Roomba. In the case of the flying car, this article is likely correct that the US FAA's safety concerns have helped stall the ultimate in American dream cars, but interest has in no way died down: As recently as 2017, major transpo-tech company Uber was hoping to launch a network of unmanned flying taxis.

SUBMERSIBLE SPEEDBOAT P.34

THE BRIGHT SIDE OF GLOBAL WARMING P.30

POPULAR SCIENCE

THE FUTURE NOW

26 HOT PRODUCTS P.16

See in the Dark
Night Vision on the Cheap

SPECIAL ISSUE: THE SCIENCE OF
SPORTS

Building the Perfect Athlete
Meet the U.S. Olympian Who Is Revolutionizing The Way Athletes Train P.48

How to Throw a 100mph Fastball
The Hidden Biomechanics of Sports P.46

No Such Thing As "Career-Ending"
Miracle Surgery for Injured Bones, Joints and Feet P.56

Juicing 3.0
Gene Doping, Flow-State Pills and Other Future Cheats P.38

TUNE IN TOMORROW
Tech That Makes TV Better Than Being There P.60

AUGUST 2008
US $4.99

2000s–2010s

February 2008 · Nick Kaloterakis · Concept art for the Reaction Engines A2, a liquid-hydrogen-powered "green" jet that gets you from Brussels to Australia in less than five hours.

❌ DID IT HAPPEN? Yeah, right. As Reaction Engines director Alan Bond put it, "Our work shows that it is possible technically; now it's up to the world to decide if it wants it." (Maybe people were turned off by the A2's lack of windows, which couldn't take the heat put off at such speeds.) Other ecofriendly aviation tactics covered in this issue, such as mixing standard Jet A fuel with biodiesel, have also yet to pan out, though Boeing's Dreamliner did come out of the gate in 2009 with a 20 percent increase in fuel efficiency.

August 2008 (left) · Nick Kaloterakis · An artist's depiction of an athlete sprinting into the future while data bursts from a cutaway of his thigh.

✅ DID IT HAPPEN? It's a mixed bag, but largely yes. This issue covers all the ways athletes might increase their performance—from stem cell treatments, which have become pretty commonplace, to gene doping, which was swiftly banned and proved too tricky to pull off anyway. We also got a first look at data-driven training regimens that foreshadowed today's fitness-tracking obsession.

February 2009 · Nick Kaloterakis · Swiss jetman Yves Rossy flies with his jet-powered wing.

✅ DID IT HAPPEN? Incredibly, yes. During one 2008 flight, Rossy flew over the English Channel—who needs the Chunnel when you have wings?—and in 2015 he performed a "dance" with an Airbus A380 at 5,500 feet (1,675 m).

March 2009 · Nick Kaloterakis · An artist's depiction of the Burj Mubarak al Kabir, a 3,300-foot (1,005-m) skyscraper.

❌ DID IT HAPPEN? Not yet, as the home of this building—Kuwait's Silk City—is still under construction. To stabilize against high winds, British architect Eric Kuhne's concept features three twisting, interlocking towers and vertical ailerons.

January 2011 · Nick Kaloterakis · An artist's concept of a weaponized robotic beast, loosely based on Boston Dynamics' BigDog.

❌ DID IT HAPPEN? This lumbering wartime pack mule was in development for a decade before DARPA shelved it in 2015. BigDog, loaded with actuators and sensors, was designed to trek for 20 miles (32 km) with 400 pounds (180 kg) of gear strapped to its back—all without refueling—in fewer than 24 hours. The verdict? After all that, it was too loud for combat.

November 2011 · Nick Kaloterakis · The hand of God, made of thousands of zeros and ones, emits a ray of light.

✅ DID IT HAPPEN? Um, no, this exact scene has yet to be pasted over Michaelangelo's *Creation of Adam* in the Sistine Chapel. But yes, big data and its attendant surge in computing power have revolutionized modern life. In 2011, we created 1.8 zettabytes—a zettabyte is 1 sextillion bytes—of digital information, and in 2025 we'll likely make a staggering 163 zettabytes. That's a lotta cat photos.

July 2010 (right) · Nick Kaloterakis · US visionary urban designer Mitchell Joachim's sustainable urban paradise.

X DID IT HAPPEN? Gleaming low-altitude blimps with hop-on, hop-off chairs, houses grown from living trees, jetpacks tethered together in swarms, and machines spitting up buildings and bridges out of recycled trash—any of these ideas from Joachim's ecotopia would have been pretty rad. Only one from this issue made it into production: solar-panel roads, recently installed in limited numbers as a test in China and France. And all the way back in 2010, Joachim said, "We could do this yesterday."

LIFE ON MARS? INSIDE THE MOST AMBITIOUS SEARCH YET p.52

POPULAR SCIENCE

THE FUTURE NOW

PLUS!
Wi-Fi Gets Supercharged p.22
Secrets of Competitive Eating p.73
188-mpg Motorcycle p.18

THE FUTURE OF MEDICINE

HUMAN ENGINE

The 10,000-rpm, No-Pulse Heart p.36

AND:
+ Rapid-Response Virus Hunters p.30
+ A Shocking Cure for Migraines p.34
+ Fighting the Flu with Data p.28
+ Bargain-Basement Genomes p.24

ROBOTIC WRECK HUNTERS
An Archaeologist's Quest To Explore the Mediterranean's Sunken Ships—
All 300,000 of Them p.46

THE BOY WHO PLAYED WITH FUSION
A 17-Year-Old Genius Builds His Own Reactor p.56

2000s–2010s

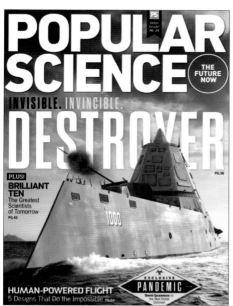

February 2012 · Unattributed · Buttons on a game pad blink with icons of future fun.

🌀 DID IT HAPPEN? Yes and no. While gamification has continued to invade all aspects of our daily lives (even—or especially?—dating), we're still waiting on this issue's promise of a zero-gravity roller coaster. Some of its other ideas were total and delightful conjecture—such as living LEGO blocks or liquid fireworks. We wish.

October 2012 · Nick Kaloterakis · The hulking USS *Zumwalt*-class stealth destroyer.

🌀 DID IT HAPPEN? Technically, it happened—but only two of the proposed 32 were completed before budget cuts forced its cancellation. Twice the size of its predecessors but with a radar footprint less than 50 percent of theirs, this "seaborne battering ram" was designed to slice through water, leaving a nearly invisible wake.

November 2013 · Travis Rathbone · An ominous black sphere stands in for mysterious dark matter.

🌀 DID IT HAPPEN? Not yet. American astronomer Vera Rubin was one of the first to infer the presence of dark matter back in the 1970s, but we've yet to officially detect the stuff, which makes up roughly 25 percent of the universe. Some scientists are doing experiments to see if it's a particle, while others swear it's a wave. Stay tuned.

March 2012 (left) · Nick Kaloterakis · A continuous-flow artificial heart pumps blood through tubes to a pair of lungs—all without a pulse.

🌀 DID IT HAPPEN? Not yet, but we've sure come a long way since the first fridge-size, out-of-body artificial heart, eh? Created by US cardiovascular surgeon and serial inventor Billy Cohn, this heart consists of two turbines and a pair of artificial ventricles, and it supported a man for five weeks in 2011 until he succumbed to other symptoms. These days, Cohn has teamed up with Australian Daniel Timms on a similar concept, the BiVACOR heart: a titanium shell that houses a fan, which levitates and spins in a magnetic field and keeps blood continuously moving. It's coming soon to a chest near you.

November 2014 · Harold Daniels · Your robotic next best friend.

🔄 DID IT HAPPEN? You tell us. One of the robot companions in this article, Pepper, is available in Japan and the UK, and if the popularity of Siri and Alexa is any indication, we'll all be sharing heart-shape BFF necklaces with machines soon enough.

October 2015 · Eric Heintz · Food gets high-tech.

🔄 DID IT HAPPEN? While corn is still thankfully made of kernels, we do have some genetically modified foods that are designed to last longer—thereby reducing waste—and that contain fewer carcinogens. The jury of public opinion on GMOs, however, is still out.

July 2015 · Travis Coburn · The Hyperloop gets you from LA to San Francisco in 35 minutes flat.

🔄 DID IT HAPPEN? Not yet. This high-speed-train concept from Elon Musk—the gift that keeps on giving—consists of a maglev in a vacuum tube. While crazy, it may not be insane: US company Virgin Hyperloop One held the world's first full-scale test in Nevada in 2017.

May 2015 · Kareem Black · MakerBot cofounder Bre Pettis holds a 3D-printed E from *Popular Science*.

✅ DID IT HAPPEN? Sure did. Invented in the 1980s, 3D printing finally caught fire in the late aughts. Pettis's company, MakerBot, was one of the first to offer a kit to the home hobbyist, and its popular Thingiverse site serves as a repository for open-source print files.

August 2015 · PriestmanGoode · Space tourists ascend up to 100,000 feet (30,500 m) to see the curvature of Earth, drink in hand.

DID IT HAPPEN? Patience, people. A handful of companies are racing to make floating to space in a gondola slung below a helium balloon a real thing you could do. More comfortable and less dangerous than rocket-propelled spacecraft, this technology has actually been around for a while: The first humans to see the curvature of Earth did so from a balloon at 74,000 feet (22,555 m)—all the way back in 1935.

MISSED A SPOT: THE LAST UNMAPPED PLACES ON EARTH

POPULAR SCIENCE

January/February 2017

- **NASA GOES TO THE ARCTIC**
- **WHERE TO LIVE IN 2100 A.D.**
- **MACHINES OF THE DEEP**

EXPLORE

CAUTION: MAY CAUSE WANDERLUST

2000s–2010s

May/June 2016 · John Kealey · Canadian inventor Alexandru Duru rides his hoverboard.

✅ DID IT HAPPEN? Definitely. In 2015, Duru broke the world record for longest hoverboard flight by traveling more than 905 feet (275 m) over Quebec's Lake Ouareau. With eight carbon fiber arms outfitted with small electric motors, all wrapped in a web, Duru's battery-powered device allowed him to make the trip 16 feet (5 m) above the lake's surface. But Duru's got competition: His record was smashed later in 2016 by French inventor Franky Zapata, who made it an insane 7,388 feet (2,250 m) with his own design.

January/February 2017 (left) · The Voorhes · A glove from a Russian Sokol space suit holds a compass, beckoning you to explore.

✅ DID IT HAPPEN? There are few more human urges than the one to explore. It did happen, it is happening, it will continue to happen. This issue specifically looks at how NASA spent two months exploring the Arctic in preparation for the Europa Clipper mission, which will scan Jupiter's ice-locked moon for signs of life below the frigid surface. The mission is planned for the 2020s.

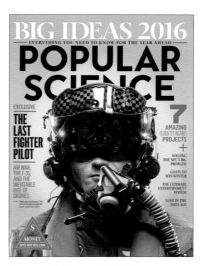

January/February 2016 · Spencer Lowell · An F-35 II fighter pilot.

✅ DID IT HAPPEN? With off-the-charts computational power, the F-35 II will change the game, practically calling the shots for pilots. Its sensors will display all data on the pilot's helmet shield.

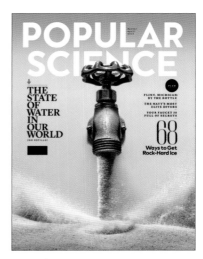

March/April 2017 · The Voorhes · Sand pours from a faucet as a reminder of the increasing lack of water.

✅ DID IT HAPPEN? Yeah, this issue details the many ways the basis of life is in danger—through scarcity, fracking pollution, lead contamination, and more. Drink up while you can.

293

ARTIST PROFILE

NICK KALOTERAKIS

By the 1990s, computer graphics had already been around for a few decades, but it was then that 3D modeling really burst onto the scene in a meaningful way. But those early iterations, while impressive for the time and like nothing that came before, weren't exactly believable or lifelike. They could be boxy and almost obviously artificial. In the 2000s and 2010s, though, the gap between 3D CGI and photographic quality became nearly nonexistent. If there's one artist who brought that kind of virtual photorealism to the covers of *Popular Science*, it's Nick Kaloterakis.

Born in Athens and raised in Crete's Chania region, Kaloterakis spent a few years studying design and photography before moving to Australia in the late 1990s. If most of his art looks like it's lifted from the movies, that's because he's spent years honing his 3D art and visual FX chops. Drawing from the best of photography, surface modeling, lighting, and compositing, Kaloterakis has developed an enviable ability to craft convincing figures and landscapes.

Starting in 2006, Kaloterakis's work regularly graced the cover of *Popular Science*. Perhaps not since the 1930s had another artist portrayed the future of science and tech so vividly and with such imagination. From entire green cities to AI bots seemingly plucked straight from the uncanny valley to futuristic weapons and modes of transportation, the fruits of Nick's virtual labor had even the editors sometimes wondering if they were photographs. And it's probably no coincidence that the first cover Nick ever illustrated was the first to include *Popular Science*'s tagline of the 21st century: "The Future Now."

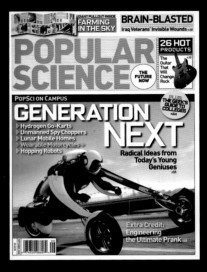

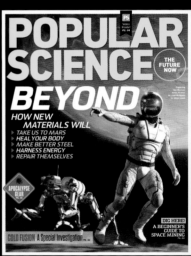

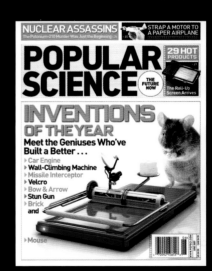

Right, top to bottom,
September 2008
November 2012
June 2007

Far right,
May 2008

MOON TRUCK
Meet NASA's Lunar Hauler P.78

LITTLE BIG BANG
How to Make a Desktop Universe P.72

POPULAR SCIENCE

THE FUTURE NOW

22 HOT PRODUCTS

Mighty Morphin' Mini Cellphone P.17

HOLLYWOOD SCIENCE
THE REAL IRON MAN

It Doesn't Fly (Yet), but Today's Most Advanced Exoskeleton Turns Soldiers Into Superheroes P.44

PLUS
PopSci's Summer Sci-Tech Movie Preview P.56

AND
How *Speed Racer* Built a World from Scratch P.58

THE 65-POUND WARPLANE
Inside the Obsessive World of Remote-Control-Jet Builders P.60

POPSCI.COM

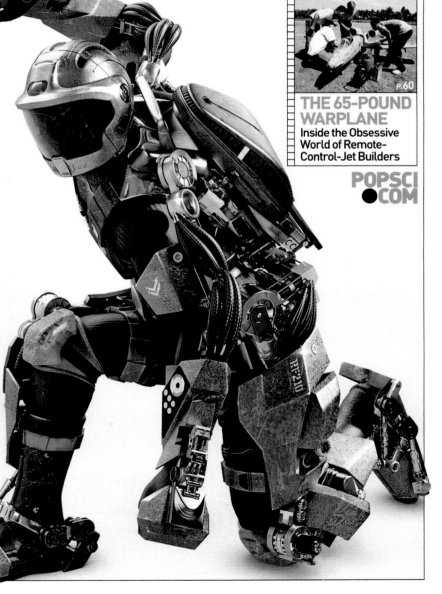

MAY 2008
US $4.99

INDEX

A

accelerographs, 61
ACVs (air-cushion vehicles), 155
AD-1 ("flying scissors" jetliner), 188–189
Adams, Stewart, 150
Adobe Photoshop, 241
Advanced Technology Transport (ATT), 188
aerial fire truck, 109
aerial tramway, 126
aero sled, 36
aerobraking, 221
Aeromobile, 142–143
aerosol spray cans, 31
AeroVironment's Black Widow spy plane, 260
African-American pilots, 88
AIDS virus, 210
air cushion vehicle (AVC), 142–143
air kits, 133
air traffic controller, 250
air-bubble sun ports, 156–157
air-cushion vehicles (ACVs), 155
air-mail planes, 49
air-propelled car, 68
air-propelled unicycle, 24
AirScooter one-seater helicopter, 276
airships, 24, 74, 104
Akashi Kaikyo suspension bridge, 260–261
Albatross human-powered aircraft, 180
Albert II monkey, 90
Aldrin, Buzz, 148
alkaline battery, 121
Allen, Bryan, 180
all-terrain vehicles (ATVs), 173
Alter, Dinsmore, 50
Alvarez, Luis and William, 242
Alvin sub, 150
Amazon.com, 240
Amber drone, 240
American rocket, 160
American sign language, chimps using, 151
American-La France, 156
Amick, James, 197
amphibious tanks, 79, 104
Amundsen, Roald, 15
amusement parks, 113
AN/ALQ-166 hydrofoil sled, 224–225
Andromeda Galaxy, 30
answering machines, 192
Antarctic Airborne Ozone Expedition, 208
antennas, TV, 139
antimatter-propelled spacecraft, 262–263
antimissiles, 218
antisub defense nets, 99
antitank missiles, 218
Apollo 1-10, 148
Apple II personal computers, 178
Apple Macintosh personal computer, 208, 223
Armstrong, Neil, 148
ARPANET, 152, 210
Arrowbile, 46
artificial hearts, 211, 288–289. *See also* organ transplants
artificial intelligence, 270, 272
artificial radiation, 60
ASCI Red, 248
Aserinsky, Eugene, 121
assembly lines, 16
AT&T, 180
Atari game, 180, 212
athletic performance, 284–285
atom bombs, 88
atomic nucleus, 15
Atomic Power Station, 120
"Atoms for Peace" speech, 120
ATT (Advanced Technology Transport), 188
ATVs (all-terrain vehicles), 173
Aurora spy plane, 230
Australopithecus afarensis, 180
Australopithecus africanus, 32
autogyro, 133, 168–169
automated air traffic control, 250
automatic weapons, 102
automobiles, 16
 1940s safety features, 109
 1960s, 150
 air-propelled, 68
 all-terrain vehicles (ATVs), 173
 battery-powered, 183
 Carter Steamer, 192
 DeLorean DMC-12, 208
 driving in winter, 170
 electric, 203
 flying, 46, 282–283
 handling accidents, 162–163
 hybrid racecar, 252
 Indy, 257
 Minicars RSV, 215
 motor oils, 187
 panel trucks, 135
 Pontiac mini-car, 173
 power-steering vehicles, 130
 race solar-powered, 228–229
 on railroad tracks, 135
 sail-powered, 193
 SNAP! Multicar, 283
 speed limits, 165
 test-driving, 128–129
 three-point seatbelt, 151
 Volkswagen Rabbit, 195
 water survival tactics, 160
 zero-emission, 183
AVC (air cushion vehicle), 142–143
aviation, 60. *See also specific types of aircrafts*
Avoskan, Thomas, 45

B

B-2 Spirit aircraft, 226, 230
B-52 bomber, 138–139
Back to the Future movie, 210
backyards, 110
"ball tank," 76
balloon spearing, 72–73
banners, 97
Bardeen, John, 92
Barton, Otis, 72
basements, recreation rooms in, 128
BASIC programming language, 152
bathyscaphe, 109
bathysphere, tanktread-fitted, 72
batteries, alkaline, 121
battery-powered car, 183
battle ship, 97
Becquerel, Henri, 14
Beebe, William, 72
bees, 43
Belanger Special, 128
Bell, Alexander Graham, 12
Bell Rocket Belt, 173
Bennie, George, 64–65
Bensen, Igor, 133
Bensen B-8 autogyro, 133
Benz Patent-Motorwagon, 16
Berliner, Emile, 15
Berman, Elliot, 182
Berners-Lee, Tim, 240
Bertelson, William R., 142–143
Big Crunch, 242
big data, 286
Big Rip, 242
BigDog weaponized robotic beast, 286
bikes. *See* motorcycles; *specific types of bikes*
Binnig, Gerd, 233
birth control pills, 150
BiVACOR heart, 288–289
blind flight, 28
blood alcohol levels, 156
Blossom capsule, 90
Bluford, Guion, 208
boatercycle, 163
boats. *See also* ships
 balloon spearing, 72–73
 jet-driven boats, 160
 outboard motors, 50–51
 "sea gull boat," 71
Bohlin, Nils, 151
Bomb, 126
bombardier, 99
bombers. *See specific types of bombers*
bombs, parachute, 100
Bond, Alan, 285
botanical gardens, 19
brain activity, 30
Brain computer virus, 210
brain-machines, 280
Branson, Richard, 245, 272
Brattain, Walter Houser, 92
breathalyzers, 156
bridges, 260–261
broadcasts, 30
Brooks, Rodney, 246–247
Brown, Louise, 181
buckminsterfullerene, 247
Buckyball, 247
bug-machines, 246–247
bugs, 229
bunkers, 126
Burj Mubarak al-Kabir skyscraper, 285
buses, 126
Butler, Lee Porter, 202–203
bypass pump, 58

C

C4004 processor, 178
calculators, 190
cameras, 15, 125, 190
Camp Century, 155
Campbell, Keith, 238
cancer pills, 276–277
Canyon Diablo meteorite, 118, 122
car navigation system, 225
car phones, 178, 180
carbon dating, 91
Carcarodontasaurus saharicus, 242–243
cardiopulmonary bypass pump, 58
cargo ships, 23
Carlson, Rachel, 151
cars. *See* automobiles
CAR-T therapy, 270
Carter Steamer, 192

catenary turbine, 193
Caterpillar 641, 158
CD-ROMs, 244
cell phones, 180
central processing unit (CPU) chip, 178
centrifuges, 110–111
CERN website, 240
CERN's Large Hadron Collider, 271
Chalk, Tom, 193
Challenger Deep, 150
Challenger space shuttle, 161
Channel Tunnel, 253
chemotherapy, 90
Chernobyl, Ukraine, 208–209
chess competitions, 256–257
Chicxulub Crater, 242
chimpanzees, 151
chlorofluorocarbons, 208
chopper/plane hybrid, 279
chronic myeloid leukemia, 276–277
Chrysler Patriot turbine-electric hybrid racecar, 252
Chunnel, 253
circular saws, 36–37
Clark, Barney, 211
Clean Air Act, 182
climate change, 268
climbers, 77
cloning, 238
Cohen, Fred, 210
Cohn, Billy, 288–289
cold fusion, 250
Collins, Michael, 148
color television, 118, 121, 171
Columbia space shuttle, 208
comets, 241, 252
Commodore 64 computer, 208
Commodore 64 synthesizers, 210
Commodore PET personal computers, 178
computed tomography (CT), 178
computers, 178. *See also* names of specific computers
 big data, 286
 laptops in 1980s, 220
 viruses, 210, 232–233
conning towers, 20
conservationist, 151
contraceptives, 150
Cooper, Martin, 180
Cosmic Egg, 30
cosmologists, 242
Cosyns, Max, 109
Cousteau, Jacques, 172–173
covered motorcycles, 43
CPU (central processing unit) chip, 178
Cretaceous–Paleogene boundary, 242
Crick, Francis, 122
CRISPR gene editing, 270
cross-sectional imaging, 178
CT (computed tomography), 178
Curie, Pierre and Marie, 14
Curie-Joliot, Irène, 60
cyclogyros, 76

D

D-21 spy drone, 252
Damadian, Raymond, 178
dark matter, 289
DART (Double Asteroid Redirection Test), 278–279
Deep Blue supercomputer, 256–257
Deep Diver submersibles, 161
Deep Space 1 space craft, 260

deepsea-sea submersible, 109
defense nets, 99
defrosters, crops, 71
DeLorean DMC-12 car, 208
demolition bombs, 94
dendrochronology, 32
depression-era movies, 58
destroyers, 97, 104
detachable engines, cargo ships, 23
Dexter Hysol Cheetah, 250
d'Harlinque, Frenchman A. F., 24
diabetes, 30
"Dinkenish," 180
dinosaurs, 242
directional sound detectors, 79
Discovery space shuttle, 208
distance shooting, 126
DNA, 122, 212, 263
Dolly, sheep, 238
Double Asteroid Redirection Test (DART), 278–279
double-envelope house, 202–203
Douglass, A. E., 32
Dover House, 112–113
drag racing, 128
driving, winter, 170
drones, 229, 240, 252
drunk drivers, 156
dual-fan-propelled backpack helicopter, 276
Duru, Alexandru, 293
dust storms, 58–59
DVDs, 238
DynaTAC mobile phone, 190–191
Dzhanibekov, Vladimir, 244–245

E

Earheart, Amelia, 60
Earth, 120, 122, 181
earth mover, 125
earth-covered home, 199
Earthwinds balloon, 244–245
Eastman, George, 15
eBay, 240
Edison, Thomas, 14
EEG (electroencephalogram), 30
Ehman, Jerry, 182
Einstein, Albert, 12
electric car, 203
electric harpoons, 130
electric razors, 28
electric shovel, 64
electric soldering iron, 55
electricity, 12
electroencephalogram (EEG), 30
Electrolux vacuum, 28
electromagnetic waves, 15
electromagnets, 50
electron micrograph, 210
electron microscope, 60–61
ELISA blood test, 210
Elmqvist, Rune, 121
emission standards, 192
energy-saving homes 1980s, 215
Engel, Joel, 180
engineering, 48–49, 53
engines, 188, 192, 200
 detachable, 23
 rear-engine vehicle, 94
 rotary, 169
 turbine, 156
Enovid, 150

environment, 151
Environmental Protection Agency (EPA), 182
environmental reform, 182
EPA (Environmental Protection Agency), 182
eponymous musical instruments, 31
ESV (GM's experimental safety vehicle), 188
Etak Navigator, 225
Europa Clipper mission, 292–293
evolution, 32–33, 180
exoskeleton suits, 164–165
expanding universe, 242
experimental safety vehicle (ESV), 188
extraterrestrial, 182
eyeglass technology, 269

F

F4 Phantom I jet fighter-bomber, 158
F4F-3 Wildcat fighter jets, 97
F-4G Phantom II, 247
F-35 II helmet, 293
F-111 fighter bomber, 170
F-117 Nighthawk aircraft, 226
F-117A stealth bomber, 252
Falcon Heavy rocket, 272
fans, 42–43
Farman, Joe, 208
fiber-optic-guided missile, 218
fighter jets. *See specific fighter jets*
fighter pilots, 97
fighter-bombers, 158
films. *See* movies
fire department, 83, 135
fire engines, 156
fire trucks, 109
fishing simulator, 80–81
Flarecraft ground-effect machines, 248–249
Flavr Savr tomato, 241
Fleischman, Martin, 250
flight simulators, 22–23, 71, 161
Flivver, 46
Florey, Howard, 90
Fluid Concepts and Creative Analogies, 240
fluorescent ink, 130
flying cars, 46, 282–283
flying carts, 155
"flying Jeep," 163
"flying scissors" jetliner (AD-1), 188–189
flywheel, 183
Ford, 16, 150
forensic science, 212
fossils, 32
Freeman, Walter, 61
frozen food, 28
Fuller, Buckminster, 121, 166

G

gadgets, 28, 166
Gagarin, Yuri, 148
galaxies, 30
Galileo's 1633, 241
Gallo, Robert, 210
game pads, 289
Gameboy, 212
Gardiner, Brian, 208
Garn, Jake, 208
Garrigue, Hubert, 74–75
gas-powered hot-air balloons, 156

INDEX

gene editing, 270
genetic code, 270
genetically modified food, 241, 290
Genghis, 246-247
geodesic domes, 121, 166
German V2 rocket, 88
giant electric shovel, 64
Gibbon, Dr. John H. and Mary, 58
Gleevec cancer pill, 276-277
gliders, 64, 102
GMOs, 241, 290
GM's experimental safety vehicle (ESV), 188
GM's new rotary engine, 188
Gnat 750 drone, 240
Goldilocks planets, 272
gondola slung helium balloon, 291
Goodall, Jane, 151
Google, 240
Gossamer Albatross II, human-powered aircraft, 180
Gossamer Condor hand-glider, 180, 186-187
GPS, 225
Graf Zeppelin airship, 53
gramophone records, 15
Gray, Tom, 180
Great Depression (1930s), 58
Gregory, Dr. William K., 32
Gross Windenergieanlage windmill, 216-217
ground-effect machines, 248-249
Growian II windmill, 216-217
Grumman 698 tilt-engine VTOL aircraft, 216
Grumman F-14 Tomcat fighter jet, 180
Grumman Nutcracker aircraft, 196-197
Grumman vertical wind turbine, 199
gull-wing doors, 215
guns, distance shooting, 126
gyroscopic wheels, 41

H

HAART (highly active antiretroviral therapy), 210
Hafstad, Lawrence R., 120
Hahn, Otto, 60
Hale-Bopp Comet, 241
Hamilton's Pulsar watch, 184-185
hang-gliders, 180
HAPP (High Altitude Performance Platform), 225
harpoons, 130
"hatbox hangar," 74
Havilland Mosquito plane, 100-101
Hawking, Stephen, 91
H-bomb, 118
heart transplants, 152, 211, 275. *See also* artificial hearts; organ transplants
Heath Company, 220
heat-seeking missile, 218
heavier-than-air machine, 16-17
HeLa cells, 122
helicopters. *See specific types of helicopters*
heliocentrism, 241
heliostat power plant, 194-195
helium balloon, 244-245, 291
Hendrickson, Sue, 242
HERO 1 robot, 220
Hertz, Heinrich, 15
Heyerdahl, Thor, 91
Higgs boson, 271
High Altitude Performance Platform (HAPP), 225
high-definition sound, 238
highly active antiretroviral therapy (HAART), 210
high-speed trains, 290
high-torque motors, 160

highways, 32-33
Hitt, Fred G., 67
HIV (human immunodeficiency virus), 210
Hofstadter, Douglas, 240
Holland Tunnel, 32
Holonyak, Nick, 152
Holtzberg, Matti, 218
home gadgets, 28
home renovations, 135, 136, 158, 165, 283. *See also* houses
honeybees, 43
Hoove, Herbert, 52-53
Hoover Dam, 62-63
hormonal contraceptive, 150
horses, mechanical, 80
hot riveting, 34-35
hot-air balloons, 156
Hounsfield, Godfrey, 178
houses, 230. *See also* home renovations
 double-envelope, 202-203
 energy-saving homes 1980s, 215
 underground and earth-covered home, 199
hoverboards, 293
hovercrafts, 142-143, 280
Hubble Space Telescope, 238
Hull, Chuck, 211
human centrifuges, 110-111
human cloning, 238
Human Genome Project, 241, 270
human immunodeficiency virus (HIV), 210
human-powered plane, 186-187
hybrid racecar, 252
HydroEngine technology, 200-201
hydrofoil sled, 224-225
hydrophilic rubber, 139
Hyperloop high-speed trains, 290
hypersonic aircraft, 275
hypothetical "merry-go-round" power plants, 68

I

IBM personal computer, 208
IBM Simon, 238
IBM's Deep Blue supercomputer, 256-257
Ibn Saud, King of Saudi Arabia, 208
ibuprofen, 150
ice cycle, 45
image-editing software, 241
immunizations, 120
impossible plastic engine, 218
Inactivated Poliovirus Vaccine (IPV), 120
Incredible Ruby Ray, 152
Indian Space Research Organization, 271
industrialization era, 12-17
Indy car, 257
infrared tools, 252
innovation, 55
Innovation House, 283
insulin, 30-31
Intel's Touchstone Delta, 248
International Space Station, 233, 238
Internet, 152, 210, 238, 240, 268. *See also* computers
Intoximeter, 156
invisible fighter jet, 258-259
IPV (Inactivated Poliovirus Vaccine), 120
iRobot, 271
Iron Lung, 120
iron wheel, 68-69
irons, 28
Ivy Mike, 118

J

Jackson II, Clayton, 163
Jacuzzi, Roy, 151
James, Richard, 91
James Bond, 166, 168-169
Jansky, Karl, 90
Jansky's Merry-Go-Round, 90
The Jazz Singer movie, 30
Jeffreys, Alec, 212
Jeminson, Mae, 238
jet airliner, multideck passenger, 38
Jet Skis, 163
jet-drive aquaplane, 163
jet-driven boats, 160
Joachim, Mitchell, 286-287
Johanson, Donald, 180
Johnson, Lonnie, 208
Johnson's Sea Link submersibles, 161
Joliot, Frederic, 60
Jones, Dr. R. T., 188-189
Jurassic Park movie, 242

K

Kamen, Martin, 91
Karem, Abraham, 240
Karman line, 272
Kasparov, Gary, 256-257
KDKA radio station, 30
Kepler Space Telescope, 272
Kepler-186f planet, 272
Kidder, Ben, 36
King Kong movie, 58
King Tutankhamen's tomb, 32
Kipfer, Paul, 60
Kirner, Arpad, 70-71
Kodachrome photograph, 125
Kodak camera, 15
Kola Superdeep Borehole, 181
Kollsman Intrument, 152
Kon-Tiki, 91
Kremer Prize, 186-187
Kuhne, Eric, 285
Kuwait 's Silk City skyscraper, 285

L

Lacks, Henrietta, 122
Lacrosse spy satellite, 244
Lansdorp, Bas, 272
laptop computers 1980s, 220. *See also* computers
Large Hadron Collider, 271
Lartigue, Charles, 36
laser discs, 198-199
laser guns, 152
Lassen Volcanic National Park, 67
LED (light-emitting diode), 152
Levitt, I. M., 140-141
lifeshirts, 269
light-emitting diode (LED), 152
Link, Ed, 161
liquid-fueled rockets, 28
liquid-hydrogen-powered jet, 285
Lissaman, Peter, 180
lithium carbonate, 203
Little Nellie, 168-169
liver transplant, 152
Living Environments House, 230

lobotomy, 61
Lockheed F-117 Nighthawk aircraft, 212-213
Lockheed MQM-105 Aquila aircraft, 229
Loewy, Raymond, 80
log jams, 50
Lucy scull, 180
Lun Ekranoplan, 249
lung transplant, 152. *See also* organ transplants

M

MacCready, Paul, 180, 186-187
Mach I airliner, 188
Macintosh personal computer, 208, 223
maglev train, 248
Magnavox laser disc player, 198-199
magnetic resonance imaging (MRI), 178
magnets, 50
Maiman, Theodore, 152
MakerBot, 290
Manhattan Project, 88
manned maneuvering unit (MMU), 218-219
Marconi, Guglielmo, 14
Marianas Trench, 150
Mariner 9 spacecraft, 181
Mariner programs, 182
Mark I, Harvard, 92
Mars, 263
Mars One, 272
Mars Pathfinder mission, 238
Mars Together rover, 259
Martin's VentureStar space plane, 257
mass media, 30
Max Knoll, Max, 60
McAuliffe, Christa, 208
McCandless, Bruce, 208, 218-219
McDonnell Douglas supersonic transport, 203
mechanical horses, 80
media technology, 30
Meitner, Lise, 60
Meitnerium, 60
Merrill, Ralph, 215
meteorites, 118, 122
microscopes, 60-61
microwave-powered plane, 230-231
Miley, Denise, 62
military bases, 104
mind-controlled robots, 279
mine-sweepers, 224-225
Minicars RSV, 215
missiles, 140, 218. *See also* bombers
Missouri Botanical Garden, 19
MIT's Mobile Robotics Lab, 246-247
Mitsubishi VisiTel, 230
Miyamoto, Shigeru, 212
MMU (manned maneuvering unit), 218-219
mobile Internet, 238
mobile phones, 190-191, 238
model buildings, 35, 49
Model T, 16
molecular biologists, 122
Moller M400 Skycar hovercraft, 280
Monnett Monerai sailplane-motorglider kit plane, 218
monorail cars, 74
moon, 140-141, 148, 200, 271
Moore, Wendell, 173
Morris worm, 210
motor oils, 187
motorcycle tractor, 76
motorcycles, 43
motorglider kit plane, 218

motorized surfboards, 79
Motorola, 180
Motorola's DynaTAC mobile phone, 190-191
motors, outboard, 50-51. *See also* engines
motorskate, 45
Mount Hood, 126
mountaineers, 77
mouse, 208
movies, 30, 170, 180, 208, 242
 computer-generated, 242
 depression-era, 58
 use of mechanical horses, 80
mp3-players, 238
MRI (magnetic resonance imaging), 178
MS-DOS systems, 210
MTV station, 211
Mubarak, Burj, 285
Muehlmatt, Ernest, 156-157
Mulder, 110
multideck passenger jet airliner, 38
Musk, Elon, 268, 272, 290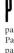
Mustang, 150
mustard gas, 90
Muster, Paul, 70-71

N

Nanogen, 263
NASA, 148, 188, 190, 257
National Oceanic and Atmospheric Administration (NOAA), 150
National Science Foundation Network (NSFNET), 210
natural satellite, 200
navigation system, 225
Navy Deep Drone, 259
Navy war planes, 98-99
near-Earth objects (NEOs), 278-279
Netscape Navigator, 240
New Deal, 62
Newman, Larry, 244-245
Nintendo, 212
nitrogen-jet backpack, 218-219
nitrogen-propelled manned maneuvering unit (MMU), 218-219
NMR (Nuclear Magnetic Resonance), 178
NOAA (Atmosphere Administration), 150
non-embryonic cells, 238
Noonan, Frederick, 60
Northrop Grumman B-2 Spirit Bomber, 212
Northrop Grumman hypersonic, 275
NSFNET (National Science Foundation Network), 210
nuclear fission, 60
nuclear fusion, 250
Nuclear Magnetic Resonance (NMR), 178
nuclear missile, 140
nuclear power plants, 208-209, 276

O

observation balloons, 24-25
Occupational Safety and Health Administration (OSHA), 45
Ocean Thermal Energy Conversion (OTEC), 216
oceanic exploration, 150
Ochoa, Ellen, 238
Oculus virtual reality headgear, 250-251
oil, 38, 208
Oldsmobile, 16
one-blade windmills, 216-217
one-man helicopter, 94-95
one-person flying machine, 133
Oppenheimer, Robert, 88

Oral Polio Vaccine (OPV), 120
organ donors, 152
organ transplants, 270, 275. *See also* heart transplants; lung transplant
Osbourne 1 computer, 220
OSHA (Occupational Safety and Health Administration), 45
Oswald, Lee Harvey, 148
OTEC (Ocean Thermal Energy Conversion), 216
outboard motors, 50-51
OV-10A Bronco, 163
oxyacetylene torches, 23
oxygen, 77
ozone layer hole, 208

P

pacemakers, 121
Pac-Man., 212
paint sprayers, 40
paleoanthropologists, 180
paleontologists, 242
panel trucks, 135
panic, combating, 100
parachuters, 24-25, 31
parachutes, 49, 98-99
passenger jet airliner, multideck, 38
Patterson, Clair Cameron, 77
PCV (positive crankcase ventilation), 150
PDA (Personal Digital Assistant), 238
pebble-bed nuclear reactors, 276
pedal-powered aircraft, 186-187
pedal-powered hang-glider, 180
penicillin, 30, 90
Pennsylvania's Shipping Port Atomic Power Station, 120
Pepper robot, 290
personal computers, 178
Personal Digital Assistant (PDA), 238
personal rapid transit (PRT) pod, 187
personal robots, 220
person-propelled aircrafts, 180
pesticides, 151
Pettis, Bre, 290
Pfister, Herbert R., 136
photography, 36
Photoshop, 241
photovoltaic cell, 182
Piccard, Auguste, 60, 109
pigmy zeppelin, 19
"the Pill," 150
pilots, 22-23, 88, 97
Pincus, Gregory, 150
Pinto's "impossible" plastic engine, 218
PistoLaser, 152
Pitchfork, Colin, 212
plane-carrying airship, 40
planes. *See specific types of planes*
planets, 211. *See also* Mars
plastic engines, 218
plastic houses, 230
plastics, 92
Plexiglas, 92
Plunkett destroyer, 96-97
pocket calculators, 190
Polaroid SX-70 camera, 190
Polimotor I plastic engine, 218
polio vaccine, 120
pollution, 1970s, 182
Pong game, 212
Pons, Stanley, 250
Pontiac mini-car, 173
Ponzi, Conman Charles, 31

INDEX

Pope John Paul II, 241
Popular Science Monthly, 12, 19, 240
portable saws, 36–37
positive crankcase ventilation (PCV), 150
postwar private planes, 102–103
Potts, William, 31
power plants, 68, 194–195
power-steering vehicles, 130
Predator drone, 240
President Eisenhower, 120
President Kennedy, 148
private planes, 102–103, 223
Project Blossom, 88
Project Iceworm, 155
Project Man in Sea, 161
Project Skyhook, 110
Prozac, 211
PRT (personal rapid transit) pod, 187
Puffin human-powered plane, 186–187

Q

Question Mark, 53

R

race-car drivers, 128–129
radar cross-section reduction, 212–213
radar detectors, 143
radar stations, 62
radar-guided missile, 218
radio headsets, 38
radio stations, 30
radio telescope, 90
radioactive elements, 14
radios, 14, 139
railplane, 64–65
railroad tracks, 135
rascal nuclear missile, 140
Raymond, Eleanor, 112–113
razors, 28
RCV-225 robot subs, 216
Reaction Engines A2 liquid-hydrogen-powered jet, 285
reactor bottom plate, 120
rear-engine vehicle, 94
Reber, Grote, 90
recumbent bikes, 46
refrigerators, 28
REM sleep, 121
remote-controlled multiscreen TV, 183
remotely piloted vehicle (RPV), 229
renewable energy, 193
reusable space shuttle, 208
rhinos, 271
Rickenbacker, Eddie, 38
Ride, Sally, 208
road expansion, 32–33
robo-breathalyzers, 156
robot subs, 216
robots, 220, 246–247, 280, 286, 290
Rock, John, 150
rockets. *See specific types of robots*
rocks, 118
Roentgen, Wilhelm, 14
Rohrer, Heinrich, 233
Roomba, 271
Roosevelt's New Deal, 62
rotary engine, 169
rotating antenna system, 90

Rotheim, Erik, 31
round boat, 72
row-powered recumbent bikes, 46
RPM, high-torque motors, 160
RPV (remotely piloted vehicle), 229
Ruben, Sam, 91
Rubin, Vera, 289
Ruggles, William G., 22–23
Ruggles orientator, 22–23
running shoe technology, 269
Ruska, Ernst, 60
Russian jets, 126–127
Rutan, Dick, 210
Rutan Voyager airplane, 210–211
Rutherford, Earnest, 15

S

SAFER (Simplified Aid for EVA Rescue), 218–219
Sagan, Carl, 182
sail bikes, 83
sailing ship simulation, 40
sailplane-motorglider kit plane, 218
sail-powered car, 193
Salk, Jonas, 120
Sanger, Margaret, 150
Santa Fe Steamliners, 125
satellites, 113, 136, 200, 244
Savin, Albert, 120
scale models, 35
scale spin, 67
scanning tunneling microscope, 233
Schick electric razor, 28
Schneekrad, 76
Schneider, Dr. Daniel, 200–201
Schütte-Lanz airships, 19
science, 90
Scopes, John T., 31
Scopes Trail, 31
scramjets, 226–227
screw-driven bus barrels, 45
SCUBA tanks, 131
SDVs (swimmer delivery vehicles), 148
Sea Doo boatercycle, 163
"sea gull boat," 71
SEALS Mark program, 143
section's rings, trees, 32
Sega's virtual reality headgear, 250–251
semiconductor, 92
Senning, Åke, 121
sequoia trees, 32
Sereno, Paul, 242–243
sexual revolution, 150
Shanklin, Jonathan, 208
SHARP-5 (Stationary High Altitude Relay Platform) plane, 230–231
Shaw, Henry, 19
ships, 20–21, 23. *See also* boats
shirt technology, 269
Shockley, William, 92
Shoemaker-Levy 9 comet, 252
shooting, distance, 126
short take-off, 196–197
shovels, electrical, 64
shuttles, airport, 105
silent films, 30
Silent Spring paper, 151
Silk City skyscraper, 285
Simplified Aid for EVA Rescue (SAFER), 218–219
Sketchpad, 152
ski wings, 67

skiing contraption, 83
skin technology, 269
Skunk Works program, 252
sky bus, 126
sky trains, 130
skyscrapers, 44–45
Slinky, 91
smartphone, 238
smoke screen, 100
SNAP! Multicar, 283
snow tires, 139
Snow White and the Seven Dwarfs movie, 58
Sojourner, 238
solar cells, 94
solar electricity, 200
solar energy, 113, 194–195, 268
Solar High Altitude Performance Platform (HAPP), 225
solar water heater, 197
solar-panel roads, 286–287
solar-powered cars, race, 228–229
soldering iron, 55
SoloTrek dual-fan-propelled backpack helicopter, 276
sound detectors, 79
South Pole, 15
Soviet Russia, 140
space crafts, 181, 260
space divers, 283
space exploration, 90, 120, 148
space missions, 274–275
space shuttles, 192, 208
space stations, 158–159
space weapons, 222–223, 280–281
SpaceX company, 272
special relativity, 12
speed limits, 165
speedriding, 74–75
Sputnik I satellite, 113, 120
spy planes, 260
SR-71 recon jet, 252
Stanford Prison Experiment, 181
Starship 1 private jet, 223
Stationary High Altitude Relay Platform (SHARP-5) plane, 230–231
Statue of Liberty restoration, 226
stealth technology, 212–213, 226, 252, 289
steam cars, 192
steamliners, 125
Stiblitz, George Robert, 92
Stirling engines, 200
Stopes, Marie, 150
stratosphere, 60
Strode, Victor W., 71
studded tires, 139
submarine probes, 260
submarines, 20, 67, 143, 167, 216
subway trains, 132–133
Sue *Tyrannosaurus Rex*, 242
Sunraycer, 228–229
sunrooms, air-bubble, 156–157
Super Mario Bros., 212
Super Soaker, 208
supersonic combusting ramjets, 226–227
superstealth aircraft, 226
surface-supplied air kit, 132–133
surfboards, motorized, 79
suspension bridges, 260–261
Sutherland, Ivan, 250–251
Swan, Joseph, 14
swimmer delivery vehicles (SDVs), 148
Symbolics.com, 211
synthesizers, 210

T

"tankettes," 80
tanks, 76
tanktread-fitted bathysphere, 72
Taung child, 32
T-cells, 210
telephones, 61
 answering machines, 192
 Bell's original telephone, 12
 car phones, 178, 180
 cell phones, 180
 Motorola's DynaTAC mobile phone, 190–191
 satellite communication, 200
 video calls, 230
telescoping platform, 83
television, 113, 118, 121, 171, 172–173, 183
Telkes, Dr. Maria, 112–113
Telstar-1 satellite, 148
TEM (Transmission Electron Microscope), 60
Terminator II movie, 242
Tesla, Nikola, 14, 91
Tesla electric car, 268, 272
test-driving cars, 128–129
tetraethyl fuel, 122
text-messaging, 238
thermonuclear device, 118
three light traffic signals, 31
3D printing, 211, 270, 290
three-point seatbelt, 151
Tiburon submarine probe, 260
time calculations, 184–185
time travel, 279
Timms, Daniel, 288–289
tires, snow, 139
TIROS-1 satellite, 148
Titanic, 15
toboggans, 38–39, 46–47
Todahl, John Olaf, 36
Tombaugh, Clyde, 61
Touchstone Delta, 248
Toy Story movie, 242
tractors, yard-dozer, 169
traffic signals, 31
trains
 electric, 125
 Hyperloop high-speed, 290
 railplane, 64–65
 sky, 130
 subway, 132–133
 Xplorer, 136–137
tramway, aerial, 126
transistor radio, 139
Transmission Electron Microscope (TEM), 60
transplants, 152
Trappist-I system, 272
tree ring records, 32
trick cars, 40
trucks, panel, 135
tuberculosis vaccine, 30
tunnels, 32–33
turbine engines, 156
turbine-electric hybrid racecar, 252
Turbo Chief, 156
TV antennas, 139
TV monitors, 140
TWA Flight 800, 259
Twitter, 268
two-man wet submarine, 143
two-stage rocket, 113

2001: A Space Odyssey movie, 170
Tyrannosaurus Rex, 242

U

underground home, 199
The Underwater World of Jacques Cousteau show, 172–173
unicycle, air-propelled, 24
universe, 30, 242
"unsinkable" round boat, 72
UPC scanner, 181
urban paradise, 286–287
Urbmobile, 169
Urry, Lewis, 121
U.S. Langley Research Center, 203
U.S. National Cancer Institute, 210
U.S. National Oceanic, 150
U.S. Navy Deep Drone, 259
U.S. Voyager program, 182
USS *Shenandoah* airship, 24
USS *Triton* submarine, 20
USS *Zumwalt*-class stealth destroyer, 289

V

V2 rocket, 88
vaccines, 30, 120
vacuums, 28
variable speech control (VSC) tape recorder, 195
vegetables, genetically modified, 241
VentureStar space plane, 257
vertical catenary turbine, 193
vertical distortion, 154–155
vertical short take-off, 196–197
vertical wind turbine, 74, 199
video calls, 230
video recordings, 238
video-games, 212
Virgin Galactic, 272
Virgin Hyperloop One, 290
viruses, 30, 90, 120, 210, 257
viruses (computer), 210, 232–233
vitamins, 1920s, 30
vitro fertilization, 181
volcanos, 67, 70–71
Volkswagen Rabbit, 195
Volvo, three-point seatbelt, 151
von Borries, B., 60
von Braun, Wernher, 160
voting machines, 35
Voyager program, 182
VSC (variable speech control) tape recorder, 195
Vulcoon hot-air balloons, 156
VW Golf, 195

W

wallet technology, 269
Wallis WA-116 Agile autogyro, 168–169
Walton, Harry, 140
Wankel engine, 192
war gliders, 102
The War of the Worlds movie, 61
war planes, 83. *See also specific war planes*
wartime tools, 88
washing machines, 28
watch technology, 269

watches, 184–185
water heater, solar, 197
water scarcity, 293
water toboggans, 38–39
Waterman, Waldo, 46
Watson-Watt, Robert, 61
weapons, 102, 222–223, 280–281, 286
weather satellite, 148
websites, 240
welding, 53
Welles, Orson, 61
Western black rhino, 271
wet submarine, 143
whale hunting, 130
Wikipedia, 271
Wild Weasel aircraft, 247
Wilmut, Ian, 238
wind farms, 76
wind tunnel, 203
wind turbine, 74
windmills, 216–217
Windmobile, 197
wing megaplane, 254–255
winged toboggans, 46–47
wingless airplanes, 72
women, in space, 238
wood-framed pigmy zeppelin, 19
World Solar Challenge, 228–229
Wright, Orville and Wilbur, 16

X

X-24B "lifting body" aircraft, 190
X-29 supersonic jets, 214–215
X-50A Dragonfly plane, 279
Xplorer train, 136–137
X-Rays, 14–15

Y

Yahoo! 240
Yamato 1 ship, 248
yard work, 165
"yard-dozer," 169
Yeager, Jeana, 210
Yost, Ed, 156
Youmans, Edward L., 19

Z

Zapata, Franky, 293
zeppelins, 19
zero-emission car, 183
Zumwalt-class stealth destroyer, 289
Zuse, German Konrad, 62

CREDITS & ACKNOWLEDGMENTS

Text Nic Albert
Design Price Watkins

Cover Art Credits
A warm thank you to the following illustrators, photographers, and graphic designers who contributed their talents to the *Popular Science* covers featured in this book:

Art Staff Inc., Austin & West Photography, Paul Alexander, James E. Bama, Stanley Bate, April Bell, Barry Bichler, Geoffrey Biggs, Robert E. Bingman, Kareem Black, Darren Blum, Robert D. Borst, Stephen Brodner, Reynold Brown, Jim Caccavo, Don Cameron, John B. Carnett, Michael Carroll, Travis Coburn, Dan Cornish, Corps of Engineers, US Army, Larry Cory, Fred Craft, Mel Crair, Alfred D. Crimi, Don Crowley, Daniels & Daniels, Harold Daniels, David Wiener Ventures, Don Davis, Walter Dey, Paul Dorsey, Danilo Ducak, William Duke, Dean Ellis, George Englert, George D. Erben, Marc Ericksen, Lester Fagans, Vincent Di Fate, Don Foley, Tom Fornander, Denver Gillen, John Gould, Orlando Guerra, Amy Guip, David A. Gustafson, A. J. Hand, Tom Haynes, Eric Heintz, Frederick J. Hoertz, W. David Houser, W. B. Humphrey, James Ibusuki, Greg Jarem, John Frassanito & Associates, Nick Kaloterakis, Craig Kavafes, Peter Kavanaugh, John Kealey, Ben Kidder, Ben Kocivar, Howard Koslow, Jo Kotula, Hugh Kretschmer, Harold W. Kulick, Frederico LeBrun, A. E. Leydenfrost, O. W. Link, Ted Lodigensky, Spencer Lowell, Hubert Luckett, John MacNeill, Jeffrey Mangiat, Ken Marschall, Robert McCall, Mark McCandlish, John T. McCoy Jr., John McDermott, Pierre Mion, W. W. Morris, Frank Murch, Matt Murphey, NASA, Herbert Paus, Toby Pederson, Phillippe Barriere Collaborative, Ray Pioch, PriestmanGoode, Ray Quigley, Tom Quinn, Travis Rathbone, Rockwell International Artist, Norman Rockwell, Jonathon Rosen, Clarence Rowe, Jerome Rozen, Terry Ryan, Bob Sauls, Greg Sharko, Arthur Shilstone, Remington Schuyler, Ted Streshinski, Ozzie Sweet, David Teich, Frederic Tellander, Ken Thompson, John Olaf Todahl, TRW Inc., The Voorhes, Harry Walton, Sigman-Ward, Tom White, Walter Wick, Edgar F. Wittmack, Ian Worpole, and Timothy Young.

All covers and interior artwork are copyright and courtesy of *Popular Science*. For each cover's credit, please see the individual caption.

We would also like to acknowledge the many artists whose works remain unattributed. We welcome the artists (or their family members) to identify themselves for attribution in future editions.

Additional Image Credits
Afro Newspaper/Gado/Getty Images: p. 88 (bottom) Courtesy of Arizona State Museum: p. 32 (bottom) Baden/Zefa/Corbis: p. 294 (mouse) Bettman/Getty Images: p. 119, p. 150 (bottom), p. 179 Barrington Brown/Science Source: p. 123 Burazin/Getty Images: p. 290 (corn) John B. Carnett/Getty Images: p. 243 Chronicle/Alamy Stock Photo: p. 29, p. 60 (bottom) Bernhard Classen/Alamy Stock Photo: p. 241 Contraband Collection/Alamy Stock Photo: p. 240 (bottom) Richard Cooke/Alamy Stock Photo p. 180 (top) Corbis: p. 276 (right; background) Culture-Images GmbH/Alamy Stock Photo: 208 (top) Thomas S. England/Getty Images: 208 (bottom) Everett Collection Historical/Alamy Stock Photo: p. 58 (top), p. 118 (top) Everett Collection Inc./Alamy Stock Photo: p. 30 (bottom) Courtesy of General Mills: p. 150 (top) Dennis Hallinan/Alamy Stock Photo: p. 149, p. 239 Ralf-Finn Hestoft/Getty Images: p. 212 (bottom) Historical/Getty Images: p. 181 Hulton Archive/Getty Images: p. 183 INTERFOTO/Alamy Stock Photo: p. 93 Keystone/Getty Images: p. 33 Keystone-France/Getty Images: p. 121 Courtesy of the Lacks family: p. 122 Library of Congress: p. 13, p. 28 (bottom) Chuck Nacke/Alamy Stock Photo: p. 209 NASA: p. 90 (bottom), p. 238 (bottom left, bottom right) PF-(bygone1)/Alamy Stock Photo: p. 92 PhotoDisc Inc.: p. 260 (left; hand) RGR Collection/Alamy Stock Photo: p. 242 Sergi Reboredo/Alamy Stock Photo: p. 180 (bottom) The Sally and Richard Greenhill Photo Library (Shadow Dexterous Robot Hand): p. 280 (left) Phillippe Barriere Collaborative: p. 283 (left) Shutterstock: p. 59, p. 89, p. 90 (top) Terry Smith/Getty images: p. 212 (top) Courtesy of the Smithsonian National Air and Space Museum: p. 211 Sueddeutsche Zeitung Photo/Alamy Stock Photo: p. 28 (top) Tom Kelley Archive/Getty Images: p. 151 US Bureau of Reclamation: p. 63 US National Library of Medicine: p. 14 (top), p. 15, p. 16, p. 17 Wikimedia Commons: p. 14 (bottom), p. 30 (top), p. 120 (top), p. 210 (top)

Icon Illustration Credits The Noun Project

Publisher Acknowledgments
Weldon Owen would like to thank Kevin Broccoli and Laura Cheu of BIM Creatives, Lily Miller, Mark Nicols, Kevin Toyama, and Marisa Solís for editorial assistance.

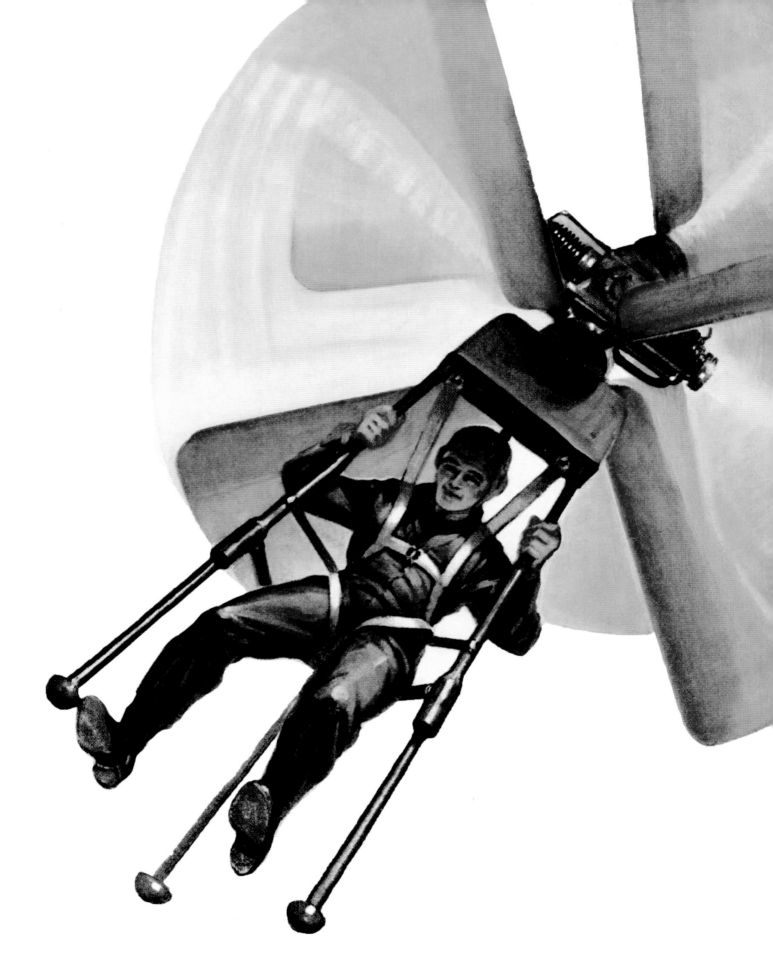

POPULAR SCIENCE

Popular Science and its logos are trademarks of Bonnier Corporation.
2 Park Avenue, New York, New York 10016
www.popsci.com

weldonowen

Weldon Owen is a division of Bonnier Publishing USA
www.bonnierpublishingusa.com
1045 Sansome Street, Suite 100, San Francisco, CA 94111
www.weldonowen.com

President & Publisher Roger Shaw
SVP, Sales & Marketing Amy Kaneko
Senior Editor Lucie Parker
Associate Editor Molly O'Neil Stewart
Creative Director Kelly Booth

Art Director Lorraine Rath
Production Director Michelle Duggan
Production Manager Sam Bissell
Production Designer Howie Severson
Imaging Manager Don Hill

Copyright © 2018 Weldon Owen

All rights reserved, including the right of reproduction in whole or in part in any form.

Library of Congress Cataloging-in-Publication Data

Title: The future then : fascinating art & predictions from 145 years of
 Popular science / Popular Science.
Description: First edition. | New York, New York : Weldon Owen, Popular
 Science, Bonnier, 2018. | Includes bibliographical references and index.
Identifiers: LCCN 2018002702 | ISBN 9781681882994 (hardcover : alk. paper)
Subjects: LCSH: Technological forecasting--History.
Classification: LCC T174 .F89 2018 | DDC 070.4/496--dc23
LC record available at https://lccn.loc.gov/2018002702
ISBN: 978-1-68188-299-4

10 9 8 7 6 5 4 3 2 1
2018 2019 2020 2021 2022

Printed and bound in China.